HERITAGE MATTERS

MAKING SENSE OF PLACE

MULTIDISCIPLINARY PERSPECTIVES

HERITAGE MATTERS

ISSN 1756–4832

Series Editors
Peter G. Stone
Peter Davis
Chris Whitehead

Heritage Matters is a series of edited and single-authored volumes which addresses the whole range of issues that confront the cultural heritage sector as we face the global challenges of the twenty-first century. The series follows the ethos of the International Centre for Cultural and Heritage Studies (ICCHS) at Newcastle University, where these issues are seen as part of an integrated whole, including both cultural and natural agendas, and thus encompasses challenges faced by all types of museums, art galleries, heritage sites and the organisations and individuals that work with, and are affected by them.

Previously published titles are listed at the back of this book

Making Sense of Place

Multidisciplinary Perspectives

Edited by

IAN CONVERY, GERARD CORSANE, AND PETER DAVIS

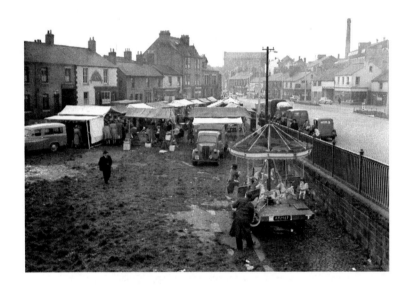

THE BOYDELL PRESS

First published 2012
The Boydell Press, Woodbridge
Paperback edition 2014

ISBN 978 1 84383 707 7 hardback
ISBN 978 1 84384 899 9 paperback

The Boydell Press is an imprint of Boydell & Brewer Ltd
PO Box 9, Woodbridge, Suffolk IP12 3DF, UK
and of Boydell & Brewer Inc.
668 Mt Hope Avenue, Rochester, NY 14620–2731, USA
website: www.boydellandbrewer.com

The publisher has no responsibility for the continued existence or accuracy
of URLs for external or third-party internet websites referred to in this book,
and does not guarantee that any content on such websites is,
or will remain, accurate or appropriate.

A CIP record for this book is available
from the British Library

This publication is printed on acid-free paper

Contents

List of Illustrations viii

Acknowledgments xi

Preface xiii
Doreen Massey

Introduction: Making Sense of Place 1
Ian Convery, Gerard Corsane and Peter Davis

HISTORIES, LANDSCAPES AND IDENTITIES

1 Land, Territory and Identity 11
 David Storey

2 Viewing the Emergence of Scenery from the English Lake District 23
 Mark Haywood

3 Cumbrians and their 'ancient kingdom': Landscape, Literature and Regional Identity 33
 Penny Bradshaw

4 Gypsies, Travellers and Place: A Co-ethnography 43
 Ian Convery and Vincent O'Brien

RURAL SENSE OF PLACE

5 Rural People and the Land 57
 Michael Woods, Jesse Heley, Carol Richards and Suzie Watkin

6 Hill Farming Identities and Connections to Place 67
 Lois Mansfield

7 Place, Culture and Everyday Life in Kyrgyz Villages 79
 Vincent O'Brien, Kenesh Dzhusupov and Tamara Kudaibergenova

8 Local Renewables for Local Places? Attitudes to Renewable Energy and the Role 93
 of Communities in Place-based Renewable Energy Development
 Jennifer Rogers, Ian Convery, Eunice Simmons and Andrew Weatherall

9 Health, People and Forests 107
 Amanda Bingley

Urban Sense of Place

10 Achieving Memorable Places … 'Urban Sense of Place' for Successful Urban
Planning and Renewal? 119
Michael Clark

11 The Place of Art in the Public Art Gallery: A Visual Sense of Place 133
Rhiannon Mason, Chris Whitehead and Helen Graham

12 Survival Sex Work: Vulnerable, Violent and Hidden Lifescapes in the North East 145
of England
Christopher Hartworth, Joanne Hartworth and Ian Convery

13 Gardens, Parks and Sense of Place 159
Ian Thompson

14 Gardens: Places for Nature and Human–Nature Interaction 169
Paul Cammack and Ian Convery

15 The Image Mill: A Sense of Place for a Museum of Images 177
Philippe Dubé

Cultural Landscapes

16 Making Sense of Place and Landscape Planning at the Landscape Scale 191
Maggie Roe

17 Cultural Landscape and Sense of Place: Community and Tourism Representations 207
of the Barossa
Lyn Leader-Elliott

18 Territorial Cults as a Paradigm of Place in Tibet 219
John Studley

19 Heritage and Sense of Place: Amplifying Local Voice and Co-constructing Meaning 235
Stephanie K Hawke

Conservation, Biodiversity and Tourism

20 Sense of Place in Sustainable Tourism: A Case Study in the Rainforest and 249
Savannahs of Guyana
Gerard Corsane and D Jared Bowers

21 Placing the Maasai 261
Mark Toogood

22 Nature Tourism: Do Bears Create a Sense of Place? 271
Owen T Nevin, Peter Swain and Ian Convery

23 What's Up? Climate Change and our Relationship with the Hills 279
Rachel M Dunk, Mary-Ann Smyth and Lisa J Gibson

24 Nature Conservation, Rural Development and Ecotourism in Central Mozambique: 291
Which Space do Local Communities Get?
Stefaan Dondeyne, Randi Kaarhus and Gaia Allison

25 Rainforests, Place and Palm Oil in Sabah, Borneo 303
Ellie Lindsay, Andrew Ramsey, Ian Convery and Eunice Simmons

Afterword: Untying the Rope 313
Josie Baxter

List of Contributors 321

Index 329

Illustrations

COVER IMAGES:

(Top) Peter Lehmann and Barossa grape growers in the weighbridge at Peter Lehmann Wines. *Image reproduced with kind permission of Peter Lehmann Wines, Barossa, South Australia.*

(Middle) Living in traditional felt Yurts, these herder families live in summer pastures (Jailoo) from late May to the end of September. © *Vincent O'Brien*

(Bottom) The Blue Planet: Earth from space. *Image courtesy of NASA and made available by The Visible Earth: http://visibleearth.nasa.gov/*

FIGURES

4.1. Caldewgate, early 1900s. *Image courtesy of www.cumbriaimagebank.org.uk* 49

4.2. Caldewgate (Paddy's Market) in the early 1950s. *Image courtesy of Cumbria Newspapers Group* 49

4.3. Caldewgate (Paddy's Market) 2010. *Authors' fieldwork* 50

6.1. Upland Habitats: Valley Floor to Fell Top. *Adapted from: Dodds et al 1996, 6, with permission from the Royal Society for the Protection of Birds (RSPB)* 56

6.2. A Typical Cumbrian Hill Farm. *Lois Mansfield* 57

6.3. Social Capital: local to local connections. *Lois Mansfield* 71

6.4. Arnstein's Ladder of Citizen Participation. *Adapted from: Mitchell 2002; Warburton 2004* 72

7.1. *Visible Voice* engages in collaborative ethnographic projects in the remote village communities of Bokonbaeva, Eky Naryn, Karakolka, Kokjar and Tolok. © *Vincent O'Brien* 80

7.2. Living in traditional felt Yurts, these herder families live in summer pastures (Jailoo) from late May to the end of September. © *Vincent O'Brien* 83

7.3. Located in a remote and windswept mountain valley, Tolok is home to around 800 ethnic Kyrgyz. © *Vincent O'Brien* 84

7.4. The Yurt provides a physical model of Kyrgyz cultural orientations. © *Vincent O'Brien* 87

7.5. The Yurt's structure provides an exceptionally mobile and durable habitat that simultaneously emphasises the co-dependency of people, spirits, earth and sky. © *Vincent O'Brien* 88

7.6. A circular opening in the roof of the Yurt, the Tunduk, provides a window between the middle world of people and the sky spirit world of Tengri. © *Vincent O'Brien* 89

7.7. A unique willow tree next to a small spring in a semi-arid region provides the focus for the sacred site at Manzhyly Ata. © *Vincent O'Brien* 90

8.1. Possible responses to a proposed RE installation as a product of interactions 94
 between attitudes towards technology, place and development process. *Jenny Rogers*
8.2. Pressures on rural communities such as Village A. *Jenny Rogers* 98
8.3. Compatibility of woodfuel heating schemes in Village A with factors affecting 101
 residents' sense of place. *Jenny Rogers*
10.1. Castlefield Canal Basin, Manchester, March 2010. *Michael Clark* 123
10.2. Bristol City Docks, September 2009. *Michael Clark* 124
10.3. Bristol City Docks, September 2009. *Michael Clark* 124
10.4. Poster advertising Urban Splash's 'Chips' development in front of derelict structure 126
 ripe for renewal or demolition, New Islington, Manchester, March 2010.
 Michael Clark
10.5. Urban Splash's 'Chips' apartment block shortly after completion, but not yet fully 126
 occupied, New Islington, Manchester, March 2010. *Michael Clark*
10.6. Urban Splash's successful conversion of the historic Royal William Yard, Plymouth, 127
 May 2010. *Michael Clark*
12.1. Summary of survival sex work lifescape. *After Hartworth et al 2010* 148
12.2. Daily drug spend (in sterling) for survival sex workers. *Source: Voices Heard (2007)* 150
12.3. Methods of payment for sex. *After Voices Heard 2007* 151
15.1. The Château Frontenac in all its architectural splendour. *Luc Antoine Couturier –* 178
 www.quebec-photo.com
15.2. *France Bringing faith to the Hurons of New France*; artist unknown, oil on canvas, 180
 late 17th century. *Collection du Monastère des Ursulines de Québec, Musée des*
 Ursulines de Québec, restored by the Centre de conservation du Québec
15.3. View of the Old Port of Quebec with the Bunge grain elevators that serve as a 182
 giant projection screen for *The Image Mill*. *Francis Vachon, 2009*
15.4. Panorama of *The Image Mill* taken during an evening screening. 184
 Francis Vachon, 2009
16.1. The multi-dimensional nature of landscape. *Source: Swanwick and Land Use* 192
 Consultants (2002)
16.2. The Blue Planet: Earth from space. *Image courtesy of NASA* 193
16.3. Wild ponies on Dartmoor. *Maggie Roe* 195
16.4. Selling to 'insiders': the representation of new settlements to potential Chinese 198
 buyers in Shenzhen, South China, provides some startling descriptions. *Maggie Roe*
16.5. Community Types. *Maggie Roe* 199
16.6. The Kent Downs Jigsaw Project, where local people took photographs then 201
 selected them in a community involvement exercise to construct a map that
 represented landscape identity. *By permission of Debbie Bartlett*
16.7. Cattle-dung sticks used for fuel drying outside the former home of the poet 202
 Rabindrinath Tagore, Bangladesh. *Maggie Roe*
17.1. Hillside vineyards and the Bethany Wines cellar door; similar images have been in 211
 use for about 20 years and are used on the Barossa website. *Image reproduced with*
 kind permission of Bethany Wines, Barossa, South Australia

17.2. Peter Lehmann and Barossa grape growers in the weighbridge at Peter Lehmann 212
Wines. *Image reproduced with kind permission of Peter Lehmann Wines, Barossa,*
South Australia

17.3. The *Barossa Valley Wall Hanging*, created by Vine Patch Quilters. 214
Left: Photograph: Douglas Coats. Right: Credit: Gerlinde Schaeffter

18.1. Tibetan nomads living in the *Obala valley* in Eastern Kham. © *John Studley 1995* 221

18.2. A *la-btsas* where *yul-lha* are honoured and territory numinised. © *John Studley 2001* 222

18.3. Map of the three *chol khar gsum* regions of Tibet (Kham, Amdo and Utsang).
© *John Studley 2005, revised 2010* 224

18.4. A Mosuo *daba* near Lugu Lake in South-eastern Kham. © *John Studley 2004* 225

18.5. Cognitive map of forest-related variables in Eastern Kham. © *John Studley 2005* 227

18.6. Cognitive map of young (16–25) respondents. © *John Studley 2005* 228

18.7. Cognitive map of old (51+) respondents. © *John Studley 2005* 228

20.1. Iwokrama Forest and Rupununi Communities. © *ICCHS (based on an original* 254
by the Iwokrama International Centre)

20.2. Iwokrama Reserve. *Photo D Jared Bowers* 256

20.3. Local Amerindian Home. *Photo Gerard Corsane* 258

23.1. The flow of carbon through upland peat expressed as (a) the relative amount of 284
carbon and (b) the relative amount of CO_2e. *Rachel M Dunk (after Worrall et al*
2009a and Worrall et al 2010)

24.1. Location of Gorongosa National Park and Chimanimani Transfrontier 292
Conservation Area in central Mozambique and new proposed boundaries of the
core zone of Chimanimani, leaving out settlement areas.
Stefaan Dondeyne, adapted from Ghiurghi et al, 2010

TABLES

5.1. Traditional and present-day markets for selected rural crafts. 61
Adapted from Collins 2004

6.1. Social capital and the upland farming system using Pretty and Ward's four-fold 70
description. *Lois Mansfield*

12.1. Sex prices. *After Voices Heard 2007* 151

18.1. Forest-related variables. © *John Studley 2005, revised 2010* 226

23.1. Anthropogenic sources of CO2, CH4 and N2O, their Global Warming Potentials, 280
and contribution to the enhanced greenhouse effect. *Rachel M Dunk (after IPCC*
1995 and IPCC 2007)

23.2. Indicative carbon storage and fluxes for a range of land use types. 282
Mary-Ann Smyth (after Ostle et al 2009 and Read et al 2009)

The authors and publisher are grateful to all the institutions and individuals listed for permission to reproduce the materials in which they hold copyright. Every effort has been made to trace the copyright holders; apologies are offered for any omission, and the publishers will be pleased to add any necessary acknowledgement in subsequent editions.

Acknowledgments

In recent decades academics from a wide variety of disciplines have been thinking and writing about sense of place. This edited collection contains contributions from some of the foremost researchers and academics working on place and provides an insight into the rich diversity of the ways of negotiating and understanding place. We offer special thanks and gratitude for the hard work and dedication of all the contributors, who have delivered fascinating texts, often in the face of obdurate demands from the editorial team.

Thanks are also due to our respective institutions, the University of Cumbria and Newcastle University. In particular, Ian Convery would like to thank Prof David Robson and Dr Owen Nevin from the National School of Forestry, University of Cumbria, who continue to accommodate his flights of fancy when he really ought to be teaching students. We would also like to acknowledge the help and assistance of all our colleagues and research students in the International Centre for Cultural & Heritage Studies (ICCHS), Newcastle University, who have helped to foster and develop our interest in place; special thanks are due to Helen Graham, Rhiannon Mason and Andrew Newman, who allowed us to use the ideas embedded in their in-depth review of theoretical approaches to thinking about place to develop our Introductory Chapter.

We are indebted to Catherine Dauncey, Publications Officer in ICCHS, who has provided support above and beyond the call of duty by dealing with the demands of the editors and the contributors, organising regular editorial meetings efficiently and reminding the editors of time-scales and deadlines. We would also like to thank Caroline Palmer at Boydell for her continued support, understanding and good humour as this book took on a life of its own and grew beyond our initial expectations.

Ian Convery, University of Cumbria
Gerard Corsane, Newcastle University
Peter Davis, Newcastle University

Preface

DOREEN MASSEY

In an age when we are constantly assailed by tales of the global, when the dominant motif is that of the network society or the prevalence of flow over stability, a book about 'sense of place' might come to some as a surprise. Can such a notion still have any purchase? The contributions to this collection demonstrate that it can.

Indeed, such a reflection might equally well be rephrased. For it seems that all the talk of flow and mobility is very frequently counterposed to an opposing view of the world which is one of local places deep and settled in the particularities of their individuality. There are some who bemoan the loss of such (imagined) places and the sense of place they are imagined to have engendered. But it is equally the case that many of the protagonists of the 'all is global flow' view of the world mobilise, to provide lift-off for their proposition, a counterposition with that same view that, once upon a time, all was settled bounded places. In fact, those who mourn the loss of such settled bounded places are mourning something that never was; and those who use such a notion as a launch pad for the announcement of a present disembedded globalism are standing on false ground. Neither the invocation of a past of untroubled authentic and simply local places, nor the appeal to a current world composed solely of movement and flow, has any real empirical validity.

On the one hand, the globalised world is not placeless. The most planetary of economic sectors, finance, has its feet very firmly on the ground. It conducts its activity of immaterial and global transactions from locations that are self-consciously 'places'. The worlds of the centres of finance in global cities – the City of London, for instance – not only have, but are consciously constructed to have, a 'sense of place' that gives off all the right signals: status, power, reliability (though that has come under some challenge recently!). The point is that globalisation is made in places and places matter to globalisation. Countless other examples could be cited.

On the other hand, 'a sense of place' never did arise from places that were internally homogeneous, or reproduced in unchanged form from generation to generation, or completely walled off from the wider world. It is important, in reasserting the continued relevance of place, therefore, to work with a much more mobile and complex imagination of what 'place' might be. The articles in this collection contribute to that kind of re-imagining.

What is presented here is a commendable variety of places and of senses of place. The geographical and cultural range of the kinds of places explored here points to the inadequacy of some of our hegemonic assumptions. Throughout there is an emphasis on place-making, in a variety of meanings, and thus of the constructedness of place. Places, and senses of place, do not, as some evocations would have us believe, arise organically out of the soil. They are the product of relations and interactions, both within the place itself and more widely. No place's 'sense of place' is constructed without relations with and/or influences from elsewhere. Nor is any place's associ-

ated 'sense of place' likely to be singular. Different social groups within any physical location may live those locations in very different ways. Elsewhere I have conceived of the 'throwntogetherness' of place, of place as meeting place. And that in turn points to the necessity of negotiation.

And that in turn raises the question of power, and of differential power. There are stories in this collection of the operation of such differential power, from local manoeuvrings to imperialistic impositions. Examples of the mobilisation of power (from top down to bottom up or somewhere in between) to construct ruling notions of what a place is, the identity of a people or group, or the characteristics of 'communities', so often thought to be co-terminous with territory. Such constructions may be mobilised for a host of reasons: for purposes of tourism, for the maintenance of order, for the maintenance of myths, for the very survival of a particular group. There are examples of all these, and more, here. Moreover, this enables a further thread of argument, that the nature of places, and of senses of place, is not static, not authentic in the sense of unchanging, but dynamic, always subject to further negotiation.

It is also true, as the collection recognises, that these ongoing makings of place and sense of place have effects – on politics, on the equally complex negotiation of the identity of a community, on the economic realm, on social relations within and beyond a place, and on the possibilities for a life, for individuals and for groups. It is in this way that 'sense of place' continues to matter but also why, while that is acknowledged, it must not be romanticised but rather explored in all its, often problematic, complexity. It is in this context that I welcome this book.

Introduction: Making Sense of Place

Ian Convery, Gerard Corsane and Peter Davis

This book draws together studies of 'sense of place', a concept defined, theorised and used across different disciplines in different ways. As Cosgrove (2004) notes, over the past two decades the social sciences have witnessed a shift towards more culturally and geographically nuanced work, taking approaches sensitive to the difference and specificity of events and locale. Put simply, understanding where events occur contributes a great deal to understanding how and why they occur.

Escobar (2001) questions: how do people encounter places, perceive them, and endow them with significance? We aim to offer a deeper understanding of 'where events occur'; in doing so (and borrowing from Lefebvre 1991) we explore place tensions between the 'always different' with the 'now repetition'. The general consensus of the authors is that the relationship between people and place is important for individual and community identity. Place, as distinct from space, provides a profound centre of human existence to which people have deep emotional and psychological ties and is part of the complex processes through which individuals and groups define themselves. Yet, as Escobar (2001) notes, space exerts hegemony over place, and he contrasts the absolute, unlimited and universal perception of space with what he argues is a limited, particular, local and bound notion of place in Western philosophy. Nevertheless, it is our inevitable immersion in place, and not the absoluteness of space, that has ontological priority in the generation of life and the real world (Casey 1996; Escobar 2001). Place is thus bound up in people's sources of meaning and experience; people and their environments, places and identities are mutually constructed and constituted (Harvey 2001). Similarly, Teo and Huang (1996, 310) view place as an 'active setting which is inextricably linked to the lives and activities of its inhabitants. As such places are not abstractions or concepts but are directly experienced phenomena of the lived world.' Such a feeling may be derived from the natural environment, but is more often made up of a mix of natural and cultural features in the landscape and usually includes the people who occupy the place. As Casey (1996, 18) indicates, 'to live is to live locally, and to know is first of all to know the places one is in'. Thus it is only through being in place that it is possible to perceive place.

Sense of place has been explored by different disciplines, drawing on different and sometimes directly conflicting theoretical and methodological traditions. Thus whilst there is a substantial body of literature which explores the relationship between people and place, it is impossible to provide a definition of place that works from all, and for all, perspectives (Escobar 2001, 152). Indeed, Shamai and Ilatov (2005) argue that 'sense of place' is often used to refer to multiple conceptualisations of place. This lack of a clear definition has led some commentators to argue that sense of place is an incoherent concept (Stedman 2003) with a chaotic literature (Jorgensen and Stedman 2006). Kaltenborn (1998, 172) also relates how sense of place resists 'any precise

definition ... there is no clear consensus on what the concept of sense of place should contain or how it should be constructed and measured scientifically'.

In this introductory chapter, which draws on previous work by the authors together with a comprehensive review of sense of place completed by Helen Graham, Rhiannon Mason and Andrew Newman from the International Centre for Cultural & Heritage Studies, Newcastle University (Graham *et al* 2009), we consider the key conceptualisations of 'sense of place', and in so doing would argue that there are two broad differences in the use of the term in the academic literature. In the first, sense of place or *genius loci* is used to explore a range of factors which together define the character, or local distinctiveness, of a specific place. In the second, the term has been used to emphasise the ways in which people experience, use and understand place, leading to a range of conceptual subsets such as 'place identity', 'place attachment', 'place dependency' and 'insiderness/insidedness'.

Places, as *genius loci*, can be thought of as being made up of a range of factors which include the topographical, the cosmological and spiritual, the built environment and people's emotional and psychological engagement with place. Theoretical and methodological considerations of place include social construction of place, how place meanings develop over time and how people become attached to places (Agnew 1987; Tuan 1977 and 1991; Massey 1994; Bender 2001; Brandenburg and Carroll 1995; Ingold 2000).

Human geography from the 1970s and early 1980s has been very influential in linking a sense of place with the idea of the rooted and healthy self. Buildings, streets or landscapes do not exist completely externally to the way people use and enjoy them on an everyday basis. Drawing on the philosophical approach of phenomenology and in particular Martin Heidegger's interest in spiritual unity between humanity and things, human geographers of the 1970s and 1980s were concerned about a perceived increasing sense of 'placelessness', an erosion of people's attachments to place (Relph 1976; Tuan 1977). Both Relph and Tuan emphasised how people inhabit place in a way which was not through conscious thought but through their bodies, feelings and emotions. Thrift (2004) also considers the relationship between place and human emotions and theorises the different ways in which a place can be (often subconsciously) interpreted.

Agnew (1987) has argued that place can be considered on two levels: first, 'location', which literally refers to fixed coordinates on earth and, second, 'locale', which relates to material settings such as the built/natural environment within which social relations are conducted. However, Agnew specifically reserves 'sense of place' to refer to the subjective and emotional attachments people have to place. Wilson (2003) has also examined the importance of exploring non-physical dimensions of place, embedded within culturally specific belief and value systems, which emphasise the social and spiritual aspects of place. Thus, as Doreen Massey (1994) states, rather than thinking of places as areas with boundaries around them, they can be imagined as articulated moments in networks of social relations and understandings. Massey (2002) also cautions that any notion of simply equating place with local community is highly problematic. People are networked to both local and extra-local places; hence they have a global sense of place and one that is locally specific (Massey 1994; Escobar 2001).

Within the fields of environmental and social psychology there has been continued interested in turning these ideas into indicators which can be explored in quantitative terms (Graham *et al* 2009). Thus 'place identity', 'place attachment' and 'place dependency' have been measured by social psychology researchers, most notably Shamai (1991), Williams (2000) and Shamai and Ilatov (2005). Williams, for example, works with two scales, one geared at a place attach-

ment measure specifically for tourism or recreational space and a second, broader, sense of place measure. Shamai and Ilatov, on the other hand, argue for the importance of what they term 'a bipolar measure', leaving room for both positive and negative feelings about place. Jorgensen and Stedman (2006, 316) use attitudinal approaches and predictive modelling to measure attachment to, dependence on and identification with place. Describing sense of place as a multidimensional construct representing beliefs, emotions and behavioural commitments, they argue that attitudinal approaches can better reveal complex relationships between the experience of a place and attributes of that place than approaches that do not differentiate cognitive, affective and conative domains. Work by Kaltenborn (1998) viewed sense of place as a complex affective bond of variable intensity, and he ranked sense of place along a continuum from weak to strong (after similar work by Shamai 1991).

Hay (1998, 6) used a mix of social surveys and ethnography to investigate the importance of time and duration of stay in relation to sense of place, and suggests that 'if a person resides in a place for many years, particularly if that person is raised there, then he or she often develops a sense of place, feeling at home and secure there, with feelings of belonging for the place being one anchor for his or her identity'. Hay also notes that age stage, insider status, local ancestry and the development of an adult pair bond are important factors in the development of a more rooted sense of place.

Given the plurality of approaches, it is perhaps unsurprising that there is very little agreement on how place identity, place attachment and place dependency interrelate (Graham *et al* 2009). Giuliani (2002) defines place attachment as both the product of attaching oneself to a place and a product of this process, and this process has been used to refer to the strong bond that exists between people and places (Altman and Low 1992) and how this relationship might develop over time (Giuliani and Feldman 1993), to the extent that when places 'that are central to our identities' are threatened by change 'we are willing to fight' (Stedman 2003, 577). Twigger-Ross and Uzzell (1996) explored the relationship between place attachment and identity in a study of 20 people living in London's Surrey Docks, an area redeveloped during the late 1980s and early 1990s. They identified three principles of place identity: distinctiveness (the way people use place to distinguish themselves from others); continuity (concept of self preserved over time, places allow a sense of continuity throughout the life course); and self-esteem (using place to create a positive evaluation of yourself). Perhaps most importantly, there is acceptance that 'place attachment' can form at a variety of geographical and spatial scales (Nanzer 2004).

Livingston *et al* (2008) identify two key factors that can lead to erosion of place attachment, namely crime and a high population turnover. They argue that these have the effect of eroding trust. Other studies have noted that crime reduces place attachment, while high neighbourhood levels of home ownership are likely to generate a strong sense of place (for example, Brown *et al* 2003). As Graham *et al* (2009) observe, the over-riding finding of Livingston *et al*'s research is that social cohesion leads to place attachment. Similarly, Lewicka (2005) argues that place attachment, civil participation and social cohesion are intimately linked and mutually reinforcing. Though as Devine-Wright (2009) indicates, a contemporary emphasis upon the socio-political aspects of place, where attachments are influenced by group level interests, can lead to negative experiences of familiar places and sometimes the desire to leave or escape.

Graham *et al* (2009) discuss how place dependence, sometimes referred to in the social and environmental psychology literature as 'functional attachment', refers to the ways a place allows us to achieve our goals or carry out certain activities (Schreyer *et al* 1981; Stokols and Schumaker

1981). Some researchers have emphasised the importance of cityscape/landscape in creating possi-
bilities for place dependency (for example, Williams and Vaske 2003). Place dependency has
been linked to place identity via the idea of self-efficacy developed by Korpela (1989). Both
place dependency and self-efficacy tend to be used to describe the ways in which an individual
will form stronger attachments to place when that place enables them to achieve their personal
goals (Graham *et al* 2009).

The relatively structured approach used by environmental and social psychology to investigate
sense of place has, however, been criticised by a number of authors. Lewicka (2005, 392) cautions
that it is very important not to conflate different elements of sense of place, stating the need
to avoid 'conceptual overlaps that are not easy to disentangle'. Graham *et al* (2009) argue that,
rather than pre-determine sense of place through the use of scales and indicators, people should
be allowed to themselves define place, thus allowing an understanding of what engagement with
place might mean for an individual (see also Walsh 1992). Similarly, Hawke (2010) contends
that the use of structured questionnaires runs counter to the teasing out of tacit understandings
of place and place relationships.

By contract, social anthropology has been interested in the complex nature of places in daily
lived experience, approached through what is called 'thick description', which aims to understand
individual people's behaviour by locating it within wider contexts (Graham *et al* 2009). As Geertz
(1996, 240) argues, 'to study place or, more exactly, other's sense of place, it is necessary to hang
around with them … no one imagines some sort of dataset to be sampled, tabulated and manipu-
lated'. In social anthropology, sense of place is evoked precisely to explore the difficult to grasp
'livedness' of place (Stewart 1996), places as they are experienced through everyday life. Bender
(2001) considers boundaries between persons and things to be osmotic and creative of one
another; people, places and spaces are intimately linked and dynamic, so that landscapes work
and are worked on many different scales. This 'cultural landscape' perspective has been talked
about as a way of seeing (Cosgrove 1985), a text that can be read (Duncan 1995) or a theatre
where society acts out its dominant values (Daniels 1993). Ingold maintains that such relation-
ships (between people and landscapes) necessarily require the 'involvement of whole persons
with one another, and with their environment, in the ongoing process of social life' (2000, 285).

What is central to these perspectives is the view that cultural meanings of landscape are not
universal but specific to particular societal groups. Such meanings are not simply an extra dimen-
sion, less important than more obvious forms of representation such as religion or class; they are
inseparable from it (Graham *et al* 2009). As Escobar (2001) observes, landscape is endowed with
agency and personhood. Indeed, what cultural landscapes mean or how they are organised are
part of complex processes through which individuals and groups define themselves. Such notions
are bound up in 'people's sources of meaning and experience' (Castells 1997, 6).

Cantrill and Senecah (2001) put forward the idea of 'self-in-place', meaning our combined
senses of place and the environmental self. They argue that 'it is from the vantage of a "sense of
self-in-place" that humans understand and process various claims and arguments regarding the
human relationship to and responsibilities for managing the natural world.' They develop this
theme, suggesting that 'If we assume that the human dimension of ecosystem management is
important … a central component of this dimension must involve understanding how people
construct their sense of self in place.' In this way, the living and non-living are not distinct and
separate domains, social relations encompass more than mere humans (Escobar 2001).

This short introductory section has explored the complex and often contested nature of sense

of place. Whilst numerous definitions exist, sense of place is perhaps most simply considered as an overarching concept which subsumes other concepts describing relationships between human beings and spatial settings (Shamai 1991, cited in Jorgensen and Stedman 2001, 233). It is an important source of individual and community identity and provides a profound centre of human existence to which people have deep emotional and psychological ties (Teo and Huang 1996). As Hawke (2010) notes, sense of place is a notion permeating every aspect of the humanities. It mediates our relationship with the world and with each other. It can be an intimate, deeply personal experience, yet also something which we share with others. It is at once recognisable but never constant; rather, it is embodied in a flux of familiarity and difference, as Lefebvre (2004, 6) eloquently observes: 'there is always something new and unforeseen that introduces itself into the repetitive: difference'. This book seeks to illuminate this nexus through five interlinked sections: *Histories, Landscapes and Identities*; *Rural Sense of Place*; *Urban Sense of Place*; *Cultural Landscapes*; and *Conservation, Biodiversity and Tourism*.

In *Histories, Landscapes and Identities*, David Storey provides a link to historical considerations of people and place through a detailed discussion of land, territory and identity. Storey draws on examples from Britain and Ireland to illustrate that the bonds between people and place serve as an integral component of identity. Penny Bradshaw and Mark Haywood then provide an historical and literary context to sense of place. They discuss the evolution of landscape and identity through complementary explorations of the Lake District and its importance to local identity, the Romantic Movement and the emergence of the picturesque. In the final chapter of this section, Ian Convery and Vincent O'Brien consider identity and cultural change in the gypsy and traveller community of Cumbria through an innovative co-ethnographic study.

In *Rural Sense of Place*, Michael Woods *et al* explore changing connections between rural people and the land. They discuss new opportunities for rural communities linked to tourism activities and also how new cultural practices might emerge to tackle climate change and its consequences. Lois Mansfield considers UK hill farming identities and connection to place before Vincent O'Brien *et al* look at land, culture and everyday life in Kyrgyz villages through a participatory visual sociology project. Rogers *et al* then take us back to the UK with a study of community-based renewable energy schemes, which re-establish links between communities and locally sourced energy supply. Amanda Bingley concludes this section with an overview of sense of place in relation to health, people and forests.

In the next section Mike Clark shifts the debate from rural to urban and considers the role of planning in achieving urban renewal and what he terms 'memorable places'. Chris Whitehead *et al* offer a discussion of art, identity and the city based on a project in Newcastle upon Tyne. Christopher Hartworth *et al* then look at the dynamics of what they term survival sex work in the North East of England. The following two chapters consider sense of place in relation to garden locations: Ian Thompson discusses how the created landscapes of botanic gardens and parkland are both new landscapes but take visitors to other, imagined environments. Paul Cammack and Ian Convery then discuss suburban gardens through the lens of birdwatching. Philippe Dubé concludes this section with a consideration of how a cultural event was used to chart the history of Quebec City, using visual technologies to echo a sense of place.

In *Cultural Landscapes*, Maggie Roe explores sense of place in relation to large-scale landscapes in India and Bangladesh, while Lyn Leader-Elliott describes how place is interpreted and understood by communities involved in small-scale and local heritage projects in Australia. John Studley then provides a rich account of Territorial cults as a paradigm of place in Tibet before

Stephanie Hawke concludes this section with a discussion of sense of place and the ecomuseum movement through a case study of heritage and community in the North Pennines, England.

Gerard Corsane and Jared Bowers commence the final section on *Conservation, Biodiversity and Tourism* with a discussion of sense of place and sustainable tourism, based on a case study of the rainforest and savannahs of Guyana. Mark Toogood then asks whose sense of place is considered in the increasingly complex dynamics of Kenyan conservation, before Owen Nevin *et al* discuss the role of charismatic carnivores in creating a sense of place for nature tourists. Rachel Dunk *et al* broaden the focus on communities, energy and carbon by investigating 'community carbon management' across a range of contexts from local to global. Stefaan Dondeyne *et al* then consider the emergence of community development approaches to conservation in post-conflict Mozambique and ask which space do local communities get? Finally in this section, Ellie Lindsay *et al* discuss the contested nature of conservation landscapes through the prism of rainforest conservation and oil palm plantations in Borneo, Malaysia.

In the Afterword, Josie Baxter explores the importance of place in the 'rhythms of everyday life' and considers the loss of tacit knowledge and understanding associated with particular ways of life.

The concept of sense of place is multitheoretical, complex and contested. The literature is often chaotic and 'sense of place' may simultaneously appear [apparent/confused]; [elusive/evident]; [consistent/contradictory]; [ambiguous/distinct]. It is also a very powerful medium for framing the relationship between people, place and events, and the chapters in this book, written from a range of different disciplines and perspectives, capture the complexity and power of sense of place in a way that no single disciplinary study could hope to do. We hope you enjoy reading it as much as we have enjoyed our role as editors.

BIBLIOGRAPHY AND REFERENCES

Agnew, J, 1987 *Place and politics*, Allen and Unwin, London

Altman, I, and Low, S M, 1992 *Place Attachment*, Plenum Press, New York

Bender, B, 2001 Landscapes on-the-move, *Journal of Social Archaeology* 1, 75–89

Brandenburg, A M, and Carroll, M S, 1995 Your place, or mine: the effect of place creation on environmental values and landscape meanings, *Society and Natural Resources* 8, 381–98

Brown, B B, Perkins, D D, and Brown, G, 2003 Place attachment in a revitalizing neighborhood: Individual and block levels of analysis, *Journal of Environmental Psychology* 23, 259–71

Cantrill, J G, and Senecah, S L, 2001 Using the 'sense of self-in-place' construct in the context of environmental policy making and landscape planning, *Environmental Science & Policy* 4, 185–203

Casey, E, 1996 How to get from space to place in a fairly short stretch of time, in *Senses of Place* (eds S Feld and K H Basso), New Mexico School of American Research Press, Santa Fe

Castells, M, 1997 The Power of Identity, The Information Age: Economy Vol II, *Society and Culture*, Blackwell, Oxford

Cosgrove, D, 1985 Prospect, perspective and the evolution of the landscape idea, *Transactions of the Institute of British Geographers* 10, 45–62

— 2004 Landscape and Landschaft, *GHI Bulletin* 35, 57–69

Daniels, S, 1993 *Fields of vision: landscape imagery and national identity in England and the United States*, Polity Press, Cambridge

Devine-Wright, P, 2009 Rethinking NIMBYism: the Role of Place Attachment and Place Identity in Explaining Place-protective Action, *Journal of Community Applied Sociology* 19 (6), 426–41

Duncan, J, 1995 Landscape geography, 1993–94, *Progress in Human Geography* 19, 414–22

Escobar, A, 2001 Culture sits in places: reflections on globalism and subaltern strategies of localization, *Political Geography* 20, 139–74

Geertz, C, 1996 Afterword, in *Senses of Place* (eds S Feld and K H Basso), New Mexico School of American Research Press, Santa Fe

Giuliani, M V, 2002 Theory of attachment and place attachment, in *Psychological theories for environmental issues* (eds M Bonnes, T Lee and M Bonaiuto), Ashgate, Aldershot

Giuliani, M V, and Feldman, R, 1993 Place attachment in a developmental and cultural context, *Journal of Environmental Psychology* 13, 267–74

Graham, H, Mason, R, and Newman, A, 2009 *Literature review: Historic Environment, Sense of Place, and Social Capital*, International Centre for Cultural & Heritage Studies, Newcastle University, available from:

http://hc.english-heritage.org.uk/content/pub/sense_of_place_lit_review_web1.pdf [21 June 2011]

Harvey, P M, 2001 Landscape and Commerce: creating contexts for the exercise of power, in *Contested Landscapes: Movement, Exile and Place* (ed B Bender and M Winer), Berg, Oxford

Hawke, S, 2010 *Sense of Place, Engagement with Heritage and Ecomuseum Potential in the North Pennines AONB*, unpublished thesis, Newcastle University

Hay, R, 1998 Sense of place in developmental context, *Journal of Environmental Psychology* 18, 5–29

Ingold, T, 2000 *The Perception of the Environment: Essays on Livelihood, Dwelling and Skill*, Routledge, London

Jorgensen, B, and Stedman, R, 2001 Sense of place as an attitude: lakeshore owners' attitudes towards their properties, *Journal of Environmental Psychology* 21, 233–48

— 2006 A comparative analysis of predictors of sense of place dimensions: attachment to, dependence on, and identification of lake shore properties, *Journal of Environmental Management* 79, 316–27

Kaltenborn, B P, 1998 Effects of sense of place on responses to environmental impacts, *Applied Geography* 18, 169–89

Korpela, K, 1989 Place-identity as a product of environmental self-regulation, *Journal of Environmental Psychology* 9, 241–56

Lefebvre, H, 1991 *The Production of Space*, Blackwell Publishers, Malden

— 2004 *Rhythmanalysis: Space, Time and Everyday Life*, Continuum, London

Lewicka, M, 2005 Ways to make people active: The role of place attachment, cultural capital and neighbourhood ties, *Journal of Environmental Psychology* 25, 381–95

Livingston, M, Bailey, N, and Kearns, A, 2008 *People's Attachment to Place: The Influence of Neighbourhood Deprivation*, Joseph Rowntree Foundation, York

Massey, D, 1994 *Space, place and gender*, Polity Press, Cambridge

— 2002 Globalisation: What does it mean for geography? Keynote lecture presented at the Geographical Association Annual Conference, UMIST, April 2002

Nanzer, B, 2004 Measuring Sense of Place: A Scale for Michigan, *Administrative Theory & Praxis* 26, 362–82

Relph, E, 1976 *Place and placelessness*, Pion Ltd, London

Schreyer, R, Jacob, G, and White, R, 1981 Environmental meaning as a determinant of spatial behaviour in recreation, in *Proceedings of the Applied Geography Conferences* 4, 294–300

Shamai, S, 1991 Sense of place: an empirical measurement, *Geoforum* 22, 347–58

Shamai, S, and Ilatov, Z, 2005 Measuring sense of place: methodological aspects, *Tijdschrift voor Economicshe en Sociale Geographie* 96, 467–76

Stedman, R C, 2003 Is it really just a social construction? The contribution of the physical environment to sense of place, *Society and Natural Resources* 16, 671–85

Stewart, K, 1996 A place on the side of the road, in *Senses of Place* (eds S Feld and K H Basso), New Mexico School of American Research Press, Santa Fe

Stokols, D, and Shumaker, S A, 1981 People in places: A transactional view of settings, in *Cognition, Social Behavior, and the Environment* (ed J H Harvey), L Erlbaum, Hillsdale, NJ

Teo, P, and Huang, S, 1996 A Sense of Place in Public Housing: a Case Study of Pasir Ris, Singapore, *Habitat International* 20, 307–25

Thrift, N, 2004 Intensities of Feeling: Towards a Spatial Politics of Affect, *Geografiska Annaler: Series B, Human Geography* 86, 57–78

Tuan, Y F, 1977 *Space and Place*, Arnold, London

— 1991 A view of geography, *Geographical Review* 81, 94–107

Twigger-Ross, C L, and Uzzel, D L, 1996 Place and Identity Processes, *Journal of Environmental Psychology* 16, 205–20

Walsh, K, 1992 *The Representation of the Past: Museums and Heritage in the Postmodern World*, Routledge, London

Williams, D R, 2000 *Notes on Measuring Recreational Place Attachment*, available from: www.fs.fed.us/rm/value/docs/pattach_notes.pdf [14 June 2009]

Williams, D R, and Vaske, J J, 2003 The Measurement of Place Attachment: Validity and Generalizability of a Psychometric Approach, *Forest Science* 49 (6), 830–40

Wilson, K, 2003 Therapeutic landscapes and First Nations peoples: an exploration of culture, health and place, *Health & Place* 9, 83–93

Histories, Landscapes and Identities

Land, Territory and Identity

David Storey

Identity is a complex, multi-faceted and many layered phenomenon which refers to our understandings of both self and others. While it might be tempting to regard identities as fixed social categories it would seem more realistic to view them as multiple, fluid, unstable and relational (see Keith and Pile 1993; McDowell 1999). An individual may have a number of identities linked to gender, ethnicity, and so on and these identities will rest partly upon what a person is not, as well as on what they are (or on what they or others perceive them to be or not to be). For example, as well as a positive affirmation of identity, being Welsh can also imply not being English. Simultaneously, in defining ourselves in certain ways, we may also be implicitly acknowledging a shared collective identity. If an individual defines themselves as Irish, it reflects a sense of their personal identity while simultaneously acknowledging membership of a broader 'imagined community' (Anderson 1991). There are a myriad of elements which contribute to identity and place may be one of these, reflected in a sense of belonging in a certain place or of a feeling of affinity with a place. For some there is a sense of attachment to land linked to ideas of home, locality and region. We can also recognise broader connections between land and national identity mediated through ideas of a national territory. Rather than being viewed simply as portions of geographic space, territory implies notions of ownership, power and control whereby that space is utilised for the attainment of particular outcomes (Sack 1986; Storey 2001; Delaney 2005; Elden 2010). Drawing on academic and literary sources, this chapter explores some of the connections between land, territory and identity through an exploration of two key strands; the first focuses on the micro-scale with particular emphasis on the rural arena. The second focuses on the importance of land within nationalist discourses. The division between the local and the national is of course far from discrete and the manner in which scale is 'constructed' has engendered much debate (Brenner 1998; Herod and Wright 2002). Furthermore, personal, local, regional and national scales of analysis (however these may be framed) are cross-cut by issues of gender, ethnicity and other social categorisations (Bell and Valentine 1995; Cloke and Little 1997; Nelson and Seager 2004).

LAND AND LOCAL IDENTITY

Precisely what we mean by place remains extremely elusive (Massey 2005) but it is apparent that people form bonds with place and this attachment may serve as an integral component of self-identity. Within a humanistic tradition, the importance of place and people's connection to place has been emphasised (Tuan 1974; Holloway and Hubbard 2001; Cresswell 2004). This tendency may be more overt for some people in certain places rather more than for others. This 'sense of place' may be associated with places we like, perhaps where we grew up or places with fond memories and associated positive experiences. Equally, places in which bad experiences

happened, or in which tragic events occurred, may be seen in quite negative terms. Whether place associations are positive or negative, what seems certain is that places 'are the focus of personal sentiments, with the feelings for place permeating day-to-day life and experience' (Muir 1999, 274).

Personal or family identity intersects with place both in the sense of home as the domain of a 'private' domestic life and a rootedness within a locality. Some families may feel they are firmly embedded in that place over many generations. In the case of farm families, while land can be viewed as an economic resource, this materialist perspective sometimes overshadows the sense that land can also be seen as a component in people's social or cultural make-up. While acknowledging functional and utilitarian interpretations, we also need to remember this more nebulous relationship. In considering farming specifically, there is a need to be mindful of the complex connections between farmers and the countryside and their relationships to the spaces in which they live and work (Holloway 2002). Some farmers have a deep knowledge of, and feeling for, their own land, gained over the years from early childhood so that the land and the surrounding environment are an integral part of their being. A broader version of this can be seen in the ancient tradition in England of beating the bounds of a parish, a custom associated with demarcating and reinforcing territorial boundaries in an era before maps and serving as a reminder of local church-sanctioned versions of community and locality (Olwig 2008). Economistic models of farmer decision-making that assume farms operate as businesses, with farmers as rational managers, ignore many intangible elements. Farmers may be motivated by more than profit maximisation and land may be regarded not simply as a factor of production but as a central element in their identity. This cultural significance is encapsulated by Scottish song-writer Dougie MacLean:

> It's the land – it is our wisdom
> It's the land – it shines us through
> It's the land – it feeds our children
> It's the land – you cannot own the land
> The land owns you (Lyrics available at www.dougiemaclean.com)

While acknowledging the connections between land and identity, it is important not to overly romanticise these, so some caution is necessary. Four key intermeshing issues here are the 'naturalising' of links between people and place, the elevation of agriculture as a worthy economic activity, romanticised notions of rural life and the idealisation of 'home' and 'community'. There is a danger of fetishising the links between people and place whereby these linkages are seen as 'natural' rather than conditioned via a variety of social, economic and cultural processes (Harvey 1996). In some discourses this may feed into a somewhat fundamentalist notion of the importance of the land and the rural, with 'tilling the soil' and 'working the land' seen as intrinsic to a natural, wholesome way of life in which the family farm household is a natural social unit, a characterisation often related quite closely to religious discourses. These somewhat rose-tinted perspectives ignore or gloss over other realities (Newby 1979).

Although farmers may have a deep-seated knowledge of 'their' land, this relationship may also reflect feelings of power, ownership and control over the landscape, manifested in a sense of custodianship, caring for the land until it is passed onto a future generation. A farmer may feel a sense of pride in having 'tamed' and cultivated the fields or having bent nature to his/her will, a domestication of the land well captured in Irish writer John B Keane's novel *The Field*. The central character,

'Bull' McCabe, takes pride in converting a rocky field (which he rents but hopes to buy) into pasture. The film version also sees McCabe voice his dislike of nomadic Irish travellers who are to be despised precisely because they are deemed to have lost their connection to the land.

Despite profound changes in the nature of rural localities, idyllic depictions of rural life have a long history, bolstered in part by a reaction to the rapid industrialisation and urbanisation of the 19th century which contributed to the elevation of rural landscapes and romanticised portrayals of rural life (Mingay 1989; Short 1991; Bunce 1994; Yarwood 2005). Within these sanitised constructions the presumed connections between rurality and community have been emphasised, with the rural portrayed as an environment characterised by close communal bonds and feelings of mutuality. Alongside this are depictions of 'rural people' as more honest, less materialistic and somehow more 'innocent': simplified portrayals which mask other realities including poverty, deprivation and social fractures. Embedded within these idyllicised portrayals of rural life are assumptions about the positive values of community and home. Idyllic constructions of the rural have played a role in attracting migrants to rural areas. Counterurbanisation has been a marked trend throughout Western Europe and North America for many decades and the pursuit of a more idyllic lifestyle is clearly one element influencing this (Halfacree 1994; Mitchell 2004; Stockdale 2010). While much attention has been given to this version of an escape to the countryside, there have been other long-standing, persistent and varied forms of 'back to the land' movements in the UK, USA and elsewhere (Halfacree 2007). Although individual motivations may differ, a desire to return to nature or to be closer to the land seems to be a significant driver, tendencies that seem to dovetail with wider philosophies of reconnecting land and people (Berry 1996; Pretty 2007).

Despite rose-tinted views of the countryside, the reality may be at variance with the ideal. Some farmers may indeed love their land and their occupation, but for others it may be a harsh and gruelling existence. Growing up on a farm may be far from romantic and the wish to escape from it may be overwhelming. Despite notions of rural areas as idyllic locations in which to raise children, young people themselves may hold more complex and contradictory views on a rural upbringing (Matthews *et al* 2000; Jentsch and Shucksmith 2003; Rye 2006; Valentine *et al* 2008). 'Community' is a term with potent meaning 'swathed in soothing feelings' (Staeheli 2008, 7), but these connotations mask alternative readings and presumptions of 'natural' rural communities essentialise what is in effect a social construction and risk ignoring social fractures and inequalities (Liepins 2000; Storey 2010). Similarly, the home is regularly depicted as a refuge from the outside world. Like community, it conjures up feelings of comfort and security but for some it may be a place of discomfort, alienation, tension or violence (Pain 1997; Morley 2000; Blunt and Dowling 2006). In a rural context, a consideration of links between people and land needs to consider the differential experiences of various groups (Milbourne 1997; Cloke *et al* 2001; Little 2002; Panelli *et al* 2009). The experience of some may be akin to that of the Irish poet Patrick Kavanagh:

> O stony grey soil of Monaghan
> The laugh from my love you thieved;
> You took the gay child of my passion
> And gave me your clod-conceived (Kavanagh 1972, 73)

Kavanagh's negative poetic depiction may have a resonance for many who leave rural areas whether because of an absence of employment or in the pursuit of what they might see as a more socially satisfying environment elsewhere.

Two inter-related factors in recent decades have served to alter the connections between people and land in Britain and elsewhere. Firstly, there is the supposed shift from a productivist phase to a post-productivist one and the emergence of what some might see as a multi-functional rural space (Argent 2002; Evans *et al* 2002; Tilzey and Potter 2008; Wilson 2008). Processes of modernisation in agriculture appear to have altered the relationship between farmers and their land, rendering it less 'intimate' and more 'functional'. Traversing small fields on foot will feel very different to hurtling across large ones on a high-powered tractor. One of the consequences of agriculture's productivist phase and increased commercialisation may have been the weakening of the bonds between the individual and the land. While we need to be careful not to overly romanticise or simplify such connections, for some smallholders and hill farmers these may remain more intimate than for larger, more commercial, operators (Burton *et al* 2005). Equally, in an era of profound technological change within society generally and agriculture specifically, we need to be mindful of the complex interplay of differing knowledges – 'scientific' and 'traditional' – which shape farming practices (Crowley 2006; Holloway 2007).

Secondly, globalisation has intensified and deepened the linkages between places so that they are increasingly inter-connected (Held *et al* 1999; Murray 2006). It is suggested that the individual 'personality' or distinctiveness of place is diminishing. Although the homogenising processes of globalisation may be exaggerated, one reaction has been an increased emphasis on preserving local distinctiveness. One manifestation of this has been the burgeoning heritage industry concerned with the preservation or recreation of elements of the past (Lowenthal 1998; Graham *et al* 2000; Timothy and Boyd 2003). The promotion of local distinctiveness, through local history, has become a key element in attempts at rural regeneration (Storey 2010), suggesting that a fear of placelessness has contributed to an increasing commodification of place. Another dimension to this reaction against perceived homogenisation is the recent concern with how food is sourced and produced, concerns influenced by considerations of health, food miles and consumer ethics, as well as ideas of reconnecting more directly to the land (Maye *et al* 2007). In turn these trends fit into broader concerns over the sustainability (economically, socially, culturally and environmentally) of rural places (Robinson 2008) and into wider discussions over the meaning of nature (Macnaghten and Urry 1998; Castree 2005).

Conserving the countryside converts land into landscape and the rural environment becomes something to be valued and gazed upon. Land is not just a material observable entity but landscapes are also associated with ways of seeing; it is 'not just about *what* we see but about *how we look*' (Wylie 2007, 7, italics in original). In this way land itself is connected to social identity (Muir 1999; Darby 2000; Winchester *et al* 2003). Some rural landscapes also become imbued with a symbolism which transcends the immediate locality. The social and cultural value placed on particular land-scapes is reflected in the designation of National Parks, Areas of Outstanding Natural Beauty and so on (Aitchison *et al* 2000) so that, for example, the Lake District in northern England assumes a national, indeed supra-national, significance. Land and landscapes become sites of consumption rather than production and are transformed into objects of the tourist gaze (Urry 2002).

TERRITORY AND NATION

Land obviously has material and symbolic importance in a rural context. However, it also assumes significance in a broader political sense, being deeply embedded in many national narratives. Notwithstanding debates over globalisation and visions of an increasingly borderless world, ideas

of the nation and the associated territorial ideology of nationalism continue to occupy a position of prominence (Gellner 1983; Hobsbawm 1990; Guibernau 1996; Smith 2001). Land is central to many nationalist discourses and habitually invoked in national conflicts where both generic territory and specific places may acquire enormous symbolism. Nations can be seen as social collectivities of people with a sense of a common identity bound together through feelings of a shared history and an attachment to a territory or homeland (Miller 1995; Penrose 2002). Nationalism is both a political and territorial ideology in which a 'national' territory is defended, claimed or sought in the name of the 'nation'; an attachment to a demarcated territory is a key component of national identity (Guibernau 1996). If nations are assumed to have a unique history, then it is one that is embedded in a unique territory – 'its "homeland", the primeval land of its ancestors, older than any state, the same land which saw its greatest moments, perhaps its mythical origins. The time has passed but the space is still there' (Anderson 1988, 24).

Within this territorial component we can identify allusions to the 'generic' territory of the nation, the national soil, land seen to belong to the 'imagined community'. Fighting for, or even dying for, the land are seen as supreme acts of patriotism, ensuring it does not fall into 'foreign' hands. In the late 19th and early 20th centuries notions of blood sacrifice in pursuit of certain ideals were reflected in calls to defend the land (or national soil) and fight for it. Irish rebel leader Pádraig Pearse once wrote that 'the old heart of the earth needed to be warmed with the red wine of the battlefields' (cited in Townshend 2005). In a different context, formulations of *blut und boden* (blood and soil) formed part of Nazi ideology, indicating a belief in an explicit link between territory and ethnicity. People fight (and die) for their country (or think that they do), indicating how strong associations with territory may be manipulated for political ends. In the 1990s, land and territory were central in the Balkans conflict, which was characterised by attempts to purify portions of land of those seen as 'other' (Glenny 1999; White 2000; Mazower 2001). While it is easy to portray such events as irrational, for some people in specific contexts strong attachments to territory may appear to make perfect sense. In colonial (and former colonial) societies, for example, where land has been appropriated, a strong sense of ownership and defence may persist through succeeding generations. In Ireland, Crowley argues that 'the collective memory of fighting for land ownership is a potent force' (2006, 135) reflecting a material (not just sentimental) underpinning to an attachment to the land.

A second element in the connections between land and national identity is the 'production' and veneration of generic landscapes. While history (actual or 'invented') is central to the nation's being, its right to exist usually rests on claims to a particular national space and, within this, particular places and landscapes often assume symbolic importance. There are numerous references to the 'generic' territory of the nation and allusions to the national soil even in what may appear quite banal ways (Billig 1995). Particular parts of the national territory acquire a significance as the presumed 'zone of origin' of the nation; its original heartland which remains the 'core' of the nation. These are often more remote and intrinsically rural places such as the Canadian north (Shields 1991). The 'taming' of the American west means that not just the 'pioneers' heading westwards, but also the landscapes through which they travelled and the land they 'conquered' assumed significance in the nation-building project. In some Welsh nationalist discourses the mountains are seen as the heart of the nation, symbolising a Wales untainted by outside influences. This is reflected in Plaid Cymru's choice of an idealised representation of mountains as the original symbol of the party. A leading figure in the party during its early years suggested that the mountains are 'the perpetual witnesses of our history, and the unchanging background of our language', while another

nationalist spoke of the mountains as 'the bread of life, and ... a holy sacrament ... (with) our lives ... woven into its essence' (cited in Gruffud 1995, 224, 228). More remote and less anglicised areas were seen to be the heartland of the nation. From this perspective, the land itself assumes the role of a sentient being, in which memories are deeply embedded (Williams and Smith 1983).

Linking back to the earlier discussion of rurality, it is significant that many of the place images of England, as with many other countries, are rural and 'old' rather than urban and modern (Lowenthal 1994). There is a long history of the use of idyllic landscape imagery (such as Constable's paintings) to conjure up the nation so that a largely industrialised and urbanised country is idealised in rural terms and landscapes emblematic of the nation are reproduced through various cultural media (Cosgrove and Daniels 1989; Taylor 1991; Daniels 1993). This emphasis on rural imagery could be interpreted as a reaction to the processes of industrialisation and urbanisation, constructions of the urban as 'evil' and contaminated mirrored by the creation of the 'rural idyll' through which all that is 'pure' and 'natural' is seen to be associated with the rural landscape and with rural life. These wholesome images are then taken to embody true Englishness.

The early-20th-century travel writer H V Morton encapsulates this notion of the land, the rural and farming as integral to the idea of the 'nation' (in this case, England).

> There rose up in my mind the picture of a village street at dusk with a smell of wood smoke lying in the still air and, here and there, little red blinds shining in the dusk underneath the thatch ... This village that symbolises England sleeps in the sub-consciousness of many a townsman [sic] ... The village and the English countryside are the germs of all we are and all we have become: our manufacturing cities belong to the last century and a half: our villages stand with their roots in the Heptarchy. (Morton 2000, 1–2)

Not surprisingly, such sentiments get reproduced in various discourses and politicians have periodically used rural imagery to promote a sense of national identity. In 1937 Stanley Baldwin spoke of:

> The sounds of England, the tinkle of the hammer on the anvil in the country smithy, the corncrake on a dewy morning, the sound of the scythe against the whetstone, and the sight of a plough team coming home over the brow of a hill, the sight that has been seen in England since England was a land, and may be seen in England long after the Empire has perished and every works in England has ceased to function, for centuries the one eternal sight of England.
> (cited in Paxman 1998, 143)

More recently, in 1993, John Major (echoing George Orwell many years previously) invoked a vision of Britain with 'old maids cycling to holy communion through the morning mist' (cited in Paxman 1998, 142).

National anthems are another form of discourse in which the rural is celebrated. The importance of territory and of specific places is emphasised in many anthems which often contain generic allusions to soil and land or more specific references to particular places or landscape features such as mountains or rivers. The lyrics reflect a strong territorial base, evoking images that constitute the essence of the nation. Austria's anthem uses generic landscape features as symbols of a country that is a 'land of mountains, land of rivers, land of tillage, land of churches'. Similarly, 'Flower of Scotland' evokes a rugged rural landscape of hills and glens defended against the marauding external foe

(England). These examples also demonstrate the elevation of quite ordinary landscapes to the realm of the sacred. There is nothing intrinsically unique about mountain ranges, coastlines or woods, but in the nationalist imagination these features assume emblematic status.

As noted earlier, political conflicts are often interwoven with territorial claims. The Balkans crisis of the 1990s and its lingering aftermath were underpinned by a series of claims to particular places seen as integral to specific ethnic identities (Campbell 1999; Storey 2002; Robinson and Pobric 2006), claims underpinned through reference to historical myths and forms of boundary-making (Kolstø 2005). Past Serbian occupation of present-day Kosovo serves as a useful justification for territorial control over an area almost exclusively occupied by ethnic Albanians. Kosovo's 2008 declaration of independence is a rupture of the territorial integrity of Serbia when seen through the lens of Serbian nationalism.

It is clear that land and territory are utilised in conjunction with selective interpretations of history in forging and reproducing a sense of national identity. While such nation-building is often driven and moulded by an intelligentsia or political elite, there are also more proletarian (and inclusive) views of the connections between citizens, nation and the land. American folk singer Woody Guthrie provided a classic exemplar of a more democratic connection between people and place:

> This land is your land, this land is my land
> From California, to the New York Island
> From the redwood forest, to the gulf stream waters
> This land was made for you and me (Lyrics available at www.woodyguthrie.org)

CONCLUDING REFLECTIONS

This chapter has investigated the linkages between land, territory and identity through an exploration at both the micro-scale and the macro-scale. It suggests there are positives and negatives to these connections. There are understandable desires for that which is comforting and familiar, be it aspects of the landscape, a 'home' territory and so on. Positive images of the connections between people and place engender a sense of mutuality, community, informal support networks and so on. At a more overtly political level, the utilisation of this attachment to inculcate support for, or defence of, territory for political ends may have quite problematic implications. Land may become a mobilising force, most notably in the case of overtly nationalist conflicts, as in the Balkans where both generic territory and specific places were invoked as reasons for war. In other, possibly less obvious, instances particular discourses surrounding land, place and territory may give rise to exclusionary practices and beliefs. The dangers inherent in simplistic constructions of place may have negative impacts on those perceived to be different on the basis of ethnicity or other social criteria who may find themselves subject to exclusionary practices and deemed to be 'out of place'. The construction of rural Britain as a relatively 'white space' reflects deeply embedded ideas associated with belonging, rurality and national identity (Panelli et al 2009). Similarly, the presence of gypsies in the British countryside has been a source of long-standing controversy centring on the competing rights of settled inhabitants and nomadic populations (Holloway 2005; Shubin 2010).

A useful contemporary example of an issue in which a range of competing interpretations surrounding the connections between land and people (and with connotations linked to both local and national identity) have emerged concerns plans by a consortium led by the Shell oil

company to bring natural gas on-shore at Rossport, in the west of Ireland. The plans, supported by the Irish government, have divided opinion amongst residents within the locality and more widely throughout Ireland. The proposed development has met with popular local resistance with overlapping concerns related to land ownership, health and safety issues and control of resources. Local opposition is linked to broader national arguments within Ireland over who should benefit from the exploitation of a national resource. For critics, the benefits would seem likely to accrue mainly to Shell and its other multinational partners, rather than to the Irish state and its citizens. A further international dimension to this apparently 'local' issue is the connections which have been made between Rossport activists and counterparts in Nigeria where Shell's oil extraction activities have engendered considerable controversy (McCaughan 2008; Gilmartin 2009).

When considered in relation to identities, land is more than just a material reality; it is also a mental construct. We might juxtapose constructs of land, territory and identity which are conservative, static and exclusionary and those which might be seen as progressive, dynamic and inclusive. Tension centres on the promotion or retention of values of mutuality and solidarity while not retreating into a defensive insularity. While there are understandable concerns over shifting economic and social relations which might seem to threaten rural stability, links between people and land at both micro- and macro-scales (while being mindful of the problematic nature of such a distinction) need to be conceived of in a more progressive way which does not leave some people or groups feeling 'out of place'.

BIBLIOGRAPHY AND REFERENCES

Aitchison, C, Macleod, N, and Shaw, S J, 2000 *Leisure and Tourism Landscapes, Social and Cultural Geographies*, Routledge, London

Anderson, B, 1991 *Imagined Communities: Reflections on the Origin and Spread of Nationalism*, Verso, London

Anderson, J, 1988 Nationalist Ideology and Territory, in *Nationalism, Self-Determination and Political Geography* (eds R J Johnston, D Knight, and E Kofman), Croom Helm, London, 18–39

Argent, N, 2002 From Pillar to Post? In Search of the Post-Productivist Countryside in Australia, *Australian Geographer* 33 (1), 97–114

Bell, D, and Valentine, G (eds), 1995 *Mapping Desire: Geographies of Sexualities*, Routledge, London

Berry, W, 1996 *The Unsettling of America: Culture and Agriculture*, 3 edn, University of California Press, Berkeley

Billig, M, 1995 *Banal Nationalism*, Sage, London

Blunt, A, and Dowling, R, 2006 *Home*, Routledge, London

Brenner, N, 1998 Between Fixity and Motion: Accumulation, Territorial Organization and the Historical Geography of Spatial Scales, *Environment and Planning D: Society and Space* 16 (5), 459–81

Bunce, M, 1994 *The Countryside Ideal: Anglo-American Images of Landscape*, Routledge, London

Burton, R, Mansfield, L, Schwarz, G, Brown, K, and Convery, I, 2005 *Social Capital in Hill Farming*, Report for International Centre for Sustainable Uplands

Campbell, D, 1999 Apartheid Cartography: The Political Anthropology and Spatial Effects of International Diplomacy in Bosnia, *Political Geography* 18 (4), 395–435

Castree, N, 2005 *Nature*, Routledge, London

Cloke, P, and Little, J (eds), 1997 *Contested Countryside Cultures: Otherness, Marginality and Rurality*, Routledge, London

Cloke, P, Milbourne, P, and Widdowfield, R, 2001 Homelessness and Rurality: Exploring Connections in Local Spaces of Rural England, *Sociologia Ruralis* 41 (4), 438–53

Cosgrove, D, and Daniels, S (eds), 1989 *The Iconography of Landscape*, Cambridge University Press, Cambridge

Cresswell, T, 2004 *Place: A Short Introduction*, Blackwell, Oxford

Crowley, E, 2006 *Land Matters: Power Struggles in Rural Ireland*, Lilliput Press, Dublin

Daniels, S, 1993 *Fields of Vision: Landscape Imagery and National Identity in England and the United States*, Polity Press, Cambridge

Darby, W J, 2000 *Landscape and Identity: Geographies of Nation and Class in England*, Berg, Oxford

Delaney, D, 2005 *Territory: A Short Introduction*, Blackwell, Malden

Elden, S, 2010 Land, Terrain, Territory, *Progress in Human Geography* 34 (6), 799–817

Evans, N, Morris, C, and Winter, M, 2002 *Conceptualizing Agriculture: a Critique of Post-Productivism as the New Orthodoxy*, Progress in Human Geography 26 (3), 313–32

Gellner, E, 1983 *Nations and Nationalism*, Blackwell, Oxford

Gilmartin, M, 2009 Border Thinking: Rossport, Shell and the Political Geographies of a Gas Pipeline, *Political Geography* 28 (5), 274–82

Glenny, M, 1999 *The Balkans 1804–1999: Nationalism, War and the Great Powers*, Granta, London

Graham, B, Ashworth, G J, and Tunbridge, J E, 2000 *A Geography of Heritage: Power, Culture and Economy*, Arnold, London

Gruffud, P, 1995 Remaking Wales: Nation-building and the Geographical Imagination, 1925–50, *Political Geography* 14 (3), 219–39

Guibernau, M, 1996 *Nationalism: The Nation-State and Nationalism in the Twentieth Century*, Polity Press, Cambridge

Halfacree, K, 2007 Back-to-the-land in the Twenty-first Century – Making Connections with Rurality, *Tijdschrift voor Economische en Sociale Geografie* 98 (1), 3–8

Harvey, D, 1996 *Justice, Nature and the Geography of Difference*, Blackwell, Oxford

Held, D, McGrew, A G, Goldblatt, D, and Perraton, J, 1999 *Global Transformations. Politics, Economics and Culture*, Polity Press, Cambridge

Herod, A, and Wright, M W (eds), 2002 *Geographies of Power: Placing Scale*, Blackwell, Oxford

Hobsbawm, E J, 1990 *Nations and Nationalism since 1780: Programme, Myth, Reality*, Cambridge University Press, Cambridge

Holloway, L, 2002 Smallholding, Hobby-farming, and Commercial Farming: Ethical Identities and the Production of Farming Spaces, *Environment and Planning A* 34 (11), 2055–70

— 2007 Subjecting Cows to Robots: Farming Technologies and the Making of Animal Subjects, *Environment and Planning D: Society and Space* 25 (6), 1041–60

Holloway, L, and Hubbard, P, 2001 *People and Place: The Extraordinary Geographies of Everyday Life*, Prentice Hall, Harlow

Holloway, S, 2005 Articulating Otherness? White Rural Residents Talk About Gypsy-Travellers, *Transactions of the Institute of British Geographers* 30 (3), 351–67

Jager, J, 2003 Picturing Nations: Landscape: Photography and National Identity in Britain and Germany

in the Mid-Nineteenth Century, in *Picturing Place: Photography and the Geographical Imagination* (eds J M Schwartz and J R Ryan), I B Tauris, London, 117–40

Jentsch, B, and Shucksmith, M (eds), 2003 *Young People in Rural Areas of Europe*, Ashgate, Aldershot

Kavanagh, P, 1972 *The Complete Poems*, Goldsmith Press, Newbridge

Keane, J B, 1991 *The Field*, Mercier Press, Cork

Keith, M, and Pile, S, 1993 *Place and the Politics of Identity*, Routledge, London

Kolstø, P (ed), 2005 *Myths and Boundaries in South-Eastern Europe*, Hurst & Company, London

Liepins, R, 2000 Exploring Rurality Through 'Community': Discourses, Practices and Spaces shaping Australian and New Zealand Rural 'Communities', *Journal of Rural Studies* 16 (3), 325–41

Little, J, 2002 *Gender and Rural Geography*, Prentice Hall, Harlow

Lowenthal, D, 1994 European and English Landscapes as National Symbols, in *Geography and National Identity* (ed D Hooson), Blackwell, Oxford, 15–38

— 1998 *The Heritage Crusade and the Spoils of History*, Cambridge University Press, Cambridge

McCaughan, M, 2008 *The Price of our Souls: Gas, Shell and Ireland*, Afri, Dublin

McDowell, L, 1999 *Gender, Identity and Place: Understanding Feminist Geographies*, Polity Press, Cambridge

Macnaghten, P, and Urry, J, 1998 *Contested Natures*, Sage, London

Massey, D, 2005 *For Space*, Sage, London

Matthews, H, Taylor, M, Sherwood, K, Tucker, F, and Limb, M, 2000 Growing-up in the Countryside: Children and the Rural Idyll, *Journal of Rural Studies* 16 (2), 141–53

Maye, D, Holloway, L, and Kneafsey, M (eds), 2007 *Alternative Food Geographies: Representation and Practice*, Elsevier, London

Mazower, M, 2001 *The Balkans: A Short History*, Phoenix, London

Milbourne, P (ed), 1997 *Revealing Rural 'Others': Representation, Power and Identity in the British Countryside*, Pinter, London

Miller, D, 1995 *On Nationality*, Clarendon Press, Oxford

Mingay, G E (ed), 1989 *The Rural Idyll*, Routledge, London

Mitchell, C J A, 2004 Making Sense of Counterurbanization, *Journal of Rural Studies* 20 (1), 15–34

Morley, D, 2000 *Home Territories: Media, Mobility and Identity*, London, Routledge

Morton, H V, 2000 *In Search of England*, Methuen, London

Muir, R, 1999 *Approaches to Landscape*, Macmillan, Basingstoke

Murray, W E, 2006 *Geographies of Globalization*, Routledge, London

Nelson, L, and Seager, J (eds), 2004 *A Companion to Feminist Geography*, Blackwell, Oxford

Newby, H, 1979 *Green and Pleasant Land? Social Change in Rural England*, Hutchinson, London

Olwig, K, 2008 Performing on the Landscape versus Doing Landscape: Perambulatory Practice, Sight and the Sense of Belonging, in *Ways of Walking: Ethnography and Practice on Foot* (eds T Ingold and J L Vergunst), Ashgate, Aldershot, 81–92

Pain, R H, 1997 Social Geographies of Women's Fear of Crime, *Transactions of the Institute of British Geographers* 22 (2), 231–44

Panelli, R, Hubbard, P, Coombes, B, and Suchet-Pearson, S, 2009 De-centring White Ruralities: Ethnic Diversity, Racialisation and Indigenous Countrysides, *Journal of Rural Studies* 25 (4), 355–64

Paxman, J, 1998 *The English: Portrait of a People*, Michael Joseph, London

Penrose, J, 2002 Nations, States and Homelands: Territory and Territoriality in Nationalist Thought, *Nations and Nationalism* 8 (3), 277–97

Pretty, J, 2007 *The Earth Only Endures: On Reconnecting with Nature and our Place in it*, Earthscan, London

Robinson, G M (ed), 2008 *Sustainable Rural Systems: Sustainable Agriculture and Rural Communities*, Ashgate, Aldershot

Robinson, G M, and Pobric, A, 2006 Nationalism and Identity in Post-Dayton Accords: Bosnia-Hercegovina, *Tijdschrift voor Economische en Sociale Geografie* 97 (3), 237–52

Rye, J F, 2006 Rural Youths' Images of the Rural, *Journal of Rural Studies* 22 (4), 409–21

Sack, R, 1986 *Human Territoriality: Its Theory and History*, Cambridge University Press, Cambridge

Shields, R, 1991 *Places on the Margin: Alternative Geographies of Modernity*, Routledge, London

Short, J R, 1991 *Imagined Country: Society, Culture and Environment*, Routledge, London

Shubin, S, 2010 'Where can a Gypsy stop?' Rethinking mobility in Scotland, *Antipode* 42 (5), 494–524

Smith, A D, 2001 *Nationalism: Theory, Ideology, History*, Polity Press, Cambridge

Staeheli, L A, 2008 Citizenship and the Problem of Community, *Political Geography* 27 (1), 5–21

Stockdale, A, 2010 The Diverse Geographies of Rural Gentrification in Scotland, *Journal of Rural Studies* 26 (1), 31–40

Storey, D, 2001 *Territory: The Claiming of Space*, Harlow, Prentice Hall

— 2002 Territory and National Identity: Examples from the former Yugoslavia, *Geography* 87 (2), 108–15

— 2010 Partnerships, People and Place: Lauding the Local in Rural Development, in *The Next Rural Economies: Constructing Rural Place in Global Economies* (eds G Halseth, S Markey and D Bruce) CABI, Wallingford, 155–65

Taylor, P J, 1991 The English and their Englishness: 'A Curiously Mysterious, Elusive and Little Understood People', *Scottish Geographical Magazine* 107 (3), 146–61

Tilzey, M, and Potter, C, 2008 Productivism versus Post-productivism? Modes of Agri-Environmental Governance in Post-Fordist Agricultural Transitions, in *Sustainable Rural Systems: Sustainable Agriculture and Rural Communities* (ed G M Robinson), Ashgate, Aldershot, 41–63

Timothy, D J, and Boyd, S W, 2003 *Heritage Tourism*, Prentice Hall, Harlow

Townshend, C, 2005 *Easter 1916: The Irish Rebellion*, Penguin, London

Tuan, Y-F, 1974 *Topophilia: A Study of Environmental Perception, Attitudes and Values*, Prentice-Hall, Englewood Cliffs, NJ

Urry, J, 2002 *The Tourist Gaze: Leisure and Travel in Contemporary Societies*, 2 edn, Sage, London

Valentine, G, 1995 Out and About: Geographies of Lesbian Landscapes, *International Journal of Urban and Regional Research* 19 (1), 96–111

Valentine, G, Holloway, S, Knell, C, and Jayne, M, 2008 Drinking Places: Young People and Cultures of Alcohol Consumption in Rural Areas, *Journal of Rural Studies* 24 (1), 28–40

White, G W, 2000 *Nationalism and Territory: Constructing Group Identity in Southeastern Europe*, Rowman and Littlefield, Lanham

Williams, C H, and Smith, A D, 1983 The National Construction of Social Space, *Progress in Human Geography* 7 (4), 502–18

Wilson, G A, 2008 From 'Weak' to 'Strong' Multifunctionality: Conceptualising Farm-level Multifunctional Transitional Pathways, *Journal of Rural Studies* 24 (3), 367–83

Winchester, H P M, Kong, L, and Dunn, K, 2003 *Landscapes: Ways of Imagining the World*, Prentice Hall, Harlow

Wylie, J, 2007 *Landscape*, Routledge, London

Yarwood, R, 2005 Beyond the Rural Idyll: Images, Countryside Change and Geography, *Geography* 90 (1), 19–32

2

Viewing the Emergence of Scenery from the English Lake District

Mark Haywood

Much has been written about how undifferentiated space, or 'wilderness', can over time coalesce into the specificity of 'place' through the deposition of cultural sediment. The process usually entails some form of sedentariness whose origins may range from simple cessation of wandering to full-blown colonial settlement.[1] By contrast, the present account seeks to describe how a sense of place may also be engendered through dynamic means, particularly the action of walking.

Over the past two and a half centuries, a mountainous corner of North West England has changed from literary figure Daniel Defoe's 1726 dismissal of it as a 'most barren and frightful'[2] backwater to a heavily protected landscape that is one of the UK's most popular tourist destinations. A notable aspect of the process is that it reflects a transformation of perception we might describe as an 'accumulation of culture', rather than any significant physical change in the landscape.

Over millennia of human settlement that included Roman colonisation and Viking invasion, the area now known as the Lake District remained largely undefined and bypassed by the grand narratives of British history. Whereas neighbouring areas such as the Scottish Borders, the fertile alluvial soils of the Eden Valley and the Furness Peninsula were fought over many times, the Lake District's lack of battlefields, castles, great abbeys and manor houses attests to its land being neither coveted nor contested. In addition to a dearth of rich farmland, the topographical structure of glacial valleys radiating from a central mountainous core meant the region never became a major communication route. In any case it was not on the way to anywhere important; today major roads still skirt the region – visitors 'go round' the Lake District, rather than travel 'through' it. However, the circular journey undertaken on foot has become an important constituent of the Lakes' transformation from undifferentiated 'space' into 'a place'.

In a recent history of the region the geographer Ian Thompson suggested that each writer describes the Lake District he or she wants to see (Thompson 2010). This chapter is no exception, but it seeks to consider the coalescence of place not in terms of its indigenous people and settlements but in the contribution of others who came to walk and view the landscape. One of the earliest was Thomas West (allegedly a former Jesuit priest, certainly an itinerant salesman and

1 This also highlights the fact that most former 'wildernesses' were actually the homelands of other cultures.
2 Ironically, present-day perceptions of Defoe's opinion as an anomaly have helped make it the most oft-cited description of the region (there is also a strong possibility that he never actually visited Westmorland).

antiquarian) who settled in Kendal, and in 1778 published *A Guide to the Lakes in Cumberland, Westmorland and Lancashire*. West died the following year, but his Guide remained in print for four decades and was one of the earliest books to alter previous, largely negative, perceptions of the region. In 1974 the redrafting of English county boundaries placed all West's lakes in the new county of Cumbria, but long before its bureaucratic reassignment the region had simply become 'the Lake District'. Furthermore, its international currency has become such that 'English' is often an unnecessary qualifier.

At the time of writing the Lake District is an aspirant World Heritage Site. Heritage implies a cultural legacy, and a landscape once misperceived as an unspoilt wilderness (rather than an ecologically degraded product of deforestation) is now undergoing a second aesthetic re-evaluation. Today it is less frequently seen as a site of 'natural beauty', and is instead increasingly valued as a complex cultural product that came to exemplify new ideals in the Western history of ideas. Ironically the original aesthetic appreciation of what was perceived to be 'natural' in turn led to further laying down of cultural strata. Probably the best-known contributors to these deposits are the early 19th-century Romantic poets of the Lakeland School, who included the Wordsworth siblings William and Dorothy, Samuel Taylor Coleridge and Robert Southey. However, in the second half of the century the Victorian polymath John Ruskin added further rich layers from the perspectives of art critic, social reformer and proto-environmentalist. It is significant that each of these figures (albeit in very different ways) was also a famous exponent of 'walking'. However, the process by which walking transformed space or wilderness into the place we today call the Lake District had begun in the previous century, and its primary driver had been the scopic regime. Put more simply, the 'Lake District' was created by people who came to 'look'.

In this account of how the act of looking contributed to the construction of place, three enduring tropes will be considered. The earliest is the Picturesque comparison of nature to art through repeated idealisation of scenery; it was subsequently joined (though not replaced) by the Romantic quest for 'authenticity' and exclusivity of experience. These two seemingly opposed forms of seeing were both largely informed through a third phenomenon, the performative act of walking as aesthetic or recreational pastime, a seemingly informal pursuit that has generated innumerable local representations and guidebooks over the past two and a half centuries. Much has been written on all of the above subjects, but less consideration has been given to them collectively from the primary perspective of a local history of looking, or an accumulation of individual explorations of the visual realm. Furthermore, despite the long history of books on Lake District walks, only recently has walking begun to be recognised as an academic research methodology.[3] When viewed together the three tropes described above constitute a succession of reiterative experiences – a historical accrual of visual understandings that has transformed space into place.

TASTE AND THE PICTURESQUE

The emergence of the Lakes as a discrete place was initiated by visual aesthetics. The process is often described as having begun in the second half of the 18th century with Picturesque tourism, but this was only part of a larger continuum of developments in judgements of taste that spanned

[3] The International Visual Sociology Association recently devoted an entire issue of its peer-reviewed journal to walking as research methodology (*Visual Studies* 25 (1), 2010).

the entire century. In England the period was one of rapid social change when proliferation of manufactured goods and expansion of bourgeois materialism prompted new definitions of the criteria of taste. These developments also brought an important shift in the methodology of writing on the arts and a change of writers' audience. Earlier accounts of theoretical issues were largely based on analysis of Classical precedents, usually in the form of manuals addressed to the creative practitioner, not the connoisseur.

A second parallel development had been the sensory emphasis of the Grand Tour, shifting from the accumulation of oral and written experiences to a scopic venture that prioritised the visual regime over the word. Young gentlemen's letters of introduction to famous men became replaced by the compilation of amateur sketchbooks and the collecting of paintings and sculpture (Adler 1989a). This coincided with increased interest in visual appreciation of 'natural scenery' instead of geometric formal gardens or landscapes that had obviously been shaped by Man.

In light of the above it may seem paradoxical that over the same period, increased value was also being given to the imaginative powers of association; however, these were most highly regarded when having originated from first-hand observation. As with the new works on taste, the primary audience for the travel guides was not the traditional aristocratic scion educated by the Grand Tour, but a burgeoning class of upwardly mobile, aesthetic tourists, who were predominantly spectators rather than artists. Nevertheless they were not entirely passive, as many were also members of a new constituency of middle-class walkers, who were pedestrian by choice, not necessity. Rebecca Solnit has described how over this period recreational walking was both democratised and undertaken in increasingly 'natural' surroundings that lay beyond the confines of the stately garden and the country estate (Solnit 2006, 81–103).

AESTHETIC DISINTEREST AND THE ROMANTIC SUBLIME

Two of the most important concepts to have shaped environmental aesthetics also emerged in the early 1700s and coalesced over subsequent decades. The respective sources of aesthetic disinterest and the Romantic sublime can be seen in two works published in consecutive years at the start of the century. Both our present concern for the environment and tourists' pleasure in viewing landscapes to which they lack any physical ties may be traced back to Anthony Ashley-Cooper, third Earl of Shaftesbury's *Characteristics of Men, Manners, Opinions, Times* of 1711. In addition to being an aristocrat and an aesthete, Shaftesbury was also a politician and philosopher who argued that, as his sector of society was not needy, they could not be bribed or swayed, and could thus be described as 'disinterested'. The art historian Ronald Paulson described Shaftesbury as advocating the balancing of monarch and church with an oligarchy of wealthy, land-owning, humanist connoisseurs (Hogarth 1997, xxiii). Shaftesbury drew parallels between morality and aesthetics and, from these disingenuous origins, the term 'disinterest' rapidly acquired moral and aesthetic currency. Though more recently the concept of aesthetic disinterest has been seen as problematic, it remains of value to environmental aesthetics. Indeed, the environmental historian Harriet Ritvo recently proposed that the origins of the green movement lay in the 1880s when disinterested parties, many of whom had never visited the Lake District, campaigned (unsuccessfully) to stop the Vale of Thirlmere being flooded to provide another reservoir for the burgeoning city of Manchester (Ritvo 2009).

The second influential concept, the aesthetic category of the sublime, which became such a central feature of 19th-century Romantic responses to landscape, had also undergone a series

of transformations during the previous century. Though its origins were far older than those of aesthetic disinterest, the present sense can be seen emerging in a series of writings by Joseph Addison during the early 18th century. Thompson (2010, 28) cites Addison's 1705 description of the Alps as generating an 'agreeable kind of horror', but the refinement and broader dissemination of his ideas on the sublime came slightly later when the original essay was published in serial form in *The Spectator*.

> By Greatness, I do not only mean the Bulk of any single Object, but the Largeness of a whole View, considered as one entire Piece. Such are the Prospects of an open Champain Country, a vast uncultivated Desart, of huge Heaps of Mountains, high Rocks and Precipices, or a wide Expanse of Waters, where we are not struck with the Novelty or Beauty of the Sight, but with that rude kind of Magnificence which appears in many of these stupendous Works of Nature. Our Imagination loves to be filled with an Object, or to grasp at any thing that is too big for its Capacity. We are flung into a pleasing Astonishment at such unbounded Views, and feel a delightful Stillness and Amazement in the Soul at the Apprehension[s] of them. (Addison 1712)

Addison asserted that the imaginative association of ideas was both intrinsic to experience of the arts and the reason for their value; he divided the pleasures of the imagination into ones stemming from grandeur, novelty and beauty. His account of grandeur introduced the two most important requirements for the experience of sublimity that recur in Burke and Kant, the two most important refiners of the theory. The first requirement was the necessity for what Addison termed a 'unified magnificence' (ibid); the second was that the experience was triggered by encounters with immense natural features such as mountains, deserts and seas.

Although Addison regarded novelty as a separate pleasure, I believe it can also play a significant part in the evocation of sublimity. My most intense experiences of the natural sublime (so overwhelming that I reeled dizzily and nearly fell over) occurred when suddenly emerging from dense bush to abrupt, wholly unexpected encounters with vast natural features – once an immense dune field, and the second time the edge of a precipitous canyon that snaked away to the horizon. On subsequent visits these views, though still spectacular, no longer generated that initial rush of total incomprehension.

Half a century after Addison the implications of his literary theories, those of his colleague, Frances Hutcheson, and recent writings on beauty by the artist William Hogarth were combined into a single aesthetic system by Edmund Burke. This was published in 1757 as a major work called *A Philosophical Enquiry into the Origins of our Ideas of the Sublime and the Beautiful*. Burke set out a new binary aesthetic system based on a gendered (and implicitly hierarchical) opposition. Though today the distinction may seem quaint, Burke usefully contrasted the feminine properties of Beauty with those of a separate aesthetic category, the masculine Sublime. Whereas Beauty was a physical property of ideal form, the Sublime was an imaginative response to a sudden encounter with a vast phenomenon that momentarily threatened to overwhelm the spectator's mind; but, after initial 'astonishment',[4] rationality triumphed and the viewer achieved aesthetic satisfaction as the mind came to terms with the subject. Beauty was a physical property (or set of physical properties) that resided in the viewed, whereas the Sublime was a mental

4 In Burke's day 'astonished' was a much stronger word that meant scared out of one's wits; 'gob-smacked' seems closer to the 18th-century sense of astonishment.

response of the viewer. During the latter part of the 18th century aspects of Burke's theories were incorporated by Kant into the *Critique of Judgement* as sections 23–29, the Analytic of the Sublime.[5] The philosopher Paul Crowther has usefully distinguished between Burke's theory organised around the positive significance of shock and horror, and the Kantian Sublime whose rational containment of excess leads to transcendence of the mundane self (Crowther 1995, 7).

SHIFTING SCENERY

The emergence of the relationship between Picturesque landscapes and theories of beauty is also seen in the use of the word 'scenery'. The OED's earliest example of this spelling of the older theatrical term 'scenary' is 1770, but within seven years painters were using conventions from contemporary stage design to construct lakeside 'sceneries' that consisted of a receding series of aesthetic framing devices, that began with foreground sidescreens (coulisses) in the form of bushes, rocks or overarching trees that framed the view. Picturesque scenes at formally desig-nated 'viewing stations' were often further modified by artists adjusting the landscape in order to enhance the composition or clarify spatial representation. Islands were particularly mobile features that could be moved towards the viewer to show they were surrounded by water, or slid sideways across the lake surface for the sake of visual harmony. Artists and aesthetic tourists also used viewing technologies such as the 'Claude glass'[6] to compositionally frame and tonally modulate the prospect.

These practices created a reciprocal cycle of reiteration and reinforcement, whereby certain views of seemingly 'natural' scenery that exemplified Picturesque principles of beauty in land-scape painting were turned into paintings and prints whose principles of spatial composition were based on the side-screens, flats and backdrops of the theatre. Many Lakeland guide books of that time use verbs such as 'display', 'disclose' and 'reveal' to describe the orderly manner by which the (feminine) landscape presented or unfolded its beauty and scenic secrets to the (predominantly male) viewer.

Despite the formal passing of the Picturesque by the end of the 18th century,[7] its tropes of depiction remain extant through their (often unknowing) adoption by amateur painters and photographers who continue to record these same scenes in what is now a time-honoured fashion. Whereas professionals in both media now seek unusual or innovative views, amateurs (like their classically trained predecessors) continue to perpetuate an earlier idealised form of representation.

THE ROMANTIC HEIGHTS

Although 18th-century Picturesque artists depicted the mountains from low level lakeside vantage points, as early as 1775 poets such as the aptly named Richard Cumberland were beginning to

5 An early version of Kant's theories occurs in *Observations on the Feelings of the Beautiful and the Sublime* of 1763. Burke's *Enquiry* was translated into German in 1773 and the *Critique of Judgement* was published in 1790.

6 There were actually Claude mirrors and Claude lenses: the former was a small convex mirror with a characteristically dark tain, while the latter usually consisted of a set of variously tinted lenses.

7 James Plumptre's satire *The Lakers* (1798) is often cited as marking the passing of the Picturesque as a serious aesthetic concern.

eulogise the very different view from the fell tops. *Ode to the Sun* is his highly wrought account of the ascent of Gowdar, 'a towering grey rock, rising majestically [above] the renowned cataract of Lowdore' (West 2008, 92–3). De Selincourt (Wordsworth 1977, xiv) described the crag as 'not very lofty', and though Cumberland's *Ode* seems rather cringe inducing, the following fragment introduces the essential tropes of Romantic and later fell-walking:

> Higher, yet higher let me still ascend:
> 'Tis done; my forehead smites the skies,
> To the last summit of the cliff I rise;
> I touch the sacred ground'
> Where step of man was never found;
> I see all Nature's rude domain around.

The American art historian Alfred Boime's term 'the magisterial gaze' describes the commanding view from a high vantage point so characteristic of 19th-century Romantic landscape painting. One of the earliest views of the Lake District looking down from the mountains is Turner's *Morning Amongst the Coniston Fells, Cumberland* (1797–8), showing dawn breaking over the mountain the Old Man of Coniston. Turner also anticipates the solitary, privileged Romantic visionary viewer depicted in Caspar David Friedrich's 1818 painting *Der Wanderer über dem Nebelmeer* (The Wanderer Gazing over the Sea of Mist).[8] Although both are idealised views, they were grounded in the practice of high altitude walking and viewing that typifies post-Picturesque aesthetic passage through Lake District landscapes. The topology of the region (see Wordsworth's account below) often means that a single ascent of a couple of thousand feet to a radial ridge can enable the walker to transit several miles at altitude, all the while gazing down at lakes or across at a succession of unfolding panoramas.

THE MAKING AND MAPPING OF LANDSCAPE

The 19th-century Romantic wanderer was not an aimless roamer, but a seeker on a quest who was guided by instinct and the power of his[9] imagination: one does not envisage him reading a map. Nevertheless, one need not be an advocate of contemporary Health and Safety culture to wince at Coleridge's descriptions of his many 'scrambles', and today only the foolhardy (of whom there are too many) venture onto the high fells without map and compass.

Maps and mapping have played a long and important role in the emergence of the Lake District as a place. Even today (despite the advent of GPS), Lakeland walkers may still be usefully divided into those who can read maps and those who cannot. Despite the existence of highly detailed walkers' guidebooks, the Ordnance Survey map is essential to planning new walks away from resorts and well-trodden lakeshore paths. The map details many accumulated constituents of place, including the intricate network of paths that generations of sheep, drovers, villagers and not least recreational walkers have impressed into the landscape, and which now link lakes, valleys and mountains in endless possibilities of perambulatory combinations. On the map their

[8] Boime describes a later branch of Romanticism that reflected a sense of privileged mastery over the land, the seeds of which may be evident in the gaze of Friedrich's *Wanderer*.

[9] The aesthetic quest for the Romantic sublime was almost entirely a male occupation.

appearance may range from bold strings of ornate green symbols to the faintest of dotted lines. On the fells and mountains they vary from scree-strewn scars many yards wide to faint trails only distinguishable by blades of grass that reflect the sunlight differently to their neighbours.

There is a fascinating interplay between the constancy of the paths on the Ordnance Survey maps and their ever-changing actuality. Whilst the former have the permanence of print, the latter deepen, widen and shift through reiterative interchange year after year between the map and the cleated soles of walkers' boots. Despite the wonderful accuracy of the cartographic representation, a common consequence is that repeated followings of map and path result in deterioration or erosion of the latter, giving rise to alternatives which may over time replace the previous route. Further shifts occur as walkers respond to changing conditions underfoot when bogs dry out or streams alter their course.

The Ordnance Survey maps came about through the Principal Triangulation of Great Britain, begun in 1791 with the aim of charting topographical features of the Channel coast in anticipation of a possible French invasion. However, the first map (of Kent) took a decade to complete and the endeavour may have been of only limited value in such an attack. The project had been initiated by the late Surveyor-General William Roy, who died just before it commenced.

As a young man Roy had worked on the original 'Ordnance Survey', which was also related to an invasion, albeit one by the English. The term 'ordnance' referred to artillery and the mapping survey reflected a militarised view of landscape; it collected geodetic measurements to provide accurate spatial representations of terrain and the understanding necessary to establish territorial control. The Survey began in 1747 after the Scots' defeat at Culloden and resulted in what is now known as the Duke of Cumberland's Map, a giant chart of the Scottish Highlands that facilitated permanent suppression of the Jacobite cause by making the Highlanders' stronghold spatially comprehensible to outsiders.

Some Picturesque Individuals

Two of the draughtsmen who worked alongside Roy in the Highlands were the brothers Thomas and Paul Sandby, who were later founder members of the Royal Academy. Paul Sandby also became an early exponent of the Picturesque, who often enlivened his increasingly exaggerated topographical depictions of English and Welsh landscapes with improbable Highland elements such as small groups of shaggy long-haired cattle, or a solitary plaid-swathed clansman silhouetted on a rocky outcrop.

Despite these additions Sandby's landscapes retained a degree of fidelity eschewed by later Picturesque artists such as John 'Warwick' Smith. The 1793 edition of West's *Guide to the Lakes* contained an advertisement of Smith's for subscriptions to a forthcoming suite of 16 'aquatinta' views of the Lake District which he was making for binding into the Guide. Purchasers who subsequently visited the region were often surprised to discover Smith's practice of heightening the drama of the topography by combining views from two or more viewpoints, his preferred method being to record the foreground by looking down on it from a medium height vantage point. The middle ground of the actual lake would often simply consist of a blank area on whose far side would rise a receding succession of mountains. Their height was considerably exaggerated by having been sketched from water level, sometimes at a spot half a mile from where the foreground had been recorded (see Haywood 2008).

From 1784, West's *Guide* also contained a quarter-inch-to-the-mile map of the region showing

the principal roads, rivers and mountains, but the stations were omitted due to the map's small scale. The date suggests it may have been a response to several maps published in the previous year by Peter Crosthwaite, self-styled 'Admiral at Keswick Regatta,[10] Keeper of the Museum at Keswick, Guide, Pilot, Geographer and Hydrographer to tourists'. Crosthwaite's first map of the area around Derwentwater bore an inscription informing the purchaser that it was 'An Accurate Map of the matchless Lake of Derwent, (situate [sic] in the most delightful Vale which perhaps Human Eye ever beheld) near KESWICK, CUMBERLAND; with West's eight Stations'.

Crosthwaite's three-inches-to-the-mile map of Derwentwater was followed by ones of Windermere[11] and Ullswater. Bassenthwaite was added in 1785, Coniston in 1788 and a map of the less frequented Buttermere, Crummock and Loweswater valley appeared in 1794. The size of the first Derwentwater edition is unknown, but a second comprising 3370 sheets was ordered in 1786. That same year the ever-enterprising Crosthwaite extended his activities, adding cartographic detail to the actual terrain by commissioning construction of a path to take tourists from the shores of Derwentwater to the top of Latrigg Fell (Rollinson 1966, n.p.).

Crosthwaite's 1783 maps show only West's viewing stations, but subsequent editions had new stations, each bearing the legend 'the Author's Station' and accompanied by precise details on how to locate them. Instructions elsewhere on the maps suggest Crosthwaite envisaged visitors touring the stations by chaise, interspersed by a few short walks to some of the less immediately accessible ones. In addition to roads, occasional footpaths to stations and famous waterfalls such as Sourmilk Gill and Scale Force, each map contained small insets of individual mountains and other natural features, as well as houses of local gentry and a panoramic silhouette of the local skyline viewed from a particular station.

UNDERSTANDING SPACE

This last innovation gave the tourist the important ability to identify and name not only individual mountains but also their spatial relationship to one another (albeit only in two dimensions, and when viewed from a particular station). Significantly, the device became a central feature of two very popular later Lake District guides, *Black's Picturesque Guide to the English Lakes*, which first appeared in 1842 and ran to over 20 editions, and Alfred Wainwright's much loved series, *Pictorial Guides to the Lakeland Fells*, which has been in print for over half a century. Comparing the most successful of the guide books from West to Wainwright (despite the textual appeal of Wordsworth's prose and Wainwright's acerbic comments), one also sees an ever-increasing emphasis on the graphic presentation of factual visual information at the expense of poetic description.

In Wordsworth's *Guide to the Lakes*, the chapter 'Description of the Scenery of the Lakes' opens with an account of understandings he had gained in Switzerland from a large topographical model of the area around Lucerne, and whereby 'the sublime and beautiful region, with all its hidden treasures, and their bearings and relation to each other is … understood and comprehended at once' (Wordsworth 1977, 21). Wordsworth employed his powerful imagination and comprehensive spatial understanding of his home region to create a vivid account of

[10] The improbable appellation arose from one of his speculative tourist ventures, a mock naval battle on Derwentwater (Thompson 2010, 64–7).
[11] On account of Windermere's greater size, the map was on a smaller scale of two inches to the mile.

its physical structure and topography. The poet aptly placed his reader on a small cloud midway between the mountains Great Gable and Scafell Pike, from where the celestial viewer could see all the vales and mountains of the Lake District radiate like gigantic 'spokes from the nave of a wheel' (Wordsworth 1977, 22).

Wordsworth's *Guide* appeared in various forms between 1810 and 1835, but in 1834 his feat of visualisation was made more concretely available to lesser imaginations when Joseph Flintoff made a 12' 9" × 9' 3" relief model of the Lake District. Flintoff acquired the necessary topographical understandings in the course of compiling his outline views of mountain groups for Black's *Guide*. Today his model is on permanent display in Keswick Museum and continues to impart topographical understandings similar to those Wordsworth acquired in Lucerne. A nearby inscription informs the viewer that 'W Wordsworth of Rydal Hall has examined the Model and greatly approves of it'.

IN THE FOOTSTEPS OF OTHERS

For the past two and a half centuries successive generations of artists, poets and tourists have followed one another, initially just around the Lakes, but soon up and over its fells and mountains. Whereas the earliest footpaths were products of necessity, desire lines determined by settlement and topography, later ones were a product of aesthetics. Many of the latter are not A to B routes along valleys between settlements; instead they are circular or simply lead to a single viewpoint, or delineate high-level continuums through sequences of panoramic vistas once only viewed by the occasional shepherd. Today, particularly when walking on steep fell-sides, one is not just following in the footsteps of others, but often stepping into their actual footprints. Each walker adds their cleat or stud marks to ones imprinted by those who passed before. The sense of continuity made visible through the reiterative imprinting of walking onto the landscape is a form of walking whose traces are now seldom seen in urban surroundings. It is therefore ironic that many of the most popular paths in the Lake District now have wooden steps or irregular stone slab paving to counter the environmental degradation caused by the heavy boots of aesthetic walkers. All too often in seemingly remote stretches of the high fells one encounters scenes of devastation as countless minor individual deviations from once narrow paths have eroded the thin topsoil and created a rocky pedestrian highway often several metres wide. Such footpaths might not be places of habitation in the usual sense, but they are certainly a collective 'leaving of "traces"', what Walter Benjamin described as 'the primal of all the habits involved in inhabiting a place' (Benjamin 1931, 472).

The Lake District's comparative absence from the earlier annals of history contrasts with its transformation into a collection of historical views and theories of landscape. It would be inaccurate to describe either these landscapes or the way we perceive them as unchanging, but the *genius loci* of the Lake District is a temporal continuum best entered by walking and looking, whether at 18th-century viewing stations or scenes that inspired Wordsworth and Ruskin. Braver souls may re-enact the famous nocturnal walks and descents of Coleridge, but the less adventurous may find it equally rewarding to be physically guided through past and present landscapes by one of the Ordnance Survey's replicas of its 19th-century maps. Whichever path is chosen, one will follow the footsteps and boot-prints of innumerable others whose collective action has inscribed the walkers' tracery that binds together the place we call the Lake District.

BIBLIOGRAPHY AND REFERENCES

Addison, J, 1712 Essay No 412, *The Spectator*, 23 June [online], available from: http://www.readbookonline.net/readOnLine/40529 [14 January 2011]

Adler, J, 1989a Origins of Sightseeing, *Annals of Tourism Research* 16, 7–29

— 1989b Travel as Performed Art, *The American Journal of Sociology* 94 (6), 1366–91

Benjamin, W, 1999 (1931) *Selected Writings Volume 2, part 2, 1921–1934*, Harvard, Cambridge

Black, A, and Black, C, 1862 (1842) *Black's Picturesque Guide to the English Lakes with a copious itinerary; a map, and four charts of the Lake District; and engraved views of the scenery*, 15 edn, Black, Edinburgh

Boime, A, 1991 *The Magisterial Gaze Manifest Destiny and American Landscape Painting 1830–1865*, Smithsonian Institution Press, Washington DC

Carlson, J S, 2010 Topographical Measures: Wordsworth's and Crosthwaite's Lines on the Lake District, *Romanticism* 16, 72–93

Crowther, P, 1995 The Contemporary Sublime: Sensibilities of Transcendence and Shock, *Art & Design Profile* 30, 7

Defoe, D, 1726 *A tour thro' the whole island of Great Britain, divided into circuits or journies*, Vol 3, Letter X [online], available from: www.visionofbritain.org.uk/text/chap_page.jsp?t_id=Defoe&c_id=34 [10 July 2010]

Derby, W J, 2000 *Landscape and Identity: Geographies of Nation and Class in England*, Berg, Oxford

Haywood, M, 2002 Imagine the City, in *Salt River Soliloquies* (ed G Younge), Bell-Roberts, Cape Town, 12–20

— 2008 (1778) *Shifting the Scenery and Restaging the Picturesque*, in *A guide to the Lakes in Cumberland, Westmorland and Lancashire* (14th edn) (eds T West and G M-F Hill), Unipress Cumbria, Carlisle

Hogarth, W, 1997 (1753) *The Analysis of Beauty* (ed R Paulson), Yale, London

Ritvo, H, 2009 *The Dawn of Green: Manchester, Thirlmere, and Modern Environmentalism*, University of Chicago, Chicago

Rollinson, W, 1966 *A Series of Accurate Maps of the Principal Lakes of Cumberland, Westmorland and Lancashire first Surveyed and Planned Between 1783 and 1794 by Peter Crosthwaite*, Frank Graham, Newcastle upon Tyne

Solnit, R, 2006 *Wanderlust: A History of Walking*, Verso, London

Thompson, I, 2010 *The English Lakes: A History*, Bloomsbury, London

West, T, 2008 (1778) *A Guide to the Lakes in Cumberland, Westmorland and Lancashire* (14 edn) (ed G M-F Hill), Unipress Cumbria, Carlisle

Wordsworth, W, 1977 (1835) *A Guide to the Lakes* (ed E de Selincourt), Oxford University

Cumbrians and their 'ancient kingdom': Landscape, Literature and Regional Identity

Penny Bradshaw

In recent accounts of the way in which a sense of place is developed and constituted there is an acknowledgement of the underlying connections between human inhabitants and the physical external signifiers of place. Such connections are reinforced, processed and developed through a variety of mechanisms, and one crucial forum in which this processing occurs is literature. Attention to the ways in which regional identity is constructed within literary texts offers us important insights into how the complex connections between a particular place and its inhabitants are negotiated, and how through this a regional identity comes to be developed. Cumbrian literature offers a particularly interesting example of this sort of negotiation since, from a very early stage, texts written about Cumbria have tended to focus on the physical drama of its natural landscape, and this has led to a related interest within this body of work as to the impact of this wild and untamed environment on its human inhabitants.

The development of Cumbrian literature is a relatively recent phenomenon, partly as a result of the entrenched Scandinavian dialect in the region which rendered Cumbrian inhabitants virtually 'unintelligible to anyone south of Morecambe Bay' but also owing to economic factors, as, well into the 17th century, the main Lake District territory was inhabited by few residents of wealth and education (Nicholson 1977, 13; Urry 1995, 193–4). The Lake District first becomes a significant presence in English literature when it is mapped from the outside by late-18th-century visitors to what was, in literary terms, uncharted territory. The region is depicted first in travel literature and journal or letter accounts of visits made and so, unsurprisingly, there is from the outset an emphasis on delineating the geographical, climatic and geological aspects of the area. Within subsequent developments of Lake District literature, however, the physical landscape continues to be a dominating presence, to the extent that human figures often come to be defined in relation to features of the natural world. Literary treatment of this region from the late 18th century to the present day raises important questions about how a sense of place develops, about the relationship between people and place and, in particular, about the role played by geographical landscapes in our imaginative understanding of ourselves and our communal identity.

The earliest literary figure of significance to visit and write about the Lake District was the novelist Daniel Defoe, who described Westmorland in the 1720s as a place 'all barren and wild, of no use or advantage either to man or beast' (cited in Nicholson 1977, 21). Defoe's response was shaped by early-18th-century aesthetic attitudes to wild and untamed natural landscapes, and consequently he experiences the landscape in deeply negative terms and as alien to human habitation and needs. He displays very little interest in the place itself and even less in the people who might live there – indeed, his description suggests that the place repels human activity and industry. The next major literary figure to visit the Lakes was the 18th-century poet,

Thomas Gray, who arrived in 1769, after Burke's development of the concept of the sublime and thus more attuned to the possible aesthetic value of wild and untamed landscapes.[1] As a result he is much more positively responsive to the natural landscape itself, but he still makes little attempt to consider or delineate the identity of the people who live here other than by mentioning certain buildings and a handful of important family names. He does at one point though refer to the 'Dale's-men' who inhabit the region and implies that there exists an intimate connection between the place and its inhabitants, since they know but 'will not reveal the mysteries of their ancient kingdom, the reign of Chaos & old Night', secrets from which the mere tourist is excluded (Roberts 2001, 47). Here we get the first literary attempt to imagine the sort of people who might inhabit and find a home within such a landscape, and already the language used by Gray begins to mark the residents out as unique and special. Gray can only imagine their identity in terms of the secret understanding which he perceives must exist between them and the natural world in order for them to survive and make a life for themselves amid this 'turbulent Chaos' (ibid, 45) and these 'fantastic forms' of nature (ibid, 47). Gray also begins the process of linking the humans with the landscape through his tendency to personify natural features. He describes Place Fell as 'one of the bravest' among the mountains, who 'pushes' a 'bold broad breast into the midst of the lake & forces it to alter it's course' [sic] (ibid, 33) and suggests that the 'bare & rocky brow' of Walla-crag 'awefully overlooks the way' (ibid, 45). Here the fells take on the character of living residents and these acts of personification recur with frequency in subsequent Lake District literature. What we also find in the literature which follows Gray, though, is a reversal of this process, in which the characteristics of the physical landscape are used to describe and define the human residents. This technique, which we might term naturification, is a means of further developing the close links which are perceived to exist between Man and his natural environment, and its use becomes central to the development of regional identity within Cumbrian literature.

The poet William Wordsworth is the first writer to give us a detailed imaginary response to Cumbria from the inside, from the point of view of someone born and raised in this landscape. He is also the first writer to really offer an in-depth consideration of the people of the Lakes and his tendency to deploy naturification within his descriptions of regional figures relates to his understanding of the ways in which we are profoundly shaped by our environment. As Newby notes, Wordsworth shows 'how man's life and attitudes were bound up with places and objects in the natural world' and many of his poems 'clearly explore ... the significance of locations for the attitudes, emotions and activities of man' (Newby 1981, 131). External determinants are apparent in his construction of the Lake District shepherds in Book 8 of *The Prelude*, the men 'Whose occupations and concerns were most/ Illustrated by Nature' (Gill 2008, 491). He rejects Arcadian images of pastoral shepherds and describes men whose 'manners' are 'severe and unadorned' as a result of their life 'among awful Powers, and Forms' (ibid, 492). The poem takes us on an imaginative journey from the pastoral landscapes of Italy – those 'serene ... / Pleasure ground[s]' of the south – to the northern landscapes of Westmorland which are defined by their wildness and their climatic extremes:

[1] Edmund Burke's 1757 publication, *A Philosophical Enquiry into the Origin of Our Ideas of the Sublime and Beautiful*, in which he argues for the powerful emotional effects of such landscapes on the mind of Man, is a significant milestone in the history of changing 18th-century aesthetic attitudes to mountainous and wild natural scenery.

> hail to You,
> Your rocks and precipices, Ye that seize
> The heart with firmer grasp! your snows and streams
> Ungovernable, and your terrifying winds,
> That howled so dismally when I have been
> Companionless, amongst your solitudes.
> There 'tis the Shepherd's task the winter long
> To wait upon the storms (ibid, 495–6)

Wordsworth suggests that the daily battle with the elements experienced by the shepherd living here produces a man who is powerfully independent: 'He feels himself/ … A Freeman; wedded to his life of hope/ And hazard' (ibid, 496). Wordsworth constructs a quasi-mythical identity for the Cumbrian shepherd which is bound up with the landscape he inhabits; he is figured as 'a Giant, stalking through the fog,/ His Sheep like Greenland Bears' and at one point he seems to rise symbolically from the rocky outcrop on which he stands:

> A solitary object and sublime,
> Above all height! Like an aerial Cross,
> As it is stationed on some spiry Rock
> … for worship (ibid, 497)

Wordsworth's own identity, like that of the shepherd, is closely connected to his habitation within this place. As critics have shown, following his return to the Lakes at the end of 1799 he takes immediate steps to anchor his poetry within specific geographical parameters and to define himself as a poet in terms of his residence in this region (Butler 1996; Bate 1991). Wordsworth has been consistently seen as a poet of place and this is partly a result of his own insistence on constructing not only his own identity but also his poetry as a product of this natural landscape. His 1800 Preface to the *Lyrical Ballads*, written largely during the early months of residence at Grasmere, makes claims for a new poetic language which draws on the language of the men who live closely with nature amongst these hills:

> Low and rustic life was generally chosen, because in that condition, the essential passions of the
> heart find a better soil in which they can attain their maturity, are under less restraint, and speak
> a plainer and more emphatic language; because in that condition of life our elementary feelings
> co-exist in a state of greater simplicity … ; because the manners of rural life germinate from
> those elementary feelings … because in that condition the passions of men are incorporated
> with the beautiful and permanent forms of nature. (Gill 2008, 597)

This passage reveals Wordsworth's perception of a dynamic connection between the physical landscape and the people who live within it: their emotional life grows out of this 'soil' as much as the trees and plants; their feelings are elemental; their passions 'incorporated' with that which is 'beautiful' and 'permanent' and even their discourse is shaped by the place they inhabit, so that they come to speak in plain, 'emphatic' language. Wordsworth 'adopts' the language of these men, which 'convey[s] their feelings and notions in simple and unelaborated expressions', as the basis for his own place-rooted poetic language because it is 'a more permanent and philosophical language than that which is frequently substituted for it by Poets' (ibid, 597). In other words,

Wordsworth strips away the flourishes and trappings of 18th-century poetic discourse and tries to develop instead a poetic language which he perceives as being elemental and at one with the landscape. Thus his poetry is not simply about the Lakes; it is shown to be intrinsically a product of this geographical region.

John Ruskin, the influential Victorian social commentator and art critic, writing a generation later, contributes to this development of a theory of the fundamental connections between the inhabitants of a particular place and the physical characteristics of the place they inhabit in his chapter on 'The Nature of Gothic' from the second volume of *The Stones of Venice* (1851–53). Here he sets out to show how the climatic differences between the northern and southern parts of the world affect not only the appearance of the landscape and the types of plants and animals which flourish there but also, by extension, the human residents and the art they produce. He describes northern architecture as 'rude and wild' and attributes this to the 'contrast in physical character which exists between the Northern and Southern countries' (Birch 2004, 36). Like Wordsworth he journeys imaginatively from the southern regions, where the emphasis is on light, fragrant flowers, exotic fragrances, heat and smooth marble, to more northerly territories, where we 'see the earth heave into mighty masses of leaden rock and heathy moor' (ibid, 36–7). For Ruskin these physical differences in natural landscape are vital in understanding 'the great laws by which the earth and all that it bears are ruled throughout their being' (ibid, 37) and he shows how these differences shape the lives and the artworks of the earth's human inhabitants. He describes the architect of the north who:

> With rough strength and hurried stroke … smites an uncouth animation out of the rocks which he has torn from among the moss of the moorland, and heaves into the darkened air the pile of iron buttress and rugged wall, instinct with work of an imagination as wild and wayward as the northern sea; creatures of ungainly shape and rigid limb, but full of wolfish life; fierce as the winds that beat, and changeful as the clouds that shade them. (ibid, 37)

Just as the art we produce is fundamentally determined by the materials with which we work, so for Ruskin and Wordsworth man himself is shaped by the climate and geology of the place in which he lives. The battle against the elements produces a 'strong spirit of men' who display 'some of the hard habits of the arm and heart that grew on them as they swung the axe or pressed the plough' (ibid, 37–8). In Ruskin's prose the linguistic echoes between specific landscape characteristics and the attributes of the human dwellers are suggestive of a deeply profound link between people and place. He describes an 'imagination as wild and wayward as the northern sea' (ibid, 37) and the use of the natural simile here is more than mere rhetorical device; it suggests that the people somehow absorb the attributes of the place they inhabit.[2] Ruskin thus

2 An interesting parallel to Ruskin's description of northern artworks and his use of naturification in the literary construction of northern identity is found in Emily Brontë's novel *Wuthering Heights* and in Charlotte Brontë's 1850 preface to the novel. The latter is a contemporaneous attempt to relate works of art and literature to geographically specific life-experiences:

> *Wuthering Heights* was hewn in a wild workshop, with simple tools, out of homely materials. The statuary found a granite block on a solitary moor: gazing thereon, he saw how from the crag might be elicited the head, savage, swart, sinister; a form moulded with at least one element of grandeur – power. He wrought with a rude chisel, and from no model but the vision of his meditations. With time and labour, the crag took human shape; and there it stands, colossal, dark, and frowning, half

reaffirms a Wordsworthian construction of a human identity which is defined by the physical characteristics of the regional landscape it inhabits, but he also begins to theorise the way in which different geographical determinants can shape and colour our imaginative and emotional responses to the world.

This essentialist understanding of identity has proven pervasive and by the 20th century the idea that there is a fundamental link between physical landscape and the identity of its inhabitants appears in Cumbrian literature in a variety of ways. Hugh Walpole, a prolific and best-selling author in the interwar period who spent the later part of his adult life living in Cumbria, published a historical series of four novels set in the region, referred to collectively as the *Herries Chronicles*. The series was published between 1930 and 1933 and within the books key characters are shown to be shaped by and psychologically in tune with the specific northern landscapes in which they live. In the first book of the series, the eponymous Rogue Herries is defined by his affinity with the remote Borrowdale valley and with the ancient estate to which he brings his family: 'the strange house in the strange country, shut in under the mountains behind rocky barriers, cut off from the world' (Walpole 1996, 20). He is drawn there by 'That part of him that loved to be alone, that loved to brood and dream and enfold about him ever closer and closer, his melancholy and dark suspicion and defiant hatred of the world' (ibid, 21), and the deep psychological link between man and place is suggested by his recurrent dream of a 'region of vast, peaked, icy mountains ... ringed round a small mere or tarn, black as steel in shadow' (ibid, 30). Ironically Herries is an 'offcomer' but the novel hints at ancestral connections with this borderland region since 'Scotch and English blood ... had gone into the making' of the Herries dynasty, and Herries himself recognises some deep affinity with those born in the valley: 'Something was in his blood that was in their blood' (ibid, 69).[3] Despite his status as outsider, the echoes between his identity and the landscape of the remote valley in which he lives become more and more apparent as the novel progresses, with Herries coming to embody this wild and tempestuous region; at one point he appears in a doorway as if a part of the natural landscape had been suddenly and incongruously transplanted inside the domestic space:

> how strange he looked standing there, wearing his own black shaggy hair, muddily booted to the thighs, his long brown coat faded and stained, his face brown and spare, the shape and form of it altered by the deep white scar that ran from brow to lip. His face was yet shining with raindrops, water dripped from his boots, the back of his hand shone with rain. ... he was lean and spare, and seemed of an immense height. (ibid, 136)

Herries' is the first important Cumbrian character to be developed in fiction whose characterisation draws extensively on 19th-century ideas about the defining relationship between people

statue, half rock; in the former sense, terrible and goblin-like; in the latter, almost beautiful, for its colouring is of mellow grey, and moorland moss clothes it; and heath, with its blooming bells and balmy fragrance, grows faithfully close to the giant's foot. (cited in Brontë 1985, 41)

Set within a Yorkshire rather than Cumbrian landscape, the novel itself is imbued throughout with a strong sense of the relationship between the physical characteristics of the land and its inhabitants, and the figure of Heathcliff remains probably the most significant example of the use of naturification in the construction of a northern character in literature.

3 'Offcomer' is a Cumbrian term for a non-native visitor or resident within the region.

and their environment. Walpole's handling of this provides a significant nuancing of this motif, however, since he sets precise historical, as well as geographical, perimeters for his character and makes clear that it is not simply the landscape but a unique moment in the history of that landscape which provides the specific coordinates for his identity. At one point Walpole suggests that human inhabitants are affected by the natural environment more so here than elsewhere:

> if you lived here your days were bound up with the sky, so that after a while it seemed to have a more active and personal history than your own. It became almost impossible to believe that its history was not connected with yours, keeping pace with you, influencing you, determining your fate.... In this world [the sky] ... drove itself into your very heart. (ibid, 64)

He reminds us though that the extent of this influence relates to the period in which the novel opens, the 1730s. Walpole notes that 'At this time' the valley of Borrowdale is 'a lost land, untenanted by man ... dominated entirely by the mountains that hemmed it in' (ibid, 62) and it is this very specific context of wild remoteness, located within time and place, which Herries absorbs into his own identity.

Although Walpole proposes a nuanced historio-geographical understanding of environment, subsequent Cumbrian writers have, on the whole, tended to emphasise a more essentialist geographical influence in their treatment of regional identity. One of the most significant literary voices to emerge from Cumbria since Wordsworth, the poet Norman Nicholson, has also produced extensive prose writings on the region and the people who live within it. Nicholson is repeatedly drawn to two correlated aspects of the region's development – its geology and its culture – and although a deeply perceptive analyst of imaginative responses to this region from the Romantic period onwards, Nicholson's interest in these two strands at times reinforces an essentialist reading of the direct correlation between the physical land and the people who inhabit it. He states bluntly in *Portrait of the Lakes* that 'At bottom the Lake District is a piece of rock. It is the rock which makes the land and the land has made the people' (Nicholson 1963, 23) and in 'The River Duddon', a poem in which he also wrestles with Wordsworth's ongoing legacy in shaping how we imaginatively respond to the Lakes, he acknowledges and affirms Wordsworth's realisation of the essential geological basis of all that happens within the surface life of the region:

> beneath mutation of year and season,
> Flood and drought, frost and fire and thunder,
> The frothy blossom on the rowan and the reddening of the berries,
> The silt, the sand, the slagbanks and the shingle,
> And the wild catastrophes of the breaking mountains,
> There stands the base and root of the living rock,
> Thirty thousand feet of solid Cumberland. (Curry 1994, 26)

While Nicholson traces the source of the visible natural world and our communal identity to their geological roots, Molly Lefebure, another significant 20th-century analyst of Cumbrian culture, returns to the techniques of personification and naturification to reinforce the connection between the physical characteristics of the place and the people who live here. She describes 'the Lakeland fells sprawl[ing] like giants who have become drowsy over the ages' and notes that 'However inanimate they may be to the dull or unobservant, they are without doubt alive' (Lefebure 1964, 16), and her description of Cumbrian dwellers draws on the characteristics of the

rugged mountainous and impenetrable landscape they inhabit: 'The Cumbrian ... has a genius for rugged individuality, independence of spirit, inspired bloody-mindedness in short, which may have a desperately disconcerting effect upon the natives of lesser counties' (Lefebure 1970, 28). As if by osmosis the fells absorb human qualities and the people absorb characteristics of the fells and, as in Wordsworth's poetry, this results in both people and place taking on a mythic quality; the fells are no longer simply geological features but living, breathing things and the human dwellers, in taking on the grand, wild and rugged characteristics of the scenery, become somehow more than ordinarily human.

This mythologising of Cumbrian identity continues to appear in more recent Cumbrian literature and particularly in the work of one of the most important literary figures to emerge from Cumbria in recent years, the Booker-shortlisted, Whitbread-prize-winning novelist Sarah Hall. Hall, who was born and who lives in Cumbria, has set several recent highly acclaimed books in the region. Of these, *The Carhullan Army*, which was published under the title *Daughters of the North* for its US release, offers a particularly interesting example of a fictional construction of regional identity as defined through landscape. Set in a dystopian future, its heroine escapes from her depressing life in Rith (a futuristic Penrith) over the fells to a female guerrilla group and self-sufficient community living in a derelict farm under the shadow of High Street. The leader of the community is the enigmatic Jackie Nixon – a hard, brutal, warrior-like woman whom Hall defines throughout the novel as a true daughter of Cumbria. She has clear ancestral ties since 'Her family were from the area' and she is descended from the 'Border Nixons ... who went out with bulldogs to meet the reivers' (Hall 2007, 51). That she is born and bred of this landscape is reinforced further though through the geological similes which find their way into Hall's descriptions of Jackie, whose eyes are described variously as 'hard-cast, like granite' (ibid, 49), as the blue colour 'of the region's quarried stone' (ibid, 50), and as 'the colour of slate riverbeds' (ibid, 78).

At times the text acknowledges the fact that the fictional construction of Jackie draws on assumptions which have become stereotypes: 'In the early reports Jackie had always been depicted as a typical Northerner; obdurate, reticent, backlit' (ibid, 51) but nothing in Hall's subsequent depictions resists this stereotype; rather, it is thought through and developed to such an extent that Jackie comes to be seen as a genuine child of the northern fells, her 'spirit' somehow 'bred from the landscape' (ibid, 55). Just as Carhullan represents the 'edge of civilisation' (ibid, 55), so the woman who is a product of this place is positioned on the edge of humanity in her cruelty, her resilience and her remoteness. In recent interviews, Hall has tended to reinforce such essentialist ideas about Cumbrian identity in a way that denies the fictionalising process at work in this construction:

> I was brought up in Cumbria where I saw all these fierce agricultural women.... They terrified me when I was young.... Being brought up here has such an effect. I love it all. The practicality, reticence and the belligerence.... I love that combination, that's here in the culture and the rocks. I feel like I'm having a dialogue with it all the time. (cited in Brown 2007)

Hall, herself a born and bred Cumbrian, subtly positions herself outside these models of regional identity as an onlooker who may choose to engage in 'dialogue' with regional cultural characteristics but who is also able to stand outside, looking in. But Hall's identity as a Cumbrian writer is itself open to the same processes of cultural identification and recent reviewers have drawn closely on geographical characteristics of the region in describing her work. Greenland

suggests that 'Hall's prose is chunky with local language, colour and landscape ... Everything is earthy, nothing idealised.... What she has given us is ... tough, thorny, bloodyminded', and Arditti observes that the novel is 'written in prose as crystalline and craggy as the landscape' (Greenland 2007; Arditti, 2007). This link between Hall's writing and the landscape in which her books are set has been extended to include her thematic interests, which have been related to the notoriously damp Cumbrian climate; Brown notes that the 'theme of waterborne revolution has run through all three of Hall's novels' and Guest comments that 'Perhaps unsurprisingly for a writer who grew up in the Lake District, her books are saturated with water' (Brown 2007; Guest 2007). What these constructions of Hall's writing suggest is that Cumbrian writers, like the imaginary Cumbrian characters they create, continue to be viewed in terms of their special knowledge of and affinity with their 'ancient kingdom'. It is clear from these accounts of Hall's work that ideas established at a very early stage in Cumbrian literature, regarding the ways in which individuals and communities are shaped by the physical characteristics of the landscape they inhabit, continue to dominate our understanding and construction of Cumbrian regional identity in the 21st century.

The parallel insistence in the literary texts considered here on viewing human identity in terms of geographical determinants and seeing nature through the imaginative lens of human experience reveals the profound psychological, cultural and emotional links which are seen to exist between people and their lived environment. Analysis of these imaginative treatments of a geographically defined identity demonstrates also though the significant role played by literature – and, by extension, other creative art forms – in shaping and constructing our sense of place and in strengthening these links. Literature provides a means of not only exploring but also reinforcing, through tropes, imagery, character construction and other strategies, the idea of underlying connections existing between a geographical landscape and its human inhabitants. As the recent discussions of Hall's writing suggest, the connections between people and place developed within these textual spaces come to be absorbed into our wider cultural understanding and continue to have a powerful influence on contemporary constructions of regional identity.

Bibliography and References

Arditti, M, 2007 Psychopath in the Community, *The Telegraph* [online], 8 September, available from: http://www.telegraph.co.uk/culture/books/fictionreviews/3667787/Psychopath-in-the-community.html [2 February 2010]

Bate, J, 1991 *Romantic Ecology: Wordsworth and the Environmental Tradition*, Routledge, London

Birch, D (ed), 2004 *John Ruskin: Selected Writings*, Oxford University Press, Oxford

Brontë, E, 1985 *Wuthering Heights*, Penguin, London

Brown, H, 2007 Sarah Hall: Floods, curses, fanatics – it's good to be home, *The Telegraph* [online], 1 December, available from: http://www.telegraph.co.uk/culture/books/3669631/Sarah-Hall-Floods-curses-fanatics-its-good-to-be-home.html [23 February 2010]

Butler, J, 1996 Tourist or Native Son: Wordsworth's Homecomings of 1799–1800, in *Nineteenth-Century Literature* 51 (1), 1–15

Curry, N (ed), 1994 *Norman Nicholson: Collected Poems*, Faber and Faber, London

Gill, S (ed), 2008 *William Wordsworth: The Major Poems,* Oxford University Press, Oxford

Greenland, M, 2007 Twisted Sisters, *The Guardian* [online], 18 August, available from: http://www.guardian.co.uk/books/2007/aug/18/featuresreviews.guardianreview18 [11 February 2010]

Guest, K, 2007 Interview: Writer Sarah Hall's novels paint communities teeming with life and teetering near death, *The Independent* [online], 10 August, available from: http://www.independent.co.uk/arts-entertainment/books/features/interview-writer-sarah-halls-novels-paint-communities-teeming-with-life-and-teetering-near-death-460868.html [23 February 2010]

Hall, S, 2007 *The Carhullan Army,* Faber and Faber, London

Lefebure, M, 1964 *The English Lake District,* Batsford, London

— 1970 *Cumberland Heritage,* Arrow, London

Newby, P, 1981 Literature and the Fashioning of Tourist Taste, in *Humanistic Geography and Literature* (ed D C D Pocock), Croom Helm, London, 130–41

Nicholson, N, 1955 *The Lakers: The Adventures of the First Tourists,* Robert Hale, London

— 1963 *Portrait of the Lakes,* Robert Hale, London

— (ed), 1977 *The Lake District: An Anthology,* Robert Hale, London

— 1982 *Selected Poems 1940–1982,* Faber and Faber, London

Roberts, W (ed), 2001 *Thomas Gray's Journal of his Visit to the Lake District in October 1769,* Liverpool University Press, Liverpool

Urry, J, 1995 *Consuming Places,* Routledge, London

Walpole, H, 1996 *Rogue Herries,* Sutton Publishing, Gloucestershire

4

Gypsies, Travellers and Place: A Co-ethnography

IAN CONVERY AND VINCENT O'BRIEN

INTRODUCTION

First recorded in Scotland in 1505 and in England in 1514 as 'Egyptians' (Bancroft 2005), Gypsies and Travellers have lived in Britain for at least 500 years, yet are the most socially excluded community in the UK, suffering from among the worst health, lowest life expectancy and lowest educational achievement of any ethnic community (Van Cleemput et al 2007; Lloyd and McCluskey 2008; Parry et al 2007; Powell 2008; Goward et al 2006; James 2007; see also Clark and Greenfields 2006; Cemlyn et al 2009). In particular, the pervasive notion that settled lifestyles are the norm and that nomadic[1] lifestyles are a threat to the norm informs much of the structural and institutional forms of discrimination experienced by Gypsy-Travellers (Kabachnik 2009; James 2007; Massey 1993). As James (2007) notes, the 20th century saw a range of policies and legislation aimed at curbing Gypsy-Traveller nomadic lifestyles and promoting settlement. There is also a relative paucity of research linked to Gypsy and Traveller communities in the UK. As Parry et al (2007) indicate, even though Gypsies and Travellers in the UK experience disproportionately high levels of discrimination, deprivation and morbidity, they appear to be invisible within mainstream studies (see also Holloway 2004).

This chapter, based on co-ethnographic research carried out with Gypsy and Traveller communities in Cumbria during 2009–2010, considers issues of identity, culture and connections to place and materials. We explore self-constructed Gypsy-Traveller identities, and in particular how 'kinship place' – geographical places as loci for kinship activities – is important for Gypsy-Traveller identity and sense of place.

METHODS

At the heart of our work is the intention to develop co-ethnographic narratives through the capture and screening of audio and video material. We see co-ethnography – by which we mean an ongoing interpersonal dialogue between researcher and respondent – as a way of overcoming at least some of the unequal power relationships inherent in 'traditional ethnography'. From our experience we know that narratives rarely simply 'reveal' what someone thinks or feels; any 'truth' is a construction. Biographical stories are always positioned, never complete (Convery et al 2008).

In practical terms, co-ethnography requires regular contact with respondents and a deep understanding of their personal situation. In this way the telling of a situated and personally

[1] We recognise that this is a contested term and refer readers to Drakakis-Smith (2007) for a discussion of nomadism in relation to Gypsy-Traveller communities.

reflective story is then told again through the actions of the researcher. After Hastrup (1995, 16), we accept our active engagement in the 'ethnographic reality, the ethnographic present'. Engagement in the recording, interviewing and commentary during screenings of edited materials enables the participants to comment upon, clarify and extend the ideas, insights and stories presented in the edited narratives and materials.

We would also argue that narratives are not fixed, nor are they limited to the prepared stories that we tell. They are also evident in the physical and visual displays that we construct to reinforce our sense of self and to display that perceived self to others. As Richmond (2002) indicates, the construction and portrayal of self comes about through the use of different narratives, depending on place, setting and audience. We also need to consider how a story is put together, the linguistic and cultural common elements that signify a shared narrative across a range of personal stories. Burr and Butt (2000) put it this way: 'we do not simply recall events as they happen; rather, we selectively recall, narrating a story of the past that makes sense to us'. Gubrium and Holstein (1998) elaborate on this 'pulling together of the parts'. They use the term 'narrative practice' to describe the dynamic processes of story composition – that which draws upon personal experience and available meanings, structures and linkages that comprise stories. Thus a narrative offers a translation of a perception of events, presenting cause and effect in a selective manner, which makes sense to the author. Constructing and composing narrative always takes place within dynamic, shifting contexts. Borrowing again from Hastrup (1995, 16), we see co-ethnography as a practice which eliminates both 'objectivism and subjectivism, and posits truth as an inter-subjective creation'.

This chapter represents a 'work in progress'; our longer-term research aim is to extend engagement of Gypsy-Traveller participants through the use of participatory video and photography in similar ways to those we have used in work with semi-nomadic communities in Central Asia (O'Brien et al 2007). Here we consider issues of identity, culture and connections to place and materials, and in particular focus on the significance of family relations as a key element of Gypsy-Traveller identity.

GYPSY-TRAVELLERS: NOMADIC AND SETTLED

In this chapter we follow Bancroft (2005) in our use of the term Gypsy-Traveller[2] to include the wide variety of people and communities who identify themselves as Roma, Romani, Show People, English Romanichels, Welsh Kale, Scottish Travellers (Nawken) and Irish Travellers (Minceir) (see also Drakakis-Smith 2007). As already stated, Gypsy-Travellers have lived in Britain for at least 500 years, yet this 500-year history and culture is rarely glimpsed within public museums, libraries and archives (Bowers 2007).

Sedentarism – the notion that settled lifestyles are the norm – lies at the heart of this discrimination and encourages the view that nomadic lifestyles are a threat to the norm (Massey 1993).

[2] Defining Gypsies and Travellers is not straightforward. Different definitions are used for a variety of purposes. At a very broad level, the term 'Gypsies and Travellers' is used by non-Gypsies and Travellers to encompass a variety of groups and individuals who have in common a tradition or practice of nomadism. More narrowly, both Gypsies and Irish Travellers are recognised minority ethnic groupings. In UK Government guidance they are defined as 'Persons of nomadic habit of life whatever their race or origin' (ODPM 2006).

The reality is that many Gypsy-Travellers, especially the Roma of Central and Eastern Europe, are settled and have been settled for some generations (Brown and Scullion 2010). While Gypsy-Travellers have been more successful at maintaining a nomadic way of life in Britain and Ireland, over time it appears that nomadism has been transformed into more of a 'state of mind' than a defining feature of everyday life for Gypsies and Travellers (Clark 2002). According to Bowers (2007), 50 per cent of all Gypsy-Travellers in England are housed, either through choice or often through a lack of accommodation. But even where Gypsy-Traveller families have been settled for years there remains a persistent 'myth' of nomadism which continues to inform regulatory practices and policies that function as a means of excluding those who might at some future time choose to travel (Turner 2002; Shubin and Swanson 2010). For many of those living in housing, their accommodation is perceived as an attempt to assimilate them into mainstream gorgia (non-Gypsy-Traveller) society (Bowers 2007) and, according to Smith-Bendell (2009, 207), the same applies to 'council sites', where 'there are so many things that are restricted on those sites that impact on our customs and beliefs, but we are just Gypsies after all'.

Of course, Gypsy-Travellers are not a homogenous group and for some their identity as a Gypsy or Traveller will be grounded in a notion of ethnicity; for others it may derive from family traditions around occupation, lifestyle and culture (Clark 2006; Brown and Scullion 2010). Certainly, claims about the importance of family and occupation were frequently evident in the conversations we had with participants. In Cumbria, participants variously identified themselves as either Gypsy or Traveller while at the same time referring to themselves as both Gypsy and Traveller. No clear distinction was made and for many respondents the terms would appear to be interchangeable. One woman suggested that 'Travellers are people who are afraid to call themselves Gypsies', suggesting that the term Gypsy holds more social stigma than Traveller.

GYPSY-TRAVELLER IDENTITY AND PLACE

The stigma or 'otherness' frequently attached to being viewed as a Gypsy in European society may be one reason why some individuals and families were reluctant to acknowledge Gypsy-Traveller ancestry. For others there may be almost a double identity: a personal 'internal' Gypsy identity and another public identity for which 'Gypsy-Traveller' may or may not be acknowledged. Our research indicated that in practice the internal self-image is 'real', yet kept within the family, while the more public self-identification as Gypsy-Traveller is hidden from the gorgia society (see also Clark 2002). As one respondent told us in Carlisle: 'I would reckon that at least a quarter of the population of Carlisle would be Gypsies and Travellers ... there's a lot that don't acknowledge it. They've settled, they're happy, they don't get no stress.'

Ethnic groups, of all kinds, are social constructions – the boundaries of which are fuzzy. The 'fuzziness' of ethnic identity, in the case of Gypsy-Traveller communities, makes the use of survey methods for research problematic. The tendency for people to reconstruct self-identity according to personal and societal influences has resulted in some interesting findings, particularly in Eastern Europe. In Bulgaria, for example, two-thirds of respondents self-identified as Roma, whereas in Hungary only one-third of respondents did so (Ladányi and Szelényi 2001). In England, Gypsy-Travellers are largely absent from the census and most forms of ethnic monitoring (Bowers 2007). Local conditions, it seems, play some part in how people perceive ethnic identity. As Covrig (2004) notes, one of the main problems one is faced with while dealing with Gypsy-Traveller issues is to find reliable statistics. He adds that even if sometimes quoting the

same sources for data on Gypsy-Travellers, for the same country and the same year, the numbers can differ, often according to the purpose for which the data was gathered.

Traditional and many non-traditional Roma Gypsies in Central and Eastern Europe share many cultural characteristics with non-Roma Indigenous Gypsy-Travellers of Western Europe. Both groups maintain a strong sense of separateness, maintained in part by internal processes and as a response to the external attitudes and practices of the settled communities they live among. Furlong (2006, 52) argues that defining 'insiders' depends on the existence of 'outsiders'. According to Verdery (1996), various aspects of post-socialist change (such as economic insecurity or alienation) can be associated with particular ethnic groups. In particular, the social group most often constructed as the 'other' are the Roma, even where they are very few in number (Verdery 1996). Guy (2001, 297) argues that the 'always low social status' of the Roma is now 'uniformly bleak' and has effectively gone 'into free fall'.

Occupation and family ties tend to be at the centre of self-declared cultural identity. The indigenous Gypsy-Travellers of Western Europe are probably descended from the groups of travelling traders and craftspeople such as metal workers and musicians that sustained a pre-industrial economy. Gypsy-Travellers often demonstrate distinctive occupational practices, which in part emphasise the importance of kinship networks (Bowers 2007; Shubin and Swanson 2010). The general view of these occupations and lifestyles as low status and undesirable by the settled population, along with various large-scale population upheavals over the centuries through land clearances in the name of agricultural improvement, may also have contributed to the development of Gypsy-Traveller communities in Western Europe (Bancroft 2005).

As we said in the methodology section of this chapter, our intention is to work with participants to create a co-ethnography of Gypsy-Traveller life which aims to retell the original narrative in an analytical yet authentic way. We seek to keep as much as possible of the original story while at the same time adding our own insights and interpretations as researchers. We have chosen one narrative (taken from a short film, made with the close cooperation of Eileen and with one of her family members acting as interviewer) as an exemplar story which we now present, almost in its entirety, along with analytical comments and links to relevant literature from other sources.

EILEEN'S STORY

> My name is Eileen and I come off the O'Neill's family. My mother was Kathleen O'Neill, a very good-looking woman and she had four good-looking sisters as well and two brothers. I was brought up with them all, every day of my life they were there, my Grandfather was there. We were a very close-knit family. We lived in Caldewgate, Byron Street. I was born in Byron Streeet in 1945, and we lived there quite a few years. In that area there was quite a few Travellers. I was brought up to survive in the jungle, I was taught wrong from right. When my parents died I took on the role of keeping the family together.

Eileen begins her story emphasising the importance of family ties: 'I come off the O'Neill's family'. In our fieldwork interviews we asked one of our participants to initiate the interviews, adding supplementary questions as required once the conversation had developed. We often came across this emphasis on family both from our participant interviewer and the respondents. During our visit to Appleby Horse Fair in 2010 we noted how the question 'where are you from?' was often followed up with a question about family origins.

Roundabout here [in Caldewgate] there was a joiners – he used to make coffins and me and me friend would go and play in the coffins, that's a memory that's just come back [laughs] and round the corner here was the back entrance to Carr's biscuit works. We used to go down there and they'd give us tins of broken biscuits for nowt … it was just a lovely place to live, it was down to earth, it was like Catherine Cookson land. There wasn't many cars, it was all horses and carts. A lot of people would come from other parts of Carlisle to visit these pubs, and that one over there, on a Sunday lunchtime there was always a man sitting outside playing the accordion, and all the kids just used to run up, they used to dance on the bottom of that street.

Here Eileen highlights the importance of geographical place in shaping sense of self. The importance of being 'down to earth' and the romanticised image of life as a child in a community where most people were nomadic or, as in the case of the refugees, displaced and separated from the local population. In addition, the co-ethnographic act of visiting locations in Carlisle with Eileen allowed this narrative to develop in a different way than if we had simply interviewed her in a fixed location. The acknowledgement of geographical place as important was repeated in other interviews, where typical responses were, 'I'm from Carlisle' or 'I'm from Penrith'. These responses were as common among those who lived in trailers, maintaining a travelling lifestyle, as they were among those who had been living in houses for three or more generations. Families who lived on campsites tended to regard one site as 'home' and travelled for trade or to meet up with other family members at various times during the year. Some families we met in Cumbria regularly travelled to Germany, France and Holland during the summer months.

There'd be a dozen stables, at least a dozen [in Caldewgate], it's where the traveller put their horse and carts, it's where my Grandfather and his brothers kept their horses. They'd [sic] be houses on this side [opposite where stables used to be, now just a brick wall], I used to sell them clothes when I was little.

The horse is a very important symbol of Gypsy-Traveller identity (Bowers 2007; Smith-Bendell 2009). Appleby Horse Fair in Northern England is one of the largest Gypsy-Traveller gatherings in Europe and a major tourist attraction (Holloway 2004). It is an important feature in the Gypsy-Traveller calendar, providing an opportunity for families to meet, to display their cultural identity through public bartering and the ritual of 'chopping' or 'clapping' hands to secure horse sales. These sales often attract a small crowd who through their presence give credence to the social status of the traders who are able to make a 'good deal'. Selling a horse to another Gypsy-Traveller has a powerful and symbolic role in affirming male identity and prowess, but selling a horse to a gorgia is simply a matter of trade (Clark 2002).

We'd all go hawking, my Grandfather, his two sons went hawking, and I used to go hawking with my mother. It was called billing – I'd put a card through the letterboxes with my mother's name and address on it, asking people if they had clothes for sale, then we'd go back in an hour and I used to run along [the street] and pick up the cards from the letter boxes, cause if they didn't have anything for sale they'd put the card back through the letterboxes. Then me and my Mam used to get loaded up with bundles [from those people who did want to sell clothes] – we'd bring them back and sort through them, which ones was good, good enough to turnover and sell, which ones was going to the ragman. I had to take the bundle up to the punters and

get the money in, 'cause money was tight, it was just after the War, there were ration books, coupons. There were a lot of people from London, refugees, and they had no money. I used to deal with them and I was only a bairn, I used deal with them for tokens for tea and sugar. You really had to buckle under when you had a house full of kids.

Hawking – selling goods door-to-door – is a common occupation for many Gypsy-Traveller women, though, as Clark (2002) notes, traditional hawking has been complemented by other trades, such as carpet-dealing and selling goods at markets, car boot sales and other local sales. Indeed, there is a strong link between Gypsy-Traveller freedom, ability to move and traditional work practices such as hawking and scrap-dealing, which call for some measure of mobility (Shubin and Swanson 2010). Involving children in this enterprise is considered an important part of their education. Schooling is often seen to be of secondary importance to the informal occupational education a child receives while accompanying parents in their normal working day. According to Bowers (n.d.) 'there are cultural reasons why Gypsy-Travellers do not value formalised education as highly as the settled population. Gypsy-Travellers expect to be discriminated against in the labour market and so value forms of self-employment much more highly than formal education and employment.' Okely (1992; 1996) also pursues a culturalist argument, stating that Gypsy-Travellers operate largely independently of wage labour and much prefer to be self-employed. Indeed, Okley views their self-employment status, especially in the informal economy, as one of the most important characteristics of their Gypsy-Traveller identity. She argues that, rather than being an indicator of marginalisation, Gypsy-Travellers' use of the informal economy provides the material context for their cultural identity, which is bound up with the rejection of wage-labour. Scrap-dealing and hawking were a familiar part of Eileen's Caldewgate lifescape:

> My Grandfather used to take scrap metal over to Newcastle for Ginger Liddle; he was the only one with a driving licence, a lot of travellers didn't have driving licences in them days. He also used to take prisoners of war to Penrith – they were Italians. There were lots of things going on when I was a lass, on a Christmas, Ginger Liddle used to knock on me Mam's door with a turkey to say thanks for me Grandfather delivering his scrap metal. I learnt how to buy and sell when I was ten, me and my brother Geordie, we used to collect scrap metal, copper and brass. Me Grandfather told us what was worth money and what wasn't – he'd weight it in for us. Then we got wise, he was diddling us, so then we'd take it to the rag shop, to Sheddy Nelson's and Mary's and got a better price. It just went on and on, buying and selling, buying and selling.

> Looking at it [street with some industrial units] now it's one big box but to me it was a thriving community, there was a lot of activity going on, your house was never empty, there was always a Traveller in my Grandfather's house and my mother's house; there was always Travellers in and out all the time … it was marvellous to live through that era, you don't forget it, it was me roots; a very thriving community was Caldewgate.

In the narratives above and below, Eileen tells us how the 'kinship place' of her childhood has been important to her. She has lived in houses all of her life and yet still strongly identifies herself as a Gypsy-Traveller. As we were told on many occasions, you do not need to travel to be a Gypsy. Being a Gypsy is more about shared cultural values, exhibited through adherence

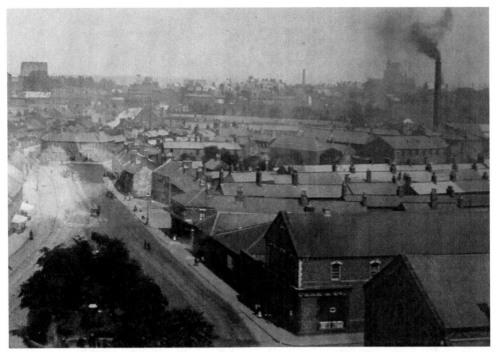

FIG 4.1. CALDEWGATE, EARLY 1900s.

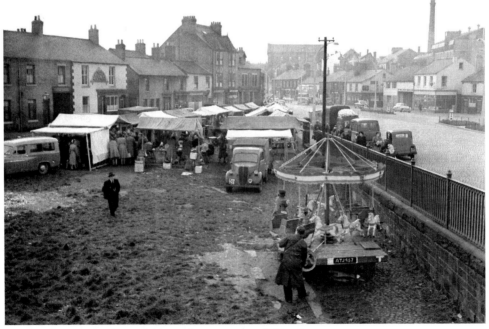

FIG 4.2. CALDEWGATE (PADDY'S MARKET) IN THE EARLY 1950s.

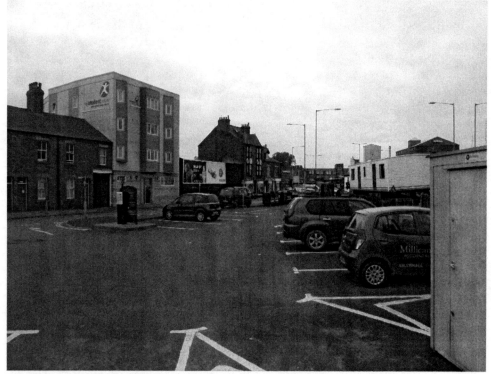

FIG 4.3. CALDEWGATE (PADDY'S MARKET) 2010.

to family traditions, occupations and trading practices. Shubin and Swanson (2010) term this the 'spirit of travel'. The family networks that sustain Gypsy-Traveller identity are located in the fact of belonging to a Gypsy-Traveller family. The 'place' of the Gypsy-Traveller is internalised within that network of family and social relationships and helps to preserve self-identity when geographical places change, are changed or are left behind, thus emphasising the importance of family, kin and friendship networks and symbolic movement (Drakakis-Smith 2007; Holloway 2004). As Liegeois (1994) notes, Gypsy-Traveller identity is not bound up in possessions or in place.

> All the relatives and friends that I knew, they're all gone, they're all dead, and you know, you're left with all these lovely memories. This is Byron Street where I was born. Round the corner was Shakespeare Street where my Grandfather and my Aunt Ethel lived, and at the top was Milton Street, where my Aunt Mary lived, and we were all together. My mother lived in the next street before she was married, then when they got married they moved round the corner to Byron Street. They moved into her sister's old house, 'cause she'd got another property and that's how we ended up living next door to my Grandfather eh. We were always together, me, my cousins – we were brought up together. I speak about it to my children, my cousins speak about it, and you never forget it. These streets were all pulled down in the 1950s.

Holloway (2004) notes that much of what makes a place comes from outwith as well as within. The importance of geographical places as loci for kinship activities may still endure even after the location has changed and Gypsy-Traveller families have long since moved on. For example, here Eileen talks about how kin reunions in locations traditionally associated with the Gypsy-Traveller community play an important role in preserving cultural traditions. In this way, events such as weddings, funerals and Christmas can provide the impetus for cultural renewal. More starkly, Smith-Bendell (2009) voices concern that the only Gypsy culture left will be funerals and horse fairs.

> But still every Boxing Day the travelling men come here, they come with all the horses and traps and they go to that pub over there ... it's just always been done, but the Police are trying to stop them and every year it's getting harder. There's not many [Travellers] in Caldewgate now; a lot of the houses have been demolished but as I say, every Christmas they'll gather up together and reminisce, have a sing-song. They don't stop eh, tradition goes on, they don't forget it. There's a lot of travellers in Carlisle, hundreds of them, and I know them all. I'm very proud to be a traveller and proud to be an O'Neill.

CONCLUSIONS

In this chapter we have considered issues of identity, culture and connections to place and materials. Using a co-ethnographic approach to focus on the story of one person, Eileen, we have explored how a sense of place may be evident in self-constructed Gypsy-Traveller identity. Eileen's story of her experiences of living and growing up in the Caldewgate district of Carlisle illustrates the place of family relations as a key element of Gypsy-Traveller self-identity and suggests, we believe, the centrality of family and internal relationships as a strong feature in the construction of personal notions of place for Gypsy-Traveller people.

Eileen's narrative is deeply rooted in her own experiences, yet it also raises important issues about being a Gypsy-Traveller in contemporary English society. Our research in Cumbria leads us to believe that kinship links (and related cultural practices) and the practice (or ideal) of nomadism informs self-identification as a Gypsy-Traveller. However, with increasing restrictions on campsites and local resistance to the presence of Gypsy-Travellers reducing the opportunity for nomadism (Kabachnik 2009) it seems that nomadism has, to some extent, been transformed into a 'state of mind' rather than a defining feature of everyday life (Brown and Scullion 2010). According to Shubin and Swanson (2010), mobility in this case is discursively linked to Gypsy-Travellers' 'unwillingness' to integrate into settled society because of their itinerant work schedules. Yet, as Bowers (2007) notes, Gypsy-Travellers do not lose their culture and heritage as soon as they move into housing. In this emerging lifescape we would argue that kinship and family become the 'sense of place' of the Gypsy-Traveller.

BIBLIOGRAPHY AND REFERENCES

Bancroft, A, 2005 *Roma and Gypsy-Travellers in Europe: Modernity, Race, Space, and Exclusion*, Ashgate Publishing, Aldershot

Bowers, J, 2007 Gypsies and Travellers accessing their own past: the Surrey Project and aspects of minority

representation, in *Travellers, Gypsies, Roma: The Demonisation of Difference* (eds M Hayes and T Acton), Cambridge Scholars Publishing, Newcastle, 17–29

Bowers, J, n.d. *Gypsies and Travellers: Their lifestyle, history and culture*, available from: http://www.travellerstimes.org.uk/downloads/TravellersTimesOnlineFAQPack_09022009122802.pdf [6 December 2010]

Bowers, J, Saunders, P and Knight, P, 2008 *Gypsy Roma Traveller History Month Evaluation Report*, available from: http://www.grthm.co.uk/downloads/GRTHM_report.pdf [14 November 2010]

Brown, P, and Scullion, L, 2010 'Doing research' with Gypsy-Travellers in England: reflections on experience and practice, *Community Development Journal* 45 (2), 169–85

Burr, V, and Butt, T, 2000 Psychological distress and postmodern thought, in *Pathology and the Postmodern: Mental Illness as Discourse and Experience* (ed D Fee), Sage, London, 186–206

Cemlyn, S, Greenfields, M, Burnett, S, Matthews, Z, and Whitwell, C, 2009 *Inequalities experienced by Gypsy and Traveller communities: a review*, Equality and Human Rights Commission, Manchester

Clark, C, 2002 Not just lucky white heather and clothes pegs: putting European Gypsy and Traveller economic niches in context, in *Ethnicity and Economy: Race and Class Revisited* (eds S Fenton and H Bradley), Palgrave, Basingstoke, 183–98

Clark, C, 2006 Who are the Gypsies and Travellers of Britain?, in *Here to Stay: The Gypsies and Travellers of Britain* (eds C Clark and M Greenfields), University of Hertfordshire Press, Hatfield, 10–27

Clark, C, and Greenfields, M, 2006 *Here to Stay: The Gypsies and Travellers of Britain*, University of Hertfordshire Press, Hatfield

Convery, I, Mort, M, Baxter, J, and Bailey, C, 2008 *Animal Disease & Human Trauma: Emotional Geographies of Disaster*, Palgrave, Basingstoke

Covrig, A, 2004 Why Roma do not Declare their Identity: Careful Decision or Unpremeditated Refusal? *Journal for the Study of Religions and Ideologies* 3, 90–101

Drakakis-Smith, A, 2007 Nomadism a moving myth? Policies of exclusion and the gypsy/traveller response, *Mobilities* 2, 463–87

Furlong, K, 2006 Unexpected Narratives in Conservation: Discourses of Identity and Place in Sumava National Park, Czech Republic, *Space and Polity* 10, 47–65

Goward, P, Repper, J, Appleton, L, and Hagan, T, 2006 Crossing boundaries: Identifying and meeting the mental health issues of Gypsies and Travellers, *Journal of Mental Health* 15, 315–27

Gubrium, J, and Holstein, J, 1998 Narrative practice and the coherence of personal Stories, *The Sociological Quarterly* 39, 163–87

Guy, W, 2001 The Czech lands and Slovakia: another false dawn? in *Between Past and Future: the Roma of Central and Eastern Europe* (ed D E Guy), University of Hertfordshire Press, Hatfield, 285–332

Hastrup, K, 1995 *A Passage to Anthropology: Between Experience and Theory*, Rouledge, London

Holloway, S L, 2004 Rural roots, rural routes: discourses of rural self and travelling other in debates about the future of Appleby New Fair, 1945–1969, *Journal of Rural Studies* 20, 143–56

James, Z, 2007 Policing Marginal Spaces: Controlling Gypsies and Travellers, *Criminology and Criminal Justice* 7, 367–89

Kabachnik, P, 2009 To choose, fix, or ignore? The cultural politics of Gypsy and Traveller mobility in England, *Social & Cultural Geography* 10 (1), 461–79

Ladányi, J, and Szelényi, I, 2001 The Social Construction of Roma Ethnicity in Bulgaria, Romania and Hungary During Market Transition, *Review of Sociology* 7 (2), 79–89

Liegeois, J-P, 1994 *Roma, Gypsies, Travellers*, Council of Europe

Lloyd, G, and McCluskey, G, 2008 Education and Gypsy Travellers – 'Contradictions and Significant Silences', *International Journal of Inclusive Education* 11, 331–45

Massey, D, 1993 Power-geometry and a progressive sense of place, in *Mapping the Futures: Local Cultures* (eds J Bird, B Curtis, T Putnam and T Tickner), Routledge, London, 59–69

ODPM, 2006 *Gypsy and Traveller Accommodation Assessments: Draft Practice Guidance*, ODPM: Gypsy and Traveller Unit

Okely, J, 1992 *The Traveller-Gypsies*, Cambridge University Press, Cambridge

— 1996 *Own and Other Culture*, Routledge, London

O'Brien, V, Dzhusipov, K, and Wittlin, F, 2007 Visible voices, shared worlds: using digital video and photography in pursuit of a better life, proceedings from *Proc Mundane Technologies and Social Interaction ACM SIG*, Melbourne

Parry, G, Van Cleemput, P, Peters, J, Walters, S, Thomas, K, and Cooper, C, 2007 Health status of Gypsies and Travellers in England, *Journal of Epidemiology & Community Health* 61, 198–204

Powell, R, 2008 Understanding the stigmatization of Gypsies: power and the dialectics of (dis)identification, *Housing, Theory and Society* 25, 87–109

Richmond, R, 2002 Learners lives: a narrative analysis, *The Qualitative Report* (7), 1 March, available from: http://www.nova.edu/ssss/QR/QR7–3/richmond.html [3 June 2010]

Shubin, S, and Swanson, K, 2010 'I'm an imaginary figure': unravelling the mobility and marginalization of Scottish Gypsy Travellers, *Geoforum* 41, 919–29

Smith-Bendell, M, 2009 *Our Forgotten Years: A Gypsy Woman's Life on the Road*, University of Hertfordshire Press, Hatfield

Turner, R, 2002 Gypsies and British parliamentary language: an analysis, *Romani Studies* 5 (12), 1–34

Van Cleemput, P, Parry, G, Thomas, K, Peters, J, and Cooper, C, 2007 Health-related beliefs and experiences of Gypsies and Travellers: a qualitative study, *Journal of Epidemiology & Community Health* 61, 205–10

Verdery, K, 1996 *What Was Socialism and What Comes Next?* Princeton University Press, Princeton, NJ

Rural Sense of Place

Rural People and the Land

MICHAEL WOODS, JESSE HELEY, CAROL RICHARDS
AND SUZIE WATKIN

INTRODUCTION

There is a long and fundamental connection between rural place and the land. Whereas land is simply the foundation for the construction of towns and cities, whose urban culture and economy thrive on human ingenuity and industry that may have little direct attachment to the physical ground over which it occurs, historical discourses of rurality place the land at the heart of the rural economy and society. Rural people, such discourses hold, live on the land, work the land, tend the land and know the land. The land formed not only the base of the rural economy (as 'a physical, tangible resource which can be ploughed, sown, grazed, built upon' (Macnaghten and Urry 1998, 200)), but also shaped rural culture and the rural calendar, and contributed to the constitution of the rural character (see Bell 1994). As such, the land is central to rural sense of place.

The connection is especially strong in the popular imagination of rural England. Although England was one of the first nations to industrialise and urbanise, the countryside has been repeatedly evoked as the epitome of Englishness, from the pastoral paintings of Constable to war-time propaganda posters (Cosgrove and Daniels 1989; Darby 2000). Neither is the association purely visual. In contrast to national cults that celebrate wilderness, as in Canada or the United States, the English idyll of fields and villages is recognised as a worked and cultivated landscape, such that the distinctiveness of rural England is also embodied in the labour of rural people working the land. This symbiotic relationship between rural people and the land has been recalled in political articulations of Englishness, from Stanley Baldwin's speech to the Royal Society of St George in 1924 describing 'the sound of the scythe against the whetstone, and the sight of a plough team coming over the brow of a hill' as 'the sight that has been seen in England since England was a land' (quoted by Woods 2005, 90), to Joanna Trollope writing in the *Sunday Telegraph* on the day of the Countryside March in 1998 that 'there is something singular about the relationship between the English and their countryside … a robust instinct for living in practical harmony with nature (resulting in that much admired social unit, the English village), and an almost pantheistic appreciation of landscape' (quoted by Woods 2005, 116).

At the same time, connections to the land were behind the diversity of rural England. Differences in soil and topography favoured different agricultural specialities, producing variations in landscape and settlement forms and informing local customs, folk culture, food and drink. These regionally distinctive products of the land – and the locally embedded knowledge that went with them – marked local senses of place within the English countryside.

The 20th century, however, witnessed a considerable weakening in the ties of rural people to the land. The rural economy has diversified away from land-based industries such as farming,

forestry and mining to the extent that only a tiny fraction of people living in rural England now can be described as working on the land. This trend has been reinforced by urban-to-rural migration, which, together with an explosion of modern media and communications, has produced a rural population that has little direct contact with, or knowledge of, the land. It is an indication of the discursive association of the land and rurality that these processes have been commonly described as the 'urbanisation' of rural society, with 'urbanisation' further elided with 'homogenisation' and the erosion of locally distinctive rural cultures.

This chapter examines the changing dynamics of rural England's connections with the land, documenting the disengagement as the economy diversified and the population restructured, but also investigating evidence for the continuing significance of the land to certain aspects of the rural economy and rural society, and the case for reconnection.

WORKING THE LAND

Economic geography traditionally identified land-based activities including agriculture, forestry and mining as the staple industries of rural areas, as represented by icons of sheep, cows and pitheads on textbook maps. Such is the popular power of this association that primary industries continue to be described as the distinguishing characteristic of the rural economy, even by serious stakeholders and commentators:

> What defines the countryside is the sustainable and productive use of the land in all its forms. It is this, after all, which differentiates it from urban economies, which are about manufacturing and information industries. (Countryside Alliance 2005, 6)

> Land management is what distinguishes a rural economy from an urban economy. Otherwise there is no other difference, the fundamental difference is that rural things are focused around land whereas urban things are focused around trade.
> (The Land Is Ours spokesperson, *pers comm* (interview), 2008)

In practice, however, the land has not directly supported the majority of economic activity in rural England for at least a hundred years. In 1950 just over a third of the rural population in the United Kingdom were dependent on agriculture and the proportion dropped sharply over the subsequent decades, especially in the last 30 years. The number of full-time farmworkers in England, for example, fell from 140,000 in 1983 to just over 60,000 in 2005 (CRC 2006). Similarly, employment in forestry and wood processing industries in the United Kingdom decreased by 29 per cent between 1988 and 1999, and stood at just 18,500 jobs in England in 1999 (PACEC 2000). The total forestry workforce in England is hence roughly equivalent to that of a medium-sized local authority. In total, agriculture, forestry and fishing now account for less than 5 per cent of the workforce in rural England and less than 2 per cent across the country as a whole (Defra 2007a).

While the decline in agricultural employment is partly attributable to mechanisation and improvements in farm efficiency, the contribution of agriculture to the economy has also slumped. In 2006, agriculture contributed approximately £5.6 billion to the UK economy, or less than 1 per cent of GDP, down from nearly 3 per cent in 1970. Farm incomes have fluctuated over the last four decades, but the overall trend has been downwards, from £7 billion in 1970 to £2.5 billion in 1999 (Defra 2006). With average farm household income coming in significantly

below the overall mean household income in rural England during the 2000s, the contribution of farming to income generation in rural communities has been considerably diminished.

There are, however, caveats to this broad picture. The economic significance of agriculture and forestry vary geographically and there were 27 local authority districts in England where these sectors employed more than 5 per cent of the workforce in 2001. Agriculture, forestry and hunting account for over 5 per cent of employment in all national parks in England, including 28.3 per cent of the workforce in Northumberland National Park. Moreover, there were more than 500 parishes in 2001 where agriculture, forestry and hunting was the single largest sector of employment for residents, including 35 parishes or groups of parishes with more than a third of the working population employed in these industries. Yet, most of these parishes are very small and the actual numbers working in land-based industries exceed 50 in very few cases. For example, in Liliburn, Northumberland, 56.4 per cent of residents in 2001 worked in agriculture or forestry – the highest proportion in England – but this translated into only 31 individuals.

Furthermore, the direct economic input of agriculture identified in the figures discussed above is complemented by a much broader indirect impact through businesses and jobs dependent on farming. These include 'upstream' activities such as equipment manufacturers and dealers, seed merchants, agri-chemical manufacturers and suppliers and agricultural suppliers; and 'downstream' activities such as abattoirs, food processors, wholesalers and retailers. Accurate valuations of this indirect impact are difficult to ascertain, but analysis for the Department for the Environment, Food and Rural Affairs (Defra) by a consultancy company, Frontier Economics, provides an indication by calculating that a 20 per cent reduction in farm production in six key sectors (cattle, sheep, dairy, barley, wheat and oilseed rape) would cost £3798 million and 12,325 jobs in associated industries (Frontier Economics 2005). While these indirectly supported jobs and businesses are not exclusively rural, many are found in rural areas, with particular concentrations in parts of eastern and south-west England (Frontier Economics 2005).

Even noting the indirect contribution of agriculture and forestry and the local pockets of strength of these industries, it is nonetheless clear that land-based industries no longer occupy a central position in the economy of rural areas and that this has had a knock-on effect for connections between rural people and the land. Not only do fewer people spend their days working on the land, but the reduced numbers of farm and forestry workers in rural communities means that the concerns, practices and routines of these industries no longer permeate through rural life in a way that they once did – as discussed further below.

However, the land's contribution to the rural economy is not limited to the traditional extractive practices of agriculture, forestry and mining. The land is a resource that can be commodified and exploited in many ways and there are signs that, as farming and forestry decrease in importance, the land is being enrolled in new economic relations, as one rural observer described:

> Because agriculture is now a relatively minor part of the rural economy in many areas … the relationship between communities, local people and the land has changed significantly. If you go on, or live in or near, the urban fringe – while still in the countryside – the use of land for urban enjoyment has become quite an industry. Whether it is equine use of land, or small holdings, or – as I have got next to me – growing turf, right down to reusing redundant farm buildings as vehicle repair yards. You name it, urban uses are now generating the rural economy; not all of which is good – but what you are seeing is a change in how rural land is being used.
>
> (ACRE rural policy officer, *pers comm* (interview), 2008)

Many of these new economic uses of the land have been adopted as part of farm diversification strategies, prompted by a changing regime of agricultural support. The Farm Business Survey suggests that 50 per cent of farms in England were engaged in some form of diversified enterprise in 2005–6, including 9 per cent supporting sport or recreational activities and 4 per cent providing tourist accommodation or catering (Defra 2006). Indeed, tourism and recreation has eclipsed agriculture in its contribution to the rural economy. Total spend by visitors to the English countryside was estimated at £12 billion in 2002 (up from £9 billion in 1994) and 320,000 jobs in rural England are directly or indirectly supported by tourism and recreation (Defra 2007a). Similarly, revenue from sport and recreation accounts for up to 50 per cent of total income for forest owners and the total economic value of recreational use of English forests has been calculated at £354.24 million annually (Willis *et al* 2003).

Some tourism and recreation in rural areas is not directly dependent on the land, including, for example, visits to theme parks, shopping villages and coastal resorts and beaches; but there are distinctive modes of rural tourism whose appeal largely rests on making a connection with the land. These include farm tourism, such as on-farm accommodation and 'farm parks' allowing visitors to experience aspects of farm life and to 'get close' to nature – generating income for farms in excess of £1500 million (Defra 2006) – as well as 'working holidays' organised by groups such as the National Trust, BTCV and WWOOF (formerly Willing Workers on Organic Farms). Voluntary work in activities such as repairing walls and planting trees is increasing in popularity and making a notable contribution to rural land management, as a national parks representative explained:

> These experiences cover a range from direct land management to survey work. In a place like the Yorkshire Dales they have waiting lists for volunteering. The demand is greater than the capacity to respond.
> (English National Parks Authorities Association spokesperson, *pers comm* (interview), 2008)

Connections with the land are also critical to the growing sector of food tourism or 'gastro-tourism', especially when practised through visits celebrating sites of regionally distinctive food production and consumption (Storey 2010). Furthermore, many traditional recreational activities involve some form of physical interaction with and require a degree of knowledge of the land, including rambling, riding, caving, shooting and hunting. These have been joined by forms of 'adventure tourism' and 'extreme sports' that involve the participant pitting their body against the natural environment in a highly physical manner, such as mountain biking, canyoning, geocaching, coasteering and mountain boarding.

In these ways, rural tourism has become increasingly focused on the sustainable use of rural resources, including land, and as such constitutes part of a broader emergent rural 'eco-economy' (Kitchen and Marsden 2009). Also included in the 'eco-economy' are local food schemes, renewable energy projects and the utilisation of wild resources for food, construction or medicine – all of which involve finding sustainable ways of drawing value from the land. Traditional rural crafts might additionally be included in this category. Trades such as blacksmiths, farriers, saddlers and thatchers declined with mechanisation and mass production, but many have experienced a revival with renewed interest in local products and traditional skills, especially from in-migrants. With new lifestyle-orientated markets (Table 5.1), there are now an estimated 30,000 full-time and 50,000 part-time and amateur rural craftworkers in Britain, including 1860 farriers, 1000

saddlers, 400 traditional smiths and 18,400 people working with traditional building crafts, including stonemasons, thatchers and dry-stone wallers (Collins 2004).

Table 5.1: Traditional and present-day markets for selected rural crafts.
Adapted from Collins 2004

Product	Traditional markets	Present-day markets
Coppicing	Wood production	Biodiversity, wildlife habitats, historic landscape features
Wattle hurdles	Sheep folds	Garden design
Charcoal	Industrial uses	Home barbecues
Post-and-rail fencing	Farms and estates	Private, residential
Pole-lathe turnery	Rough chair legs	High-quality, hand-made furniture
Blacksmithing	Farm and community needs	Artistic wrought-iron work
Farriery	Farm and trade horses	Leisure horses
Thatching	Low-status roofing	High-status roofing
Dry-stone walling	Stock-proof fencing	Historic landscape feature
Traditional building crafts	Repair and maintenance of the basic housing stock	Heritage conservation work, repair and extension of historic properties for affluent in-migrants, pastiche
Millwrighting	Household flour and provender	Wholemeal flours for the health food industry

The land is hence being worked in new ways as part of a changing rural economy, but it can also contribute to the rural economy by *not being worked*. Since the early 1980s, agricultural subsidy payments to farmers have progressively been shifted from production support to 'agri-environmental' funding for environmental stewardship. Farms in England earned over £200 million from agri-environmental support in 2005–6, constituting around 10 per cent of total farm income (Defra 2006). Agri-environmental schemes have established the principle of rewarding landowners for environmental good practice that has been expanded in attempts to recognise and calculate the 'total economic value' of the full range of services provided to society by an ecosystem. These include not only conventionally commodifed provisioning services such as food, fibre and fuel; but also regulating services including air quality maintenance, carbon sequestration, erosion control, water purification, bioremediation and protection from natural hazards such as floods and landslides; cultural services, encompassing recreational use, the aesthetic value of landscape and the spiritual and inspirational value of nature; and supporting services such as soil formation, nutrient cycling and the provision of habitats for wildlife (Defra 2007b).

The 'ecosystem services' approach aims to develop a market-based system for paying landowners for these services, which could substantially boost the value of the land to the rural economy. For example, the social and environmental benefits of forestry in England have been valued at £844.55 million, on top of direct and indirect earnings of forestry production of £2939 million (PACEC 2000). As such, ecosystem services have been heralded as the way of securing the long-term future of the farmed rural landscape:

The strap-line which I've got is about working landscape development; that private land owners and farm businesses will be able to find a sustainable future on the basis of all the services they

provide to the public; possibly carbon reduction, possibly energy, but access, wildlife values, recreation of all forms. (RSPB regional officer, *pers comm* (interview), 2008)

Writing in an American context, Gutman (2007) proposes that ecosystem services could provide the foundation for a 'new rural–urban compact', replacing the previous compact based on the supply of food and natural resources. Yet, there are considerable obstacles to realising this vision, not least the questions of how payments would be made and by whom, as well as resistance to the commodification of all nature that the approach implies.

LIVING WITH THE LAND

If economic use is what ties rural people to the land, the significance of the land in shaping sense of place in rural England follows the translation of these economic relations into social relations. Sense of place in this respect is a composite entity that starts with the physical geography and topography of the locality, but is embellished by the cultivation of the land and by the social and cultural associations that follow from this. For some observers, it is agriculture that pins these layers together:

> It is not only national identity; it is local identity. If you go to the Pennines or Exmoor or Dartmoor or the Chilterns or the Norfolk Broads, the Welsh mountains, the Scottish Highlands – wherever you go there is a human presence. Even in the most rugged areas, this is crucial, and the countryside is our most precious asset and it goes way beyond the national and goes to the very heart of how the local population sees it. If you consider the Lake District, that whole tapestry has its basis in agriculture.
> (Countryside Alliance Deputy Chief Executive, *pers comm* (interview), 2008)

The impact of agriculture is in part material (in the field structure, walls and hedgerows, farm buildings, etc) and in part social. The character of farming has been reflected in cultures of both self-reliance and cooperation and in social networks constructed through organisations such as the National Farmers Union and Young Farmers' clubs and through events such as agricultural shows, livestock marts and auctions (Burton *et al* 2005), which in turn formed the architecture of rural social life. The rhythms of the farming year were encoded in the rural calendar: in arable areas, harvest was celebrated by the whole community, while in sheep-farming areas social activities were attuned to the demands of lambing season.

However, the influence of farming within rural society has been marginalised by three linked factors. Firstly, the declining farm workforce has hit the critical mass of the agricultural community, reflected in the closure of livestock marts and the discontinuation of agricultural events. Nearly a third of farmers are reported to have less contact with other farmers than a decade ago (Lobley *et al* 2005). Secondly, fewer farmers has meant reduced involvement in the rural community. Farmers are about half as likely to be 'very active' in rural community life as non-farmers (Lobley *et al* 2005) and one in seven rural residents claim to have no social contact with any farmers (Milbourne *et al* 2001; CRC 2006). Contracting agricultural employment has also been linked to lower trade for village shops and services, contributing to their closure (Errington 1997), which in turn removes opportunities for interaction between farmers and non-farming residents. Thirdly, the dilution of the agricultural population in rural areas has been intensified

by the migration of ex-urbanites into rural communities with non-agricultural employment and with little direct knowledge of traditional rural culture or of the land.

Indeed, as the rural population has been restructured, connection with the land has been seized on as a mark of true rural identity and a dividing line within rural communities. Bell (1994), in his ethnographic study of a southern English village, identified 'countryism' or knowledge of country life as an attribute used to distinguish between 'country people' and 'city people' in the community:

> Knowledge about farming would be an example – for instance, the ability to distinguish fields of wheat and barley before their distinctive seed heads form. Other realms of countryism include pet raising and pet care, botany, riding, hunting, walking, a knowledge of local history, appropriate country dress, and authentic remodelling. Another is the distinctive food that real country people eat. As Rachel Wood said, 'My aunt always told me that I can't be a country girl until I learn to eat jugged rabbit.' (Bell 1994, 104)

The distinction has been incorporated into political discourse with the mobilisation of a rural movement through groups such as the Countryside Alliance, which is essentially founded on a land-centred understanding of rurality (Woods 2005). Thus, hunting was defended as a way of connecting with the land that was central to traditional rural culture and identity against threats from 'misguided' urban opinion. Other campaigns have similarly focused on issues such as shooting, access to rural land and farming practices, positioning an 'authentic' understanding of the land against perceived urban ignorance.

Education has also been part of the strategy, with bodies such as the Countryside Alliance, the NFU, the Countryside Restoration Trust and LEAF (Linking Environment and Farming) running advertising campaigns, producing information packs, arranging educational visits and sponsoring events such as 'Countryside Comes to Town' days, 'Cooking Roadshows' and 'Open Farm Sunday'. These are all explicitly aimed at informing the public about the workings of the land and food production.

However, the rhetorical contrast between real rural people with an understanding of the land and ignorant in-migrants who are disconnected from the land does little justice either to the complexity of in-migration or to the motivations of individual incomers. While people move to the countryside for many reasons, lifestyle migrants will often be at least in part motivated by a desire to connect with the land, even if only as scenery or as a platform for recreation (Halfacree 1994; Smith and Phillips 2001). Halfacree (1994) also suggests that living in a rural community can develop understanding of the land and forge new connections, as other commentators have similarly claimed:

> I think that [in-migrants] do gradually get absorbed into rural ways of life, and even if they are bringing in money from the city, which they usually are, I mean, they are a market and the people that come and install themselves in the country do buy local produce because they do recognise that that is part of what they value. (The Land is Ours spokesperson, *pers comm* (interview), 2008)

Incomers can become vehement defenders of local landscapes – mobilising to oppose perceived threats from new roads, house-building and windfarms (Woods 2005) – and significant patrons

of farm shops, farmers' markets and rural craft businesses. Furthermore, as incomers seek to identify with their new homes they can play a critical role in reviving abandoned local traditions and participating in local history projects and the compilation of 'parish maps' describing in detail the local land. Such activities serve to facilitate the sharing of knowledge of the land between long-term local residents and in-migrants and to build community cohesion.

Some in-migrants, though, make a more direct connection with the land. These include affluent incomers seeking to join the 'new squirearchy', who often purchase land for use as paddocks or extended gardens and practice a lifestyle characterised by 'traditional' land-based pursuits such as hunting, shooting and equestrianism (Heley 2010). More significant, perhaps, are 'back-to-the-land' migrants, who have bought up smallholdings to take up farming either full-time and part-time in a rejection of an urban lifestyle. Although 'back-to-the-land' farming is often primarily for household consumption, some practitioners will sell their produce commercially and members of the movement were instrumental in pioneering organic farming (Halfacree 2001; 2007). A further extension of the 'back-to-the-land' philosophy is the creation of small-scale experimental communities designed to practise sustainable, self-sufficient cooperative living, including the Affinity Woodland Workers in Devon and Kings' Hill and Tinker's Bubble communities in Somerset (Halfacree 2007).

Growing interest in 'back-to-the-land' lifestyles has highlighted tensions around the availability of land and the control of development in the countryside. Land rights groups such as The Land is Ours (TLIO) have campaigned for a fairer distribution of land ownership (Parker 2002) and promoted the model of 'low impact development' which expressly aims to reconnect people with the land through sustainable communities that are designed to blend with the local landscape, use local natural building materials, obtain energy from renewable sources and grow their own food (Fairlie 1996). Yet, attempts to put this philosophy into practice have so far largely been thwarted by inflexible planning policies. A parallel, more mainstream movement has championed the creation of community land trusts to purchase land for community benefits, including providing affordable housing and securing farmland in working, local ownership. The best-known example is the Fordhall Community Land Initiative in Shropshire, established to enable the children of long-term tenant farmers to buy the farm and keep it working (Hollins 2007).

Conclusions

Connections between rural people and the land are more fluid and resilient than the conventional privileging of agriculture at the heart of rurality suggests. It is true that agriculture was historically the means through which most rural people were connected to the land, that agriculture transformed the raw physical geography of the land into the cultivated landscape that is venerated in local attachments to place today and that the demands of agriculture shaped the traditional social structure and culture of rural communities. However, while the contraction of agriculture and forestry as contributors to the rural economy and labour market has undoubtedly weakened these traditional ties between rural society and the land, this is not to say that the land has become marginal to the contemporary countryside. Rather, the land is being put to new economic uses – in tourism, recreation and other aspects of the eco-economy – and the prospect of payment for ecosystem services raises the potential of the land contributing to the rural economy by not being worked. At the same time, rural communities are also forging new

connections with the land. Most rural residents today may lack the detailed knowledge of the land that is often held up as a mark of rural identity, but they nonetheless frequently have an interest in the land, which can provide a shared focal point for community cohesion. In these ways, the land remains central to the sense of place of rural communities, with the fluidity of connections appropriately mirroring the dynamism of place.

ACKNOWLEDGMENTS

This chapter is based on research funded by the Commission for Rural Communities.

BIBLIOGRAPHY AND REFERENCES

Bell, M, 1994 *Childerley*, University of Chicago Press, Chicago

Burton, R, Mansfield, L, Schwarz, G, Brown, K, and Convery, I, 2005 *Social Capital in Hill Farming*, Macaulay Institute, Aberdeen

Collins, E J T (ed), 2004 *English Rural Crafts, Today and Tomorrow*, Countryside Agency, Cheltenham

CRC [Commission for Rural Communities], 2006 *State of the Countryside Report 2006*, CRC, Cheltenham

Cosgrove, D, and Daniels, S (eds), 1989 *The Iconography of Landscape*, Cambridge University Press, Cambridge

Countryside Alliance, 2005 *Blueprint for the Countryside*, Countryside Alliance, London

Darby, W J, 2000 *Landscape and Identity: Geographies of Nation and Class in England*, Berg, Oxford

Defra [Department for Environment, Food and Rural Affairs], 2006 *Non-agricultural Income and Diversified Enterprises: Results from the Farm Business Survey*, Defra, London

— 2007a *Rural Development Plan for England*, Defra, London

— 2007b *An Introductory Guide to Valuing Ecosystem Services*, Defra, London

Errington, A, 1997 Rural employment issues in the periurban fringe, in *Rural Employment: An International Perspective* (eds R D Bollman and J M Bryden), CAB International, Wallingford, 205–24

Fairlie, S, 1996 *Low Impact Development: Planning and People in a Sustainable Countryside*, Jon Carpenter, Charlbury

Frontier Economics, 2005 *Modelling the Impact of CAP Reform on the Agricultural Supply Chain*, Report to Defra, Frontier Economics, London

Gutman, P, 2007 Ecosystem services: foundations for a new rural–urban compact, *Ecological Economies* 62, 383–7

Halfacree, K, 1994 The importance of 'the rural' in the constitution of counterurbanization: evidence from England in the 1980s, *Sociologia Ruralis* 34, 164–89

— 2001 Going 'back-to-the-land' again: extending the scope of counterurbanisation, *Espace, Populations, Sociétés* 2001–1–2, 161–70

— 2007 Trial by space for a 'radical rural': introducing alternative localities, representations and lives, *Journal of Rural Studies* 23, 125–41

Heley, J, 2010 The new squirearchy and emergent cultures of the new middle class in rural areas, *Journal of Rural Studies* 26 (4), 321–31

Hollins, B, and Hollins, C, 2007 *The Fight for Fordhall Farm*, Hodder and Stoughton, London

Kitchen, L, and Marsden, T, 2009 Creating sustainable rural development through stimulating the eco-economy: beyond the eco-economic paradox? *Sociologia Ruralis* 49, 273–94

Lobley, M, Potter, C, Butler, A, Whitehead, I, and Millard, N, 2005 *The Wider Social Impacts of Changes in the Structure of Agricultural Businesses*, Centre for Rural Research, Exeter

Macnaghten, P, and Urry, J, 1998 *Contested Natures*, Sage, London

Milbourne, P, Mitra, B, and Winter, M, 2001 *Agriculture and Rural Society*, Defra, London

PACEC, 2000 *English Forestry Contributions to Rural Economies*, Report for the Forestry Commission, PACEC, London

Parker, G, 2002 *Citizenships, Contingency and the Countryside: Rights, Culture, Land and the Environment*, Routledge, London

Smith, D P, and Phillips, D, 2001 Socio-cultural representations of greentified Pennine rurality, *Journal of Rural Studies* 17, 457–71

Storey, D, 2010 Partnerships, people and place: lauding the local in rural development, in *The Next Rural Economies: Constructing Rural Place in Global Economies* (eds G Halseth, S Markey and D Bruce), CABI, Wallingford, 155–65

Willis, K, Garrod, G, Scarpa, R, Powe, N, Lovett, A, Bateman, I, Hanley, N, and Macmillan, D, 2003 *Social and Environmental Benefits of The Forestry in Great Britain*, Forestry Commission, London

Woods, M, 2005 *Contesting Rurality: Politics in the British Countryside*, Ashgate, Aldershot

Hill Farming Identities and Connections to Place

Lois Mansfield

Introduction

Sense of place can be described as the distinctiveness of a place for people, whether they are the local population or transients (see earlier chapters in this book). Typical aspects of the concept include: natural and man-made features; heritage, culture and traditions; and produce and industries developed as a result of that place. The idea of *geographical place* has received extensive attention by geographers (see the review by Castree 2004) where structures, processes and networks are perceived as important. In other disciplines the psychological *lived experience* of place is also significant (Hay 1998). By combining both these approaches, sense of place can be used as a practical rural regeneration tool to aid struggling communities. This has been enthusiastically embraced by many farming businesses seeking to diversify their farm incomes (eg Bessière 1998; Robinson 2004); upland farming communities are no exception. As a result farmers seem to be commodifying their own sense of place. This chapter will begin by exploring the relationship between sense of place and the upland farming system in terms of geography and lived experience. Next it will consider how both these ideas of sense of place can be used to promote rural regeneration. Finally, it will examine whether constraints created by other controls on upland farming systems are detrimentally affecting the application of sense of place and how these can be overcome.

Sense of Place and the Upland Farming System

It can be argued that upland farming exhibits both facets of sense of place; the tangible geographical idea of place, along with the intangible concept of lived experience (Graham *et al* 2009). Geographically the upland farming landscape is a dynamic palimpsest evolved through the inter-relationship of physical, ecological, social, historical, economic and political factors, processes and agents (Mansfield 2011). These physically manifest themselves as three distinct land types expanding out from the farmstead (Fig 6.1). *Inbye* land is by far the best land, close to the farm buildings and used for the production of hay or silage for winter fodder, grazing land in winter months and lambing areas in spring. At the other extreme are the *fells* at the highest altitudes (usually 300m asl or more in Britain). These are areas typically of heather moorland or rough unimproved grass pasture highly prized in terms of nature conservation in the UK and Europe (English Nature 2001; Thompson *et al* 1995). In between the fells and the inbye lies the *intake*, or *allotment*. This is land that has been literally taken in from the fell and enclosed often using drystone walls made of locally field-cleared stone. At various points in history these land types and other farm resources have been exploited to develop a sustainable farming system controlled fundamentally by environmental determinism (Grigg 1984). The resultant management effect is a continuum of ecologically diverse habitats running from valley bottom to fell top (Fig 6.2).

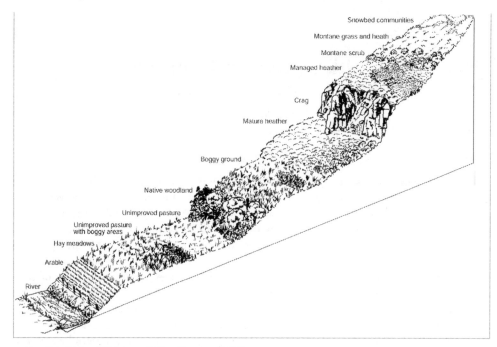

Snowbed communities
Montane grass and heath
Montane scrub
Managed heather
Crag
Mature heather
Boggy ground
Native woodland
Unimproved pasture
Unimproved pasture with boggy areas
Hay meadows
Arable
River

Fig 6.1. Upland Habitats: Valley Floor to Fell Top.

Farmers operate sheep and/or beef enterprises in the upland core. Dairy cows occupy the valley bottoms and upland margins. Occasionally farms will run combinations of the three, although this is labour intensive. Upland farms, themselves, are divided into two types; true *upland farms* containing inbye, intake and fell and *hill farms*, which contain intake and fell with little or no inbye. This tends to restrict hill farms to running just sheep, whereas the true upland farms have historically run sheep flocks and cattle herds in combination, although beef is now uncommon owing to agricultural subsidies favouring sheep (Winter *et al* 1998). From the farmers' point of view the landscape they have developed has a number of practical functions. Walls keep livestock from straying, they keep rams away from ewes outside of the tupping season and they allow stock to be grazed in winter on a rotational basis to ensure sustainable grassland management. The fell areas are summer pasturage, when the enclosed land's productivity has been exhausted or allocated for the production of grass and hay crops for winter feed. In order to support the same number of sheep on the fell as in the inbye, this lower productive land needs to cover a substantially larger area over which the sheep disperse.

To these physical structures of sense of place we can add the more intangible aspect of process (Massey cited in Castree 2004). Within upland farming communities there is a range of unique processes derived from the practicalities of the farming system which add to a strong sense of place: hefting, gathers and shepherds meets. The *hefting* or *heafing* instinct, the detailed operation of which can vary from upland to upland (Hart 2004), is perhaps the most well known. This

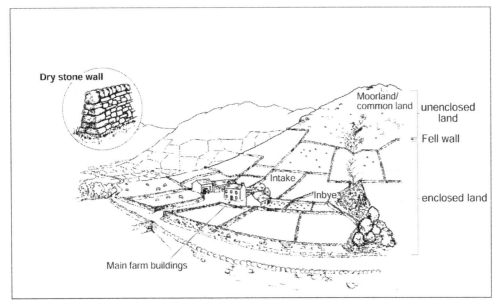

FIG 6.2. A TYPICAL CUMBRIAN HILL FARM.

practice has developed over the centuries as a mechanism to apportion the fair use of *commons*.[1] Historically, as time passed, flocks learnt to stay on their grazing area and gradually intensive shepherding was withdrawn so that the stock became self-managed geographically and, as a consequence, self-managed and self-policed the grazing pressure. The ewe passed its knowledge of the *virtual* area (heft) on to her lambs, which in turn passed it on to their lambs. In this way it became important that the farmer maintained a multi-generational flock (Brown 2009).

Derived out of hefting is the *gather* and related *shepherds meet*. Sheep are collected and gathered together from the open fell at various times of year and brought down to the farm for shearing, worming, winter grazing, sales and lambing (few farmers lamb their sheep out on the fell now as a result of a combination of expediency and agri-environmental grant rules). An important aspect of the hefting system is local knowledge. Once established on-heft, sheep behave in particular ways, returning to the same places to feed or seek shelter at different times of year. For the farmer, understanding this geographical behaviour is essential for effective gathers or even to be able to judge episodes of overgrazing in lean times. Where continuity of land management continues from one farming generation to another, this knowledge is transmitted orally and practically, tying people to certain parcels of land. Because hefts are geographically extensive, over difficult terrain, the labour requirements for gathering are high: as many as 25 people for a single gather from multiple hefts, drawing together staff, extended families and neighbours to operate

1 Common Rights – the '*right of common*' includes: grazing rights (typical of upland areas); dead wood collection from the ground (termed *estover*); peat extraction (*turbary*); fishing (*piscary*), or pig grazing (*pannage*), as well as other rights such as bracken or gorse gathering or mineral exploitation (Aitchison *et al* 2000).

effectively. The reliance on manual labour is exacerbated by precipitous landscapes that do not lend themselves to modern All-Terrain Vehicle egress: 'These fells have been shepherded. They're shepherded the way now as they were 200 years ago with a dog and a stick. You know, there's no flying around on motorbikes or whatever on the high fells so they've got to be managed as they were years ago' (Farmer 5, Burton *et al* 2004).

In this way a large number of people work cooperatively to clear all sheep from the fell land in an efficient manner (Burton *et al* 2004). The sheep are then divided into the distinctly owned flocks down at the fell wall either there and then, or through the shepherds meet, a separate event at which mis-gathered sheep are exchanged between farmers. These events have been times of great social gatherings where the bonds of kinship and community are re-cemented, forming the traditions of this farming sector.

The shepherds meet, as well as being a process, is also an example of the *relation* of place described by Massey (cited in Castree 2004); sometimes referred to as social capital (Putnam 1993). Typically social capital has four dimensions to it (Pretty and Ward 2001): relations of trust; reciprocity and exchange; common rules and norms; and connectedness, networks and groups. Table 6.1 demonstrates how these relate to upland farming.

Table 6.1: Social capital and the upland farming system using Pretty and Ward's four-fold description

Element	Tradition	Characteristics
Relations of Trust	Hefting Gathers	Shared grazing areas require managers to not over stock or let stock drift affecting others resource base. Increasingly undermined by destocking and heft abandonment
Reciprocity & exchange	Shepherds meet Machinery Labour Other equipment	These types of return grow less due to time cost and the increased number of stock drifting further as grazing pressure is reduced
Common rules and norms	Heft management Common land	Ensuring stock are appropriately dipped and wormed to avoid spread of disease. General animal welfare. Maintaining stock on heft.
Connectedness, networks and groups	Breed associations Commons associations Farmers' markets social networks Livestock markets	How people communicate to achieve common goals varies in different ways within upland farming communities

The latter of these, *connectedness, networks and groups*, warrants further attention in relation to sense of place. It refers to the ways in which people communicate and work with each other to achieve common goals. The effect can be one or two way, preferably the latter as this strengthens the social capital which develops. Pretty and Ward (2001) suggest there are five types of connectedness:

- Local connections
- Local to local connections
- Local to external connections
- External to external connections
- External connections

These connections are fundamental to creating and maintaining the intangible lived experiences of sense of place in upland farming communities. *Local connections* are perhaps the strongest because they occur on a daily basis, examples being gathering, commons committees and breed associations. At the next level there are *local to local connections* which extend beyond the farming community, as shown in Fig 6.3. This is an interesting aspect because it demonstrates positive reinforcement of sense of place through the creation and maintenance of the network, but also temporal shifts of social capital bolstering or degrading sense of place. In upland communities there is evidence that the church is playing less of a role than it used to; instead it has been replaced by new networks and groups that have entered the arena, such as farmers' markets (Burton *et al* 2004).

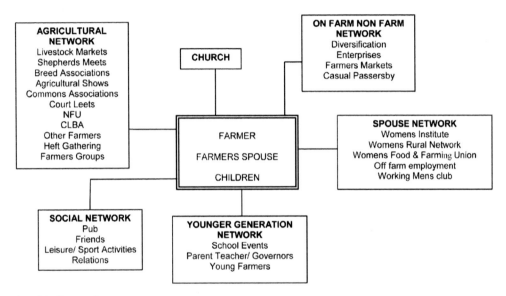

FIG 6.3. SOCIAL CAPITAL: LOCAL TO LOCAL CONNECTIONS.

There are also instances where local to local connections are improving. Historically each common has had its own committee (or association) which sorted out disputes and issues related to the management of the land. These organisations are beginning to be replaced by *commoners' federations*, loose affiliations of associations who have like-minded aims and objectives, which use consensus to manage commons. Aided by the new *Commons Registration Act* 2005, federations, associations and committees can form statutory *Commons Councils* as umbrella organisations (FCC 2009). Councils have the ability to manage agricultural activities, common rights and vegetation on common land. While some commoners may be wary about Commons Councils in relation to power, control and rule setting, councils offer potential as regards greater social capital with respect to the next level of connectedness, that of *local to external*. These take us outside farming and rural communities in the local area to similar communities elsewhere geographically, or even further to development connections with non-farming external agencies. This is an important step for farming communities as it allows for the development of what has been

Degree of Power Sharing			Nature of Involvement
	8	Citizen control	
Degrees of citizen power	7	Delegated Power	Citizens are given management power for selected or all parts of a program
	6	Partnership	Trade offs are negotiated
Degrees of Tokenism	5	Placation	Advice is received from citizens but not acted upon
	4	Consultation	Citizens are heard but not acted upon
	3	Informing	Citizen rights or options are identified
Non participation	2	Therapy	Power holders educate or cure citizens
	1	Manipulation	Rubber stamping committees

FIG 6.4. ARNSTEIN'S LADDER OF CITIZEN PARTICIPATION.

termed *translocal justice*, in which similar but geographically disparate places can work towards common agendas (Harvey cited in Castree 2004).

Another way of looking at these social capital networks is to consider how people move around Arnstein's ladder of citizen participation (Arnstein 1969). Arnstein envisaged that citizens would engage with the wider world at different levels when decision-making was needed about a topic of concern (Fig 6.4). As people climb the ladder so their level of involvement with and control of decision-making increases. It can also be argued that as people and organisations climb the ladder so their social capital increases and thus their sense of place. Each increasing stage is typified by being more externally looking, developing more capacity building and being more effective as a collective. Many upland farmers towards the end of the 20th century felt manipulated by agendas outside their control, placing them on the first rung of Arnstein's ladder. Typically these have suffered greatest from the cost price squeeze, labour reductions and poor diversification opportunities (Ponder and Hindley 2009). Pretty and Ward (2001) refer to this situation as *Reactive Dependence*, whereby individuals or groups react to a threat or crisis by relying on external agencies for support and typically fear change. At the other extreme we could argue that Commons Councils and federations sit above the fifth rung, depending on their lobbying powers. Pretty and Ward term this *Awareness Interdependence*, where the group can shape its own reality and begin to resist external influences and threats by joining with other groups, creating local identity and forms of translocal justice. In between these two extremes is *Realisation Independence*, the phase when newly emerging capabilities within individuals and groups develop. Members will begin to invest more time in the 'project' and begin to look outwards to develop advantage for the group

as a whole; this is, in effect, the beginnings of an awareness of the use of sense of place for rural regeneration. For farmers, by exploiting the commodification of sense of place, they may be able to control their position on the ladder in differing circumstances.

USING SENSE OF PLACE: CASE STUDIES

It is at this point that we need to understand what sense of place is in the eyes of the farmers themselves. Within upland farming communities there is evidence that both aspects of sense of place can be used for rural regeneration. A contrasting concept to rural development, rural regeneration is a bottom-up, community-led, endogenous approach which taps into local resources. The classic example of this is LEADER (*Liaisons Entre Actions de Developpement de l'Economie Rurale*) and its associated Local Action Groups (LAGs), which now form the umbrella system for the new EU Rural Development Regulation. LAGs also demonstrate a further endogenous process, *rural restructuring*, whereby cross-cutting of power and association forces alternative combinations of actors from different contexts and political levels to seek common ground typical of awareness interdependence (Marsden and Sonnino 2008) and translocalism advocated by 'place' geographers (see Castree's 2004 review).

The classic use of sense of place is its geographical context. Bessière (1998) demonstrates how communities can use tradition as a starting point to revive themselves by encouraging local people to promote transmittable skills and expertise. He cites the case of *Le Haut Plateau de l'Aubrac* in France, where the community promoted the local heritage and gastronomy to help revitalise a flagging economy. The inclusion of the tradition of cheese production by local shepherds helped to save the locally distinctive *Aubrac* cow from extinction. These types of projects, which draw on the traditional products of wool and meat, are now well-established methods of revitalising marginalised farming communities. In upland Cumbria these geographical sense of place ideas have been used effectively by the Hill Lamb and Mutton Marketing Scheme (HLMMS), part of the Cumbria Hill Sheep Initiative. The HLMMS developed a number of projects based on three indigenous breeds of sheep associated with geographically distinct areas of Cumbria: Herdwick (in the Lake District core), Rough Fell (in the Howgills and Northern Yorkshire Dales) and Swaledale (in the Pennines). Meat cutting plants, visitor centres, butter production, light lamb,[2] carpet, wall insulation, meat marketing cooperatives, *Product of Designated Origin* (PDO) and *Product of Geographical Indication* (PGI) labelling, wool for craft spinning and felt-making were all supported by LEADER+ (Mansfield 2008). A noteworthy geographical sense of place project was the Rough Fell Sheep Breeders Association (RFSBA)'s pursuit to label their meat as a PDO or PGI. These EU initiatives allow for the creation of a protected food name, such as that of Parma Ham. The difference between the two labels is that a PDO requires the product to be produced, slaughtered, cut and processed completely within the region of origin. For the PGI, the area must have some recognised historical character, and the product must be grown and processed in the region (Banford 2010, *pers comm*). This project demonstrates that commodifica-

2 Light lamb: young lambs which are not weaned, considered to provide sweeter, more succulent meat than sheep fed on grass once weaned.

tion of sense of place can vary, because in this instance it could only fit the weaker PGI regulations, which led to sales premiums being much lower.

The more intangible 'lived experience' dimension of sense of place has also been used effectively by the RFSBA through the production of a promotional video entitled *Rough Fell Heritage – a celebration of the life, work and landscape of the Rough Fell sheep farming community*. In this video the farmers themselves talk about their connectedness with the landscape and their way of life by progressing through the farming year. The unique processes and structures of the Rough Fell farming system are explained and connections made to the farming community. Particular attention is paid to the lived experience aspects of hill farming. The importance of shared cooperation, hefting and traditional knowledge and skills are typical processes commented upon by the commentating farmers. Networks and structures such as the livestock markets, church festivals, sheepdog training and agricultural shows are portrayed as important shared experiences among the farming community. Concerns regarding succession, environmental demands, tourism, changes in practice and politics are recognised as challenges to address. The video, therefore, is a clear example of how sense of place plays an important role in this farming community, as well as providing visitors and other interested parties a glimpse of the distinctiveness of the people, heritage and landscape of Rough Fell sheep farming.

CONSTRAINTS OF USING SENSE OF PLACE

We have seen that sense of place offers great potential for rural regeneration in upland farming areas. However, the effectiveness of sense of place as a tool is somewhat diminished because of various constraints which have developed in the structures, processes and relations within this farming sector.

Probably the most obvious constraint is the weakening of the sector's structural integrity caused by a range of economic and political changes within and without the industry, which have squeezed profit margins. The effect can be four-fold: a contraction of the labour force (in many cases to just one person full time per unit); the discouragement of young people from entering the industry; destocking or abandonment of heft management on those units still operating; or a complete withdrawal from farming altogether. All result in a collapse of skills and knowledge transmission to the next generation of farmers. The continuation of these *local knowledge systems* is widely recognised by many as essential if these forms of resource management are to continue (eg Gray 1998; Hay 1998; Bell *et al* 2008). The problem is intensified if a farmer opts to withdraw from farming altogether, creating ripple effects out into the wider community. Those that have sold up altogether have often split house and land. This has happened in south Cumbria around the Howgills, where 45 per cent (17 out of 36) of farm units are no longer farming (Wilson 2003, *pers comm*). The land then becomes farmed on a more ranching-style basis by a neighbour, while the house remains lived in either by the original family or perhaps a new non-farming family.

A second constraint for upland farming is the erosion of processes and relations which give the farmers and communities their sense of place as a lived experience. Probably the most notable is the corrosion of social capital. Burton *et al* (2004) showed that some processes within upland farming were definitely degrading. Farmers expressed their concern over the loss of gathering, hay-making, shearing rings, local community participation and visits to stock sales. Clipping, for instance, is no longer the social occasion it was now that contractors or automation are used. Fewer farmers now take their stock to market; the lorry turns up, stock are loaded and those not

sold are returned at the end of the day (IEEP 2004). Instead the farmer's wife's own social capital has grown with rising farm diversification and the need for off-farm employment to supplement farm incomes (Gasson 1988). The summative effect of loss of social capital is to descend back down Arnstein's ladder, which could take upland farming communities back toward reactive dependence and isolationism (Castree 2004).

A more insidious process collapse is related to the abandonment of hefting. While conservationists may rejoice at the destocking or total exclusion of stock from fell areas for ecological reasons, the outcome for the upland farming community is more complex. Many farmers now report undergrazing as an issue as adjacent hefts are abandoned and, with no intra-heft competition, sheep graze less intensively across wider areas (Dunford and Feehan 2001; Poschlod and WallisDeVries 2002; Evans 2005). For the farmer, the more extensive spread of his/her stock across several hefts makes gathering more costly and time consuming, a situation compounded by labour shortages. These circumstances simply add to the decision of many farmers to abandon heft management in a form of positive feedback. Once the heft is abandoned the farmer needs to reorganise the farm's entire management system. The upshot of this situation can often be a less financially viable business in spite of agri-environment payments, thus leading again to eventual withdrawal from farming. Others argue that this land could be switched over to re-wilding projects instead; however, there is a great deal of debate about the environmental, social and economic value of such projects at present (Soliva *et al* 2008; Reed *et al* 2009).

Concluding Remarks – Keeping it all Going

From the discussion above, we can see that hill farming requires economic and political support if it is to remain sustainable, the outcome of which should be a large enough population to maintain the local knowledge system required to run the complexities of the farming system itself. However, there may within this be structures and processes which could be abandoned or diminished which have limited impact on the farming community's sense of place. One such example might be hefting. On the one hand this system could be abandoned and replaced with a type of ranching, whereby one farmer manages an entire common; this would help maintain ecological value through careful stocking density management. Consequently geographical sense of place could be maintained. However, the overall reduction of hefts would lead to fewer people to maintain the local knowledge system, which would diminish the lived experience of sense of place. The real issue is therefore to determine which aspects (or *keystones*, borrowing from the ecology discipline) are needed to sustain *lived* sense of place and which are not. Of course, we may not wish to maintain either geographical or lived, and consign this form of farming to the annals of history. However, such decisions are currently socially, morally and politically unacceptable (Woods 2005).

Furthermore the loss of upland farming is not an option because the geographical sense of place this form of farming has created is valued too greatly by the local and visitor alike (McVittie *et al* 2005; Lake District World Heritage Project 2008). In order, therefore, to maintain both aspects of sense of place, it is likely that a form of resource management, *co-management*, would work. Co-management blends the experience, traditions, custom and practice and self-regulation of the local resource managers with those of the establishment which adopts a scientific approach (Mitchell 2004). While there is much understood about the two halves of this form of resource management in upland farming systems, there is still far to go in terms of the two integrating

effectively. It is postulated here that understanding more about the keystones of sense of place would go far to developing a co-management approach to this limited and celebrated resource.

Bibliography and References

Aitchison, J, Crowther, K, Ashby, M, and Redgrave, L, 2000 *The Common Lands of England: a biological survey*, University of Aberystwyth, Aberystwyth

Arnstein, S P, 1969 A Ladder of Citizen Participation, *American Institute of Planners* 35, 216–24

Banford, A, 2010 Interview with the author, 23 April, Redhills, Cumbria

Bell, S, Hampshire, K, and Tonder, M, 2008 Person, Place and Knowledge in the Conservation of the Saimaa Ringed Seal, *Society & Natural Resources* 21, 277–93

Bessière, J, 1998 Local Development and Heritage: Traditional Food and Cuisine as Tourist Attractions in Rural Areas, *Sociologia Ruralis* 38 (1), 21–34

Brown, G, 2009 *Herdwicks: Herdwick Sheep and the English Lake District*, Hayloft, Kirkby Stephen

Burton, R, Mansfield, L, Schwarz, G, Brown, K, and Convery, I, 2004 *Social Capital in Hill Farming*, Report to the International Centre for the Uplands, Hackthorpe, Cumbria

Castree, N, 2004 Differential Geographies: place, indigenous rights and 'local' resources, *Political Geography* 23, 133–67

Dunford, N B, and Feehan, J, 2001 Agricultural practices and natural heritage: a case study of the Burren Uplands Co Clare, *Tearmann* 1 (1), 19–34

English Nature, 2001 *State of Nature: the upland challenge*, External Relations Team, NE, Peterborough

Evans, R, 2005 Curtailing grazing – induced erosion in a small catchment and its environs, the Peak District, Central England, *Applied Geography* 25, 81–95

Federation of Cumbria Commoners, 2009 [online], available from: http://www.cumbriacommoners.org.uk [10 June 2009]

Gasson, R, 1988 *The Economics of Part time Farming*, Longman Scientific & Technical, Harlow

Graham, H, Mason, R, and Newman, A, 2009 *Literature review: Historic Environment, Sense of Place, and Social Capital*, Commissioned for English Heritage by International Centre for Cultural and Heritage Studies (ICCHS), Newcastle University, UK

Gray, J, 1998 Family Farms in the Scottish Borders: a practical definition by hill sheep farmers, *Journal of Rural Studies* 14 (3), 341–56

Grigg, D, 1984 *An Introduction to Agricultural Geography*, Hutchinson, London

Hart, E W, 2004 *The Practice of Hefting*, Edward W Hart, Ludlow

Hay, R, 1998 Sense of Place in Developmental Context, *Journal of Environmental Psychology* 18, 5–29

Institute for European Environmental Policy, 2004 *An assessment of hill farming in England on the economic, environmental and social sustainability of the uplands and more widely*, Reports of Case Studies Volume 3, IEEP, Land Use Consultants and GHK Consulting, London

Lake District World Heritage Project, 2008 *Outstanding Universal Value (OUV) Statement 2008*, available from: http://www.lakeswhs.co.uk/documents/LakeDistrictStatementofOutstandingUniversalValue190808.pdf [5 October 2010]

McVittie, A, Moran, D, Smyth, K, and Hall, C, 2005 *Measuring public preferences for the uplands*, Final Report to the Centre for the Uplands, Hackthorpe, Cumbria

Mansfield, L, 2008 The Cumbria Hill Sheep Initiative: a solution to the decline in the Upland Hill Farming Community in England?, in *Sustainable Rural Systems – Sustainable Agriculture and Rural Communities* (ed G Robinson), Ashgate, Aldershot, 161–84

— 2011 *Upland Agriculture and the Environment*, Badger Press, Windermere

Marsden, T, and Sonnino, R, 2008 Rural development and the regional state: denying multifunctional agriculture in the United Kingdom, *Journal of Rural Studies* 24, 422–31

Mitchell, B, 2004 *Resource & Environmental Management* (2 edn), Prentice Hall, London

Ponder, V, and Hindley, A, 2009 *Farming Lives – Using the Sustainable Livelihoods Approach in the Peak District Farming Community*, Oxfam & National Farmers Network

Poschlod, P, and WallisDeVries, M F, 2002 The historical and socioeconomic of calcareous grasslands – lessons from the distant and recent past, *Biological Conservation* 104, 361–76

Pretty, J, and Ward, H, 2001 Social Capital and the Environment, *World Development* 29 (2), 209–27

Putnam, R, 1993 *Making Democracy Work: Civic Traditions in Modern Italy*, Princeton University Press, Princeton

Reed, M S, Arblaster, K, Bullock, C, Burton, R F J, Davies, A L, Holden, J, Hubacek, K, May, R, Mitchley, J, Morris, J, Nainggolan, D, Potter, C, Quinn, C H, Swales, V, and Thorp, S, 2009 Using Scenarios to explore UK upland futures, *Futures* 41, 619–30

Robinson, G M, 2004 *Geographies of Agriculture: Globalisation, Restructuring and Sustainability*, Pearson and Prentice Hall, London

Rough Fell Sheep Breeders Association, 2005 *Rough Fell Heritage: a celebration of the life, work and landscape of the Rough Fell sheep farming community* [DVD], Eden Media Production, Penrith

Soliva, R, Rønningen, K, Bella, I, Bezak, P, Cooper, T, Egil Flø, B, Marty, P, and Potter, C, 2008 Envisioning upland futures: stakeholder responses to scenarios for Europe's mountain landscapes, *Journal of Rural Studies* 24, 56–71

Thompson, D B A, Macdonald, A J, Marsden, J H, and Galbraith, C A, 1995 Upland Habitat Management in Great Britain: a review of international importance, vegetation change and some objectives for nature conservation, *Biological Conservation* 71, 163–78

Warburton, D, 2004 Community Involvement in Countryside Planning in Practice, in *Countryside Planning: New Approaches to Management and Conservation* (eds K Bishop and A Phillips), Earthscan, London, 250–70

Wilson, H, 2003 Interview with the author, High Carlingill, Cumbria, 12 November

Winter, M, Gaskell, P, Gasson, R, and Short, C, 1998 *The effects of the 1992 reform of the Common Agricultural Policy on the countryside of Great Britain: final report Vol 2, main findings*, Countryside and Community Research Unit, Cheltenham and Gloucester College of Higher Education, Cheltenham

Woods, M, 2005 *Rural Geography*, Sage, London

Place, Culture and Everyday Life in Kyrgyz Villages

Vincent O'Brien, Kenesh Dzhusupov and Tamara Kudaibergenova

Introduction

In this chapter we draw upon our experiences of using participatory video and photography in a collaborative ethnography of village life in the Naryn and Issy Kul regions of Kyrgyzstan. We describe some of the key features of Tengrianism, a pre-Islamic belief system that informed everyday life amongst the nomadic Kyrgyz. Using examples from fieldwork during *Visible Voice* projects since 2006, we describe how the underlying philosophical principles, beliefs, customs and traditions of their nomadic ancestors continue to exert an influence on everyday life in rural Kyrgyzstan. We describe the physical structure and orientation of the traditional Yurt dwelling, which provides a model of the spiritual and social world of the Kyrgyz and illustrates the primacy of sense of place in Kyrgyz culture.

Context

Kyrgyzstan is a small former Soviet republic located on the ancient Silk Road trade routes between China and Europe. Although there are more than 80 ethnic groups living in the Kyrgyz Republic, the majority of people are ethnic Kyrgyz. Kyrgyzstan is unusually mountainous, with more than 94 per cent of its territory above 1000 metres and more than 40 per cent above 3000 metres. Nomadic by tradition until the 1930s, many remote communities maintain a semi-nomadic herder lifestyle. There are few jobs to be found in rural communities and in the more remote villages herding livestock provides the only real source of income for families. Some 40 per cent of Kyrgyz people live in rural areas above 1000 metres with many semi-nomadic herder communities living in the high mountain valleys that characterise Kyrgyzstan's physical landscape (UNDP 2002). Living in a remote, mountainous, landlocked country, with nomadic traditions spanning many centuries, the Kyrgyz people occupy a unique physical and cultural environment in which the importance of place is evident in everyday life.

Visible Voice

Since 2006 we have been using participatory video and photography in our work with communities in the remote rural villages in Kyrgyzstan (O'Brien *et al* 2008). Through a participatory visual ethnography project called *Visible Voice* (www.visiblevoice.info), we bring together researchers and community participants in a creative process of collaborative ethnography with the aim of

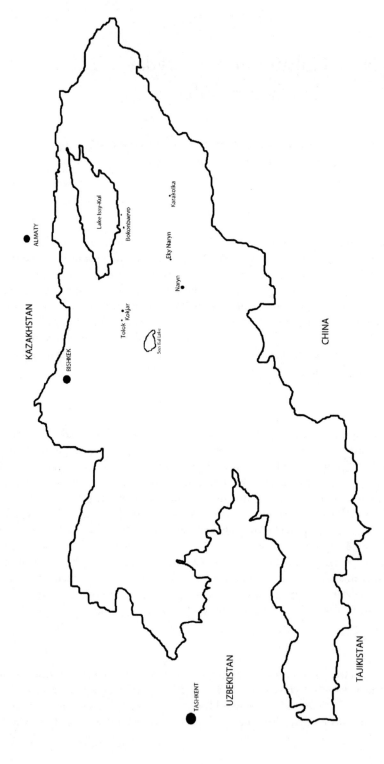

Fig 7.1. *Visible Voice* engages in collaborative ethnographic projects in the remote village communities of Bokonbaeva, Eky Naryn, Karakolka, Kokjar and Tolok.

helping communities and researchers understand the nature, relational influences and meanings of lived experiences. Engaging in participatory video workshops, villagers devise, record and edit their own visual accounts of everyday life. Through observation and engagement with the production process and viewing of the completed films, we are able to gain an insight into the ways in which villagers interact with and assign importance to the physical and cultural places that give meaning to their everyday lives.

Our work is informed by our view that social disadvantage thrives on a limited capacity for social analysis and initiative that exists within communities. In our research we use participatory visual media techniques to engage and establish a rapport with participants, encouraging and facilitating the production of collaborative community narratives. These techniques enable us to establish an effective visual and interpersonal basis for cross cultural, co-ethnographic analysis of community issues. Our approach is in line with the Freirean objective of raising critical consciousness as a key mechanism for social improvement. Paralleling Freire's approach to adult learning, we place strong emphasis on collaborative engagement of participants and researchers as co-creators of knowledge (Freire 1996). Participatory ethnography, such as that practised within the *Visible Voice* projects, engages participants in reflection on their own lives, on their personal and shared perceptions, and on the physical, economic, social, cultural and spiritual spaces they inhabit and construct. The process of collective storytelling – for an explicitly global audience – focuses attention on the shared perspectives, beliefs and aspirations of the groups producing the films. Identifying, negotiating, prioritising and explaining shared and contradictory views and understandings provides a mutually beneficial learning environment for participants and researchers. In the hands of the participants, cameras and camcorders capture and express the participant's view and help to provide opportunities to erode the 'invisible wall' of disproportionate powers that haunt ethnographic research relationships, creating instead a more negotiated 'fluid wall' (Shrum *et al* 2005) between researchers and participants. Working in this way, we make explicit our desire to shift the power dynamics of knowledge creation away from researcher-driven enquiry to a more egalitarian pursuit of knowledge through collaborative introspection.

METHODOLOGY

During fieldwork visits we invite participants to produce short videos telling stories of everyday life in their village. At the same time we use conversational interviews, co-analysis of photographic and video footage and observation of the production and display of villager exhibits to gain insights into the lived experiences of village communities. Participants in *Visible Voice* projects often continue to develop and display new visual narratives, acting as *Visual Activists* portraying community life, educating and lobbying for change and challenging the 'outsider' portrayals of 'Big Media' (O'Brien *et al* 2007). *Visual Activism* is evident in many of the villagers' films as they portray village life and make explicit their needs for such things as improvements in welfare support (Visible Voice 2009), support for environmentally sustainable craft production (Visible Voice 2006b) and sports facilities for young people (Visible Voice 2006a). In rural Kyrgyzstan we are working with predominantly ethnic Kyrgyz participants living in five villages in the Naryn and Issy Kul *oblasts* of northern and central Kyrgyzstan. These are regions in which elements of nomadic cultural traditions remain strong.

THE VILLAGES

Naryn is a dry mountainous region and one of the least densely populated areas in Kyrgyzstan with an estimated population density of six people per square kilometre. The villages of Eky Naryn, Tolok and Kokjar are some six to nine hours' drive from the capital Bishkek, assuming favourable weather and road conditions. The Issy Kul oblast to the north and east of Naryn centres on the 180km-long, 60km-wide lake Issy Kul, the second-largest high-altitude (1600m) lake in the world (Mitchell 2007). The lake provides a comparatively low-level base for travel into the higher mountain valleys in the Issy Kul oblast. Our work in Issy Kul involves villagers from Bokonbaevo and Karakolka. Bokonbaevo is a large village close to lake Issy Kul. The least remote of the *Visible Voice* communities in Kyrgyzstan, the village suffers high levels of unemployment. Karakolka, the smallest and most remote of the villages we worked in, located at 3600m, is home to around 140 people who make their living almost entirely from herding. Getting to the village from the lakeside village of Barskoon, the next largest village on the banks of lake Issy Kul, is a difficult four-hour drive across a 4000m mountain pass. The village is effectively cut off from the outside world for six months during the winter, but attracts additional herder families from the lower villages during the summer months. The geographical location of the villages, the seasonal movement of herder families and the practical and cultural significance of location, orientation and placement of people, homes and tools has, for centuries, provided the foundation for the inner ecology of the Kyrgyz people. Not only do place, landscape and environment determine the economy sustaining village life, but the high mountains, reaching towards the sky world, provide the spiritual link that is essential to sustain 'Kut' well-being.

KYRGYZ SENSE OF PLACE

The Kyrgyz people are descended from one of the ancient Eurasian nomadic peoples that lived along the Silk Road trade routes. Kyrgyz nomads could be found throughout East and West Turkestan, Central Asia and Southern Siberia (Nusupov 2009). The development and maintenance of the contemporary Kyrgyz state rests, at least in some part, on the strong sense of place that permeates Kyrgyz spiritual and cultural attitudes to traditional dwelling places, territories and homelands.

For the Kyrgyz, the significance of 'place' is not limited to the physical territory on which their dwelling stands – it is also the wider ancestral space which is considered to be worthy of special reverence and even worship. Linkages between people and land are evident in Kyrgyz proverbs: '*Elin suibos er bolboit, jerin suibos el bolboit*' (There is no man who does not love his people. There are no people who do not love their land) (Shambaeva and Iptarova 2008).

The traditional Kyrgyz nomad's dwelling is the *Yurt*, a transportable, felt-covered dome. The name Yurt derives from '*jurt*' which holds a variety of meanings in Kyrgyz culture including: people, citizens, relatives, previous camping place, homeland and territory (Urmanbetova and Abdrasulov 2009). The *Jurt* is a significant spiritual and territorial space for the Kyrgyz. It is the place where Kyrgyz peoples and their ancestors dwell, and is the collective clan space, the space where relatives live, where the *ayil* (village, settlement or community) is located. '*Jurt*' also refers to the wider physical and spiritual territories, the space where not only the *ayil* but also the transitional spaces where herder families camp during their migrations to and from the *jailoo* – summer pastures – in the high mountains are permanently located.

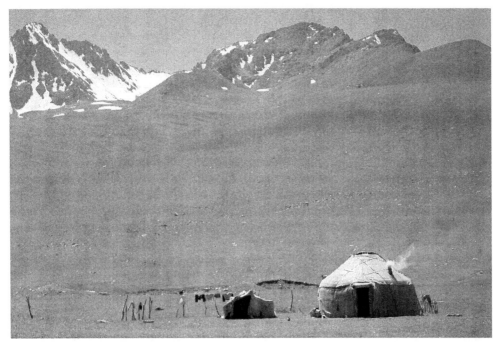

FIG 7.2. LIVING IN TRADITIONAL FELT YURTS, THESE HERDER FAMILIES LIVE IN SUMMER PASTURES (JAILOO) FROM LATE MAY TO THE END OF SEPTEMBER.

Selecting a suitable location for *Jurt* territories and encampments – placement of individual yurts within the *Jurt* – has to be considered carefully. Selecting the best *Jurt* space requires a well-developed capacity to understand the locality and its spiritual and material qualities. For the Kyrgyz nomad this means listening to, respecting and loving the landscape. The *Jurt* has a special spiritual status which makes it important not only to take care in choosing its location but also to organise the space so that place and people correspond to each other. Only then can it be worthy of the name *Jurt*. If a place is inspired (spiritual), the spirituality inherent in that place can inspire a person's life, and that person, in turn, can provide spiritual inspiration for all that share in that world (Urmanbetova and Abdrasulov 2009).

Contemporary Kyrgyz *ayils* consist of small groups of houses, inhabited by close relatives from a single tribal group (Abramzon 1990). In our work with villagers in Kokjar, Tolok, Eky Naryn, Bokonbaevo and Karakolka, only Tolok differs from this familial pattern. In Tolok, the community is made up of Kyrgyz people from 17 different tribal groups. This exception to the normal pattern of family relationships in Kyrgyz villages arises from Tolok's unique history. Tolok valley had long been a stopping place for Kyrgyz herders from different clan groups (Ak Terek Public Fund 2006). However, the village only really became established as a small settlement in the late 1930s, when around ten wattle and daub houses were constructed. At that time *Kulaks*, wealthier land-owning peasants, were considered 'class enemies' (Stalin 1930) and were being forcibly moved from their land in other parts of the Soviet Union, principally Russia and the Ukraine. A small number settled in Tolok. At this time nomadic lifestyles were under pressure throughout

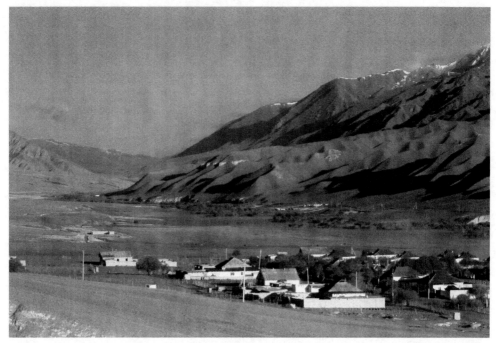

Fig 7.3. Located in a remote and windswept mountain valley, Tolok is home to around 800 ethnic Kyrgyz.

the Soviet Union. The Soviet system favoured collective land management, settled communities and large-scale industrialisation, and life for Kyrgyz nomads was becoming increasingly difficult. Located at 2600 metres above sea level, Tolok village occupies a cold, windswept, dry valley on a traditional herder route to the *jailoo* on the banks of Son Kul Lake. Seasonal migration was increasingly curtailed by the new Soviet measures and nomadic Kyrgyz, who were struggling to feed their families as they passed through the Tolok valley, saw an opportunity for a better way of life. Gradually these herder families joined the village, shifting from a nomadic to a semi-nomadic way of life. In 2006, Tolok was home to an estimated 1460 people (Ak Terek Public Fund 2006) living in wattle and daub houses. Two years later, largely because of the increasingly difficult economic conditions in the valley, the population had dropped below 1000 inhabitants.

The Construction of Kyrgyz Sense of Place

The meanings attached to physical landscapes derive from the complex interactions between individuals, places and social worlds (Kyle and Chick 2007). In the Kyrgyz social world, belonging to a 'homeland' is linked directly to well-being and the stability of the social world. For the Kyrgyz, 'homeland' is both a material and spiritual space. At the same time, in keeping with nomadic traditions, it is not an entirely fixed territory. A Kyrgyz person needs to be able to locate their spiritual centre in order to understand and establish an essence of a place. Away from home a

Kyrgyz person will try to establish a rapport with the material and spiritual qualities of the local environment, perhaps through conversation with local people or through contemplation of the 'feel' of a place. This process is necessary to enable the traveller to gain an understanding and to be safe in a new locality. To have a good knowledge of a place is essential in order to be able to sustain oneself, to be able to flourish and prosper in that place.

The Kyrgyz tradition of hospitality to strangers provides an encounter space in which the hosts try to understand the relationship between their own values and those of the guest. At some point within the encounter a discourse will develop in which the host will seek to understand the spirituality of the visitor. Before learning a stranger's name, Kyrgyz people often ask 'where are you from?', opening up an enquiry into the visitor's homeland, spiritual and family origins. For the Kyrgyz, homeland is of critical importance in ensuring well-being. A person who has no homeland, who has no love for his 'own' land, is considered to have become rootless, to have become disconnected, a predicament that foreshadows material and spiritual destruction. The Kyrgyz approach such 'rootless' people with mistrust: '*Jerinen ashcan el onbos, jergeden kachkan er onbos*' (It is not good for people to wander on foreign land, it is not good for a man to run from his people) (Sarbagyshova 2007).

ETHNOREGIONALISM

Ethnoregionalism – placing special emphasis on a person's regional and local origins in assessing their character and social status – is a prominent feature of Kyrgyz culture. In everyday Kyrgyz greetings, introductions and descriptions of self, we find implicit and explicit references to place in declarations of birthplace, in regional characterisations and in the family names that reveal the tribal allegiances important in political and business life. The importance of belonging to a tribe, region or locality is evident even in the naming of the republic as the Kyrgyz Republic, making explicit the link between ethnicity and state (Dzhusupbekov 2009).

Self-identification with locality entails a commitment to a perceived system of shared regional or local values. At times expressed as local patriotism, even relatively small communities tend to prioritise the interests of the locality over those of other localities and sometimes over the wider interests of the nation state (Dzhusupbekov 2009). Attempts to balance ethnoregionalism are observable in contemporary Kyrgyz politics and it is common that where the minister is from the south of Kyrgyzstan, the deputy will be from the north, and vice versa (ibid).

SACRALITY AND PLACE

Sacrality refers to the extent to which places, objects, behaviours and so on are considered to be sacred or worthy of special reverence. Sacrality in Kyrgyz culture is derived from the pre-Islamic, metaphysical traditions of Kyrgyz nomads' Tengrianism. At the heart of the Kyrgyz metaphysical universe is the god of blue sky, *Tengri*. According to Kyrgyz Tengrianism, the universe exists as a unified whole in which all living and non-living parts – living humans, ancestral spirits, animals, plants and even rocks – are considered to be of value. The past and present co-exist in a three-dimensional sacral space consisting of the upper sky spirit world of *Tengri* and the super-natural forces of Mother Earth (Abazov 2006). *Father Sky* fertilises *Mother Earth* who, in turn, gives birth to and nurtures life. In between Sky and Earth and located at the intersection point between the sky spirits and the supernatural forces of the earth is the human world. Growing

up from the earth is a mature and sacred tree that forms a link between the worlds of sky and earth and provides vertical (top–bottom), horizontal (left–right), and depth (front–back) planes that inform the spiritual orientation of humans living in between these worlds. This sacred tree provides a spiritual point of reference, providing a spatial reference point for human centring. A Kyrgyz person travelling to an unknown territory will seek out a 'sacred tree' or high point in a landscape as a point of spiritual centring and tranquillity.

East and South are linked in the semantic spectrum and share the spiritual nature of the 'Top' world, while West and North correspond to the spiritual nature of the 'Bottom' world. The characteristics of the 'middle' world, the world of the people, are the characteristics of connection and interconnectedness. The centre is the place where birth occurs, where space and time connect. In the Kyrgyz ancestral 'map of the world', the Earth is a circle. At the middle is *Bos-Dobo* – Grey Mountain – the sacral centre and 'home' territory of the Kyrgyz people. The fearsome *Jelpinish* – edge of the world – is where *Jin* and other spirits live. In essence, the 'map of the world' of ancient Kyrgyz people represents an axiological, moral perception of space, with a gradual transition from the intense sacrality of *Bos-Dobo*, located at the 'middle' of the Earth, to the less sacral, and consequently less safe, periphery. The further we move from our central place, the place that we know, the more that place loses the qualitative characteristics of our 'own world'. Our centre, our home, becomes vague and unknown and we become estranged.

The Kyrgyz epic song poem *Manas*, handed down through generations of *Manaschi* singers, tells the story of *Manas*, a hero who, through his adventures, acts as a *World Tree*, linking the Top and Bottom worlds of Father Sky and Mother Earth (May 1995). In *Manas* the essential interaction between place and people is located in the presence of supernatural forces assigned to the land (Vinogradov 1939). Territory is, therefore, established as the most fundamental of Kyrgyz values (Akaev 2003). The earth, water, nature and all that constitutes the landscape is established as the focus for special veneration and spiritual significance. According to *Manas*, the space we occupy, our 'own land', constitutes our physical and spiritual world. An enemy attack on this 'own land' can cause our world to collapse, resulting in the transformation of order into chaos (Akmoldoeva 2009). One of the prominent features of *Manas* is the use of regionalism and locality to confirm the geography of the epic and its actors. The names of mountains, lakes and valleys in *Manas* help the *Manaschi* to construct a vision of a Kyrgyz *Jeri* (land) united by territorial and spiritual boundaries. The names of regions and localities prompt associations of identity and spiritual significance that create a link between mythological homelands and contemporary geographical spaces (Akmoldoeva 2009).

THE SIGNIFICANCE OF THE YURT

The traditional Kyrgyz dwelling is a yurt, a dome-shaped felt tent supported on a wooden framework. A large circular roof opening (*tunduk*) allows light and fresh air into the yurt and provides an exit for smoke. The interior of the yurt is organised around the *Tor* (honourable space) directly opposite the *Bosogo* (threshold or entrance). Valuable family items, such as felts and blankets, wooden chests and so on, are placed in the *Tor*. The space between the *Tor* and *Bosogo* is aligned to the *ochok* – the heart of the family. Special attention is given to the arrangement of household items and other things in the dwelling space. For example, a broom should be hidden from public view; it should be laid down on the floor and never leaned against the wall of the yurt. The bottom of a bed should never be orientated to the north or west. Breaking

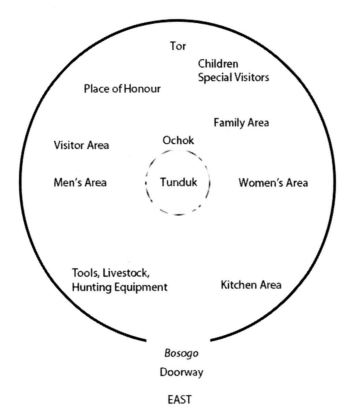

FIG 7.4. THE YURT PROVIDES A PHYSICAL MODEL OF KYRGYZ CULTURAL
ORIENTATIONS.

such conventions could result in illness or misfortune for the family. Footwear should never be
placed with the sole turned up for fear that 'the world will turn over'.

Family life takes place, for the most part, to the left of the *Tor* in the female half. To the right
of the *Tor*, the male area is largely reserved for entertaining visitors. The visitors' area may also be
used to house marriageable daughters or newlyweds. After death the bodies of family members
are often placed in the men's area to await the funeral rituals (Russian Museum of Ethnography,
n.d.); however, in some cases, the bodies of the dead may be placed according to their sex in the
male or female areas.

In the framework of the yurt there is no superfluous detail. The ties for the trellis walls are
made of small pieces of leather with the overlapping frameworks pivoting through the use of
small leather tags that secure each moving element of the frame. Everything in the yurt, structur-
ally and organisationally, is interconnected and consequently interdependent, almost as a living
body (Urmanbetova and Abdrasulov 2009).

The *Tunduk* is a critical part of the Yurt and the most fearful curse of Kyrgyz nomads is
'*Tundugun tushsun*' (Let your yurt's tunduk fall). If the *Tunduk* falls, the vital spiritual centre of

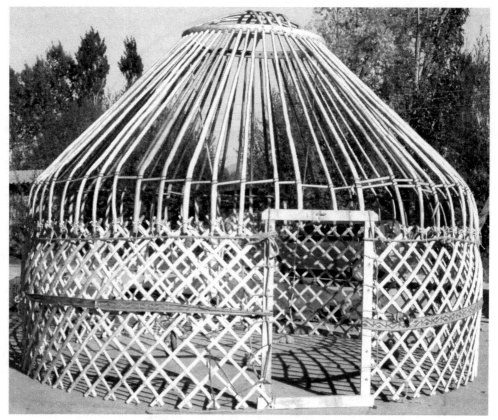

FIG 7.5. THE YURT'S STRUCTURE PROVIDES AN EXCEPTIONALLY MOBILE AND DURABLE HABITAT THAT
SIMULTANEOUSLY EMPHASISES THE CO-DEPENDENCY OF PEOPLE, SPIRITS, EARTH AND SKY.

the yurt will diminish, resulting in the loss of the yurt's physical structure and spiritual orderliness. The collapse of the *Tunduk*, for the family, is equivalent to death. If the material and spiritual world which gives rise to and sustains the Kyrgyz nomad falls, it brings about automatic destruction of all that is in it, including the man and his family (Urmanbetova and Abdrasulov 2009).

SPATIAL ETIQUETTE

The Kyrgyz believe that *kut* (well-being) will be damaged if insufficient concern is paid to spiritual and physical organisation in the home, and sense of place within the home and in everyday life informs the spatial basis of Kyrgyz etiquette. Social etiquette follows spatial arrangements and the order and nature of dialogue at formal meals and meetings. The Kyrgyz seating ritual arises and is realigned according to the status of persons entering or leaving a space. Places are allocated to participants strictly on the basis of rank. The honourable place, *Tor*, is offered to the most revered visitor with others seated at the table in descending order. The 'top' and right part of the

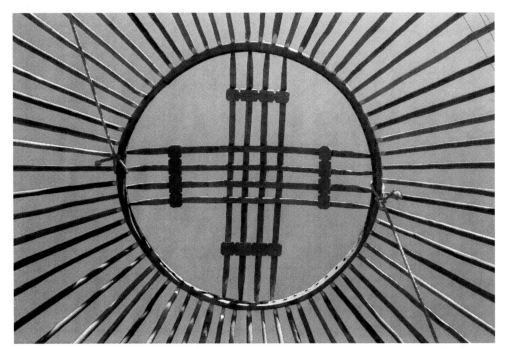

FIG 7.6. A CIRCULAR OPENING IN THE ROOF OF THE YURT, THE TUNDUK, PROVIDES A WINDOW BETWEEN THE MIDDLE WORLD OF PEOPLE AND THE SKY SPIRIT WORLD OF TENGRI.

table are the most prestigious while the 'bottom' and left part are less prestigious (Akmoldoeva and Niyasalieva 2005). At meals the seating ritual is accompanied by the ritual of distribution of meat, following an established link between the status of guests and the status of *ustukan*, the different parts of the carcass. Each *ustukan* corresponds to the status of the guest, determined by age, sex and social status. Notions of the unequal values of different parts of the cattle body underlie this ritual. For example, the sheep's head – *bash* – is given to the most honoured guest, because offering the head symbolises the gifting of the whole animal. The ritual distribution of space and meat serves to reinforce strict age and social hierarchies and is important in maintaining protective cultural boundaries (Akmoldoeva and Niyasalieva 2005). Ignoring or breaking spatial relations displays ignorance, disrespect or deliberate insult.

SACRED PLACES

Beyond the world of the yurt, there are many sacred locations in Kyrgyzstan deemed to possess the qualities and powers exemplified by *Manas*, who formed a bridge between the spirit worlds of Earth and Sky. These sacred places may be identified by the presence of a solitary mature tree, a spring or unique geological structure rising towards the sky. Strong and powerful spirits may reside on specific mountain tops and in passes. Local people place offerings to spirits at *Oboo*, sacred places which are marked by stone piles, hedges or sometimes clay brick structures. *Oboo*

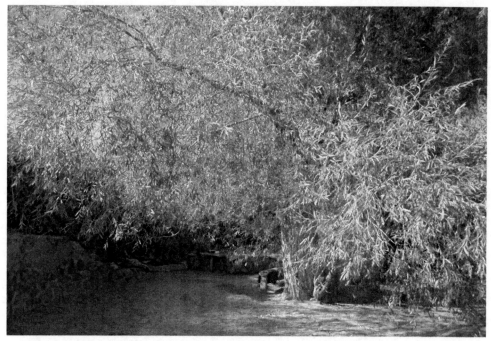

FIG 7.7. A UNIQUE WILLOW TREE NEXT TO A SMALL SPRING IN A SEMI-ARID REGION PROVIDES THE FOCUS
FOR THE SACRED SITE AT MANZHYLY ATA.

offerings may take the form of mountain goat horns, poles decorated with yak tails or wool and
ribbons of fabric tied to the branches of trees or nearby bushes (Abramzon 1990). Manzhyly Ata,
located near to Lake Issy Kul, is believed to have special properties that help infertile couples
have children.

ANCESTRAL SPACES

The worlds of spirits and supernatural forces co-exist with the lives of the living and Kyrgyz sense
of place cannot be limited to the visible territories of the material world. Kyrgyz culture encom-
passes traditional veneration of nature, spirits of the dead and ancestral connections. Statues of
deer, mountain goats, snow leopards and other culturally significant animals, as well as marker
stones imprinted with images of deceased relatives, are evident throughout the rural landscape.
The Kyrgyz *ae* or *ata* patron spirits are often linked to local geographical features such as moun-
tains, rivers or lakes. In Kyrgyz culture, the *masardyn aesi* is a patron spirit of a sacred place; the
bashattyn aesi is patron spirit of a sacred spring and the *arashandyn aesi* is a patron spirit of a
curative spring (Anochin 1924).

According to Kyrgyz tradition, children should remember the names of seven generations of
grandfathers. This, it is said, will help to ensure that men, knowing their names will be remem-
bered for seven generations, will live honourably. In Kyrgyz mythology, when we die our soul

becomes an *arbak*, a patron spirit for those left alive (Abramzon 1990). This patron spirit holds an important place in everyday rural Kyrgyz life and by tradition even the slightest misfortune that falls upon an individual or family is likely to prompt the sacrifice of an animal in the name of the *arbak* at the ancestor's tomb, or some other spiritually significant place (Valichanov 1961).

Committing an act unworthy of ancestral spirits can cause them to 'give up' on the living and there are many rituals enacted to ensure that patron spirits continue to protect the living. Kyrgyz funerals are important and often expensive events, during which families must show reverence for the deceased through extravagant demonstrations of hospitality lasting two or three days. Women following the Kyrgyz custom of *arvai ashy* take clay pots of *ystyk ash* – hot food – as an offering for the *arbak*. In some Kyrgyz tribes the tradition is for women to visit the tomb every day for 10–15 days, or sometimes for 30–40 days, after the funeral. The women take food and eat it there, leaving some of the food around the tomb for the spirits of the ancestors (Abramzon 1990).

In final recognition of the importance of place and spatial organisation, the dead are buried at the patrimonial cemetery and those sharing a common ancestral origin – *bir atanyn baldary* – are usually buried in the same place. The correct arrangement of the body in the tomb is important and the body must be aligned in relation to appropriate cardinal points. The tomb is a rectangular hole, *aivan*, with a cross cavity cut at right angles at the bottom of the western wall. This cavity, the *kasyna*, is an underground chamber in which the body is placed with the head toward the west (Abramzon 1990).

CONCLUSION

In our brief description of Kyrgyz culture we have shown how place and space are at the centre of the spiritual and everyday lives of Kyrgyz people. Sense of place, in Kyrgyz culture, embodies the past, present and future. As Chingiz Aitmatov, the most famous of Kyrgyz writers, wrote about the spatial world of the Kyrgyz nomad: 'this was that spatial world, accessible to a sight and understanding, in which the man lived and on which he depended. It was mighty and giving, as a god, as a terrestrial embodiment of god' (Aitmatov 1985). Kyrgyz people aspire to conserve the sacred structure of their world, to retain its global order, passing these values from generation to generation through ritual practices, and encouraging in their children the special attitude to their native land which they have inherited from their ancestors, the ancient nomads.

Place and the special reverence for place afforded by tradition and culture remains a guiding force in contemporary Kyrgyz political culture. The traditions, customs and cultural values of their nomadic ancestors are still evident in contemporary Kyrgyz families and are enacted in an everyday spiritual attitude and concern for the changing economic and climatic conditions that threaten the stability of interdependency and interconnectedness of people and the places we inhabit.

BIBLIOGRAPHY AND REFERENCES

Abazov, R, 2006 *Culture and Customs of the Central Asian Republics*, Greenwood Press, Westport, CT

Abramzon, C M, 1990 *The Kyrgyz: Ethnological, Historical and Cultural Communication*, Frunze, Kyrgyzstan [translation from Russian]

Aitmatov, C, 1985 *Cry of a Bird of Passage*, The Stories, Publicism [translation from Russian]

Ak Terek Public Fund, 2006 *Project Report*, Ak Terek, Bishkek

Akaev, A A, 2003 *State Organisation and the National Epos: 'Manas'*, Bishkek [translation from Russian]

Akmoldoeva, S B, 2009 *The Universe of 'Manas'*, Arabaev Kyrgyz State University, Bishkek [translation from Russian]

Akmoldoeva, S B, and Niyasalieva, J K, 2005 Kyrgyz Etiquette, Ilim, Bishkek [translation from Russian]

Anochin, A V, 1924 *Materials on Shamanism Amongst Altay People* 4 (2) [translation from Russian]

Dzhusupbekov, A K, 2009 *Ethnic Identity of Nomads*, Ilim, Bishkek [translation from Russian]

Freire, P, 1996 *Pedagogy of the Oppressed*, Penguin Books Ltd, Harmondsworth

Kyle, G, and Chick, G, 2007 The social construction of a sense of place, *Leisure Sciences* 29, 209–25

May, W, 1995 *Manas*, Door, Bishkek

Mitchell, L, 2007 *Kyrgyzstan (Bradt Travel Guide)*, Bradt Travel Guides

Nusupov, C T, 2009 *Ideological, philosophical, cultural and ethical problems of development in Kyrgyzstan*, Kyrgyz National University Press, Bishkek [translation from Russian]

O'Brien, V, Dzhusipov, K, and Wittlin, F, 2007 *Visible voices, shared worlds: using digital video and photography in pursuit of a better life*, Proc Mundane Technologies and Social Interaction ACM SIG

O'Brien, V, Dzhusipov, K, and Esengulova, N, 2008 *Embracing the Everyday: reflections on using video and photography in health research*, Social Interaction and Mundane Technologies (SIMTECH) 08

Russian Museum of Ethnography, n.d. *Kirghiz: house-world – universe of the nomad!*, available from: http://eng.ethnomuseum.ru/section69/71/279/177.htm [17 May 2011]

Sarbagyshova, N M, 2007 *Kyrgyz Proverbs and Sayings*, Bishkek [translation from Russian]

Shambaeva, B S, and Iptarova, A S, 2008 *Kyrgyz–Russian–English Proverbs and Sayings*, Biyiktik, Bishkek [translation from Russian]

Shrum, W, Duque, R, and Brown, T, 2005 Digital Video as Research Practice: Methodology for the Millennium, *Journal of Research Practice* 1 (1), Article M4

Stalin, J, 1930 *Concerning the Policy of Eliminating the Kulaks as a Class*, Krasnaya Zvezda, Collected Works 12, 189

UNDP, 2002 *Human Development in Mountain Regions of Kyrgyzstan*, United Nations Development Programme Kyrgyzstan, Bishkek

Urmanbetova, J K, and Abdrasulov, C M, 2009 *Sources and Tendencies in the Development of Kyrgyz Culture*, Ilim, Bishkek [translation from Russian]

Valichanov, C, 1961 *Complete Works* Vol 1–4, Alma Ata [translation from Russian]

Vinogradov, V, 1939 *Music of Soviet Kirghizia*, Moscow [translation from Russian]

Visible Voice, n.d. *Visible Voice Project Website* [online], available from: www.visiblevoice.info [17 May 2011]

— 2006a *Everyday Life in Our Kyrgyz Village: Kokjar Village*, Threevoices Films, Levens

— 2006b *Mountainous Initiatives: Tolok Village*, Threevoices Films, Levens

— 2009 *Social Problems: Eky Naryn*, Threevoices Films, Levens

Local Renewables for Local Places?
Attitudes to Renewable Energy and the Role of Communities in Place-based Renewable Energy Development

JENNIFER ROGERS, IAN CONVERY, EUNICE SIMMONS
AND ANDREW WEATHERALL

INTRODUCTION

This chapter discusses the concept of community-based renewable energy (RE) development in relation to themes of place and place-based community. We start from the assumption that there is a need for more RE, and look at how this might be achieved in the UK, focusing on rural places.[1] Increasing RE capacity addresses the twin goals of mitigating climate change and increasing energy security (HM Government 2009). Since RE targets are unlikely to be met under current trends (UKERC 2009), new approaches to increasing capacity are required. Historically, energy policy has favoured large-scale RE development, especially wind power, by large private companies which currently dominate the energy market (Woodman and Baker 2008). However, public opposition to proposed developments has sparked interest in the potential for more localised RE development centred on geographic communities (Walker *et al* 2007; Rogers *et al* 2008).

This chapter explores how perceptions of place affect the potential for community-based RE development. After briefly reviewing the literature on public attitudes to RE, showing how interpretations of place influence attitudes, a case study of a community-based RE project[2] is presented to illustrate how and why this approach can work in practice. We then consider the implications for future development of place-based RE projects.

PUBLIC ATTITUDES TOWARDS RE DEVELOPMENT

Given evidence of strong public support for the general principle of increasing renewable energy capacity (eg Ellis *et al* 2007), many studies have sought to explain the reasons for opposition to

[1] This paper assumes a knowledge of countryside contexts and organisations in England and Wales. Space limitations prohibit further explanation, but for those seeking such background the following references may be useful: Woods (2005), Halfacree (1995; 2007).

[2] This research was carried out as part of the first author's PhD study funded by the UK Energy Research Centre.

specific projects. Much of this research indicates support for renewable energy is conditional or qualified (Bell *et al* 2005; Wolsink 2007), with the decision to support or oppose a given project dependent on a wide range of factors. Perceptions of three main aspects of developments appear most important: the technology (Upham and Shackley 2006a; Ellis *et al* 2007; McLachlan 2009); the project development process (ie *how* a project is proposed, designed and executed) (Upham and Shackley 2006b; Gross 2007; Wolsink 2007); and the place for which it is proposed (van der Horst 2007; Haggett 2008; McLachlan 2009; Devine-Wright and Howes 2010). Perceptions of these three elements depend on individuals' values, beliefs and norms (arising from their personal experience and wider socio-cultural environment). Interactions between perceptions of all three factors determine attitudes to specific developments (Fig 8.1).

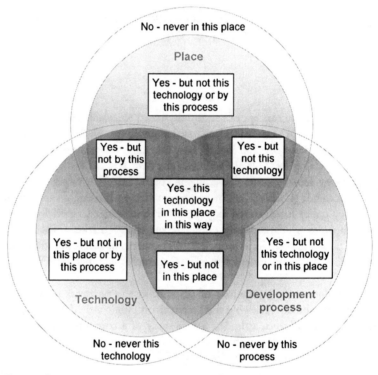

Fig 8.1. Possible responses to a proposed RE installation as a product of interactions between attitudes towards technology, place and development process.

The Influence of Place

Recent contributions to the literature have emphasised the central role of place in formation of attitudes (Vorkinn and Riese 2001; van der Horst 2007; Haggett 2008; Devine-Wright 2009; McLachlan 2009; Devine-Wright and Howes 2010). Van der Horst (2007) argues people will react differently to an RE development in a given place because places hold different 'use values' for various groups. Devine-Wright (2009) draws on sense of place and social representations

theory to develop a framework of place change providing a new context for understanding responses to RE developments. He argues that RE projects may be opposed if they change places, particularly landscapes, in ways that challenge symbolic interpretations of place and/or sense of identity derived from association with place.

Empirical research comparing attitudes to a proposed off-shore wind farm in two nearby towns appears to support this theory (Devine-Wright and Howes 2010). One town was perceived by its residents as an attractive tourist destination, while residents of the second described their town as more industrial and run-down. The wind farm was viewed more negatively in the former settlement, where higher levels of place attachment were associated with active opposition. Interestingly, qualitative data also suggested the wind farm might be viewed less negatively in the second town because it had a better fit with local sense of place; an industrial development in this community could signify appropriate regeneration rather than landscape desecration and damage to tourist revenue.

Similarly, McLachlan (2009) explains local responses to a wave energy development as the product of symbolic interpretations of place and technology. She shows how interpretations of the site – eg 'place as nature' versus 'place as resource' – interacted with those of the technology – eg as 'pioneering' or 'experimental' – to influence opinions. Interpretations of development process can also be shaped by perceptions of place; if a place is perceived as locally owned, RE development led by a commercial company for private profit can be interpreted as unfair exploitation of a local resource (Haggett 2008; Warren and Birnie 2009). Conversely, opposition may be tempered by perceived benefits resulting from projects such as an enhancement of the landscape or the bringing of local economic benefits such as employment (Graham *et al* 2009). Consultation or provision of other options for residents' involvement are potential ways to shape a project's development process to reflect local sense of place. Offering such participation opportunities and acting on feedback may enhance support for projects (Devine-Wright 2005; Gross 2007; Jones and Eiser 2010).

This brief overview illustrates two points: firstly, formation of attitudes towards RE implementation is highly context-specific; secondly, understanding individuals' relationships with places appears fundamental to understanding attitudes. This suggests a place-based approach to the deployment of new RE provision would be appropriate. Walker and Cass (2007) show that the 'hyper-sizeability' of RE technologies and the potential of decentralised[3] generation opens up a myriad of possibilities for implementation at different scales under different models of ownership and use. The weight of policy support for large-scale RE development noted earlier has meant that the full variety and potential of alternative 'socio-technical configurations' (Walker and Cass 2007) for RE implementation have not yet been widely exploited.

Given general public support for RE and the scope for different modes of development, it is possible to imagine that an appropriate 'socio-technical configuration' for RE generation could be identified in most localities. Findings from research with residents of valued landscapes support this, showing RE development can be acceptable if it fits the local context (Hanley and Nevin

3 Following Woodman and Baker (2008), decentralised energy is defined here as small- to medium-scale electricity or heat generation (<1kW up to tens of MW) which may be used close to the point of generation and/or exported via transmission networks. Although decentralised generation can use fossil fuels, only RE is considered here.

1999; Rogers *et al* 2008). A bottom-up, place-based approach could potentially deliver locally appropriate RE provision enhancing sense of place and attracting public support.

Community RE

One type of approach to localised RE planning is community RE development. Community RE is generally understood to signify development with a focus on local public interests and some element of active involvement by local stakeholders, generally including residents (Rogers *et al* 2008; Walker and Devine-Wright 2008). Previous work suggests it can lead to successful developments with public support, but this depends heavily on context (Walker *et al* 2010). In the following section we consider how relationships with place influence community RE development, drawing on qualitative research into the development of an established project.

Case Study Background

Village A is an isolated rural community in Cumbria, geographically defined by a valley and including isolated houses as well as the main village. No administrative designation exactly corresponds with this area but the parish covering the upper valley has a population of c.250. The RE project was initiated in 2004 by an existing resident-led community group (Group 1), formed in 2001 to support local livelihoods. The project aim was to install woodfuel boilers in the village and supply heat to local properties via a community-owned energy supply company (ESCO). A subset of Group 1 set up a limited company to deliver the project, run as a social enterprise by volunteer directors. Data presented here are from a series of 12 semi-structured individual or small group interviews with 20 people. Five interviewees were project directors (D1–D5), two of whom were interviewed twice. Others (R1–R15) were purposively sampled (through a snowball process) to represent a range of views and varied levels of interest/involvement in the project. Roles represented in the sample included parish councillor, parent (of children at village school and elsewhere), prospective district heating system customer, woodfuel user, forestry worker, local business owner and housing association tenant. Most occupied multiple roles. Analysis followed a grounded theory approach (Charmaz 2006).

The aims of the woodfuel project were to reduce not only carbon emissions but also local fuel costs (the valley does not have mains gas and woodfuel heating is cost-effective compared to alternatives), to make use of timber from neglected local forests, to regenerate these forests and to provide local employment. The under-managed forestry was a resource on which the directors could create 'a real, sustainable community business' (D1):

> We got very excited about this because here we were with a ... potential use of the local product, use of local skills, the money would go back into the community, there was the chance of diversification for farmers, because we could use them to distribute [wood]chip. (D1)

As a starting point the directors aimed to install three 'demonstration' woodfuel boilers. At the time of the research, two were installed (at the local school and youth hostel) and supplied with fuel by the ESCO. The third planned system was a micro district heating scheme. The project also led to plans for another district heating system by a charitable organisation owning property in the valley. Here we present analysis showing how conceptions of place motivated both the directors' leadership of the RE project and public support for it.

SHARED PLACE-BASED VALUES CAN MOTIVATE LOCAL RE DEVELOPMENT

The directors' motivation to develop this community RE project was based around a shared discourse of perceived need to secure the future of 'the community', which they viewed as threatened by a range of pressures associated with its small size and remote rural situation. Their primary concern was sustaining a social community – 'what makes a village ultimately sustainable is the people who live in it' (D3) – and their comments portrayed Village A currently as an idealised community:

> I really love living here and I appreciate what this village has got compared to some of the villages in the central lakes [Lake District National Park], where they are much more geared around visitor numbers and the tourism side and are havens for retired people who've come to live in the pretty countryside ... I don't want that to happen to our community. (D1)

The 'ideal' characterisation was based on local infrastructure (school, shops, post office, pubs etc), relative socio-demographic diversity, and sense of community. Although community development projects based on geographic communities have been extensively critiqued (Shucksmith 2000; DeFilippis *et al* 2006), it is clear that the directors experience and identify with Village A as a place-based community and the shared meanings they attach to it played an important role in mobilising them to lead the woodfuel project. It could be argued that their idealised conception, conforming to the standard 'rural idyll' social representation of rural communities (Halfacree 1995), is problematic, as it may hide and maintain local inequalities (Shucksmith 2000; Watkins and Jacoby 2007). However, despite rejection of idyllic rural communities as a flawed concept or 'myth', many authors acknowledge the idea continues to have considerable prevalence, power and desirability (Halfacree 1995; Panelli and Welch 2005; Watkins and Jacoby 2007). Interviews with other residents appeared to corroborate the directors' view of a close-knit community, suggesting that, even if idealised, this representation has wider symbolic appeal:

- All interviewees obtained most of their knowledge about the project through word of mouth and referred to social and economic ties with other residents.
- A third of interviewees were involved in local civic activity, eg parish council, regular events.
- Turnout at public meetings organised by Group 1 (two for this project and one for another project which was largely opposed) was high, with 30–50 per cent of households represented.

Panelli and Welch (2005) claim humans have a fundamental psychological need to identify with the concept of community, showing that valuing and identifying with a community ideal does not preclude subtle understanding of the concept and awareness of internal differences. DeFilippis *et al* (2006) also acknowledge criticisms of 'romanticised' communities while defending the view that 'shared experience in places' does provide a foundation for social cohesion. Finally 'shared *place-based* values' can be powerful motivators for community activity (Manzo and Perkins 2006, original emphasis); the directors' conceptualisation of Village A appears to be an example of this.

Desire to protect these shared place-based values motivated the directors to develop a community RE project. They felt the community's sustainability was highly fragile: D2 described it as 'in danger of dying' while D3 stated 'it's pretty clear that we're going to die out in thirty, forty [years' time], the school's going to go, unless you do something'. Interviewees traced a natural

progression from recognition of an initial threat (the 2001 foot and mouth disease outbreak) to growing awareness of wider, more complex, issues:

> The whole idea of [Group 1] now would not be facing the foot and mouth problem, but emerging out of the whole threat, economic, school, population, because the countryside is now under great pressure of sustainability. So [Group 1] now, instead of being based around foot and mouth is based around how do we keep the community … going and sustainable? (D3)

A consistent discourse of threat emerged (Fig 8.2). Economic 'pressure not to live out here' (D2) was felt to be changing community demographics and reducing local services' viability and social sustainability.

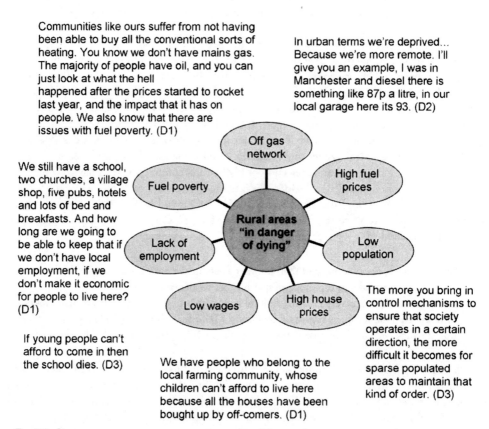

Communities like ours suffer from not having been able to buy all the conventional sorts of heating. You know we don't have mains gas. The majority of people have oil, and you can just look at what the hell happened after the prices started to rocket last year, and the impact that it has on people. We also know that there are issues with fuel poverty. (D1)

In urban terms we're deprived… Because we're more remote. I'll give you an example, I was in Manchester and diesel there is something like 87p a litre, in our local garage here its 93. (D2)

We still have a school, two churches, a village shop, five pubs, hotels and lots of bed and breakfasts. And how long are we going to be able to keep that if we don't have local employment, if we don't make it economic for people to live here? (D1)

If young people can't afford to come in then the school dies. (D3)

We have people who belong to the local farming community, whose children can't afford to live here because all the houses have been bought up by off-comers. (D1)

The more you bring in control mechanisms to ensure that society operates in a certain direction, the more difficult it becomes for sparse populated areas to maintain that kind of order. (D3)

Off gas network — High fuel prices — Fuel poverty — Low population — Lack of employment — Low wages — High house prices — **Rural areas "in danger of dying"**

FIG 8.2. PRESSURES ON RURAL COMMUNITIES SUCH AS VILLAGE A.

Disruption, actual or threatened, to sense of community and place identity can inspire voluntary civic action (Dalby and Mackenzie 1997; Cantrill and Senecah 2001; Manzo and Perkins 2006). Previous work has focused on physical, relatively sudden disruption, although Devine-Wright's (2009) analysis of protests against RE developments as 'place-protective action' shows

long-term threats can have similar effects (RE planning processes can be very drawn-out). In Village A, the threat is not only gradual but is to the community rather than landscape and broad-spectrum rather than specific. This may explain the directors' focus on threats to physical spaces where community is performed, such as the school (Halfacree 2007), because their potential loss makes the diffuse threat tangible.

The final element of threat catalysing the RE project was perceived lack of official support for rural areas. Despite policy supporting UK rural affairs (eg DEFRA 2007) and the existence of the Commission for Rural Communities to advocate rural issues, the directors felt the pressures facing Village A were exacerbated by the progressive withdrawal of state support, an analysis supported by Lowe and Ward (2007). For example:

> They stopped managing the forestry in probably the early 70s when the funds were cut off. I mean when I was a kid in the 60s there were still foresters living in forestry houses in and around this area, now there are none. (D2)

State neglect was thought due to higher costs of service provision in remote areas and interpreted as part of general policy objectives to deliver economies of scale. Lack of policy provision for rural circumstances was seen as strategic:

> The government really don't mind, in a cynical way, the depopulation, or the population of the countryside by the second home owners, because they have enough wealth to sustain themselves in terms of private healthcare, travel and all sorts. And it's much better for government to run urban areas, much more manageable, much more economic, than a rural area. (D3)

These quotations show that the directors' shared identity as members of this rural community includes a sense of isolation and marginalisation. This was also part of their wider identity as Cumbrians. As North West England's most rural county, Cumbria was felt to be overlooked by regional bodies:

> Cumbria has to look after itself ... Cumbria doesn't enter on their [NWDA's][4] horizons, they like Merseyside, they like Lancashire ... and what Cumbria's very bad at is shouting about Cumbria and if we don't do it they don't listen. (D1)

Although Regional Development Agencies are officially responsible for promoting socio-economic welfare in rural areas, their prescribed targets and focus on 'city-regions' give them a strong urban, large-scale focus, sidelining rural development and smaller projects (Lowe and Ward 2007). Overall, perceptions of official indifference produced a sense of responsibility for ensuring the community's viability:

> We have a right to live here and it's our responsibility to make sure that we can cope. You know we shouldn't depend on other people making it right to live here; we've got to help ourselves.
>
> (D1)

[4] North West Development Agency.

As five of the six directors live in the valley, their interest in its future was personal. Sustaining the community was also seen as a means of sustaining personal identity as a community member, again supporting Devine-Wright (2009):

> I felt I'd moved in to this community and I was getting a lot from the community, feeling quite enriched, and I just felt, it would be nice if I could give something back.... So I got involved in [Group 1] and for me it was that sense of identity, and a group of people who actually wanted to do something, just to help other people for no other reason than that really. (D4)

Although these threats and lack of support are general, affecting all rural areas, it is their implications for this specific place-based community which inspire responsibility. Motivation therefore stems from place attachment as well as sense of community because it is centred on this location: the terms 'the valley' and 'the community' were used interchangeably. This supports research suggesting local social interaction/cohesion and place attachment are mutually reinforced through participation in community activity (Lewicka 2005; Manzo and Perkins 2006), including community RE projects (Hoffman and High-Pippert 2008).

LOCAL RE DEVELOPMENT IS SUPPORTED WHEN IT RELATES TO RESIDENTS' SENSE OF PLACE

Interviews suggested the woodfuel project enjoys support from the local community because it largely coincides with their sense of place (Fig 8.3). This supports the research discussed above, concluding that local attitudes towards RE development are significantly shaped by the extent to which a development is seen as supporting or detrimental to the character and integrity of its proposed location and the place-based identities of local residents (Cass and Walker 2009; Devine-Wright 2009; Devine-Wright and Howes 2010). Similarly, Middlemiss and Parrish (2010) observe that low-carbon community projects are successful when framed in a way corresponding to the community's self-image, thus drawing on local 'cultural capacity'.

Three main discourses relating the project positively to sense of place emerged (Fig 8.3). Firstly, the project entails sympathetic management of the forestry resource, enhancing and making productive use of the landscape. Frustration was expressed about previous 'appalling' (R14) under-management of local forests. Interviewees believed the project would improve the landscape:

> Has it made a difference? Yes, because we walk the dogs, and we see where there's the wood piles, and they're moving and they're being used, rather than just rotting, so in fact, it is better ... also where that old timber has been blown and cleared, ready for the biomass being used, they've replanted so there's been regeneration, which is good. (R9)

Even in the context of general sustainability projects, the public may interpret 'the environment' as local environment, expecting benefits in terms of visibly improved green spaces (Cantrill and Senecah 2001; Collins 2004). This project's visible effects – in addition to more abstract environmental benefits in terms of climate change mitigation – were therefore useful in building support.

Secondly, residents approved of the wood being used locally, a view perhaps partly explained by feelings of symbolic ownership, suggested by references to 'our wood' (R8). McLachlan (2009) documented support for a wave energy development based on symbolic ownership of

"One of the things I was told which I have used for the grant applications [for woodfuel heating system for own property], is that by buying the pulp from here I am actually helping to enhance the beauty of the area, by helping to promote the management of woodland. But other renewables would have to blend in. We don't have anything round here that destroys the area and I wouldn't want to see that start. (R1)

Yeah I've seen the tractor and trailer going up, a big load of woodchip on the back of the trailer, so he must supply the wood. Which is good, I say, because the wood's coming out of the forests round here, being used, and then planted back up again. (R8)

It's a two-edged sword, it should save money eventually and be good for the planet [and] there's plenty of wood on hand. (R14)

Enhances physical place

Sense of place

Use of "own" resources for self-sufficiency

Strengthens social community

There's a couple of people who are now making a living out of it, it's their job to saw the wood down, log it, dry it, chip it, put it into logs and deliver it to your house. I mean I'm quite happy that it's a local industry. You know there's no point in travelling coal from blimmin' Poland or South Africa to here, when you've actually got a heat source right there. (R2)

We were sold on the idea from the outset. I think most people round here were. It sort of sells itself. Logically, it's a system people should support because it is supporting the community, it is a carbon neutral scheme, and it saves people money. (R9)

FIG 8.3. COMPATIBILITY OF WOODFUEL HEATING SCHEMES IN VILLAGE A WITH FACTORS AFFECTING RESIDENTS' SENSE OF PLACE.

the resource and the power generated from it, even though power will actually be fed into the grid. With locally sourced woodfuel, residents' ownership may be symbolic but their use is literal, suggesting support on these grounds is even more likely. Other research also found householders prefer community RE schemes involving local use of energy generated (IPSOS MORI 2009). Local use makes intuitive sense to residents and has connotations of community self-sufficiency (Fig 8.3). Another strand of this discourse is economic self-sufficiency, achieved by providing jobs which residents thought would 'go to someone local' (R8). Although the RE technology is new here, jobs associated with it complement local cultural heritage because they link to a traditional occupation, forestry.

Most interviewees also shared the directors' view that employment through the project would strengthen the social community. The choice of the school as a demonstration site was cited as a

way in which the project was supporting the community, as were fuel cost reductions for individuals through district heating. However, a minority felt the project could threaten local social cohesiveness because of unevenly distributed benefits, with individuals able to connect to district heating potentially enjoying disproportionate gains which could create 'bad feeling' (R4). One interviewee also questioned the community benefit of the school system because 'not everyone has children' (R1).

CONCLUSIONS

This case illustrates how RE can be planned and implemented in a way which complements local needs and sense of place as well as contributing to wider goals of carbon emission reductions. The project was successfully developed owing to the directors' shared vision for the future of a geographic community and because this vision had symbolic appeal for others. Identification with a place-based community can therefore inspire voluntary effort to install community RE as a form of place-protective action, because of the local benefits projects can bring, just as place-protective emotions can be manifested in opposition to RE development (Cass and Walker 2009; Devine-Wright 2009). This was demonstrated specifically in relation to the use of forest biomass for woodfuel heating, but may apply to other resources/technologies.

This supports research arguing that place-based development projects appear to be appropriate, relevant and appealing, particularly in remote rural areas (Weber 2003; Lawrence *et al* 2009; Steward *et al* 2009). Community RE projects may work as a means for people to 'rekindle a sense of geographic belonging' (Bailey *et al* 2010) and for communities 'to reassert their identities and economic connections with the land around them' (Lawrence *et al* 2009). The recent growth of public interest in grassroots sustainability initiatives focusing on local action and strengthening of place-based communities, such as Transition Towns (Bailey *et al* 2010), could therefore represent a strong foundation for further localised RE development, as community RE projects have an excellent fit with such groups' agendas.

BIBLIOGRAPHY AND REFERENCES

Bailey, I, Hopkins, R, and Wilson, G, 2010 Some things old, some things new: the spatial representations and politics of change of the peak oil relocalisation movement, *Geoforum* 41 (4), 595–605

Bell, D, Gray, T, and Haggett, C, 2005 The 'social gap' in wind farm siting decisions: Explanations and policy responses, *Environmental Politics* 14 (4), 460–77

Cantrill, J G, and Senecah, S L, 2001 Using the 'sense of self-in-place' construct in the context of environmental policy-making and landscape planning, *Environmental Science & Policy* 4 (4–5), 185–203

Cass, N, and Walker, G, 2009 Emotion and rationality: the characterisation and evaluation of opposition to renewable energy projects, *Emotion, Space and Society* 2 (1), 62–9

Charmaz, K, 2006 *Constructing grounded theory: a practical guide through qualitative analysis*, SAGE Publications Ltd, London

Collins, A J, 2004 Can we learn to live differently? Lessons from Going for Green: a case study of Merthyr Tydfil (South Wales), *International Journal of Consumer Studies* 28 (2), 202–11

Dalby, S, and Mackenzie, F, 1997 Reconceptualising local community: environment, identity and threat, *Area* 29 (2), 99–108

DeFilippis, J, Fisher, R, and Shragge, E, 2006 Neither romance nor regulation: re-evaluating community, *International Journal of Urban and Regional Research* 30 (3), 673–89

DEFRA, 2007 *Rural Development Programme for England 2007–2013* [online], available from: http://www.defra.gov.uk/rural/rdpe/progdoc.htm [16 February 2010]

Devine-Wright, P, 2005 Local aspects of UK renewable energy development: Exploring public beliefs and policy implications, *Local Environment* 10 (1), 57–69

— 2009 Rethinking NIMBYism: The role of place attachment and place identity in explaining place-protective action, *Journal of Community & Applied Social Psychology* 19 (6), 426–41

Devine-Wright, P, and Howes, Y, 2010 Disruption to place attachment and the protection of restorative environments: a wind energy case study, *Journal of Environmental Psychology* 30, 271–80

Ellis, G, Barry, J, and Robinson, C, 2007 Many ways to say 'no', different ways to say 'yes': applying Q-methodology to understand public acceptance of wind farm proposals, *Journal of Environmental Planning and Management* 50 (4), 517–51

Graham, J B, Stephenson, J R, and Smith, I J, 2009 Public perceptions of wind energy developments: case studies from New Zealand, *Energy Policy* 37 (9), 3348–57

Gross, C, 2007 Community perspectives of wind energy in Australia: the application of a justice and community fairness framework to increase social acceptance, *Energy Policy* 35 (5), 2727–36

Haggett, C, 2008 Over the sea and far away? A consideration of the planning, politics and public perception of offshore wind farms, *Journal of Environmental Policy and Planning* 10 (3), 289–306

Halfacree, K, 2007 Trial by space for a 'radical rural': introducing alternative localities, representations and lives, *Journal of Rural Studies* 23 (2), 125–41

Halfacree, K H, 1995 Talking about rurality: social representations of the rural as expressed by residents of six English parishes, *Journal of Rural Studies* 11 (1), 1–20

Hanley, N, and Nevin, C, 1999 Appraising renewable energy developments in remote communities: the case of the North Assynt Estate, Scotland, *Energy Policy* 27 (9), 527–47

HM Government, 2009 *The UK Renewable Energy Strategy* [online], available from: http://www.decc.gov.uk/en/content/cms/what_we_do/uk_supply/energy_mix/renewable/res/res.aspx [6 May 2010]

Hoffman, S, and High-Pippert, A, 2008 It takes money to buy whiskey: local energy systems and civic participation, paper presented at the *MPSA Annual National Conference*, 3 April, Hilton, Chicago

IPSOS MORI, 2009 *The Big Energy Shift: report from citizens' forums* [online], available from: http://www.big-briefs.com/big_energy_shift/Big_Energy_Shift_Final_Report_300609.pdf [14 June 2010]

Jones, C R, and Eiser, R J, 2010 Understanding 'local' opposition to wind development in the UK: how big is a backyard?, *Energy Policy* 38 (6), 3106–17

Lawrence, A, Anglezarke, B, Frost, B, Nolan, P, and Owen, R, 2009 What does community forestry mean in a devolved Great Britain? *International Forestry Review* 11 (2), 281–97

Lewicka, M, 2005 Ways to make people active: the role of place attachment, cultural capital, and neighborhood ties, *Journal of Environmental Psychology* 25 (4), 381–95

Lowe, P, and Ward, N, 2007 Sustainable rural economies: some lessons from the English experience, *Sustainable Development* 15 (5), 307–17

McLachlan, C, 2009 'You don't do a chemistry experiment in your best china': symbolic interpretations of place and technology in a wave energy case, *Energy Policy* 37 (12), 5342–50

Manzo, L C, and Perkins, D D, 2006 Finding common ground: the importance of place attachment to community participation and planning, *Journal of Planning Literature* 20 (4), 335–50

Middlemiss, L, and Parrish, B D, 2010 Building capacity for low-carbon communities: the role of grassroots initiatives, *Energy Policy* 38, 7559–66

Panelli, R, and Welch, R, 2005 Why community? Reading difference and singularity with community, *Environment and Planning A* 37 (9), 1589–1611

Rogers, J C, Simmons, E A, Convery, I, and Weatherall, A, 2008 Public perceptions of opportunities for community-based renewable energy projects, *Energy Policy* 36 (11), 4217–26

Shucksmith, M, 2000 Endogenous development, social capital and social inclusion: perspectives from LEADER in the UK, *Sociologia Ruralis* 40 (2), 208–18

Steward, F, Liff, S, Dunkelman, M, Cox, J, and Giorgi, S, 2009 *Mapping the Big Green Challenge: An analysis of 355 community proposals for low carbon innovation* [online], available from: http://www.swslim. org.uk/documents/themes/lt18-resource48.pdf [15 February 2010]

UKERC, 2009 *Energy 2050 Making the transition to a secure and low carbon energy system: synthesis report* [online], available from: http://www.ukerc.ac.uk/Downloads/PDF/U/UKERCEnergy2050/0906UKERC2050.pdf [17 March 2010]

Upham, P, and Shackley, S, 2006a Stakeholder opinion of a proposed 21.5 MWe biomass gasifier in Winkleigh, Devon: implications for bioenergy planning and policy, *Journal of Environmental Policy & Planning* 8 (1), 45–66

— 2006b The case of a proposed 21.5 MWe biomass gasifier in Winkleigh, Devon: implications for governance of renewable energy planning, *Energy Policy* 34 (15), 2161–72

van der Horst, D, 2007 NIMBY or not? Exploring the relevance of location and the politics of voiced opinions in renewable energy siting controversies, *Energy Policy* 35 (5), 2705–14

Vorkinn, M, and Riese, H, 2001 Environmental concern in a local context: the significance of place attachment, *Environment and Behaviour* 33 (2), 249–63

Walker, G, and Cass, N, 2007 Carbon reduction, 'the public', and renewable energy: engaging with socio-technical configurations, *Area* 39 (4), 458–69

Walker, G, and Devine-Wright, P, 2008 Community Renewable Energy: what should it mean?, *Energy Policy* 36 (2), 497–500

Walker, G, Hunter, S, Devine-Wright, P, Evans, B, and Fay, H, 2007 Harnessing community energies: explaining and evaluating community-based localism in renewable energy policy in the UK, *Global Environmental Politics* 7 (2), 64–82

Walker, G, Devine-Wright, P, Hunter, S, High, H, and Evans, B, 2010 Trust and community: exploring the meanings, contexts and dynamics of community renewable energy, *Energy Policy* 38 (6), 2655–63

Warren, C R, and Birnie, R V, 2009 Re-powering Scotland: wind farms and the 'energy or environment?' debate, *Scottish Geographical Journal* 125 (2), 97–126

Watkins, F, and Jacoby, A, 2007 Is the rural idyll bad for your health? Stigma and exclusion in the English countryside, *Health & Place* 13 (4), 851–64

Weber, E P, 2003 *Bringing society back in: grassroots ecosystem management accountability, and sustainable communities*, MIT, USA

Wolsink, M, 2007 Wind power implementation: the nature of public attitudes: Equity and fairness instead of 'backyard motives', *Renewable and Sustainable Energy Reviews* 11 (6), 1188–207

Woodman, B, and Baker, P, 2008 Regulatory frameworks for decentralised energy, *Energy Policy* 36 (12), 4527–31

Woods, M, 2005 *Contesting Rurality: Politics in the British Countryside*, Ashgate Publications Ltd, Aldershot

Health, People and Forests

Amanda Bingley

Introduction

Forests are healthy places to visit, live near, learn and work in. This is the message that has emerged with remarkable strength over the past three decades since the now classic studies by environmental psychologists Ulrich (1984), Kaplan and Kaplan (1989) and Hartig *et al* (1991), who demonstrated the restorative value of spending time in 'natural' places, including forest and woodland. Walking or cycling in the forests and taking part in organised woodland recreation and play are found to have tangible benefits for mental and physical health and well-being (O'Brien 2005; Tabbush and O'Brien 2002). Forest environments support nutrition, shelter, medicinal needs and economic livelihoods, and researchers exploring health and place in forest environments report strong links between forests and health in diverse populations around the world (Colfer 2008; Colfer *et al* 2006; Nielsen and Nilsson 2007; Morita *et al* 2007; Perlis 2006; Townsend 2006; WWF 2010). Health benefits include physical and psychological reduction in stress and mental fatigue, with improvements in social and cultural interactions.

An extensive literature now demonstrates the therapeutic potential of spending recreational and play time in forest and woodland, prompting initiatives in health and education in many countries that encourage forest activities and access. For example, the 'Forest Schools' movement that began in Scandinavia is now rapidly developing in the UK (O'Brien 2008a), while the 2004–2008 European Union initiative, COST Action 39, drew researchers from 23 countries in the EU and from Russia with the aim of contributing to knowledge about the relationship between forests and human health and well-being. The Action successfully sought to demonstrate how benefits might be incorporated into health and social policy and develop further research (Gallis 2005). Similar initiatives are reported in the US, Australia, Japan and South East Asia. In tandem with these findings, however, lies a backdrop of the late 20th-century revolution in technology and globalisation that has led to profound changes in our relationship with natural, outdoor spaces.

Globally, in increasingly urbanised environments, there are large populations who have little regular contact with natural, wild space, including woodland and forests in rural or urban areas. As work in agricultural and forest environments has become more mechanised, fewer people are routinely employed in these occupations (Oaks and Mills 2010). Over the last 20 years, in particular, this trend has been compounded in many Western countries by the widespread and exponential rise in the use of electronic media for entertainment, study and work, resulting in adults and children spending a large percentage of their time indoors (Jago *et al* 2010; Marshall *et al* 2006). Concurrent to this trend, there is greater anxiety about giving children freedom to play outdoors owing to the perceived dangers of increased traffic and a heightened fear of 'stranger danger' (Valentine and McKendrick 1997; Valentine 1997). Despite the apparent health benefits

of forest environments, there can be a general fear of being 'outside in nature' which extends to forests and woodland where women especially report anxiety about walking alone in forests, whether urban or rural (Burgess 1998; 1996). These fears are exaggerated in those who from childhood have little experience of forests or woodland as places to play and explore (Milligan and Bingley 2007; Ward Thompson *et al* 2004; Bell *et al* 2003). So extreme is the resulting lack of contact with the natural world that Louv (2005) suggests children in the Western world are in danger of suffering from what he describes as 'nature-deficit disorder'. Thus, although as noted above there is a clear endorsement of the health benefits gained from access to forest environments, the changing human relationship to the natural world presents a considerable barrier to developing and sustaining successful forest projects.

In this chapter I explore perceptions of health in relation to forests and woodland by first defining the characteristics of a forest environment and then looking at two key theories in health and social research that specifically relate to these settings. The first and overarching concept is 'attention restoration theory', which contends that natural or urban 'green spaces', including forests and woodlands, are inherently 'restorative', with health and educational benefits for individuals and the wider community. I note how a fear of nature and forests in particular, together with a degradation or misuse of forest environments, is seen to have negative impacts on social behaviour and health. Reviewing relevant research literature in the field, including some that has emerged from the European Union COST Action 39 'Forests, trees and human health and well being', I describe recreational and working experiences of forests and woodlands and initiatives, such as Forest Schools and 'NeighbourWoods', which are being developed to improve urban and rural forest access and activities for children and adults.

THERAPEUTIC FOREST AND WOODLAND LANDSCAPES: DEFINING AND REFINING CONCEPTS

The terms forest and woodland are used interchangeably in many texts to refer to any place with trees as the dominant vegetation. Rackham (1989, 1–2) notes that the accepted modern meaning of forest in Britain is 'a place of planted trees'. In Britain, much of Europe and many other countries around the world, the terms forest and forestry typically refer to wooded regions with specific commercial value, often plantations of mixed or single species. The origins of these areas, however, are not uncommonly ancient woodland (in Europe) or tropical rainforests (in South East Asia, Africa and South America). The term 'forest' is also widely used to refer to extensive non-commercial 'wild' areas or partly managed wooded areas which are maintained and used to harvest naturally occurring resources of fuel, food produce and medicinal herbs. In Britain and Northern Europe the term 'woodland' is also used, in tandem with or instead of forest, to describe areas with naturally occurring trees. These areas usually have a history of traditional commercial management such as 'coppicing' that makes use of the natural cycles of tree regrowth to harvest a variety of woodland products, although currently many woodlands in Britain are neglected coppice with potential for use in new areas of commercial and community work in the woods (Oaks and Mills 2010).

Since forest and woodland resources have been shown to include health and social benefits, social forestry has become an important aspect of maintaining and renewing these landscapes, with organisations such as the UK Forestry Commission promoting recreational and educational activities in forest spaces to improve mental and physical health and well-being (O'Brien 2008b; 2006). The idea that forests and woodland are intrinsically healthy places has caught the imagi-

nation of researchers, public health policymakers and educationalists at the forefront of social forestry, education and long-term healthcare in many countries around the world. The apparent fervour for promoting the therapeutic benefits of forests and woodland is supported by some key concepts developed from an extensive body of research in environmental psychology, geography, social forestry and, latterly, anthropology: that certain landscapes including 'green spaces' and forests can be therapeutic (Williams 1999; 2007). Forests are seen as a 'natural health service' (O'Brien 2005), natural or urban 'green space' landscapes are found to be inherently restorative, reducing stress (Kaplan and Kaplan 1989; Hansmann *et al* 2007), and forest or woodland-based activities are reported to enhance educational abilities (Knight 2009).

The idea of a landscape or place having restorative and therapeutic qualities is not new, as Gesler (1993) illustrates in his work on therapeutic landscapes (described below). Kaplan and Kaplan (1989) set out to understand the underlying principles about why people preferred and appeared to benefit from 'green spaces'. They developed the concept of 'Attention Restoration Theory' (ART) to describe the inherent restorative qualities of looking at or being in certain natural and urban landscapes. Their work complements that of Ulrich (1984), who introduced a similar concept of green space influencing recovery from physical and mental stress termed 'Stress Reduction Theory' (SRT) (Hansmann *et al* 2007), and evolutionary psychology that posits we have evolved to prefer natural landscapes where we are most likely to thrive (Orians 1986; Kuo 2001). These ideas have been developed by others in environmental psychology (see Hartig 2007; Hartig *et al* 1991; Cimprich 1993).

ART proposes that for a space to be restorative, four elements must be active: 'being away' from one's usual or current environment, enjoying a change of space; 'fascination' with the landscape being viewed or visited, as diverse natural spaces are more likely to hold one's attention and reduce mental fatigue than a similar time spent in a uniform built space; sufficient 'extent' and variation in the landscape to sustain interest and attention; and a sense of 'compatibility' or ease with the landscape (see also Kaplan 1995). These core elements are regarded as inherently therapeutic and, depending on the activity or individual circumstance, in an educational context the presence of these core elements are shown to bring about enhanced learning. Supporting the premise of ART, there is found to be a strong link with positive preference for 'green spaces', much of which specifically includes wooded or forest views in studies where, for example, participants score a range of photographs with views of rural and urban green or built space. Forests and woodland landscapes are found to strongly match the four restorative elements of ART (Kaplan 1995; Van den Berg *et al* 2010). Woodland is an ever-changing scene of flora and fauna, with extraordinary seasonal and daily variations in light and colour, together with a myriad of other sensory stimuli: sounds, smells and touch (Bingley 2003). In contrast, the built environment tends towards uniformity and lacks variation; as Kaplan (2004) suggests, this blunts our attention, resulting in mental fatigue and a tendency to aggressive behaviour and depression. Kaplan specifically discusses the benefits of urban forest green space as a rich source of the key elements of ART, with improvements in mental well-being enhancing sociability. This effect, as Kuo (2001) found, improves behaviour and interactions in the community.

In the early 1990s Gesler introduced the concept of certain landscapes having therapeutic qualities, such as those traditionally used as sites for restorative healing purposes, including Epidauros in Greece (Gesler 1993). Gesler's ideas, developed from a cultural geography perspective of the human propensity to attribute psychological, physical and social meaning to space and place, complement and develop work by the Kaplans and others on the restorative qualities

of being in landscape. Gesler suggested that a therapeutic landscape might include a view that is experienced as simply restful or even actively beneficial; this is similar to the benefits of having a view of green spaces demonstrated by Ulrich (1984) in his now classic study of recovering surgical patients. Ulrich found patients with a view of trees from their hospital window recovered from surgery significantly quicker and with less need for painkilling medication than those limited to a view of a brick wall. These effects have since been replicated by Cimprich (1993) in her work with cancer patients. Gesler, however, suggests there is also a spiritual dimension invoked in some land-scapes that people equate with a therapeutic quality rich with elements associated with healing: forests, individual special trees, water (rivers and lakes) and mountains. Each of these elements can invoke powerful emotions of awe or reverence, tranquillity and peace, and the symbolism of these elements have potential to affect individuals and communities psychologically, physically and socially. The concept of therapeutic landscapes has now evolved to encompass a range of spaces and places (Williams 2007), including healthcare environments (Gesler and Curtis 2007), older people's allotment gardening (Milligan *et al* 2004), 'cyberspace' (Davidson and Parr 2007) and fictional landscapes (Baer and Gesler 2004) – even the effects of absence or fragility of a therapeutic landscape in the Soviet gulag (DeVerteuil and Andrews 2007). Indeed, as Williams (2007, 2) concurs, 'healing places are not limited to places celebrated for their reputed healing qualities. Rather healing can take place in everyday, ordinary places.' In other words, it is not necessarily the place itself that is inherently healing but the intention of those using that space in a way that enhances some therapeutic effect. However, as Gesler suggested, some landscapes naturally hold our attention and acquire a reputation for being places that enhance healing, rest, enjoyment and well-being. As this chapter observes, forests and woodlands are found to be one of those places that have acquired just such a reputation for being therapeutic.

Strengthening the theoretical basis for linking forests and health was one outcome of the European Union COST Action 39, an initiative that aimed 'to increase the knowledge about the contribution that forests, trees and natural places make, and might make, to the health and well-being of people in Europe' (COST 2008, 2). Interim and final reports cited research funded by COST 39 (Gallis 2005; COST 2008) that not only demonstrated clear evidence of the benefits of forest environments on human health but in many instances drew on and confirmed the value of applying theories such as ART, SRT and similar concepts of forest as therapeutic to their work (O'Brien 2008a; Hansmann *et al* 2007; Hartig 2007). Government policymakers in healthcare are increasingly aware of these positive effects of forests on health, the interactive relationship between human activities and healthy forests, and the enhancement of mental and physical health (COST 2008). In the next section I look at some of the ways this knowledge has been applied to encouraging initiatives that bring people of all ages into contact with forests and woodland for recreation and education.

Recreation and Learning in the Forests: Restorative Space

Learning in a landscape, such as a forest or woodland, that is diverse, fascinating and reduces stress has tangible restorative qualities that enhance attention and receptiveness. These precepts have been powerfully demonstrated by the 'Forest Schools' movement in the UK, which began at Bridgwater College, Somerset, in the mid-1990s, when members of the early learning depart-ment, inspired during an educational visit to Denmark, saw young children in nursery schools entirely based in and around forested areas. Following a Scandinavian model developed in

the 1950s, these schools allow children from a very young age to enjoy supervised 'free play' in outdoor woodland-based activities. Impressed by the high level of confidence and mental, physical and social development seen in the children, Bridgwater College set up a trial 'Forest School'. Their success encouraged the development of Forest Schools around the UK, a movement that now lies within the remit of the Forest Education Initiative (FEI), set up in 1992 as 'a partnership between the Forestry Commission, Woodland Trust, Tree Council, British Trust for Conservation Volunteers, Groundwork, ConFor, Timber Trade Federation, Community Forests, and the Field Studies Council' to promote woodland education and knowledge (see Murray and O'Brien 2005, 10). FEI, along with other independent Forest School ventures and more recently the Forest School Network set up by the Forestry Commission, trains and supports Forest School coordinators to deliver training and advice in setting up a wide range of recreational and educational woodland activities for children and young people across the UK. Forest School is one of these ventures that has proved to be a highly effective and beneficial learning environment at an individual and social level in a range of urban and rural settings (Murray and O'Brien 2005; Knight 2009).

Forest School typically works with a basic format: small groups of children or young people, accompanied by teachers and/or Forest School practitioners, visit a designated woodland area usually within walking distance or a short drive of their school or community. The woodland may be publicly or privately owned, with the school or community project negotiating use of an area specifically set up with a site for the activities. The children and young people go out rain or shine, learning how to be suitably clothed for all weathers (except in very high winds with a risk of falling trees) (Knight 2009). They are introduced to outdoor play and recreation in the woods and encouraged to lead their own activities as a group, making wooden items, cooking on a camp fire, and if suitable, depending on their age, also being allowed to climb trees and build dens. Murray and O'Brien (2005, 6), evaluating Forest School in England, note that children benefit socially, developing confidence, language skills and communication. They gain physical confidence, dexterity and spatial ability, moving around the wood in play that involves total sensory engagement with different natural woodland materials. This is seen to improve their motivation, concentration and behaviour. These benefits are found equally to help disadvantaged and less able children and those with behavioural difficulties. They acquire new knowledge about woodland wildlife and the lifecycles of trees and other forest flora and fauna. These skills are shared by children and adults alike and often result in the adults gaining knowledge and, as Murray and O'Brien suggest, a 'new perspective' on woodland areas. All this goes beyond actual Forest School sessions, as the children and adults share their experiences with those outside school, encouraging visits to woodland areas for recreation at weekends and holidays. The beneficial effects of these focused woodland experiences resonate with the principles of ART and SRT. The children and adults are 'away' from their usual living and school spaces, they are taken to forested areas rich in 'fascination', 'extent' and 'diversity', where children gain a sense of 'compatibility' with natural woodland. In this way children and adults are more likely to get to know a woodland and start to feel confident to visit woodlands in the future, with consequent lifelong health benefits.

The health-enhancing benefits of forest environments are, however, tempered by the fears surrounding forest and woodland areas that can discourage people from using these places for recreation (Bell *et al* 2003). Much of human history over millennia is inextricably linked to forests via our dependence on forests for shelter and the diverse resources of forest flora and fauna. A rich cultural history has evolved associated with this close relationship between forests,

woods and trees in general. Within this complex relationship, as Jones and Cloke (2002) argue, it is acknowledged that trees also have biological agency which is to some extent independent of human activity, albeit modified by human management of trees and forests over the ages. But the sense of trees and woodlands, writ large, as having independent agency is a powerful source for the imagination for good or ill (Schama 1995). On the one hand, forest and woodland spaces are thought of as tranquil, idyllic and beneficent, having, and still holding, a special and benign significance in many rituals and spiritual practices, from invoking health and healing to the honouring and burial of the dead. On the other hand, forests and their trees are described as fearful spaces on the fringes of local, rural or urban communities. At the extreme end of the spectrum, young women taking part in research in the North of England report being affected by the modern media discourse of the forest as a place of malign non-human forces, articulated in films such as *The Blair Witch Project*, or a place where violent crimes are committed and murder victims buried (Milligan and Bingley 2007). Burgess (1998) likewise reported in research on urban woodland access in London and Nottingham that women, in particular those from ethnic minorities, felt unsafe walking in urban forests and woodland, noting that these are places where they feel at risk from male violence and teenage abuse. Less extreme but still very real obstacles to enjoyment in visiting woodland areas is the fact woods are rendered unsafe and visually unpleasant by vandalism or misuse, resulting in a stressful scene of burnt-out cars, litter and damage to trees. Ward Thompson (2004) and Bell *et al* (2003) echoed these findings in their research on people's access and engagement with local woodlands in Scotland. They recommend that this problem is addressed by encouraging local woodland managers to seek ways to meet the needs and activities of different age groups. This approach distinguishes between actively criminal behaviour and legitimate woodland activities, allowing managers to negotiate woodland use between young children's play space, personal or family walks and older teenagers using the woods to escape adult, societal constraint, exercise some independence and claim their own space. However, Ward Thompson and Bell *et al* also found that adults who recalled the freedom to play outdoors and in woodlands as children were more likely to enjoy, feel confident about and actively visit woodland as adults. This conclusion was similar to Bingley and Milligan's (2004) findings with young people in relation to urban or rural woodland. The less access children have to woodland, the less familiar with, and more fearful they are, of this environment. Bell *et al* offer a bleak picture of the current trend of children having little or no encouragement towards outdoor recreation in forest and woodland or other green space:

> We may be facing a future where the next generation of adults have even less interest in, or positive desire to use, woodlands and other green open space than at present. This has serious implications for the physical and mental health of future citizens and for social equity.
>
> (Bell *et al* 2003, 98)

Such a forecast may be, to some extent, mitigated by initiatives such as the Forest Schools movement that actively promote children's introduction to woodland play from an early age. Social forestry research reports on other similar ideas, such as the European 'NeighbourWoods' Project (Simson 2004), which looked at ways that urban and rural communities could be involved in accessing local woods, designing new woodland, taking part in learning how to manage and maintain the woodland and developing employment opportunities.

CONCLUSION

In this chapter I have reviewed a number of different aspects of the relationship between forest and health, outlining two key theoretical perspectives, Attention Restoration Theory (ART) and 'therapeutic landscapes', that inform our understanding of the psychological and socio-cultural processes by which forests and woodland contribute to health and well-being. I have argued that there is abundant evidence to demonstrate that forests are therapeutic landscapes with a powerful restorative effect that can be enjoyed by people of all ages, with the potential to reduce physiological and psychological stress, enhance learning and increase social confidence and physical skills. The past 10–20 years have seen social and educational forestry initiatives in the UK, Europe and other parts of the world develop a range of new ventures that aim to harness these health benefits and improve access to local woodland areas. Forest Schools in the UK, supported by FEI and the Forest Schools Network, modelled on the Scandinavian approach to forest play space for children from an early age upwards, is one example of successful development of woodland recreation and education involving children, young people and adults of all ages. Evaluations show improvements in children's behaviour and educational ability, as well as encouraging them and their families to visit woodland for recreation, thus potentially benefiting their overall health and well-being.

There are also obstacles to people enjoying the benefits of forest environments. One problem is a fear of forests. Women, in particular, report feeling at risk in urban woodland from male anti-social, abusive or criminal behaviour. Another issue is vandalism in and misuse of forests and woodland, resulting in, for example, unsightly damage to trees and vegetation and the dumping of burnt-out cars and litter. Overcoming these adverse elements is considered to be essential in order to encourage people to enjoy the health benefits of forest activities. Suggestions include a combination of education and recreation from an early age and good woodland management that involves all age groups in local communities. Other initiatives, such as the NeighbourWoods Projects, help organise community groups to be actively involved in designing and managing local and easily accessible woodland and this encourages the increase of woodland acreage, especially in disadvantaged urban areas, improving woodland access and employment in urban and rural woodlands.

BIBLIOGRAPHY AND REFERENCES

Baer, L D, and Gesler, W M, 2004 Reconsidering the Concept of Therapeutic Landscapes in J D Salinger's 'The Catcher in the Rye', *Area* 36, 404–13

Bell, S, Ward Thompson, C, and Travlou, P, 2003 Contested views of freedom and control: children, teenagers and urban fringe woodlands in Central Scotland, *Urban Forestry & Urban Greening* 2, 87–100

Bingley, A F, 2003 In here and out there: sensations between self and landscape, *Social and Cultural Geography* 4, 329–45

Bingley, A F, and Milligan, C, 2004 *Climbing Trees and Building Dens: mental health and well-being in young adults and the long-term effects of childhood play experience*, End of Project Report, Institute for Health Research, Lancaster University

Burgess, J, 1996 Focusing on fear: the use of focus groups in a project for the Community Forest Unit, Countryside Commission, *Area* 28, 130–35

— 1998 'But is it worth taking the risk?' How women negotiate access to urban woodland: a case study, in *New Boundaries of Space, Bodies and Gender* (ed R Ainley), Routledge, London and New York, 115–28

Cimprich, B, 1993 Development of an intervention to restore attention in cancer patients, *Cancer Nursing* 16, 83–92

Colfer, C J P (ed), 2008 *Human health and forests: a global overview of issues, practice and policy*, Earthscan, London, UK

Colfer, C J P, Sheil, D, and Kishi, M, 2006 *Forests and human health: assessing the evidence*, Bogor, Indonesia: Center for International Forestry Research (CIFOR), CIFOR Occasional Paper No 45

COST ACTION E39, 2008 *Forest, Trees and Human Health and Well Being, Final Report* [online], available from: http://w3.cost.esf.org/index.php?id=143&action_number=e39 [15 April 2010]

Davidson, J, and Parr, H, 2007 Anxious subjectivities and spaces of care: therapeutic geographies of the UK National Phobics Society, in *Therapeutic Landscapes* (ed A Williams), Ashgate, Aldershot, 95–110

DeVerteuil, G, and Andrews, G J, 2007 Surviving profoundly unhealthy places: the ambivalent, fragile and absent therapeutic landscapes of the Soviet gulag, in *Therapeutic Landscapes* (ed A Williams), Ashgate, Aldershot, 273–87

Gallis, C, 2005 *First European COST E39 Working Group 2 Workshop – Forest Products, Forest Environment and Human Health: Tradition, Reality, and Perspectives*, University Studio Press, Thessaloniki

Gesler, W M, 1993 Therapeutic landscapes: theory and a case study of Epidauros, Greece, *Environment and Planning D: Society and Space* 11, 171–89

Gesler, W M, and Curtis, S, 2007 Application of concepts of therapeutic landscapes to the design of hospitals in the UK: the example of a mental health facility in London, in *Therapeutic Landscapes* (ed A Williams), Ashgate, Aldershot, 149–63

Hansmann, R, Hug, S-M, and Seeland, K, 2007 Restoration and stress relief through physical activities in forests and parks, *Urban Forestry & Urban Greening* 6, 213–25

Hartig, T, 2007 Three steps to understanding restorative environments as health resources, in *Open Space: People Space* (eds C Ward Thompson and P Travlou), Taylor & Francis, London, 163–79

Hartig, T, Mang, M, and Evans, G W, 1991 Restorative effects of natural environment experience, *Environment and Behaviour* 23, 3–26

Jago, R, Fox, K R, Page, A S, Brockman, R, and Thompson, J L, 2010 Parent and child physical activity and sedentary time: do active parents foster active children?, *BMC Public Health* 10, 194

Jones, O, and Cloke, P, 2002 *Tree Cultures: The Place of Trees and Trees in their Place*, Berg, Oxford and New York

Kaplan, S, 1995 The restorative benefits of nature – toward an integrative framework, *Journal of Environmental Psychology* 15, 169–82

— 2004 Some hidden benefits of the urban forest, in *Forestry Serving Urbanised Societies* (selected papers from conference jointly organised by IUFRO, EFI and the Danish Centre for Forest, Landscape and Planning, 27–30 August 2002, Copenhagen) (eds C C Konijnendijk, J Schipperijn and K H Hoyer), IUFRO (IUFRO World Series Vol 14), Vienna, 221–32

Kaplan, R, and Kaplan, S, 1989 *The Experience of Nature: a psychological perspective*, Cambridge University Press, Cambridge

Knight, S, 2009 *Forest Schools and Outdoor Learning in the Early Years*, Sage, London

Kuo, F E, 2001 Coping with poverty: impacts of environment and attention in the inner city, *Environment and Behavior* 33, 5–34

Louv, R, 2005 *Last Child in the Woods: saving our children from nature deficit disorder*, Algonquin Books, Chapel Hill, NC

Marshall, S J, Gorely, T, and Biddle, S J, 2006 A descriptive epidemiology of screen-based media use in youth: a review and critique, *Journal of Adolescence* 29, 333–49

Milligan, C, and Bingley, A F, 2007 Restorative places or scary spaces? The impact of woodland on mental health of young people, *Health & Place* 13, 799–811

Milligan, C, Gatrell, A C, and Bingley, A F, 2004 'Cultivating health': therapeutic landscapes and older people in Northern England, *Social Science & Medicine* 58, 1781–93

Morita, E, Fukuda, S, Nagano, J, Hamajima, N, Yamamoto, H, Iwai, Y, Nakashima, T, Ohira, H, and Shirakawa, T, 2007 Psychological effects of forest environments on healthy adults: shinrin-yoku (forest-air bathing, walking) as a possible method of stress reduction, *Public Health* 121, 54–63

Murray, R, and O'Brien, L, 2005 'Such enthusiasm – a joy to see'. An evaluation of Forest School in England, *Forest Research* [online], available from: http://www.forestresearch.gov.uk/pdf/ForestSchoolEng-landReport.pdf/$FILE/ForestSchoolEnglandReport.pdf [15 April 2010]

Nielsen, A B, and Nilsson, K, 2007 Urban forestry for human health and wellbeing: editorial, *Urban Forestry & Urban Greening* 6, 195–7

Oaks, R, and Mills, E, 2010 *Coppicing and Coppice Crafts: a comprehensive guide*, Crowood Press, Ramsbury

O'Brien, E, 2005 *Trees and Woodlands: nature's health service*, Forest Research, Farnham

O'Brien, L, 2006 'Strengthening heart and mind': using woodlands to improve mental and physical well-being, *Unasylva 224 FAO* 57 [online], available from: ftp://ftp.fao.org/docrep/fao/009/a0789e/a0789e14.pdf [1 June 2010]

— 2008a Forest School and outdoor education in Britain, *Dansk Friluftslive* 74, 8–12

— 2008b An increasing focus on health and well-being and the contribution of trees and woodlands to this agenda, *A World of Trees* 16, 34–5

Orians, G H, 1986 An ecological and evolutionary approach to landscape aesthetics, in *Landscape meanings and values* (eds E Penning-Rowsell and D Lowenthal), Allen and Unwin, London, 3–25

Perlis, A, 2006 Editorial: forests and human health, *Unasylva 224 FAO* 57 [online], available from: ftp://ftp.fao.org/docrep/fao/009/a0789e/a0789e01.pdf [1 June 2010]

Rackham, O, 1989 *The Last Forest: the story of Hatfield Forest*, Phoenix, London

Schama, S, 1995 *Landscape and Memory*, Fontana/Harper Collins, London

Simson, A, 2004 NeighbourWoods – the benefits of a design-led approach to encouraging and facilitating public access to peri-urban woodlands, in *Openspace Peoplespace: an international conference on inclusive environments* [online], available from: http://www.openspace.eca.ac.uk/conference/proceedings/PDF/Simson.pdf [15 June 2010]

Tabbush, P, and O'Brien, L, 2002 *Health and well-being: trees, woodlands and natural spaces: outcomes from expert consultations held in England, Scotland and Wales*, Forestry Commission, Wetherby

Townsend, M, 2006 Feel blue? Touch green! Participation in forest/woodland management as a treatment for depression, *Urban Forestry & Urban Greening* 5, 111–20

Ulrich, R S, 1984 View through a window may influence recovery from surgery, *Science* 224, 420–21

Valentine, G, 1997 A safe place to grow up? Parenting, perceptions of children's safety and the rural idyll, *Journal of Rural Studies* 13, 137–48

Valentine, G, and McKendrick, J, 1997 Children's outdoor play: exploring contemporary parental concerns about children's safety and the changing nature of childhood, *Geoforum* 28, 1–17

Van den Berg, A E, Maas, J, Verheij, R A, and Groenewegen, P P, 2010 Green space as a buffer between stressful life events and health, *Social Science & Medicine* 70, 1203–10

Ward Thompson, C, 2004 Playful natures?, in *Openspace Peoplespace: an international conference on inclusive environments* [online], available from: http://www.openspace.eca.ac.uk/conference/proceedings/PDF/Ward. pdf [15 June 2010]

Ward Thompson, C, Aspinall, P, Bell, S, Findlay, C, Wherrett, J, and Travlou, P, 2004 *Open Space and Social Inclusion: Local Woodland Use in Central Scotland*, Forestry Commission, Edinburgh

Williams, A, 1999 Introduction, in *Therapeutic Landscapes: The dynamic between place and wellness* (ed A Williams), University Press of America, Lanham, MD, 1–11

— 2007 The continuing maturation of the therapeutic landscape concept, in *Therapeutic Landscapes* (ed A Williams), Ashgate, Aldershot, 1–12

WWF, 2010 *Human health linked directly to Forest Health* [online], available from: http://wwf.panda.org/ wwf_news/?uNewsID=191323 [19 March 2010]

Urban Sense of Place

Achieving Memorable Places …
'Urban Sense of Place' for Successful
Urban Planning and Renewal?

Michael Clark

Introduction

This chapter seeks a critical appreciation of the idea of 'sense of place' with particular reference to plans, management and other forms of intervention that seek to create or enhance places in ways that meet development and other goals. It is difficult to discover why some schemes and places perform well while others fail. Successful places may just be carriers for, or associated with, people who are successful in other ways, and whose purchasing power and status out-compete those of other people. But there are examples of 'elite' places that fail and, perhaps more rarely, of good-quality residential and social environments used by the general public.

How do places succeed or fail?

Does how a place works and is perceived relate directly to it being a product, something provided by firms and agencies and delivered and maintained by the specialist employees of these organisations, or is it in some way 'owned' by its users, who take responsibility for some of its upkeep and delivery? There is a tension between our roles as passive consumers of products and as active producers of individually and communally held assets. Most of what we do occupies a confusingly shared space between market and state provision, partly based on purchasing power and consumer status, entitlement and knowledge, and partly through direct action that maintains and enhances individual and collective ownership. This relates to place where a product is specific to a particular location.

> A good quality public realm helps to attract private investment. People are unlikely to invest in an area that looks unwelcoming or inaccessible … (Falk n.d., 21)

Problematic locations, such as Kirkby New Town in the late 1970s (Clark 1982) and, until recently, parts of most UK inner city former council estates, have been characterised by 'voids' – unoccupied and often vandalised properties where effective demand was less than supply – and associated with failure to maintain the surrounding areas and with fear that these locations were dangerous and crime-ridden. The media are unlikely to dispel such beliefs and may favour dramatic 'solutions', often with little reference to, or respect for, current residents; part of the problem, not people with rights or the best hope for successful recovery. 'Solutions' can include

restoring a market in property by physical restoration and linking it to new commercial opportunities, which requires attitudes to the location to become favourable. This is well illustrated by investment in and promotion of 'New Islington' in East Manchester, and by countless other partnerships between public sector local authority and redevelopment bodies and private sector developers. The recent crisis affecting the 'buy to let' market in the UK stalled many such initiatives and may create opportunities for alternative, more community-based and locally grounded types of redevelopment and renewal, though it is unlikely to challenge the basic assumptions behind a speculative, market-based approach to 'urban fallow' (Clark 2001). Short-term use beyond car parking and a few types of business are discouraged. Vacant land is often left derelict and abandoned, fenced off to stop public use or avoid liability if anything happens to people using the land. Such property-market-led neglect reduces the likelihood of commercial recovery. Creating a different sense of place is important in such places' recovery, as in Nick Falk's call for redevelopment to be animated and vibrant if it is to succeed:

> The four steps to urban renaissance are: an imaginative vision, a phased strategy, orchestration of investment, and the maintenance of momentum. The ingredients include revealing the potential; providing the initial impetus; engaging the community; starting small; involving developers at the right time; attracting settlers; evaluating the outcomes and celebrating success ...
>
> One of the most difficult challenges is how to turn spaces that seem dead or dangerous into living space where people will feel secure and enjoy the experience. (Falk n.d., iv, 19)

MAKING SENSE OF PLACE

'Sense of place', the relationship between people and place, is an important source of individual and community identity, a profound centre of human existence to which people have deep emotional and psychological ties, part of complex processes by which individuals and groups define themselves and bound up in people's sources of meaning and experience. Its academic context (eg Ashworth and Graham 2005; Cresswell 2004) gives salience to applications such as HRH The Prince of Wales' Affordable Rural Housing Initiative – *Creating a Sense of Place: A Design Guide* (2006) – and the related concept of *eco-vernacular* (Prince's Foundation 2008).

A sense of place
The prototype Natural House will embody generic building traditions but it is hoped that when built commercially, local sourcing of materials and skills and respect for local building traditions and architecture will result in a product that echoes the 'DNA' of the building context ... Whilst the house delivers vital energy savings within its own building 'envelope' The Prince's Foundation believe that massive additional savings can be made if groups of Natural Houses are built as communities, close to public transport and local amenities ...
(Building Research Establishment 2008)

From a more demanding perspective, Sense of Place, defined as 'community location and scale; restoration & preservation of nature', is the first item in the *EcoVillage Community Sustainability*

Assessment Ecological Checklist, which offers a way of quantifying sense of place by accumulating scores for aspects such as 'people "connected with and living harmoniously with" where they live'.

'EXPERT' KNOWLEDGE AND AN OBLIGATION TO CONSULT LOCAL PEOPLE

More pragmatically, Cartlidge and Haughton (2009) explore sustainability aspects of the links between knowledge of a place and how it is valued, and so represented in environmental policy development and application. Crookes takes this further:

> planners and policy-makers continue to privilege 'expert', scientific and technical knowledge over local knowledge – the understanding that comes from an intimate, everyday familiarity with a specific place or system.... Efforts to regenerate the area have frequently stalled as local residents and the Council have disagreed over the nature of the place as it is now and the place they would like it to become. (Crookes 2009)

Crookes seeks to identify and trial participatory techniques that better represent local people's perceptions of place to the authority. Worpole reports the widely-held belief that neglected and unattractive environments not only send messages to people that their quality of life does not matter very much politically but can be breeding grounds:

> design alone doesn't guarantee success ... A *melange* of prettification schemes, token works of public art, and a few new planters and street benches have often been vandalised within weeks, leaving the areas supposedly regenerated looking just as depressing and unloved as they did before. (Worpole 2003)

Most UK regeneration activity has concentrated on the physical, neglecting places' symbolic messages of power, control and ownership and failing to deal adequately with relational aspects: benefits beyond simply permitting people to be there. Communities require 'well made and well connected places that have a carefully constructed spatial identity' (Weinstock and Woodgate 2000, 23, 78); a notion of communication central to but at odds with Mitchell's *City of Bits* (1998, 118, 122). While it is naïve to assume that people will act together as a community, relationships are structured and influenced by the places chosen. Our non-spatial and instantaneous cyber existence is lived in real locations. As these places are managed and manipulated, so our behaviour, interactions and social networks are structured and limited by this qualitative control.

PEOPLE MAKE PLACES, OR DESTROY THEM

Plans depend on designers' and operators' ability to create places that users relate to in a positive way. Falk shows how developments range from commercial success to unrealised expectations and unmet goals. However, such observations relate to dynamic processes that take many years to complete (Clark 1988) and may result in different, not necessarily unwelcome, outcomes to those initially intended.

> Merton Abbey Mills in South London shows how an oasis can be created in an apparent desert whereas Tobacco Dock in Tower Hamlets failed, even though £70 million was invested. The key

is probably having the right management and responding to local markets first by filling a gap, but for every success there are many failures. The best examples, such as the superb complex under the railway at Leeds, complement and reinforce the city centre. In contrast, neither Sheffield nor Coventry Canals Basins has as yet established themselves as venues or 'watering holes', and lack critical mass, though they provide a pleasant relief from their respective cities.

(Falk n.d., 17)

Successful places are more likely to evoke pride, feelings of ownership and identity, positive aspirations and commitment and behaviour that favours localised business and protects the physical structure of the place from casual or intentional damage. Not achieving such a relationship reinforces failure, especially when intervention to control threats such as vandalism, petty crime and 'anti-social behaviour' discourages or expels people with access to, as they see it, better alternatives. The market for property, retail space and employment picks up and reinforces such signals and is helped by the way that problematic places are portrayed in the media. Some examples suggest a one-way 'crisis circle' process of socio-economic decline into a 'black hole' which is difficult, if not impossible, to reverse. Once the 'event horizon' is passed, recovery is impossible and death, or demolition, inevitable. Other cases suggest that successful intervention is possible. This 'spiral of decline' model is borrowed from nurse education and the care of the frail elderly and terminally ill (eg Hudson 1997; Watters and Meehan 2006), and is probably most familiar to readers of science fiction. Animated urban landscapes, places populated with people who want to be there, liveable neighbourhoods and the – sometimes unlikely – outcome of imaginative intervention and market forces counter the depressing reality of places where successive interventions, and much public money, have failed to reverse decades-long decline. Here positive feedback that reinforces failure is opposite to self-correcting ('steersman') cybernetic systems (Clark 2002; 2005) and contradicts *ecosystems* optimism:

> niche constructers can enable other species to live in otherwise physically stressful environments by providing critical resources such as moisture, shade, favourable soil chemistry and refuges...
> 'In most habitats [...] ecosystem engineers provide the template for all other ecosystem'.
> (Laland and Boogert 2010).

RECIPES FOR SUCCESS

There are probably no easy fixes or simple solutions to 'problem neighbourhoods', but places that 'work' seem most likely to permit a sense of ownership, be permissive about how they are used, lack heavy-handed officialdom and have variety and organic dynamism, so one may expect failure to be associated with 'one size [must] fit all' authoritarianism, arbitrary controls and unthinking conformity to a master-plan. Paradoxically, good situations may also come out of single-minded, master-plan-based leadership. Successive interventions tend to conform to current priorities, fashions and terminology: 'Greening' replaced 'Environmental' and was succeeded by 'Sustainable Development' and 'Sustainability', and then the need to 'Act on CO_2' and combat climate change; 'Social Inclusion' followed 'Enterprise', was superseded by initiatives to address 'Crime' (Clark and Cox 2003) and then by an emphasis on 'Community' that is, in 2011, being refocused on 'Localism'. Successive urban fashions and fads do not explain what has happened or prescribe solutions, though chronologically locating initiatives may account for much, including

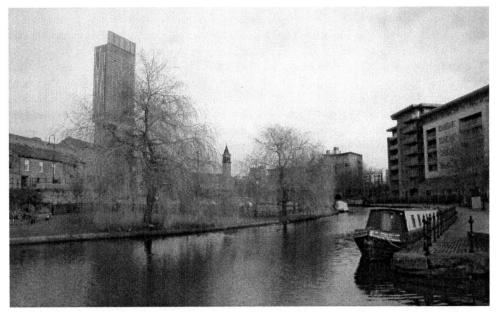

Fig 10.1. Castlefield Canal Basin, Manchester, March 2010.

the tendency for interventions to cease before effectiveness is properly determined, and for replacements to be briefly dominant before, in turn, being replaced by other political imperatives. Changes that seek wider participation may have the opposite effect (Ashley and Clark 2005; Clark and Ashley 2004).

Relationships between policy, intervention, policy appraisal and research beg further exploration, especially in places and for groups of people judged to be 'problematic' by other people who seek to manage them. An unfashionably 'managerialist' perspective may be of more use here than one that seeks 'structural' explanation (Williams 1978). To what extent are problem areas and populations self-fulfilling consequences of outsider, 'expert' and market designations that serve other interests: professional careers, the convenience of blameworthy local groups and safeguarding of private and state capital?

Waterside Urban Renewal: Places with a Particular (usually Profitable) Sense

As part of a visioning exercise it has been suggested that the south end of the Preston–Kendal Canal be reinstated (Preston City Council n.d.). This may create opportunities for waterside development similar to Castlefields in Manchester, whose success can be linked to Falk's Principles for a Successful Waterfront: make the most of their special qualities, their spirit, urban context and potential: 'look unique. Provide a continuous and cared for public realm' and interpret and respect the past 'while avoiding pastiche' (Falk n.d., 25). This requires good links to neighbouring areas. Castlefield (see Fig 10.1) is, just about, 'a short pleasant walk from the rest of the town or city' and 'offer[s] attractions for all parts of the community', though one might argue that the waterside bars and restaurants and occasional outdoor events serve only a few.

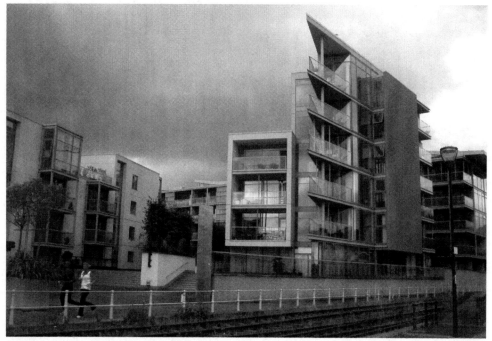

FIG 10.2. BRISTOL CITY DOCKS, SEPTEMBER 2009.

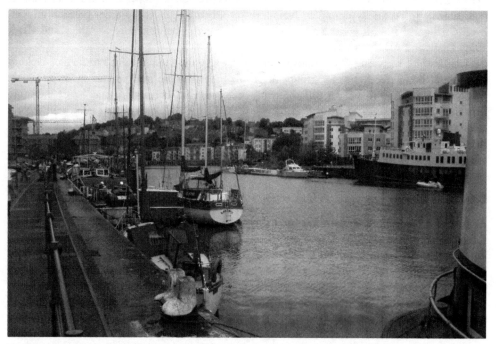

FIG 10.3. BRISTOL CITY DOCKS, SEPTEMBER 2009.

The sense of place provided draws on the appeal of the location's unique place in industrial and transport history, with interpretive boards (now shabby) and urban trails, and while, again, one might criticise the pastiche of modern buildings that ape traditional canal-side architecture, some historic buildings have been conserved and adapted to new uses in ways that 'respect the area's history and architectural heritage', or at least create an attractive urban landscape with interesting historic remnants.

Falk's argument in favour of 'Resourcefulness' suggests development that responds to demand and makes the most of existing assets. The best waterfronts create places that exploit, add value to, maintain and enhance people's experience of water on a human scale. They give these places vitality. 'Imaginative vision' is necessary where long neglect is followed by what some may see as an inappropriate master-plan that favours outside interests and priorities over those of residents and neighbours (Falk n.d., 27, 29; Clark 1985). Preston's future 'vision' favours corporate investors and other 'leaders' in a planning policy vacuum (Clark 2008) – not opportunistic individuals and groups, as in areas of successful renewal such as Bristol City Docks (see Figs 10.2 and 10.3) or Vancouver's Granville Island (Clark 1988; 2005). Success here can be linked to flexible and non-dogmatic decisions that enabled a dynamic and mutually reinforcing mixture of activity and land uses, resulting in places that are animated and vital, with a quality which attracts people both locally – to routinely use their markets, shops, cafes and cultural facilities – and from a distance as a major tourist attraction and, to some extent, an unexpected bonus of visiting the city. The sense of place achieved is not easy to copy. Many developers have sought to apply similar formulas, but with less and sometimes little effect, perhaps because developers' favoured 'clean sheet' approach misses their pragmatic reuse of existing buildings and dynamic nature (Falk n.d., 30) and maybe because it is not in the corporate sector's interests or mindset to encourage rival types of economy or aspirations.

NEW ISLINGTON, MANCHESTER: STALLED MARKET-LED RENEWAL VERSUS STEALTHY REGENERATION

There is a contrast between Falk's pragmatic and realistic approach to redevelopment opportunities, the commonplace observation that some places 'work', for various reasons, and the media presentation associated with places such as New Islington. Urban Splash's *Chips* modernist apartment block (see Figs 10.4 and 10.5) and associated developments are promoted by arty, trendy (and perhaps irritating) websites and publicity (Urban Splash 2010). These contrast with low-key marketing of nearby converted mills and an executive-lifestyle-focused sales office on an adjacent new development. Conversations with sales staff suggest that Urban Splash's rivals were more successful in attracting new residents, probably because their accommodation was available just before the market crashed. Earlier parts of the company's New Islington project are reported a success. But environmental and image problems may also have had an effect. This contrasts with Urban Splash's better fortune with other conversions, most notably Royal William Yard in Plymouth (see Fig 10.6), and is despite events such as the New Islington Festival (Urban Splash 2008; 2010).

Perhaps the most convincing argument that sense of place contributes to successful schemes is provided by an example from Cambridge, and by the place-making *Building for Life*'s criteria which informed its development and execution and on which it scored highly, as it did for other awards. *Building for Life* asks 20 questions that include 'Does the development provide commu-

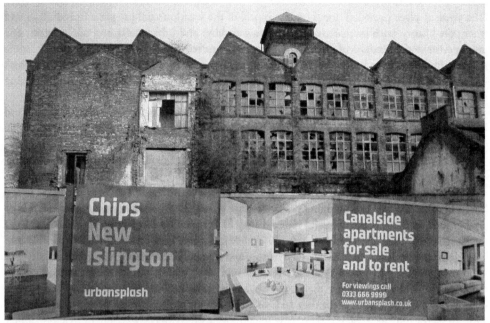

Fig 10.4. Poster advertising Urban Splash's 'Chips' development in front of derelict structure ripe for renewal or demolition, New Islington, Manchester, March 2010.

Fig 10.5. Urban Splash's 'Chips' apartment block shortly after completion, but not yet fully occupied, New Islington, Manchester, March 2010.

FIG 10.6. URBAN SPLASH'S SUCCESSFUL CONVERSION OF THE HISTORIC ROYAL WILLIAM YARD, PLYMOUTH, MAY 2010.

nity facilities? Does the scheme feel like a place with a distinctive character? Are public spaces and pedestrian routes overlooked and do they feel safe?' and 'Is public space well designed and does it have suitable management arrangements in place?' Critics might observe that the sympathetically designed high-density Accordia scheme is in Cambridge, a notoriously overheated property market.

Official enthusiasm for the language and concept of sense of place is seen in MPs (and ministers) Ben Bradshaw and Ian Austin's foreword to the 2009 HM Government report *World Class Places*: 'Places that people don't like, or where they don't feel safe, soon become underused and underloved, and end up crying out for redevelopment. Ultimately this leads to more costs to put these places right, which we simply cannot afford to do' (HM Government 2009). Prescriptions include 'Encouraging community involvement in ownership and managing the upkeep of the public realm and community', 'Encouraging local authorities to set clear quality of place ambitions in their local planning framework' and 'Attaching conditions to the disposal of public land to ensure high quality development', suggesting that 'sense of place' is not yet embedded in normal practice.

ART AND POLITICS IN THE PROCESS OF PLACE ABANDONMENT AND REUSE

Sense of place encapsulates most of the intangibles that determine if projects and policy work. It is prone to constant rediscovery, as in Will Self's reinterpretation and promotion of *Psychogeography*, an established concept based on naïve appreciation of how individuals relate to place (Pittard 2009) which Self's popular writing and broadcasts use to provide structure to what might otherwise be seen as critical ramblings: literally where he describes walking between places

that are usually connected by other modes.[1] Psychogeographers praise radical town planners who are 'seeking a revolution in urban design to let citizens make decisions about where they are to live', refer to being 'stifled by the city' and seek to 'study the effects of geographical settings on mood & behaviour' (Parker 2002).

> Through psychogeography, the letterists and situationists combined playful-constructive behaviour with a conscious and politically driven analysis of urban ambiences and the relationships between cities and behaviour. But they also sought out a better city, one that was more intense, more open and more liberating according to paths, movements, desires and senses of ambience. (Pinder 2005)

Artists' associations with attempts to reclaim abandoned territory (Speight 2008) and enthusiasm for the work of Bunge (Goodchild 2008) raise questions about the effectiveness of what might be seen as counter-cultural sniping. Banksy (2005) is probably more effective in popularising the case against a stifling corporatism that appropriates places and marginalises, and even criminalises, non-corporate aspirations and behaviour. The awful images and optimistic tales of eventual, if partial, reoccupation of Detroit's abandoned Black neighbourhoods in *Requiem for Detroit* may justify Bunge's dismal assessments of mutually reinforcing injustice and both imposed and self-inflicted destruction of the community's physical, economic and social core. Bunge's 2001 wider view is also salient:

> So what is the state of geography today? It is in a mess – hyphenated, obfuscated, as confused as it is confusing. Why? Society is itself degenerating. The culture is coarse, vulgar, prostituted, chaotic, 'dummied down'. We are in desperate need of intellectual reinforcements, and geography can help some. (Cox 2001)

But it is not clear if shocking photo journalism and documentary-making can accommodate the complexity of the situations they expose (Temple 2010; Observer 1979). There is a risk of hopelessness in Bunge's (1975) suggestion that a variant of the bid rent model and other fixed relationships determines that there will always be an underclass and in the widely made *Environmental Justice* assertion that corporate decisions will always do these people harm. But also of naïve optimism: a Detroit documentary concluding with a romantic image of a new breed of pioneer, around a campfire, reoccupying the abandoned acres of burnt-out suburbs and abandoned factories and schools and of homesteaders growing crops in a few parts of a depopulated, apparently post-apocalyptic city that has largely returned to nature (Temple 2010).

Despair, naïve optimism and artistic attempts to reclaim lost territory miss the point that most people sensibly avoid such places. How we live is orchestrated and manipulated by corporate bodies and professional managers whose interests may be at odds with our own. While the rhetoric of inclusion and individual expression permeates official media, alongside a succession of non-negotiable imperatives, opportunities for individual and communal action and choice are constrained by monopsomistic markets and by official providers' limited range of options and

[1] It is perhaps apt that the short-lived journal with this title had its website appropriated by a travel company (H-Net 2001; Travel and holiday News and Information n.d.).

inflexibility. A few very big stores control both retailing (Lang 2010) and the spaces, once the social hubs of our town and city centres but now including out-of-town complexes and virtual online shopping, dominated by 'comparison' shopping. Even periodic events such as pop festivals and summer showgrounds are retail events: good places to buy from small-scale producers who are generally excluded from shopping centres and whose goods are not stocked by the big retailers. The media favour slow local food and individual endeavour, but with a few exceptions it is rare for 'ordinary' people to be properly consulted about the products and places they would like or to have convenient access to a good range of non-corporate goods and services. Focus group and participation exercises abound, but serve to establish market potential, not to empower or to offer the full range of possible choices, whether as consumers or as active citizens.

Conclusions

Identifying which places 'work' and promoting criteria that should lead to better designed and run projects may help achieve memorable and desirable places. But for places to have true meaning they need something more. Utility, accessibility, perceived safety and aesthetic appeal may be necessary conditions that emerge as a place becomes established, rather than prior conditions. 'Ownership' is easy to assert as a way of promoting alternative, non-corporate lifestyles, but in a rigorously planned and corporate dominated, artificially expensive and constrained property market, access to land and buildings is outside most people's grasp, or is at the margins. We need 'ownership' to range from identification with and taking responsibility for a place, perhaps through its cultural or historical associations, to direct action that meets one's own needs – allotments, DIY, community activity and mutual self help – to purchasing decisions that let one buy into a product that is much more than a functional thing. This particularly applies to accommodation, where property determines access to local amenity and services, especially schools, but may also apply to other purchasing decisions. One may choose the lower impact or better quality of particular types of energy, transport, food or holidays and perhaps as a result identify oneself as part of a community, though this may be a luxury many cannot afford. Historically, religious, social, cultural and political affiliations were part of this process of individual choice and identity, but these have tended to be subsumed in or replaced by a culture of individualistic mass consumption, which may be why place matters and why there is so much scope for consumption of and engagement with localised identity. Or it may be why naïve attempts to promote any vision of place fail. A world that subscribes to and enjoys individual anonymity and the range of goods provided by capitalism is unlikely to throw these away, even if the places that it produces are not as vital or as satisfying as they might be.

Mills (2006) may be correct in calling for places that have soul:

When organic growth is supplanted by imposed ideas, the fertile, fragile spirit, the soul, of place comes under attack, falling victim to ill-conceived plans. Mystical spiritualities tell of a 'creative breath', or melody, that breathes place into existence. Call it what you may, but it is this 'life-force', the dynamism, that gives place soul, that makes a space a Place.

But this 'mojo' is not easy to instil or enforce, perhaps because places reflect the people that use them more than their designers' and managers' skill and manipulation. Can and should we educate and empower, or cajole and control, to achieve places that are memorable and popular?

Or must we accept that sense of place is an expression of individual identity and community values? So in an individualistic and globalised world we should not be surprised that places with such attributes are exceptional, to be celebrated and enjoyed, and that people who manage to create and maintain such places will be rewarded. So it is in all our interests to favour places with which we can identify, to seek out and use those that are memorable, and to avoid, or perhaps change, those that lack meaning or that are managed in ways that serve narrow interests and perceptions, and that deny their potential. A neo-liberal solution to market failure? Perhaps not. But we ignore the market implications of how people relate to places at our peril. Where markets fail to use opportunities we should let those who can relate to the place take over: beneficial urban fallow rather than neglect and continuing decay.

BIBLIOGRAPHY AND REFERENCES

Accordia, n.d. *Cambridge high density new scheme* [video], available from: http://www.cabe.org.uk/videos/accordia-walkthrough [14 December 2010]

Ashley, J, and Clark, M, 2005 Creating sustainable communities: LDFs and LSPs as new forms of governance, *IBS-RGS Annual Conference*, August, London

Ashworth, G J, and Graham, B, 2005 *Senses of Place: Senses of Time*, Ashgate, Aldershot

Banksy, 2005 *Wall and Piece*, Century, London

Building for Life, n.d. *The 20 criteria*, available from: http://www.buildingforlife.org/criteria/1 [14 December 2010]

Building Research Establishment, 2008 *news from BRE: Construction to start on Prince's Foundation Natural House*, 12 December, available from: http://www.bre.co.uk/newsdetails.jsp?id=529 [14 December 2010]

Bunge, W, 1975 Detroit Humanly Viewed: The American Urban Present, in *Human Geography in a Shrinking World* (eds R Abler *et al*), Duxbury Press, North Scituate, MA, available from: http://issuu.com/partizanpublik/docs/atlas_of_love_and_hate [14 December 2010]

Cartlidge, C, and Haughton, G, 2009 Call for papers: session Valuing Place: Environmental Policy Formation and Enactment, *RGS Annual Conference*, 26–28 August, Manchester

Clark, M, 1982 New priorities for outer estates, *Planning* 499, 17 December

— 1985 Fallow land in old docks: why such a slow take up of Britain's waterside redevelopment opportunities? *Maritime Policy & Management* 12 (2), 157

— 1988 The Need for a More Critical Approach to Dockland Renewal, in *Revitalising the Waterfront: International Dimensions of Dockland Redevelopment* (eds B S Hoyle, D A Pinder and M S Husain), Belhaven Press, London

— 2001 Urban fallow and the surface economy, *Futures* 33, 213–18

— 2002 A Cybernetic Approach to Sustainable Development? Planning in North West England during the 1990s, *Global Built Environment Review* 2 (1), 34–49

— 2005 Why Not Take a Cybernetic Approach to Sustainable Development? Planning and Environmental Management in North West England During the 1990s, in *Cities in Transition: Transforming the Global Built Environment* (ed T Shakur), Open House Press, Cheshire, 118–32

— 2008 Environmental Leadership and Expertise: poor substitutes for responsible ownership and the ability to get and apply relevant intelligence? *RGS Annual Conference*, 27–29 August, London

Clark, M, and Ashley, J, 2004 Environmental justice through regional sustainable development frameworks: any lessons from North West England? *IGC/RGS Annual Conference*, Glasgow

Clark, M, and Cox, S, 2003 Combating Social Exclusion: Focus Groups, Local Empowerment and Development, a Preston Case Study, in *Local Environmental Sustainability* (eds S Buckingham and K Theobald), Woodhead, Cambridge, 93–113

Cox, K R, 2001 Classics in Human Geography Revisited: Bunge, W. 1962: Theoretical geography 1966, *Progress in Human Geography* 25 (71), 71–7

Cresswell, T, 2004 *Place: A Short Introduction*, Blackwell, Oxford

Crookes, L, 2009 Understanding local communities: bridging the gap between official and local understandings of place, University of Sheffield, Town & Regional Planning Department, current PhD research, available from: http://www.shef.ac.uk/trp/researchschool/currentresearch/leecrookes [14 December 2010]

EcoVillage Community Sustainability Assessment website, n.d. available from: http://gen.ecovillage.org/activities/csa/English/eco/eco1.php http://gen.ecovillage.org/activities/csa/English/spirit/spirit_intro.php [22 June 2010]

Falk, N, n.d. *Turning the tide: the renaissance of the urban waterfront*, available from: http://www.urbed.co.uk/ [14 December 2010]; http://www.urbed.com/cgi-bin/get_binary_doc_object.cgi?doc_id=262&fname=extra_pdf_1.pdf [15 January 2011]

Goodchild, M F, 2008 William Bunge's Theoretical Geography, in *Key Texts in Human Geography* (eds P Hubbard, R Kitchin and G Valentine), Sage, Los Angeles, 9–16, available from: http://www.geog.ucsb.edu/~good/papers/450.pdf [14 December 2010]

HM Government, 2009 *World class places: Action plan*, November, available from: http://webarchive.nationalarchives.gov.uk/+/http://www.culture.gov.uk/images/publications/worldclassplaces-actionplan.pdf [14 December 2010]

H-Net, 2001 *Call for Contributions: Journal of Psychogeography and Urban Research*, July, available from: http://www.h-net.org/announce/show.cgi?ID=128061 [14 December 2010]

Hudson, H, 1997 The practical accomplishment of care in two homes for the elderly, PhD thesis, University of Edinburgh

Laland, K N, and Boogert, N J, 2010 Niche construction, co-evolution and biodiversity, *Ecological Economics* 69 (4), 731–6

Lang, T, 2010 *Cesagen Public Lecture on Food, Health and Sustainability*, Lancaster, 14 October

Mills, F A, 2006 'The Soul of Place' *Flâneur*, available from: http://www.frankamills.com/emptyspace.htm http://www.urbanparadoxes.com/ http://www.frankamills.com/pages/Gleanings.html [14 December 2010]

Mitchell, W J, 1998 *City of Bits. Space, Place and the Infobahn*, MIT Press, Cambridge, MA

The Observer, 1979 *New Jerusalem Goes Wrong*, 11 March

Parker, S, 2002 Power to the psychogeographers, *Society Guardian*, 22 February

Pinder, D, 2005 Arts of Urban Exploration, *Cultural Geographies* 12, 388

Pittard, C, 2009 'We are seeing the past through the wrong end of the telescope': Time, Space and Psychogeography in Castle Dor, *Women: A Cultural Review* 20 (1), 57–73

Preston City Council, n.d. *Riverworks: a bold vision for our City*, available from: http://www.preston.gov.uk/Category.asp?cat=785 [15 January 2007]

Prince's Foundation, 2006 *HRH The Prince of Wales's Affordable Rural Housing Initiative: Creating a Sense of Place: A Design Guide*, available from: http://www.princes-foundation.org/sites/default/files/arhi_creating_sense_of_place_guide.pdf [8 June 2011]

— 2008 *HRH The Prince of Wales accepts The Athena Award from The Congress for New Urbanism*, 5 April, Austin, Texas, available from: http://princes-foundation.org/index.php?id=308 [14 December 2010]

Speight, E, 2008 *Tunnel Visions*, UCLAN, available from: http://www.tunnelvisions.info/contextualreport.pdf [14 December 2010]

Temple, J, 2010 *Requiem for Detroit*, BBC4, available from: http://www.freep.com/article/20100317/BLOG36/100317044/BBC-documentary-%5C-Requiem-for-Detroit?%5C--tracks-city%5C-s-fall--future [14 December 2010]

Travel and holiday News and Information [website], n.d. available from: http://www.psychogeography.co.uk/ [15 June 2010]

UNECE, 2008 *Introducing the Aarhus Convention*, available from: http://www.unece.org/env/pp/ [14 December 2010]

Urban Splash, 2008 *Newsplash: the Urban Splash Newsletter*, August, available from: http://images.urbansplash.co.uk/news/2008/aug08/aug08.html#story4 [14 December 2010]

— 2010 *New Islington Millennium Community*, Manchester, available from: http://www.newislington.co.uk/ [14 December 2010]

Watters, C L, and Meehan, A, 2006 Care of the frail elderly, a call for action, *Clinical Review in Bone and Mineral Metabolism* 4 (1), 3–4

Weinstock, M, and Woodgate, S, 2000 *Living in the City: An Urban Renaissance: an exhibition of the international ideas competition organised by the Architecture Foundation*, The Architecture Foundation, London

Williams, P, 1978 Urban managerialism: a concept of relevance, *Area* 10 (3), 236–40

Worpole, K, 2003 A space – or a place – for everyone?, *Town & Country Planning* 72 (8), September, 242–4

The Place of Art in the Public Art Gallery: A Visual Sense of Place

Rhiannon Mason, Chris Whitehead and Helen Graham

> In art historical studies of the past, geography thus affected many views, opening up avenues for investigation and closing off others. Far from being resolved, geographical considerations are still debated. They involve such issues as how art is related to, determined by, or determines – or is affected by or affects – the place in which it is made; how art is identified with a people, culture, region, nation, or state; how art is to be interrelated, through diffusion or contact.
>
> (DaCosta Kaufmann 2004, 7–8)

Looking North: Displaying Art in the North East of England

It has become almost commonplace to see heritage and sense of place as closely linked. For built heritage and museums which deal with natural history, social history, archaeology, or ethnography, it seems self-evident that 'place' should be of central importance as a frame of reference for collections, interpretation and visitors (Davis and Huang 2010). This assumption is, however, rarely extended in the same way to art galleries and their collections. Here place is more likely to be invoked when differentiating between the national, regional and local nature of institutions, their funding, and, all too often, their perceived status. Otherwise, geographical 'schools' or 'traditions' might form art historical and curatorial classification structures for differentiating bodies of art from one another, but the deeper relations between art and place are not often evoked. Indeed, within modern Western cultural traditions, art is accorded a status which positions it as 'above' place, as universal in its range and meaning and transcending the local circumstances in which its production and consumption take place. But what aspects of art are obscured by ignoring place? We address this gap by asking: how can we understand the significance of place within the public art gallery context? Does the public art gallery contribute, and relate, to a visual sense of place for visitors and if so, how? We consider these questions by examining how Newcastle's Laing Art Gallery has represented the art of Tyneside and the North East of England through one of its fine and decorative art display spaces.[1] We reflect on how this display was previously organised and interpreted under the title 'Art on Tyneside' (1991–2010) and discuss how it is now being re-imagined (within the context of a research and display project in which we are involved) as 'Northern Spirit: 300 years of Art in the North East'.

A significant difference between the two displays is that the 2010 one will include contributions from people living within North East England, thus offering new opportunities to explore the

1 The Laing is the flagship art venue of Tyne & Wear Archives & Museums (TWAM). It is based in Newcastle city centre and in 2009–2010 attracted 269,350 visits.

relationships between art, place and identity. The participatory element reflects current trends in museological theory and practice towards the greater involvement of members of the public and communities (however defined) in the production of both temporary and permanent museum and, to a lesser degree, art gallery displays. This kind of activity can be variously described in terms such as consultation, participation, collaboration, engagement and co-production. The degree and nature of involvement and control available to participants, institutions and visitors in such projects is the subject of much debate in the literature and sector (Watson 2007; Simon 2009; Lynch 2010; Black 2010).

While those working in art museums and galleries may not explicitly set out to represent place through their professional practice – and it would be reductive to think of such practice as totally or solely informed by place – it remains the case that place suffuses gallery representations. In this sense the gallery can be thought of as a nexus for a whole range of networks and associated practices, such as economics and trade, artistic communities and art collecting, geography and transport. These networks and practices connect people, places and material culture throughout the region and far beyond. In other words, there is a two-way interrelationship, with places making galleries and galleries contributing towards the making of places. Our argument is that art galleries with displays and collections which set out to represent places (for example, through displays of work produced by artists working locally, or of topographical images) themselves operate as a 'meeting place', as Massey (1991) describes it, for many convergent and divergent ways of knowing place, both historical and contemporary.

To see the relationships between places and galleries in this way is to see them as mutually iterative. However, it is important to recognise that this iteration is not fully congruent; there is not an equal two-way traffic between places making galleries and galleries making places. In the same way it is important to avoid oversimplified distinctions between what we think of as being inside and outside of the gallery, representation versus experience, or production versus consumption. Rather than seeing place and gallery as bounded entities, we argue that it is more helpful to see them as two nodes in a constellation of relationships. These relationships are always on the move but are temporarily fixed for our contemplation through the act of producing and presenting a gallery display and given a materiality in the form of specific paintings, specific views and the specific memories and connections they inspire in those that visit.

In this regard we draw on Doreen Massey's 'global' or 'progressive' sense of place as 'extro-verted, which includes a consciousness of its links with the wider world, [and] which integrates in a positive way the global and the local' (1991, 28). In these terms we can imagine 'place' as a 'meeting place' and 'as articulated moments in networks of social relations and understandings, but where a large proportion of those relations, experiences and understandings are constructed on a far larger scale than what we happen to define for that moment as the place itself, whether that be a street, or a region or even a continent' (ibid).

It is important to stress that the research project connected to the Northern Spirit gallery is yet to be completed. Consequently, this chapter will focus, firstly, on how we have sought to connect theoretical debates about 'sense of place' with our understanding of how and why public art galleries might contribute to it, in visual terms. Following this, we set out how we used this understanding to frame our research methodology. This chapter therefore uses 'place' to rethink how galleries operate and vice versa. As Kaufmann's quotation above indicates, there are many ways in which to understand the relationships between art and place. We are specifically inter-ested in the relationships between public art galleries and place for a number of reasons, some

intellectual and some practical, relating to issues of interpretation and the challenge of attracting new and repeat visitors to public art galleries. Before moving to these specifics, it is useful to consider the ways in which the relationships between galleries and places can be understood more broadly.

ENVISIONING SENSE OF PLACE IN THE ART GALLERY

> Places are [...] not so much fixed as implicated within complex networks by which hosts, guests, buildings, objects, and machines are contingently brought together to produce certain performances at certain places at certain times. (Sheller and Urry 2006, 214)

Art gallery displays which represent given locales make public statements about the perceived, collective and recognised meanings of place. Such displays offer authorised frames of reference for visitors because of the high status of public art galleries and the authoritative position they have historically occupied within Western European societies (Whitehead 2005). Since the 19th century, public art galleries have been enlisted in the promotion of national and regional identity and the fostering of civic pride in cities throughout Britain, continental Europe and many other parts of the world (Mason 2007; Whitehead 2005). In this way, artists and art galleries construct and offer up particular visions of a place and its histories, cultures and peoples to its inhabitants and visitors; they 'envision place', as Whitehead has described it (2009). These visions are structured and produced by a constellation of factors: the collections of art the gallery has inherited and acquired, the architecture of the building it inhabits, the institutional identity the gallery has formed over time, trends in curation and technologies of display, as well as the operational configuration which informs the gallery's practice, past and present. The latter comprises its staffing arrangements, its funding arrangements, its ethos, its relationships with its communities (and how it imagines and defines them) and its web of connections with other constituencies within the art world and beyond.

Notwithstanding artistic licence, some visions of place will be explicit and representational, as in the topographical paintings which feature prominently in many displays about art in relation to place. Artists are commonly inspired by what they encounter in a place to attempt to capture something about its apparent distinctiveness. They produce artworks which over time and through their reproduction, association and circulation may become iconic in the vernacular sense – that is to say, both embedded within, and productive of, a sense of place (Pollock and Sharp 2007). Antony Gormley's *Angel of the North* – a 20m-high steel sculpture standing above the main road and rail routes through North East England and towards the east of Scotland – is a clear example. From its conception in 1994 it has achieved such a degree of familiarity through its reproduction on news programmes, tourist literature, local transport and through people's interaction with it that it has become a widely recognised form of visual shorthand for NewcastleGateshead and the North East of England.

Places can also be said to produce art by virtue of providing those conditions which enable art and an art-scene to be possible. These conditions include a particular quality of light, noteworthy topography, interesting subjects (as perceived by artists and as appreciated by patrons and buyers) and a successful combination of affordable studio space and venues for display. They also require critics to raise the profile and awareness of artists and galleries as well as educational institutions to disseminate knowledge about art and artists and train further artists and critics. Last but not

least, they require visitors to view the works and dealers, patrons and institutions who/which purchase and promote art, thereby supporting artists and, in turn, fostering the production of more art.

Art galleries will, of course, hold materials which are not directly representational of place but equally have an important connection to its specificity. For example, they may hold decorative arts collections that indicate the long history of the production of glass or ceramics in a given locale which could support that trade. This support will depend on the right configuration of natural resources, economic capital, geographical suitability for easy import and export, transport links, professional expertise and human labour. Public galleries will also hold art produced by those who may have inhabited that place at some time but whose practice is focused not on representation of places but more exclusively towards issues of form and style or, indeed, other imagined or real places far away from their current location. Over time, visitors may incorporate their memories of seeing these artworks in various places, thus binding the two together. For example, the experience of seeing 19th-century painter John Martin's imagining of the biblical scene of Sodom and Gomorrah becomes associated with the experience of seeing it in the Laing Art Gallery in Newcastle. As Arturo Escobar reminds us, we may be encouraged to think of our contemporary culture in terms of the relentless ascendance of the global over the local, but 'culture always sits in places' (2001, 139).

Last but by no means least, public galleries collect works which do not relate in terms of their content to the place in which they are found but have been collected because of the gallery's desire to tell the story of a particular artist or movement or because they have been bequeathed by an individual collector. Even in this situation the artworks still tell a powerful story about the relations between art and specific places; they tell us about the histories of patronage, the economic prosperity which enabled the art gallery to be created and sustained, or the civic aspirations within a particular city at a given moment which led to the decision that it should have its own public gallery. In all these ways and to borrow John Agnew's terms, the actual location of art galleries is a significant factor in creating a locale for art which contributes to the production of a visual sense of place, both as it is now and as it has been in its past.[2]

At the same time, it is crucial to remember how art galleries do not attend to certain aspects of places. Collections and displays may not represent aspects of places for many reasons. This could be because these are perceived to fall outside the frame of the collecting policies of galleries or because artists did not choose to represent certain places or practices associated with places. It could be because collectors did not collect the material culture of representations of those places owing to their judgements not only about what constituted art but also what was perceived to be worth collecting at a given moment in time.

It is also important to remember where individual museums and galleries sit in the vast networks of cultural institutions involved in the collecting and display of material culture of the past. This can be thought of at the regional, national or international scale. Visual culture

[2] Agnew has argued that 'place' can be understood as being made up of different, but always interrelated, aspects: 'location', which refers to fixed coordinates on earth – literally where somewhere is – and 'locale', which points to the material settings – such as the built/natural environment – within which social relations are conducted. He specifically reserves 'sense of place' to refer to the 'subjective and emotional attachments people have to place' (Cresswell 2004, 7).

– like all cultural artefacts – will be categorised, divided and allocated to different institutions according to institutional histories and identities which are themselves the product of traditional disciplinary distinctions between archives and collections of fine art, photography, decorative arts, ceramics, glassware, art, social history and so on. The collections of any public art gallery only ever represent the tiniest residue of visual culture after it has been thoroughly filtered by passing through the political nexus of long-standing institutional, aesthetic and collecting practices. What is left out of view may still circulate and contribute visually to a sense of place but its omission from the public space of the gallery marks it out as being in a different league of visual culture. Invariably, what is included and excluded from the public art gallery speaks to a wider politics of how sense of place is visualised and validated in society at a given moment.

Sense of Place as Local Knowledge

Local knowledge is a mode of place-based consciousness, a place-specific (even if not place-bound or place-determined) way of endowing the world with meaning. (Escobar 2001, 153)

The above discussion helps us to think about the way that sense of place might be articulated visually through and within the gallery as both a conceptual and physical space of display and a set of practices with material and intellectual politics. However, it does not address the question of how this envisioning of place might be taken up, rejected or deemed irrelevant by those who come into contact with the gallery. If we start from the principle that 'place' is not defined in advance and that people create a sense of place for themselves and others through their use and understandings of that place, then what role might an art gallery play in contributing to 'sense of place'? What is the relationship between 'sense of place' as produced by the gallery and that produced through people's own lived experiences and sense of place? Can we assume that place is the primary interpretative framework even where art is explicitly related to a place – be that a city or a region?

If we look at the relationship between gallery and place from the perspective of inhabitants and visitors rather than artworks and collections, we can say that art galleries with displays which explicitly set out to represent the artistic heritage of a given location offer a connection point between historical and artistic perspectives and individuals' contemporary experiences. Implicitly, they highlight how places change and how there can be a diversity of ways of knowing and inhabiting any given place. As extensive research has demonstrated, visitors bring their own diverse perceptions, knowledges and experiences to bear on what they encounter in all museum and gallery displays (Hooper-Greenhill 1994; Leinhardt *et al* 2002; Falk 2009). In practice, therefore, the actual meanings of any museum or gallery display are always co-created and held in tension between it and its visitors. The challenge we set ourselves for our contribution to the new 2010 display at the Laing Art Gallery was to find a way to accommodate and capture this diversity of sense of place as it is linked to the visual culture of the region. This needed to be balanced with the production of a display which could speak to those with insider knowledge in terms of both geography, art history and general cultural capital – (local inhabitants and/or art aficionados) – and those without – (new visitors to the North East and/or the non-gallery visitor). At this point it may help the reader to revisit the terms of reference for our research project and the display.

Background to the Project

This two-year project is a collaboration between the International Centre for Cultural and Heritage Studies (ICCHS) at Newcastle University and the Laing Art Gallery, part of Tyne & Wear Archives & Museums (TWAM). The Laing is the main gallery in Newcastle. Founded in 1901, it has a collection of decorative arts, paintings, engravings, books and watercolours. Our project concentrates on a ground-floor display area which will house the new display: 'Northern Spirit: 300 years of Art in the North East'. We are funded by the Arts and Humanities Research Council (AHRC) but the overall project also involves other funding from the Heritage Lottery Fund (HLF) and the DCMS Wolfson Foundation Museums & Galleries Improvement Fund. The total budget is £1.1 million. We became involved to research the relationships between art, identity and place and to develop research-informed content co-produced with members of the public in various media for display purposes. This content, and insights derived from the research, will be integrated within the new display at the Laing Art Gallery.

At the time of its opening in 1991, the original 'Art on Tyneside' display broke with convention by explicitly emphasising relationships between art objects and place. Indeed, place was the display's primary framing device. Part of the rationale behind this was to encourage non-traditional local visitors to the Laing Art Gallery. It was felt that using a familiar starting point (that of local place) could help to achieve this and – in the words of the then director David Fleming – 'humanize' the gallery (1992). The display did achieve this aim, and over its first few months the Laing attracted 70 per cent more visits from the same period in the previous year (Millard 1992). It also attracted some sharp criticism from national art critics who objected to the socio-historical approach taken to the display and interpretation of art and to the inclusion of interactives, both of which disrupted modernist conventions of presentation (Whitehead 2009).[3]

For all of these reasons, 'Art on Tyneside' was a groundbreaking display and an innovative approach to presenting art in its historical and geographical context for new audiences. However, the display is now nearly two decades old; permanent displays are usually planned to have a ten-year shelf-life, hence its redevelopment. The redevelopment presented an opportunity to revisit the display's original premises – both curatorial and academic – drawing on all the recent thinking about place, identity, curation, audiences and the use of technology within museums and gallery visiting which has emerged since the 1990s.

Research Approach

Based on these initial parameters, our understanding of current museological thinking and our reading of theories of place in terms of gallery history and practice, we developed, in discussion with staff at Tyne & Wear Archives & Museums, these research questions:

- How is the relationship between people's identities and sense of place performed, produced, and negotiated through, or in response to, art (with specific reference to the Laing's collection)?

[3] See Whitehead 2009 for more detail about the original display and the various interpretive strategies which envisaged and addressed the audience in terms of place-based knowledge.

- How is sense of place represented and constructed in a display like 'Art on Tyneside' and what role can audience perspectives play within this process?
- How can the polyvocality of audience perspectives be represented in a coherent and engaging display?
- Can the use of digital technology within the redeveloped display fulfil the Laing's objective to work towards the 'democratisation of curation'?

As indicated above, a key objective was to test theoretical ideas of polyvocality and new museology in a gallery setting. New museology has problematised the impersonal, authorial and institutional voice of the museum and gallery and highlighted how questions of voice and authorship are intimately connected to issues of knowledge and authority. Many writers have questioned whether the museum's voice might be made more clearly authored and whether the mode of address might be changed from monologic to dialogic and from a monovocal to a polyvocal mode of address (Bennett 1995; Lavine 1991; Vogel 1991). The idea that the museum can be repurposed as a democratic space for public discourse is much discussed at present with varying degrees of enthusiasm and scepticism (Black 2010; Dibley 2005).

With this in mind, we have designed the project to place different voices alongside each other in the display. Ideally, we wanted to see if we could create a dialogue in the display between different perspectives by connecting them through their shared engagement with both the collection and the idea of place and its visual representations. We hope that the new display will offer an opportunity to juxtapose and make visible different types of knowledge usually held apart intellectually and physically in museums and galleries. One broader aim is to question conventional boundaries between categories such as art/geography/social history; amateur/expert; scholarly/vernacular; and public/personal.

At the same time, we aspire to contribute to a display that people will want to visit, which will be accessible and able to speak to multiple audiences. We want the display to offer something for the first-time visitor, the repeat visitor, the local, the tourist, the art expert, the art novice, adults, young people, lone visitors and groups. We hope to do this through building multiple perspectives into the actual materials of the display itself. Equally, the use of digital media technology is intended to enable visitors actively to select different interpretive routes throughout the display according to their preferences, expertise, experience and motivations.

Our project has been shaped throughout by working closely with a range of museum professionals: exhibition designers, audio-visual consultants and museum staff (curators, senior managers, learning and outreach), as well as participants drawn from the general public locally. The display concept has also been shaped by many other factors, including the nature of the collection, the physical space available and its architectural qualities, the conservation requirements of listed buildings and technical experts and the requirements of funding bodies.

RESEARCH METHODOLOGIES: ASPIRATIONS AND CONSTRAINTS

Our approach is a fusion of participatory research methods and standard practices in community engagement, as pioneered, for example, by Glasgow's Open Museum. Since beginning the project in 2008 we have recruited a total of 43 participants (both individual members of the public and via pre-existing groups) to visit the gallery, hear about the gallery plans from curators, visit picture stores and work with a creative facilitator to make something for inclusion in the new

display. The choices of what people could make were as follows: (1) photographs, (2) a digital story, (3) a short film or (4) a sound-piece. All of the 'outputs' will feature in the gallery and on a website. In the gallery, the outputs will be accessed via touch-screens, sound cones, digital projectors and an interactive touch-table. In terms of the platforms for the delivery of the audio-visual materials, we are designing the conceptual architecture of the digital media specifically to make different knowledges resonate against one another, to disrupt conventional boundaries between types of material culture, and to call into question the traditional hierarchies which underpin assumptions about different kinds of visual culture and representations of place.

'PLACE' AS A FRAMING DEVICE

We specifically chose place as a framing device for the research because this is a display with a regional focus. We also felt that place would work effectively as a means of engaging a range of visitors and especially those without a prior art background. If people do not have art-history-based cultural capital, they can draw on their knowledge of the North East. If they do have art historical knowledge they could do either or both. If they are not familiar with the North East they can relate to the idea in terms of places they know. Although the reality of place is always specific and particular, the idea of place is sufficiently generic to work as a common frame of reference for a wide range of visitors. A comparable theme could be belonging, home, journeys, travel, or family (although of course none of these is universally positive in their possible associations for individuals). As indicated above, we wanted to understand more about people's sense of place to know how it might shape and be shaped both by visual representations of places and people's experiences of living in those places. We thus used theories of place as both an interpretive strategy and a methodological approach. So, for example, we elected initially not to recruit participants by predefined identity categories, as is common in museum practice (eg 'socially excluded', 'black and minority ethnic groups' and so on). Instead, we were interested in capturing and tracing the ways and moments in which people make *identifications* with places and visual representations and what this might tell us about how they understand and perform their own identities on a number of fronts.

At the same time we recognised that places are always already differentiated because of the nature of their historic communities, housing stock and socio-economic profiles. To use Massey's terms, we aimed to be attentive to 'power geometry', which acknowledges that 'different social groups, and different individuals, are placed in very distinct ways in relation to flows and interconnections' (1991, 25). With this in mind, we deliberately chose a contrasting range of socio-economic areas from within Newcastle and North Tyneside (Wallsend, Newcastle City Centre, Fenham, Tynemouth and Cullercoats). We also chose this range of places in relation to the findings of a mapping exercise we carried out on the paintings selected for the display. Our mapping exercise revealed that the collection featured certain areas disproportionately, such as the coast (Tynemouth and Cullercoats), the river, the quayside and the city centre markets, and featured certain trades, such as coal-mining and seafaring, more than others. The new industrial suburbs which grew up outside the city from the late 19th century tend not to be represented in the fine art collections, although products at factories such as Maling Pottery will be included in the display. These industrialised areas do feature heavily within the visual iconography of the North East but largely through the media of film and photography – neither of which feature in the permanent collection of the Laing gallery because traditionally it has focused on paint-

ings and decorative arts. In this sense the history of collecting practices within an Edwardian art gallery such as the Laing, where most of the collection was acquired in the first half of the 20th century, produces a particular kind of visual lexicon which sets parameters for what it is possible to represent today. It is important to say that our rationale is not to provide a corrective to the weighting of representations which have arisen through collecting and artistic practices. It is an impossibility to fully represent all of society in any museum display (or indeed in any other medium) because displays are, by their nature, selective. However, it is important to be attentive to the implications and politics of this inherent selectiveness. Specifically, we wanted to provide new points of identification through the co-produced material where visitors can see how these same places resonate differently for different people over time.

Once we had identified our four areas we set up stalls in some highly visible public spaces through which people tend to flow: markets, train stations and community centres. Here we were informed by cultural geography's recent emphasis on place as open and as constituted by mobilities and flows. On the stalls we placed reproductions of a selection of paintings from the planned display and talked to people who were attracted by the pictures. We estimate that we spoke to around 200 people via this method and recruited around 30 people directly to work with us on the co-production of audio-visual materials. Through the stalls we attracted people that we would not normally have contacted through the gallery's established channels.

The result is that our group of participants encompasses a considerable range in terms of people's familiarity with art, the gallery and its collection, as well as their educational and employment backgrounds. The gender balance was also equally weighted. Where it did not produce diversity was in terms of ethnicity or age and it was less successful in terms of attracting people who were newer to the region. People tended to be mostly older (50+) long-term residents and were frequently attracted to the paintings precisely because of their familiarity with the location and their family history in the region. What became apparent was the degree to which specific groups' uses of public places remains clearly differentiated, leading to over- or under-use by certain demographic groups. This was probably compounded by the type of art on our stalls, which was primarily Victorian and topographical, thereby also attracting certain constituencies to it as opposed to others. While this attraction would be explained by participants on the basis of personal 'taste', 'taste' in art is always socially constructed (Bourdieu 1984). It was therefore necessary to make some strategic interventions once patterns emerged from the first round of recruitment.

To respond to this, we embarked on a second round of recruitment during which we deliberately targeted some groups which were identified through pre-defined identity classifications. These were refugees and asylum seekers, family groups, young people from a local school, blind and partially sighted people and people with learning difficulties. In addition, we identified two other target groups defined by their specialist interest – the Friends of the Laing and members from the art community (artists, curators, art historians) with connections to the North East.[4] We decided upon this second round of recruitment because while we may want to problematise the category of identity and find alternative ways to approach people, it is equally essential to think about the politics of display in the context of contemporary debates about the traditional

4 We also decided to run a photography competition through Flickr to raise profile for the display and research and to generate more photographic content for the gallery.

representation of (and lack of) certain social groups (eg Sandell *et al* 2010). In this regard it was important to consider what it would mean to visitors, actual and potential, if the display appeared conspicuously to omit certain groups, particularly on the lines of ethnicity or disability. Having recruited these further participants, we then worked with everyone to produce audio-visual materials for the display as described above and subsequently interviewed everyone individually to try to understand if, and how, they connect their sense of place to visual representations and how this might relate to questions of identity.

As stated at the outset, this project is yet to be completed. We will therefore report more in forthcoming publications. However, at this point, we can offer the following provisional findings:

- in the absence of, or in addition to, art historical knowledge, place is one of the ways that people seek to make sense of certain types of art;
- visual representations which feature place are used by people as cues for the remembering and retelling of their own memories of places, people and significant life-events;
- place and its visual representation appear to play an important role in anchoring autobiographical memory and aspects of personal identity;
- people orientate themselves and their use of places, in part, through referencing of iconic visual and aural landmarks of place – bridges, public art, statuary, Metro signage and sounds, natural topography (river and sea), etc. However, this is mixed in with very personal and more everyday points of reference. Much of the iconic heritage has similarly attracted the attention of artists and thus features in the historical art collections;
- people use historical visual representations of place as a means of understanding historical change in society and their personal experiences of it;
- place plays a crucial role in providing a setting for collective memory which can differ markedly across cohorts. These differences might be explained in terms of the intersection between generational differences and the ways in which use of place is structured socio-economically;
- rapid and repeated regeneration schemes remove some of that capacity for collective sharing of place memory across a city to the point where the visual history of a certain place can become a 'foreign country' to some of its contemporary inhabitants.

Our future analysis will explore these initial findings, bearing in mind Graham, Ashworth and Tunbridge's comment that: '[p]lace remains a fundamental icon of identity but one individual self identifies with multiple layers of place and with other manifestations of identity, not necessarily spatially defined' (2000, 90). Through our study we aim to better understand the ineluctable significance of place within gallery representations and the affective, mnemonic, personal and social politics of the visitor experience.

ACKNOWLEDGMENTS

We wish to thank all the staff involved in the Northern Spirit display at the Laing Art Gallery, Tyne & Wear Archives & Museums, and the participants who made this project possible.

BIBLIOGRAPHY AND REFERENCES

Agnew, J, 1987 *Place and Politics*, Allen and Unwin, Boston

Bennett, T, 1995 *The Birth of the Museum*, Routledge, London and New York

Black, G, 2010 Embedding Civil Engagement in Museums, *Museum Management and Curatorship* 25 (2), 129–46

Bourdieu, P, 1984 *Distinction: A Social Critique of the Judgement of Taste*, Harvard University Press, Cambridge, MA

Cresswell, T, 2004 *Place: A Short Introduction*, Blackwell, Oxford

DaCosta Kaufmann, T, 2004 *Toward a Geography of Art*, University of Chicago Press, London

Davis, P, and Huang, H-Y, 2010 Museums as Place, in *The Encyclopedia of Library and Information* Sciences, 3rd edn (eds M J Bates and M N Maack), Taylor and Francis, London and New York

Dibley, B, 2005 The museum's redemption: contact zones, government and the limits of reform, *International Journal of Cultural Studies* 8 (1), 5–27

Escobar, A, 2001 Culture Sits in Places: Reflections on Globalism and Subaltern Strategies of Localization, *Political Geography* 20, 139–74

Falk, J, 2009 *Identity and the Museum Visitor Experience*, Left Coast, Walnut Creek, CA

Fleming, D, 1992 Letter from Newcastle upon Tyne, *Museums Journal* (2), 56

Graham, B, Ashworth, G J and Tunbridge, J E, 2000 *A Geography of Heritage: Power, Culture and Economy*, Arnold, London

Hooper-Greenhill, E, 1994 *Museums and their Visitors*, Routledge, London and New York

Lavine, S, 1991 Museum Practices, in *Exhibiting Cultures: The Poetics and Politics of Museum Display* (eds I Karp and S D Lavine), Smithsonian Institution Press, Washington and London, 151–8

Leinhardt, G, Crowley, K and Knutson, K, 2002 *Learning Conversations in Museums*, Lawrence Erlbaum Associates, London

Lynch, B, 2010 *Whose cake is it anyway? A collaborative investigation into engagement and participation in 12 museums and galleries in the UK*, summary report for the Paul Hamlyn Foundation, available from: www.phf.org.uk/downloaddoc.asp?id=547 [13 December 2011]

Mason, R, 2007 *Museums, Nations, Identities: Wales and its National Museums*, University of Wales Press, Cardiff

Massey, D, 1991 A Global Sense of Place, *Marxism Today*, June, 24–9

Millard, J, 1992 Art History for all the Family, *Museums Journal* (2), 32–3

Pollock, V L, and Sharp, J P, 2007 Constellations of Identity: Place-Ma(r)king Beyond Heritage, *Environment and Planning D: Society and Space* 25, 1061–78

Sandell, R, Dodd, J, and Garland Thomson, R, 2010 *Re-Presenting Disability: Activism and Agency in the Museum*, Routledge, London and New York

Sheller, M, and Urry, J, 2006 The New Mobilities Paradigm, *Environment and Planning A* 38, 207–26

Simon, N, 2009 *The Participatory Museum* [online], available from: http://www.participatorymuseum.org/chapter1/ [15 March 2010]

Vogel, S, 1991 Always True to the Object, in our Fashion, in *Exhibiting Cultures: The Poetics and Politics of Museum Display* (eds I Karp and S D Lavine), Smithsonian Institution Press, Washington and London, 191–204

Watson, S (ed), 2007 *Museums and Their Communities*, Routledge, London and New York

Whitehead, C, 2005 *The Public Art Museum in 19th Century Britain: the development of the National Gallery*, Ashgate, Aldershot and Burlington, VT

— 2009 *Museums and the Construction of Disciplines*, Duckworth Academic Press, London

Survival Sex Work: Vulnerable, Violent and Hidden Lifescapes in the North East of England

CHRISTOPHER HARTWORTH, JOANNE HARTWORTH AND IAN CONVERY

INTRODUCTION

This chapter looks at survival sex work and is based on research in the North East[1] of England (along with findings from a peer-led project, Voices Heard, 2007). Survival sex is the practice of exchanging sex not only for money but also for a range of essential resources such as accommodation, drugs, food, laundry and tobacco. From our research (Hartworth 2009), we would estimate that over a thousand people are involved in survival sex work within the study area, either full-time or occasionally, both male and female (although predominantly the latter). Here we explore the lifescapes where people exist, why they came to exist there and the reasons why they remain there. Although this study is focused on the North East of England, there are similar populations living in cities across the United Kingdom who share this lifescape.

THE CONCEPTUAL FRAMEWORK

The concept of lifescapes has evolved within social anthropology (with much of the early work taking place in Burkina Faso) as a descriptive and analytic term used to frame how local communities interacted with their local environment (Nazarea et al 1998; Howorth 1999). These authors defined it as the social, cultural and economic interactions that occur across the landscape. In particular, it was used to explain how the social interacts with the physical to ensure livelihoods. The concept of lifescapes has been developed and applied to other groups in different countries, most notably by Convery et al (2008) in UK rural communities affected by the foot and mouth epidemic of 2001. Lifescapes are necessarily interactive; people and places are intimately interconnected and, as such, lifescapes provide an essentially phenomenological understanding of people–place dynamics. It also links with a substantial body of literature which explores the relationship between people and place. Convery et al (2008) discuss these links in great detail, highlighting how, for example, lifescapes have meaning in the transformations of social space which Bourdieu (1977) refers to as the habitus and in the phenomenology of perception discussed by Merleau-Ponty (1962). It can also be found in the *lifeview* literature of social archaeology (Bender 2001; Robin 2002) and the emotional landscapes literature of Gesler (1992; 1993; 1996), which empha-

1 For purposes here, the North East is made up of Darlington, County Durham, Northumberland and the five Tyne and Wear authorities. We have, however, specifically excluded Middlesbrough, as much is already known about sex work and street sex markets.

sises the importance of places for maintaining physical, emotional, mental and spiritual health. In geography, the lifeworld (Buttimer 1976 and later Seamon 1979) has been used as a means of drawing together the phenomenological with the existential to bring new meaning to emerging concepts of humanistic geography (Daniels 1994).

In this research we have taken the concept of lifescapes and applied it to a particular group of sex workers in the North East of England involved in 'survival sex'. However, as in most applications, the lifescape as a conceptual framework changes and here we are concerned less with interactions across a landscape and more with interactions across a community and individuals (although there are aspects of landscape which shape the lifescape – see Fig 12.1). However, the consistent similarity since the concept's development in Burkina Faso is that the lifescapes relate to subsistence and varying levels of social reproduction. This is no different in our current application; we are interpreting the lifescapes of those involved in survival sex as the social, cultural and economic interactions that occur across a group of people in order to meet subsistence needs.

THE RESEARCH

This chapter is based on data gathered from a qualitative knowledge mapping approach (including over 300 interviews with representatives from both statutory and non-statutory agencies that work with vulnerable groups)[2] and builds on our earlier work into sex work and exploitation in the North East.[3] The research used 'snowballing techniques' to recruit research participants. Snowball sampling is particularly effective in locating members of hard-to-reach populations where the focus of the study is on a sensitive issue (Hendricks and Blanken 1992). Data were analysed using the grounded theory constant comparison method, where each item is compared with the rest of the data to establish and refine analytical categories (Pope *et al* 2000). Themes emerged within individual interviews and across different interviews. Recurring themes across transcripts were taken to reflect shared understandings of the participants (Smith and Marshall 2007). The analysis presented here is based on our research in Darlington, County Durham, Northumberland and the five Tyne and Wear authorities as well as the peer-led research carried out by the Voices Heard (2007) group in Tyne and Wear. A full description and analysis of our methodology is found in Hartworth 2009.

THE SURVIVAL SEX LIFESCAPE

We are concerned here with one particular group of sex workers ('survival sex workers') and the lifescape they inhabit. We recognise that sex workers will inhabit different lifescapes, with corre-

[2] In this context, vulnerable groups include the homeless, problematic drug and alcohol users, those at risk of physical and sexual abuse, children in the looked-after system, asylum seekers and other groups who live on the margins of society.

[3] It has been possible to investigate survival sex markets in the North East through the interest and willingness of charitable funders, including The Scarman Trust and Northern Rock Foundation. The latter, through their Safety and Justice Programme, have funded our research into sex markets in the North East as well as funding voluntary sector providers to deliver services to those involved. Without the funding of research, it is likely that the majority of the survival sex lifescapes would have remained hidden and unknown. http://www.nr-foundation.org.uk/publications_think.html

sponding differences in characteristics and control. For example, in our research in the North East, we can roughly categorise the sex market into high, middle and low sections.

- The high section includes workers attached to certain escort agencies or independent workers who charge high fees (eg around £1500 for an overnight stay).
- The middle section includes independent workers, those attached to escort agencies and those working in most brothels. People working in this section of the market can be 'career' sex workers, or many simply drift in and out of sex work over considerable periods of time (when they need the money).
- The low section includes problematic drug users, failed asylum seekers and those working on the streets.

The socio-spatial organisation of sex work varies greatly across these groups, and while the high and middle sections described above have received much research interest (as have on-street sex markets) and have been heavily studied (see, for example, Bellis *et al* 2007; Hester and Westmarland 2004; Sanders 2005; 2006), survival sex workers have received scant attention. This is largely because this group are the hardest to reach and gain access to; they rarely access statutory services, there are high levels of criminality associated with their lives, they are socially isolated, being connected only to their own social networks, and they are less spatially defined than the other groups.

THE CHARACTERISTICS OF THE LIFESCAPE

Although those involved are not a truly homogenous group, individuals were found to share similar spaces, experiences and characteristics to the extent that it is possible to discuss them as a discrete group. Thus, as Hubbard and Sanders (2003) note, sex markets, like other spaces in the city, are created through different understandings, occupations and uses of space. Bailey *et al* (2010) also highlight how the spatial-cultural configuration of sex work is constituted by not only the places where sex is negotiated and transacted but also a range of other socio-cultural factors that together form a survival sex lifescape. Fig 12.1 summarises this lifescape and the following sections explore these experiences and characteristics further.

PROBLEMATIC DRUG USE

McKeganey (2006) notes that high proportions of sex workers are drug-dependent (see also Church *et al* 2001; El-Bassel *et al* 2001; Nadon *et al* 1998). Almost all survival sex workers in this study are problematic drug users and most report that drug use is the main reason for engaging in sex work. Substance misuse among this group is wide and varied, mostly being made up of poly substance use, and commonly includes alcohol, benzodiazepines, cannabis, cocaine, crack, heroin, methamphetamine and others. The main drug that must be taken regularly (mostly daily) is either crack or heroin (mostly the latter) and a high proportion (60 per cent and above) are injecting drug users. For many women with problematic drug use, sex work may be the only means by which to finance a drug habit and this often leads to the entrapment of women in sex work (Gossop *et al* 1994). Most survival sex workers have high drug spends, which compounds a low available income (Fig 12.2).

Over half of those women about which situations were known were problematic drug users. The nature of these exchanges varied greatly from some people with problematic drug use and chaotic lifestyles who were reported to exchange sex for drugs "*while under the influence*" or "*a shag for a bag*" to more stable drug users one of which was reported to describe herself as a "*high class prostitute*". There was evidence of women being coerced into sex work by their 'boyfriends' or partners for money with which to buy drugs, particularly heroin, and reports of women being forced into sex work as a result of loans that they had taken out for money with which to buy drugs.

There were numerous reports of people involved in sex work or exchanges with mental health problems. For example, one woman in her 30s was reported to suffer from depression and is known to be exchanging sex for money and alcohol. She lives in a flat whose tenants are mostly problematic drinkers. She is reported to have said "*they can do what they want to us*". There was another report of an escort who lived in S who was reported to be bipolar.

There were reports of directly related crime. For example, one agency had knowledge of one couple who were convicted of 'clipping' (the practise of luring a client to seemingly have sex with a prostitute and then the male partner threatening them and taking their money). In another similar case, a woman was reported by another agency to have sex with men in exchange for money and then her partner would threaten the men for more money.

'19 year old female who has been exchanging sex for money in Middlesbrough since she was 12 years old'

'A woman who had started work as a prostitute when she was 15 and was described as having a "*hugely troubled background*" and had current mental health problems.'

Sexual exchanges and sex work were identified with specific areas in X, particularly those associated with drug users. In these areas there were known to be "*slum landlords*", B&Bs and low rent housing and it was reported that "*there are a couple of streets C Road, S Road, N Road*". Such areas are likely areas for the location of brothels (low rent, unscrupulous landlords, absent tenancy agreements).

Friendships are quick to develop and often seemingly strong with a heightened distribution of essential resources. One professional said "*Networks are really quick to develop you can be from out of the area, then before you know it, they're best buds with them* [resident groups of homeless or drug and alcohol users]". A common adage amongst survival sex workers is reported to be 'there's nothing we won't do for each other'. However, these strong networks, whilst almost playing the role of ensuring social reproduction within the lifescape, also serve to entrap people within it. These networks serve to connect individuals to drug use and the associated way of living.

Another agency had knowledge of two cases of sexual exploitation in residential care homes in the last year. One case has been ongoing for three years and started when the girl was 14 years old. She was living in a care home and was frequently 'disappearing' and going missing. She would return to the home by taxi and would be in receipt of new items, such as mobile phones and money. When asked how did she afford the taxi fares home, she was reported to have said "*they owe me and my dad favours*". It was known that her father had previously been sexually exploiting her with his friends and this was the reason she was taken into care.

Mental & physical health

Drug & alcohol use – crime

Survival Sex Lifescape

History of abuse - local authority care

Location & poor housing

Social networks

FIG 12.1. SUMMARY OF SURVIVAL SEX WORK LIFESCAPE.

POOR AND UNSTABLE HOUSING

Survival sex workers typically live in a range of poor and insecure housing tenures, often provided by 'slum landlords' (Hartworth 2010; McKeganey 2006), or are homeless. In the North East, the most common types of accommodation among this group were hostels and bed and breakfasts. These tenure types are used either because people have been recently released from prison or they are in receipt of emergency housing from the local authority (owing to their homelessness). Other survival sex workers will 'sofa surf' or stay with clients, exchanging sex for accommodation. Those involved will commonly switch from living in poor accommodation to being homeless.

MENTAL HEALTH PROBLEMS

Most survival sex workers will experience a range of severe mental health problems as a direct result of their work. Disorders include depression, anxiety and panic, post-traumatic stress disorder and self-harming. Survival sex workers typically also have low self-confidence and self-esteem, which is attributed to their lifestyle, drug use and involvement within the sex industry. As a demonstration of this, the Voices Heard (2007) study found that most sex workers left their house only to work and to buy drugs and almost half of the respondents said that the only time they felt that they had confidence was with a client, feeling that a tentative client boosted self-esteem and confidence. Voices Heard then asked respondents what makes them happy outside of work and drug use:

> in reality the general feeling was that the respondents did not spend a great amount of time doing things which made them happy, concentrating more on survival, one person said 'I used to go into dancing competitions and I used to love it, I can't do it anymore cause I've got track marks up my neck and I'm completely ashamed of myself'. Other respondents said that they could not remember a time in their lives when they had been happy with others reporting drugs as the only thing that brings them close to happiness. Three respondents cited 'nice punters' as something that makes them happy. (Voices Heard 2007, 72)

Involvement in the sex industry and mental health problems have been well documented (El-Bassel *et al* 2001; Fullilove *et al* 1992; McKeganey 2006; Smith and Marshall 2007), but, from our research, they are more apparent in survival sex workers because of their living conditions, social isolation and low take-up of services.

POOR GENERAL HEALTH

Those involved in survival sex work typically suffer from poor general health. This includes trauma and physical pain connected with violent clients, high levels of sexually transmitted diseases (and a corresponding low uptake of sexual health services), a poor diet and a high drug intake (again with corresponding associated risks of blood-borne virus infection). Poor dental health is particularly associated with survival sex workers because of their drug use, poor oral hygiene and limited contact with dentists. Many sex workers have described carrying out dental procedures on themselves or each other; for example, one worker stated that 'I had to pull my wisdom tooth out with pliers ... my tooth had snapped in half so I went grafting got meself some coke and got my mate to take it out' (Voices Heard 2007, 45).

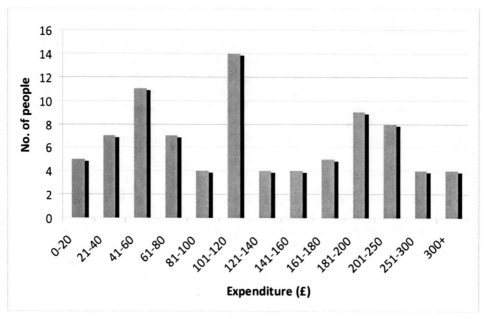

Fig 12.2. Daily drug spend (in sterling) for survival sex workers.

The Experience of Violence

Living with violence and its experience is common among survival sex workers and can take many forms, from direct violence from clients to domestic violence (Church *et al* 2001; May *et al* 1999). A selection of comments from research participants indicates such violence:

> I got burnt with fags cause I let this bloke tie me up for an extra 30 quid and he basically kept me the night and tortured me, took my clothes off and kicked me in the street.

> I got done in and I was really worried cause it was when my friend had just been murdered in bro' [Middlesbrough].

> I was raped while staying at a man's house I'd already gave him sex so that I could stay there he woke me up for sex again I said no he got violent raped me and hit me.

In the Voices Heard (2007) research, a total of 57 per cent of the sex workers reported experiencing physical pain (caused by assaults from clients) and a total of 41 per cent of people reported being in a violent relationship. Such violence rarely if ever gets reported to the police.

Low income

The majority of income earned through sex work is spent on drugs (Fig 12.2). In addition to the income gained from sex work, most survival sex workers will receive state benefits, either Income Support or Jobseeker's Allowance. This income will be supplemented through other means such

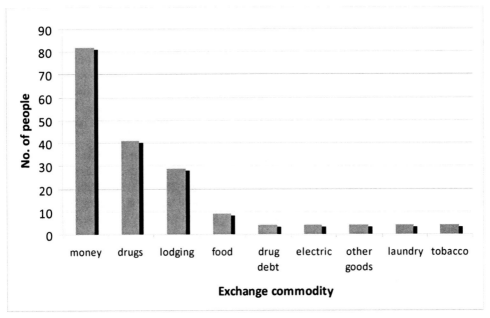

FIG 12.3. METHODS OF PAYMENT FOR SEX.

as begging or other illegal activities, including selling drugs, fraud/forgery, handling stolen goods, shoplifting, theft from property and vehicles and benefit fraud. The high amounts of daily drug spends leaves little money to spend on other essential life items and as a result of this sex is often exchanged for such items as food, laundry and tobacco (see Fig 12.3).

As already stated, those involved in survival sex are at the low section of the sex market and Table 12.1 shows the average and lowest prices which are charged for sex. It is fairly apparent that the lower prices can only be used for subsistence. Because of their problematic drug use, many of those involved will exchange sex for the value of a drug deal (eg a £10 bag of heroin).

Table 12.1. Sex prices (after Voices Heard 2007)

Description	Average price
Full sex[4]	£37 (lowest £5)
Oral sex	£18 (lowest £3)
Hand job	£11 (lowest £2)
Anal sex	£30 (lowest £5)
Watersports	£32 (lowest £10)

4 Penetrative vaginal sex.

ENTERING THE LIFESCAPE

People enter this lifescape through a series of routes, many of which are associated with histories of abuse. McKeganey (2006) reports from a study of street prostitution in Scotland, where for some of the women the decision to start working as a prostitute was shaped by early experiences of childhood sexual abuse. For many sex workers there is also a link to local authority care, often as a result of suffering abuse or neglect from their parents (40 per cent of those identified in the North East cohort). As Coy (2008) notes, the care system functions as a way of introducing girls to exploitative men and lifestyles.

Our research in the North East found many incidences of cases where children from the care system were involved in survival sex, as well as young adults who had been involved since a child (this concurs with national research: see, for example, Coy 2008; Davies 1998; Gibson 1995; El-Bassel *et al* 2001). These experiences of abuse commonly lead to risk-taking behaviour and substance misuse, another explanation given by people as to why they began survival sex work. The following two case studies illustrate some of these issues.

CASE STUDY: SEXUAL EXPLOITATION OF GIRL X

Girl X was 15 and living in supported accommodation in local authority 'a'. Suspicion was initially raised when she became involved in a relationship with a 20-year-old man and started using drugs, but not paying for those drugs. She started a friendship with another girl (who was on the Child Protection Register as at risk of sexual exploitation) from local authority 'b'. She started absconding from her supported accommodation and was known to be staying in local authority 'b' and involved in sexual exchanges. She was then raped by two men and, although she was taken to a paediatric unit, where she was shown to have serious internal injuries, and she made a complaint to the police, the case was not taken to court as 'it was thought that it wouldn't make a very good case ... she wouldn't make a very good witness' (Hartworth 2009, 29). She then went to live at a women's refuge in local authority 'c', near to three hostels. She then disclosed that she was having relationships with some residents of those hostels and once returned with bite and hand marks around her neck, although no complaint was made. She then started a friendship with a young woman at the refuge whose mother ran brothels and she disclosed soon after that she was working as a sex worker. She was moved out of the refuge and is now over 18 and pregnant and living back in local authority 'a'.

CASE STUDY: SEXUAL EXPLOITATION OF GIRL Y

Girl Y is an 18-year-old female who has been sexually exploited since she was 14 years old and is now pimped by her father and brother who also live in the same B&B. She works from the B&B and advertises both on the internet and in *The Sport*. It was reported that 'she doesn't like having sex without a condom but is sometimes forced to ... her father or brother negotiate a price with the customer over the phone on her behalf' (Hartworth 2009, 31). Girl Y has a dependency on heroin and her drug intake is controlled by her father depending on how much money she has earned. At the moment she injects around six times a day and has seen up to 14 clients in one day.

Some others have entered the lifescape as an adult because of drug addiction. The Voices Heard (2007) research showed that 43 per cent of their respondents (n=37) reported drugs to be the primary reason for first becoming involved:

I went out one night as rattling me arse off, some bloke asked if I was doing business, I did it, I cried all the way through and was so desperate to get away I forgot the money, it was the drugs not really me, it's as simple as that. (Voices Heard 2007, 67)

Others become involved through homelessness, as one respondent explained: 'I met a girl when lived on streets we were desperate so when she told me she did it I started doing it too.'

It is often the case with survival sex that people begin to enter the lifescape by engaging in sex work only occasionally; these are usually problematic drug users who engaged in such work when other forms of access to money were not available. However, this frequently leads to much greater involvement in sex work and some go on to become full-time sex workers.

LOCATIONS OF SURVIVAL SEX

The space in which sex work takes place is an integral part of why and how sex is sold in certain streets of cities and towns. Sanders (2004) argues that sex work locations are frequently the target of resources from public services, especially the growth of multi-agency partnerships and forums created to act upon what has historically been considered spoiled identities associated with drugs, disease, dysfunctional families and danger. As McKeganey (2006, 153) notes, sex work locations are typically described as having a 'very run down, derelict feel'.

McIlwaine (2006) states that involvement in the sex industry creates a different set of spatial aspirations and awareness among sex workers compared with those of the wider population and Hubbard and Saunders (2003) argue that sex workers are actively engaged in adapting and moulding the space so that they can successfully sell sex. While 'spatial shaping' is doubtless true of the higher and middle sections of the sex market, it is less prevalent among survival sex workers, who are as likely to be 'shaped by' the spaces they inhabit.

Accordingly, while sexual exchanges and sex work were identified with specific areas in the North East, particularly those associated with drug users, survival sex was also found to take place in a range of other locations, including the outdoors (parks, woodland, etc), cars, hostels, B&Bs, fast-food outlets (in rooms commonly at the back of such venues) and people's houses. Street-based male and female sex work was reported to be taking place in car parks, bus interchanges, around hostels, pubs, clubs and on the streets. The on-street areas are not traditional red-light areas and, in a seeming contradiction, they are not places where clients tend to go to buy sex, but are places where sex workers know they can go if they need to sell sex. It has been pointed out by a sex worker support project manager in Newcastle that, in all of these on-street locations, 'if you didn't know what you were looking for, you wouldn't know it's there' (Hartworth 2009, 20). The off-street locations, such as B&Bs, people's houses and hostels, are equally hidden and will only be known to those who purchase and sell sex.

SOCIAL NETWORKS

Very strong social networks exist among those involved in survival sex. Friendships are quick to develop and often seemingly strong, with a heightened distribution of essential resources. A common adage among survival sex workers is reported to be 'there's nothing we won't do for each other' and this is demonstrated by their sharing of essential resources (eg food and accommodation), helping another if they are financially able (eg with a train fare for an unexpected prison

visit) and the provision of care (after violent assault) and medical assistance (eg removing teeth). However, these strong networks, while almost playing the role of ensuring social reproduction within the lifescape, also serve to entrap people within it. These networks serve to connect individuals to drug use and the associated way of living and, when trying to stop drug use, these connections are almost impossible to maintain contact with. The resulting loss of social belonging and identity makes it very difficult for sex workers to leave the lifescape. Merleau-Ponty (1962, 286) describes the importance of belonging, of having a place in the world, and that without such social networks an individual is robbed of 'individuality and freedom ... I can literally no longer breathe'. Throughout our research, those few sex workers who have managed to leave the lifescape have reported that it was their social networks that made it so hard to get out. Without this social network they found it initially very difficult to negotiate the world outside of selling sex.

DISCUSSION

The lifescape that we have presented here is one of drug use and addiction, homelessness, poor health and violence. It is a lifescape shaped by the interpretation and negotiation of 'everyday places'. Cultural anthropologists Quinn and Holland (1987, 4) write about the 'presupposed, taken-for-granted models of the world that are widely shared by the members of a society and play an enormous role in their understanding of that world and their behaviour in it'. Such a view, according to Reybold (2002, 539), supports both a way of knowing and a way of being. Reybold refers to this as an individual's pragmatic epistemology, the experience of epistemology in everyday life. 'These ways of being shape both mundane daily routines as well as profound life experiences' and shape lifescapes.

We would argue that there is a need to better understand the value of 'everyday places', specifically the culturally specific dimensions of the links between well-being and place, and the significance of place in people's everyday lives. Within the last five years and particularly within the geographies of health, such work is beginning to emerge. For example, a mixed method study of four localities in two cities in the North West of England explores the links between place, health-related social action at the individual and collective level and lay knowledge. In so doing, the study questions how shared social meanings about a place, what the authors refer to as 'normative dimensions', may shape the way people respond to the everyday experiences of living in a particular place (Popay et al 2003).

Minh-ha (1994, 15) writes about how 'every movement between here and there bears with it a movement within here and within there'. Accordingly, McIlwaine (2006) notes how sex workers experience and construct urban spaces through residence and working patterns. On the one hand, they are constrained in their experiences of space. On the other, the construction of their own particular spaces reflects a high degree of resourcefulness and resistance. However, we would argue that, while spatial shaping is true of the higher and middle sections of the sex market, survival sex workers are more likely to be shaped by the spaces they inhabit.

Once again in this chapter we return to the work of Doreen Massey (1994; 2002), who states that rather than thinking of places as areas with boundaries around them, they can be imagined as articulated moments in networks of social relations and understandings. In this way the sex work lifescape is negotiated, shared and reaffirmed. Teo and Huang (1996, 310) state that place is an 'active setting which is inextricably linked to the lives and activities of its inhabitants'. Thus

place is also about situated social dynamics and is multi-dimensional, holding different meanings for different social groups. As we discussed earlier, 'if you didn't know what you were looking for, you wouldn't know it's [sex work] there'.

Earlier we wrote that the lifescapes concept links with a substantial body of literature which explores the relationship between people and place. In this chapter we have used lifescapes to try to articulate that which is the sum of a 'way of life'. Although it guarantees subsistence to those involved, it is a bleak lifescape and one that is difficult to escape, because people are trapped by addiction with few ways or means of an exit route. Leaving the lifescape is made harder by those networks that have supported those involved and made such a bleak life possible. This is compounded by its hidden nature; the majority of people do not know that the lifescape is there and this increases people's isolation and the difficulty of escape.

BIBLIOGRAPHY AND REFERENCES

Bailey, A, Hutter, I, and Huigen, P P, 2010 The Spatial-Cultural Configuration of Sex Work in Goa India, *Tijdschrift voor Economische en Sociale Geografie*, no. doi: 10.1111/j.1467–9663.2010.00607.x

Bellis, M, Watson, F, Hughes, S, Cook, P A, Downing, J, Clark, P, and Thompson, R, 2007 Comparative Views of the Public, Sex Workers, Businesses and Residents on Establishing Managed Zones for Prostitution: Analysis of a Consultation in Liverpool, *Health & Place* 13, 603–16

Bender, B, 2001 Landscapes on the move, *Journal of Social Archaeology* 1, 75–89

Bourdieu, P, 1977 *Outline of a Theory of Practice*, Cambridge University Press, Cambridge

Buttimer, A, 1976 Grasping the dynamism of lifeworld, *Annals of the Association of American Geographers* 66 (2), 277–93

Church, S, Henderson, M, Barnard, M, and Hart, G, 2001 Violence by clients towards female prostitutes in different work settings: questionnaire survey, *British Medical Journal* 322, 524–5

Convery, I, Bailey, C, Mort, M, and Baxter, J, 2008 Altered Lifescapes, in *From Mayhem to Meaning: the cultural meaning of the 2001 outbreak of foot and mouth disease in the UK* (eds M Döring and B Nerlich), Manchester University Press, Manchester

Coy, M, 2008 Young Women, Local Authority Care and Selling Sex: Findings from Research, *British Journal of Social Work* 38, 1408–24

Daniels, S, 1994 Grasping the dynamism of lifeworld (communication), *Progress in Human Geography* 18 (4), 501–6

Davies, N, 1998 *Dark Heart: The Truth about Hidden Britain*, Virago, London

El-Bassel, N, Simoni, J M, Cooper, D K, Gilbert, L, and Schilling, R F, 2001 Sex Trading and Psychological Distress Among Women on Methadone, *Psychology of Addictive Behaviors* 15, 177–84

Fullilove, M T, Lown, A, and Fullilove, R E, 1992 Crack 'hos and skeezers': Traumatic Experiences of Women Crack Users, *Journal of Sex Research* 29, 275–87

Gesler, W, 1992 Therapeutic landscapes: medical geographic research in light of the new cultural geography, *Social Science & Medicine* 34, 735–46

— 1993 Therapeutic landscapes – theory and a case study of Epidauros, Greece, *Environment and Planning D* 11, 171–89

— 1996 Lourdes: healing in a place of pilgrimage, *Health & Place* 2, 95–105

Gibson, B, 1995 *Male Order: Life Stories from Boys who Sell Sex*, Cassell, London

Gossop, M, Powes, B, Griffiths, P, and Strang, J, 1994 Sexual behaviour and its relationship to drug-taking among prostitutes in South London, *Addiction* 89, 961–70

Hartworth, C, 2009 *Hidden Markets – Sex Work in Northumberland and Tyne and Wear*, Think 4, Northern Rock Foundation, Newcastle upon Tyne

Hendricks, V M, and Blanken, P, 1992 Snowball sampling: theoretical and practical considerations, in *Snowball Sampling: A Pilot Study on Cocaine Use* (eds V M Hendricks, P Blanken and N Adriaans), IVO, Rotterdam, 17–35

Hester, M, and Westmarland, N, 2004 *Tackling Street Prostitution: Towards a Holistic Approach*, Home Office Research Study No 279, Home Office, London

Howorth, C, 1999 *Rebuilding the local landscape*, Ashgate, Aldershot

Howorth, C, and O'Keefe, P, 1999 'Farmers do it better: Local management of change in Southern Bukina Faso', *Land Degradation and Development* 10, 93–109

Hubbard, P, and Sanders, T, 2003 Making space for sex work: female street prostitution and the production of urban space, *International Journal of Urban and Regional Research* 27, 73–87

McIlwaine, C, 2006 The Negotiation of Space among Sex Workers in Cebu City, The Philippines, *Singapore Journal of Tropical Geography* 17, 150–64

McKeganey, N, 2006 Street Prostitution in Scotland: The Views of Working Women, *Drugs, Education, Prevention and Policy* 13, 151–66

Massey, D, 1994 *Space, Place and Gender*, Polity Press, Cambridge

— 2002 Globalisation: What does it mean for geography? Keynote lecture presented at the Geographical Association Annual Conference, 3–5 April, UMIST, Manchester

May, T, Edmunds, M, and Hough, M, 1999 Street business: the links between sex and drug markets, *Police Research Series Paper* 118, Home Office, London

Merleau-Ponty, M, 1962 *Phenomenology of Perception*, Routledge & Kegan Paul, London

Minh-ha, T, 1994 Other than myself/my other self, in *Travellers Tales* (eds G Robertson, M Mash, L Tickner, J Bird, B Curtis and T Putnam), Routledge, London, 9–26

Nadon, S M, Koverola, C, and Schludermann, E H, 1998 Antecedents to Prostitution: Childhood Victimization, *Journal of Interpersonal Violence* 13, 206–21

Nazarea, V, Rhoades, R, Bontoyan, E, and Flora, G, 1998 Defining Indicators Which Make Sense to Local People: Intra-Cultural Variations in Perceptions of Natural Resources, *Human Organisation* 57 (2), 159–70

Popay, J, Thomas, C, Williams, G, Bennett, S, Gatrell, A, and Bostock, L, 2003 A proper place to live: health inequalities, agency and the normative dimensions of space, *Social Science & Medicine* 57, 55–69

Pope, C, Ziebland, S, and Mays, N, 2000 Qualitative research in health care: Analysing qualitative data, *British Medical Journal* 320, 114–16

Quinn, N, and Holland, D, 1987 *Cultural models in Language and Thought*, Cambridge University Press, New York

Reybold, L E, 2002 Pragmatic epistemology: ways of knowing as ways of being, *International Journal of Lifelong Education* 21, 537–50

Robin, C, 2002 Outside of houses, *Journal of Social Archaeology* 2, 245–68

Sanders, T, 2004 The Risks of Street Prostitution: Punters, Police and Protesters, *Urban Studies* 41, 1703–17

— 2005 *Sex Work – A Risky Business*, Willan Publishing, Devon

— 2006 Sexing Up the Subject: Methodological Nuances in the Female Sex Industry, *Sexualities* 9, 449–68

Seamon, D, 1979 *A geography of the lifeworld*, St Martin's, New York

Smith, F M, and Marshall, L A, 2007 Barriers to Effective Drug Addiction Treatment for Women Involved in Street-level Prostitution: A Qualitative Investigation, *Criminal Behaviour and Mental Health* 17, 163–70

Teo, P, and Huang, S, 1996 A Sense of Place in Public Housing: A Case Study of Pasir Ris, Singapore, *Habitat International* 20, 307–25

Voices Heard, 2007 *Hidden for Survival: Peer Research into the Lives of Sex Workers Within Newcastle, Gateshead, Sunderland, South Tyneside and North Tyneside*, Tyneside Cyrenians and Counted 4, Newcastle upon Tyne and Sunderland, UK

Wilson, K, 2003 Therapeutic landscapes and First Nations peoples: an exploration of culture, health and place, *Health & Place* 9, 83–93

Gardens, Parks and Sense of Place

Ian Thompson

Gardens are instances of an uncommon collaboration between nature and culture, between living materials and the human imagination. For the most part they are site-specific, in that they are made in a particular place, with a particular topography, a particular climate and particular soils which limit the range of plants which may grow there; and, although human ingenuity has frequently prompted the owners and designers of gardens to push hard against these constraints (Louis XIV being an extreme example of this inclination), successful gardens are often a concentration of place. Public parks, whose design lineage can be traced to the landscape gardens of country estates, often provide communities not only with a place for recreation and contact with nature but also with a repository for collective memories. This chapter will examine the complex relationship between the garden, the park and broader notions of open space, landscape and place.

THREE NATURES

Cicero, in describing landscape, wrote: 'We sow corn, we plant trees, we fertilize the soil by irrigation, we dam the rivers and direct them where we want. In short, by means of our hands we try to create as it were a second nature within the natural world.' As John Dixon Hunt remarks in *Greater Perfections*, his history of garden theory, Cicero's statement implies the existence of a 'first nature' unaffected by human activities, within which this humanised landscape can sit. Second nature comes into being as the result of human needs and purposes and includes not only the landscapes of cultivation, agriculture and forestry but also our towns and cities and the entire infrastructure of roads, railways, ports, bridges and pipelines which maintains human habitation. Following two Italian Renaissance humanists, Bartolomeo Taegio and Jacopo Bonafadio, Hunt then postulates that gardens constitute a 'third nature' in which nature and culture are deliberately mixed (Hunt 2000, 32–5).

These 'three natures' provide us with a useful starting point for classifying landscapes. 'First nature' can be regarded as what we might now call wilderness. Whether our ethics and aesthetics are anthropocentric or ecocentric, this category contains landscapes we are likely to value and want to conserve, although it might be argued that there are no true wildernesses remaining, since human-generated climate change already affects the whole of the planet. 'Second nature' can be thought of as the cultural landscape. Much of this was created without aesthetic intent (or aesthetic concerns were subsidiary to economic or practical ones), yet we have come to value it aesthetically, so we seek to conserve such things as vernacular buildings, dry-stone walls, old vineyards and ancient olive groves and are troubled when new practices, techniques or materials (such as poly tunnels or the grubbing up of hedgerows) threaten to alter the character of landscapes which are familiar and cherished.

'Third nature' is different in that the outdoor places human beings make specifically for their pleasure *are* designed with aesthetic intent, though they often employ mimesis, borrowing features both from first nature and from second nature. A garden cascade is a representation of a waterfall, a rill is a stream, a rockery is a rocky hillside and a grotto is a cave. Japanese gardens, in particular, are often representations in microcosm of larger landscapes. Thus the truncated cone of sand that stands next to the Sea of Silver Sand in Ginkaku-ji, the Garden of the Silver Pavilion at Kyoto, is said to resemble the volcanic peak of Mount Fujiyama, while the Mirror Lake in front of the Golden Pavilion at Kyoto is said to represent the Seto Inland Sea, with rocks standing for its many islands. Regular groves of trees, such as may be found in formal gardens in the West, make reference to orderly orchards and plantations. The canals of Persian gardens may be given cosmological significance, but they are also versions of the *qanats* and *jubs* of traditional irrigation systems.

While broadly useful, this classification is fuzzy because practical and aesthetic intentions can often go hand in hand. Parks, squares and gardens may clearly be 'third nature', but any comprehensive typology of green spaces would also have to include such areas as cemeteries, allotments, botanic gardens, motorway verges, canal towpaths, school grounds, university campuses, business parks and so on. These may be functional places, but aesthetics have very often played a part in their design, and members of my own profession of landscape architecture may well have been involved in their layout.

Nor can we overlook the fact that many perfectly utilitarian and often quite humble buildings and everyday landscapes have tremendous aesthetic appeal. The design theorist Christopher Alexander said that they exhibited 'goodness of fit' (Alexander 1964), a quality that could only be produced by a process of incremental improvement of the building type over successive generations. Architects working at speed in an office could never achieve it. David Pye, who was Professor of Furniture Design at the Royal College of Art, argued that even the most functional of designs could show qualities of workmanship, which is an aesthetic consideration (Pye 1978). So the distinction between second nature and third nature is not clear-cut.

For the rest of this chapter I am going to put first nature to one side, but not because the protection of wildernesses is unimportant. It is clearly of great concern, not only on environmental grounds but also for aesthetic and spiritual reasons. Few of us may ever visit a true wilderness, but these places are part of our natural heritage and it seems to be important to us, and in some way reassuring, to know that such places still exist. However, I want to focus here upon our cultural heritage, paying particular attention to those places which have been consciously designed for pleasure and thus belong squarely within third nature. How do such places embody or contribute to a 'sense of place'?

THE *GENIUS LOCI*

'Sense of place' is a contemporary reformulation of ancient notions of 'spirit of place' or *genius loci*. The latter is an animistic idea, the roots of which are lost in prehistory, though it is frequently associated with the Romans, for whom the *genius loci* was a kind of protective spirit dwelling in a particular place. This idea was revivified in 18th-century landscape theory when authors such as the Earl of Shaftesbury and Alexander Pope stressed the need for garden designers to respect the inherent, pre-existing qualities of a site. Shaftesbury (Anthony Ashley Cooper) was a philosopher of aesthetics who linked beauty with moral virtue. Pope was a poet and a pioneering

landscape gardener: his injunction, delivered in a line of his *Epistle to Lord Burlington* (Pope 1731) was to 'consult the genius of the place in all', and this fundamental principle of dialogue has resounded through the subsequent history of garden design and landscape architecture, particularly in English-speaking countries.

In her review of the 'nexus of ideas' associated with the term *genius loci*, the philosopher Isis Brook noted a proliferation of definitions, ranging from animistic beliefs involving goddesses, sprites and fairies to notions of essence, pantheism, 'placemind', authenticity, narrative, local distinctiveness, ecosystem, essence and character, before concluding that 'spirit of place' was more than a missing referent or a useful myth, but really did describe something real, an emergent quality that could not be enumerated among the contents of a place or among descriptions of our feelings about it (Brook 2000).

For my own part, I find *genius loci* useful as a near synonym for 'character', which avoids the supernatural connotations but accepts that sometimes we use the same words to talk about places as we do about people – so a beach may be jolly and a garden serene. The analogy between places and people can be helpful, up to a point. Just as an individual's personality is regarded as something relatively stable and different from their fluctuating moods, so the character of a place can be regarded as relatively enduring, even though it may seem different at different times of day, in different seasons or in different weather conditions. The square which is home to a genteel antiques market during the day can become a boisterously festive place in the evening. And just as a person's character might be altered by a traumatic event, so too can the character of a place be drastically altered by industry or development. Consider, for example, how mining has altered the face of the countryside in any coalfield district. Reclamation, again by analogy, can be seen as a sort of therapy, during which a new and different character can be established. As practised in the second half of the 20th century, reclamation often meant the obliteration of both the original character and all traces of the industrial phase. Nowadays it would be more common to build the new character out of surviving fragments of the pre-industrial original, together with the accrued cultural and ecological assets of the industrial phase. But, as Brook cautions, this sort of anthropomorphising of place also has perils. It is important to keep in mind that we are using a metaphor. We need to be able to see a place as the thing it is and not as a sort of person.

Returning to Pope's injunction, the central idea – another anthropocentric one – is that there should be a dialogue between the designer and the site. Pope's guidance to the designer was to *consult* the genius of the place, which does not suggest a deterministic outcome. One of the most important late 20th-century theorists of landscape architecture, Ian McHarg, advocated a process, modelled on science, which was essentially deterministic, to the extent that McHarg thought that any two designers presented with the same site, the same brief and the same survey data, ought to come up with the same design solution. That such a view could have any purchase demonstrates something about the dominance of scientific paradigms at the time, but it was never a view that could stand up. As Tom Turner, who teaches landscape architecture at the University of Greenwich, has written, design interventions can try to merge seamlessly with the pre-existing character, they can pursue a strategy of similarity, or they can respond to the site with a strategy of difference (Turner 1996, 108–12). All of these, and myriad amalgamations of them, are possible outcomes of the consultation with the *genius loci*. He is also right when he suggests that the modern-day conversation with the site has often become a study of data sets and sieve maps, and that the accumulation of detailed information can sometimes blur the essential character of the site, which is to be intuited by other means.

What is a Garden?

Gardens are so various in type and form that it can be difficult to define just what a garden is. The first designed landscapes were either clearings in a forest or walled gardens which created paradisiacal conditions in the midst of a desert. Writers on garden history like to point out the etymology of the word, noting that the Latin *gardinium* meant an enclosure, while the Old English word *geard* (also meaning fence or enclosure) became 'yard', which in American English is a garden. Meanwhile, the Dutch word for garden is *tuin* and is related to the Old English word *tūn*, which, again, means an enclosure. Clearly the idea that a piece of land is cleared, taken in and enclosed (from first or even second nature) seems central, but etymological origins do not necessarily reflect subsequent usage.

The concept of 'borrowed landscape', found both in oriental garden traditions and in the landscape gardens of 18th-century England, undermines the idea of enclosure. Gardens were designed to appropriate views that lay beyond the ownership boundary of the garden. It may not be clear at all, in such cases, where the garden ends and the surrounding landscape begins. Nor does a garden have to be out of doors; winter gardens are housed in glasshouses.

Similarly, a lay person might easily seize upon the idea that a garden is concerned with the production or display of plants, but in Chinese gardens more attention is paid to interestingly shaped rocks, while in the celebrated dry garden of Ryoan-Ji in Kyoto, Japan, there are almost no plants at all, apart from some circles of moss around the carefully placed stones. The avant garde designer Martha Schwartz, who came into garden and landscape design from art practice, often deliberately eschewed plants, using artificial turf, plastic trees and empty plant pots in her wittily subversive designs.

Can some definition be found which divides those places which are gardens from those which are not? It does not seem like an unreasonable request, until one recalls that Wittgenstein, in his *Philosophical Investigations*, was unable to do so for the concept of a 'tool' (some tools cut, but not all; most manipulate material, but what about a ruler or a plumb line?) (Wittgenstein 1953). Wittgenstein found it more useful to talk in terms of 'family resemblances' and perhaps that is true also of the places we would like to call gardens. There is probably no single characteristic which defines a garden. Moreover, there are Wittgensteinian family resemblances not just between different sorts of gardens but also between all of the sorts of places that comprise third nature, including parks, squares and pleasure grounds, and beyond into second-nature sites like business parks, cemeteries and transport corridors. The best that can be said is that gardens are to be found at the nucleus of this web of familial relationships and similarities.

The Significance of Gardens

On the grounds that some gardens are microcosms of larger landscapes, and taking further support from the tradition of the *genius loci*, it might be tempting to argue that gardens are always a concentration of place, and that their creators' skill lies in the distillation of the essence of the surrounding landscape. While this might be true of some gardens, a moment's reflection on garden history shows it to be untrue of many more. Islamic gardens were not a distillation of desert scenery, but a reaction against its harshness, and throughout history the owners and designers of gardens have often borrowed from other cultures and traditions. An early example is the pool known as the Canopus at Hadrian's Villa near Tivoli, which was an attempt to recapture

the Emperor's memories of a visit to the Nile: gardens can be created as souvenirs of places other than the places in which they are made.

The styles associated with cultural ascendancy have always tended to be copied, so, for example, in the 17th century, French garden designers adopted from Italy the Renaissance tradition which had been culturally pre-eminent for the previous two centuries, but they then adapted Italian garden ideas to a different topography. Italian gardens had been built on hillsides close to important cities such as Rome, whereas the most important French gardens were created in the relatively flat landscape of the Île de France. There was innovation, with expansive canals and reflecting basins of water becoming the hallmarks of a style which reached its apotheosis in the gardens of Versailles, which then, in turn, became an enduring model for courtly gardens outside France. It was not only copied throughout the many states of pre-unification Germany, but also in Spain (La Granja), in Russia (Petrodvorets) and in Austria (Schönbrunn). A century later the plan of Versailles would be the principal influence on L'Enfant's city plan for Washington DC.

The influence of oriental gardens in the development of the English Landscape School of the 18th century has probably been overstated, but what is undeniable is that the English imported the Palladian country house, itself a reinterpretation of classical architecture, from Italy, and placed it in a relaxed style of garden which was a conscious rejection of French formalism. Thus a new naturalistic style was developed (which the French dubbed the *jardin anglo-chinois*), which in turn became a cultural export, so that such gardens were created not only by Marie Antoinette at Versailles, but also by Count Rumford in Munich (Englischer Garten) and by Leopold III, Duke of Anhalt-Dessau, at Wörlitz. This sort of borrowing, cross-fertilisation and hybridisation has occurred throughout garden history and it undermines the notion that any particular style of gardening is uniquely linked to a particular place or time. A Dutch landscape academic, Han Lorzing, has plotted many recognised styles and types of garden against two axes, one running from 'man-made' to 'natural', the other from 'native' to 'foreign', to produce a classification system with four categories: 'Traditional' and 'Ecological' designs are rooted in the local ecology and vernacular practices, whereas 'Rational' and 'Romantic' designs – which are respectively artificial and idyllic – are not. While such styles may have their origins in particular places, they become deterritorialised and can ultimately be made anywhere. In his 'park shift map', Lorzing has also attempted to map the European migrations of some such styles, including the English Landscape style, the Cottage Garden style, the French Baroque and the Scandinavian Volkspark (Lorzing 2001).

This raises questions about the attribution of 'authenticity' to a garden, or, conversely, to the labelling of a garden as 'inauthentic', 'derivative' or 'kitsch'. Perhaps there is nothing more kitsch than building a large pool near Rome and saying that it resembles the Nile. Western attempts to create Eastern gardens are often criticised because they are considered not to use authentic materials, evince some shortcomings in workmanship or technique, or fail to interpret underlying principles or beliefs. But *chinoiserie*, considered as a Western phenomenon born of stylistic migration, comes to have value in its own right and thereby becomes something which we make efforts to conserve as heritage.

Another pervasive idea associated with gardens is that, since they are natural places transformed by human artifice, they inevitably signify something about the relationship between human beings and the natural world, and this inevitably raises their significance. In the case of useful sorts of gardens, such as botanic gardens, nursery gardens and potagers, this relationship may be unwittingly revealed or it may be celebrated, as nature is probed, investigated, manipu-

lated or harnessed to production. Different possibilities might be suggested by gardens which are not practical in this way, but were created to give pleasure or to convey philosophical or political ideals. Gardens, as in ancient Rome or Ming and Qing dynasty China, have sometimes been places where the world-weary have retreated from the hurly-burly of political life to live in closer association and harmony with the natural world. On the other hand, in the gardens of Versailles, with their ordered plan, clipped hedges and geometrical topiary, the symbolic relation between humans and nature is brought to the fore in an entirely different way; it is the human dominion of nature which is celebrated, with evidence provided at every turn of the way in which nature can be shaped to human purposes. A naturalistic garden, such as the 20th-century Thijsse Park at Amstelveen, just outside Amsterdam, appears different again. Here plants grow in their natural forms and their natural associations and the scenes created look like those we might expect to find in nature. However, the Thijsse Park requires high levels of maintenance to preserve its habitat diversity and its look of nature, so all is not quite as it seems. The difference, though, is that, where a formal garden like Versailles deliberately draws attention to artificiality and the role of human intervention, in the Thijsse Park the idea is that the human involvement should be as inconspicuous as possible.

The Grand and the Vernacular

There is also an issue of scale; how big must a garden be before we start to refer to it as a park or as a landscape? Many family gardens, like most family homes, are not bespoke creations. Though single houses do feature in architectural histories, the houses in which most of us live are either builders' standard house types or the result of vernacular traditions. Something similar is true of most small gardens, few of which have been laid out by a professional designer, although the tradition of advice to homeowners which began with J C Loudon's *The Suburban Gardener* and *Villa Companion* (Loudon 1838) continues today in countless magazine articles, books and TV garden makeovers. Loudon was a Scottish garden designer who established himself in London, where he became a prolific writer on parks, gardens and city planning.

Loudon's book was squarely aimed at the middle classes, who did not own a park, estate or demesne. The sorts of gardens which have tended to be of most interest to garden historians, however, have belonged to the upper echelons of society, to royalty or landed aristocrats who had the wealth, power and resources to garden at a grander scale – indeed the word *grandeur* is often associated with such places. Such historians, whose approach was initially shaped by scholarship in art and architectural history, have tended to be interested in the layout of larger gardens by named designers and in the careers of those designers. As with architectural history, much effort has been put into the identification of styles, correct attribution of designers, identification of influences and commentaries upon underlying themes and meanings.

It took resources and power to create such large-scale gardens. At one time during the construction of Versailles, for instance, 36,000 men, the majority of them soldiers, were employed in earthworks and engineering projects related to the gardens. Garden designs themselves carry messages about power, status and politics. Louis XIV's gardens were intended to impress his own courtiers and visiting ambassadors with the *gloire* of France, personified in the king. The landed estates of English aristocrats in the 18th century, conversely, were the *seats* of their power and, in developing them along lines which, in their supposed naturalness, were the antithesis of the

style associated with Louis XIV, they were making a political assertion about their independence from the monarchy.

The art-historical approach to gardens studies now seems tired and interest has shifted towards the social aspects of garden-making. In the case of Versailles, for example, the move is illustrated by the publication of Garrigues' *Jardins et Jardiniers de Versailles au Grand Siecle* (Garrigues 2001), which was devoted not to analysis of design or to the biography of Versailles' principal designer, Andre Le Notre, but to the working lives and practices of the various contractors and under-gardeners who physically created and maintained the gardens. In similar vein, Quest-Ritson's popular *The English Garden: A Social History* (Quest-Ritson 2001) set out to put the history of gardening into its social and economic context. Vernacular gardens, meanwhile, have been studied by both cultural geographers and garden historians. In 1993 Dumbarton Oaks published papers from a symposium on *The Vernacular Garden* held three years earlier (Hunt 1995), and a decade later a whole issue of the *Geographical Review* (2004) was dedicated to the same topic. The geographer David Crouch has also written extensively about the history and the future of the allotment garden (Crouch and Ward 1988). This now well-established theme is a corrective to the study of garden or landscape design as a high art, as it foregrounds garden-making practices which have no place in the canon.

GARDENS AND PLACE-MAKING

We have seen that the term 'garden' covers a wide range of cultural objects, linked together by a web of family resemblances, that these objects often, but not necessarily, represent wider land-scapes through mimesis, that they can embody a range of responses to the *genius loci*, including design strategies of deliberate contrast, that they often, though again not necessarily, involve the borrowing and sometimes the hybridisation of existing styles from elsewhere, that they often represent symbolically social relationships or the relationship between humans and the nature. It is also worth pointing out that there is a necessary connection between making a garden and making a place. A quick thought experiment shows that it is impossible to think of a successful garden without concluding that that it is also a successful place. Indeed, making a successful garden is a sufficient condition – though not a necessary one – for making a successful place. This logical underpinning says nothing about the temporal sequence that might be involved and I suspect that in most cases the garden-making and the place-making occur hand-in-hand. 'Capability' Brown did not call himself a landscape gardener, but liked to be known as a 'place-maker'. Professor Hunt believes that gardens are privileged because they are a concentrated or perfected form of place-making (Hunt 2000, 11).

And, since the goal of much urban planning is to create a sense of place, it is not surprising, therefore, to find that the construction of gardens or their near cousins, city parks and city squares, has often played a central role in the layout of new urban areas or the reconfiguration of old ones. I have already alluded to Versailles' role as the prototype for Washington DC, but its axial design was also an influence on the City Beautiful plans for a host of North American cities, including Chicago, Cleveland, Denver and San Francisco, as well as on colonial plans for Lusaka and New Delhi and 20th-century totalitarian visions for Moscow, Berlin and Rome. Meanwhile, the English country house in its landscaped park was brought to town by entrepreneurs such as John Nash (1752–1835), who laid out Regent's Park as part of his plan for the development of

West London. In similar vein, John Wood II (1728–1781) built the Royal Crescent and Circus in Bath, where elegant townhouses enjoyed a view over park-like open space.

In Britain, official recognition of the need for public parks came in 1833 in the form of a parliamentary report from the Select Committee on Public Walks, which argued that densely packed urban populations needed opportunities for fresh air, exercise and contact with nature. This ushered in a pioneering era for the creation of public parks in the 1830s and 1840s, but new parks continued to be laid out until the advent of World War I. The initial impetus was for *rus in urbe*, the countryside in the town, with country house landscapes and London's royal parks providing the necessary design templates. Later the *Gardenesque* style made popular by Loudon took over, with municipal gardeners competing to produce the most spectacular displays of horticulture and mosaiculture. Parks were places for the display of civic pride, for the commemoration of victories or tragedies (think of the number of war memorials which are located in parkland), and also operated as metaphors for social order, with neatly maintained borders, clipped shrubs and polite promenaders kept in their place by bye-laws and signs which said 'Keep Off the Grass'.

Changing mores, combined with straightened economic circumstances, put much of this in danger in the 1980s, when public parks became the Cinderellas of free-market ideology, but it is now generally recognised that they contribute hugely to the quality of life in our cities. In Britain such recognition now comes with a heritage listing in the Register of Parks and Gardens of Historic Interest, maintained by English Heritage,[1] through the Green Flag[2] scheme which recognises good management and maintenance and, in the case of new or regenerated parks and squares, through recognition by the Commission for Architecture and the Built Environment, which from 1999 to 2011 gave independent advice on making better buildings and places.[3] Also worthy of mention is the website of the Project for Public Spaces,[4] which is based in the United States but aims to be global in its coverage.

In Britain the Heritage Lottery Fund, formed to distribute some of the proceeds from the National Lottery, launched its Urban Parks Programme in 1996 with a budget of £50 million for its first three years. People proved enthusiastic about improvements in their local parks and the HLF found that it had hit upon a popular success. The restoration and conservation of historic parks had moved well up the official agenda. The UPP and its successor programmes, the Urban Parks Initiative and Parks for People, have invested over £400 million of HLF funds in the improvement of 275 parks and largely reversed the decline that was apparent in earlier decades (RUDI n.d.). It remains to be seen whether current levels of support are sustained in the more straightened economic circumstances which seem to be upon us.

Meanwhile, the creation of new parks (and new heritage) has been at the forefront of recent urban regeneration projects. Noteworthy European examples include the Parc de la Villette (Paris 1987), created on the site of a former cattle market, the Harbour Park (Copenhagen 2000), created on a disused quayside, and Thames Barrier Park (London 2000), built on brownfield land beside the River Thames.

Though such new parks are celebrated in the design journals of my profession, the real measure of their success will come only with time. Will they be taken to heart by their users? Will they

1 http://www.english-heritage.org.uk/server/show/nav.1411 [7 December 2009].
2 http://www.keepbritaintidy.org/GreenFlag/ [9 December 2009].
3 http://www.cabe.org.uk/ [9 December 2009].
4 http://www.pps.org/ [9 December 2009].

offer the direct encounters with nature, with the weather and with the changing seasons that parks have traditionally offered? Will they provide opportunities for sport and recreation and for a sense of sociability and shared experience? Will they became places which people remember and care about? A design passes out of a designer's hands and becomes public, subject to change, adaption, unforeseen uses, vagaries of maintenance, but it is every designer's hope that this new intervention in collective space will acquire the characteristics of a distinctive place and will thus be cherished for generations.

BIBLIOGRAPHY AND REFERENCES

Alexander, C, 1964 *Notes on the Synthesis of Form*, Harvard University Press, Cambridge, MA

American Geographical Society, 2004 *The Geographical Review* 94 (3), July, 263–414

Brook, I, 2000 Can Spirit of Place be a Guide to Ethical Building? in *Ethics and the Built Environment* (ed W Fox), Routledge, London

Crouch, D, and Ward, C, 1988 *The Allotment: its landscape and culture*, Faber and Faber, London

Garrigues, D, 2001 *Jardins et jardiniers de Versailles au Grand Siècle*, Champ Vallon, Seyssel

Hunt, J D (ed), 1995 *The Vernacular Garden*, Dumbarton Oaks Colloquium Series in the History of Landscape Architecture 14, Harvard University Press, Cambridge, MA

— 2000 *Greater Perfections: The Practice of Garden Theory*, University of Pennsylvania Press, Philadelphia

Lorzing, H, 2001 *The Nature of Landscape, A Personal Quest*, 101 Publishers, Rotterdam

Loudon, J C, 1838 *The Suburban Gardener and Villa Companion*, Longman, Orme, Brown, Green and Longmans, London

Pope, A, 1731 *An epistle to the Right Honourable Richard Earl of Burlington: Occasion'd by his publishing Palladio's Designs of the baths, arches, theatres, &c. of ancient* Rome, printed for L Gilliver, London

Pye, D, 1978 *The Nature and Aesthetics of Design*, Van Nostrand Reinhold, New York

Quest-Ritson, C, 2001 *The English Garden: A Social History*, Viking, London

RUDI (Resource for Urban Design Information), n.d. *Heritage Lottery Fund and its parks programme*, available from: http://www.rudi.net/node/16662 [7 December 2009]

Turner, T, 1996 *City as Landscape*, Routledge, London

Wittgenstein, L, 1953 *Philosophical Investigations*, Blackwell, Oxford

Gardens: Places for Nature
and Human–Nature Interaction

PAUL CAMMACK AND IAN CONVERY

The 20 million or so private domestic gardens in Britain are important sites of both leisure activity and conservation interest. They occupy more than ten times the area of protected nature reserves (Loram *et al* 2005; Bhatti and Church 2000; 2001) and they are important sites for several species of conservation concern, such as the song thrush (*Turdus philomelos*) and house sparrow (*Passer domesticus*) (Gaston *et al* 2005; Bland *et al* 2004). Moreover, birdwatching is an important leisure pursuit in Britain: around 10 per cent of the population engage in bird-watching on an occasional or regular basis and approximately 50 per cent provide food for birds (Bargheer 2008; Rotherham *et al* 2004). However, despite the importance of gardens as sites of environmental interest and birdwatching as a leisure activity with connections to environmental conservation, there have been relatively few studies linking leisure activities and environmental management to domestic locations (Rotherham *et al* 2004).

Indeed, as sites of conservation interest, gardens can be seen as key locales for debates about nature and wider environmental issues, as they link 'nature, everyday social worlds and micro-geographies' (Bhatti and Church 2001, 366; Head and Muir 2006; Askew and McGuirk 2004). Such debates need to consider the spatial element of different human activities and how activities influence the transformation of nature and spaces (King 2003). Smith (2002, 3) writes that the transformations of social space central to Bourdieu's *habitus* (a 'coping-mechanism' that enables us to respond immediately and appropriately to the circumstances of everyday life) are fostered by particular social practices and the adoption of particular dispositions towards one's surrounding environment, including the relationship between humans and the natural world. However, many empirical analyses of nature and everyday life tend to focus on non-domestic spaces, largely ignoring everyday spaces such as domestic gardens, which are important because of their tenure and ownership and their connections to home and identity. Gardens are interfaces between domestic, private uses of space and the social and cultural expectations of conformity regarding that space (Head and Muir 2006; Askew and McGuirk 2004). Gardens also reflect a tension between 'natural' and 'artifactual' (Doolittle 2004; Brook 2003) and provide the opportunity to investigate human–nature connections within an everyday context (Head and Muir 2006; Power 2005). However, in order to understand the practices and values of the construction and transformation of nature it is necessary to analyse the everyday practices of people in their familiar places (Castree 2004; Bhatti and Church 2001; Macnaughton and Urry 1998).

Despite the number and importance of gardens, there have been relatively few studies of the relationships between human activity and human/animal relations in garden environments (Head and Muir 2006; Palmer 2003; Whatmore and Hinchcliffe 2003; Power 2005; King 2003). Further, many studies adopt a 'control of nature' perspective that obscures the non-

human presence by envisaging gardens to be merely created, manipulated spaces that couple ideals of a 'stylised wild' with a desire to soften human-dominated environments. In such a view, passive non-humans simply provide a backdrop to the needs and understandings of humans (Power 2005; Gaston *et al* 2005). The view of non-humans as a backdrop needs to be challenged, however, because while many authors envisage the garden as a stage upon which nature is a scenic background to human action, Power (2005) sees neither human nor non-human agents as being central to gardens. Clearly, gardeners control and manipulate 'nature', but there are also 'relations of collaboration, negotiation, competition and challenge' influencing both humans and non-humans.

It is important to note that the concept of 'nature' is contested. 'Nature' is an ambiguous term with a variety of social constructions open to challenge from conflicting theoretical perspectives (Ginn and Demerritt 2009) and this study does not engage directly with wider debates about the 'meaning of nature' but instead seeks to explore how human activity in familiar everyday locations relates to the use of those locations to engage with an aspect of 'nature'. This situated study explores how a popular leisure activity (birdwatching) occurs in an everyday locality (gardens) as a way of illustrating how relationships between human activity and non-human presence combine to modify and shape garden environments.

METHODS

Thirty-two self-identified birdwatchers in North Lancashire and South Cumbria were interviewed following advertisements placed in the newsletters of two local birdwatching societies. A number of these respondents were already known to the first author through birdwatching activities. A qualitative approach using semi-structured interviews was used for the study, which successfully captured the complex variety of interactions and relationships between humans, birds and gardens. Data were analysed using the grounded theory constant comparison method, where each item is compared with the rest of the data to establish and refine analytical categories (Pope *et al* 2000).

Emergent themes included how the garden was used for birdwatching; how the garden was modified for birds and birdwatching; the extent of providing food and other resources for birds; and attitudes to issues of 'attachment' and 'responsibility' for their gardens and its birds. Almost all interviews were conducted in the homes of respondents, often in rooms overlooking the garden: this was an advantage as many interviewees were drawn into discussion and illustrative examples by referring to their gardens. The respondents comprised a spectrum of birdwatchers ranging from expert to beginner; from those for whom birdwatching is a daily, fundamental part of life to those with a more sporadic interest; from enthusiastic members of societies to those with no social engagement with other birdwatchers. The gardens ranged in size from small to large gardens with adjacent land that was managed for nature conservation purposes. Two respondents lived in apartments with no garden. Thirty out of the 32 participants were aged over 40 and there were more males (19) than females (13). All respondents have been given pseudonyms to maintain anonymity.

FINDINGS

The interviews suggested that gardens are important and frequently-used (albeit often subconscious) locations for birdwatching and that the potential of a garden for birdwatching had formed

little part of the residential selection process, even for those who had considerable income at their disposal. Some respondents were reluctant to recognise the importance of their gardens to their birdwatching: Pandora, for example, initially denied the importance of her garden yet she had deliberately arranged the furniture in her room in order to see the garden and during part of the interview she was absorbed in watching birds using feeders that had been carefully placed so as to be seen from where she sat. In a similar manner, Victor initially overlooked mentioning his garden yet clearly took considerable pleasure from watching birds there, even though his garden birdwatching was a 'daily ritual; a duty almost both to the birds and to myself'. On the other hand, neither Charlie nor Jeanette regarded their garden as being important to their bird-watching probably because the thrill of seeing new birds meant that the garden offered nothing of value to this style of birdwatching. Responses such as these suggested that the potential of gardens as places for birdwatching was not consciously recognised by most birdwatchers.

Prior to conducting the interviews it had been anticipated that environmental alteration in the form of 'gardening for birds' would be important for many respondents, yet conscious alteration of the garden for wildlife purposes was discussed much less frequently than had been expected. Interestingly, some respondents did not initially consider the degree to which they had altered their gardens for birdwatching. For example, Ross had made considerable changes to his garden yet denied this was linked to birdwatching and only later did he recognise that 'a big element of (my) gardening is to catch[1] birds there'. Similarly, Beatrice at first denied that she had gardened for birds before admitting that she had completely redesigned the garden: she had chopped down certain trees and a hedge and planted other shrubs and bushes for food and cover for the birds, trained ivy up walls and fences and put up nest boxes. Fifty-five per cent of the respondents had manipulated their gardens for birds: many had made considerable and wide ranging efforts to do so and were able to identify and explain such actions, though social constraints and other users and uses of the gardens were also apparent.

In addition to altering the layout or composition of their gardens, almost all participants reported that they provided food for birds, with many also providing water, nest boxes and some providing other resources, including nesting materials. For many respondents, 'providing for the birds' in these ways was an integral part of their birdwatching activity. Gordon, although denying that he was a birdwatcher, enthusiastically talked about watching birds in his garden:

Oh yes, I look at the birds in my garden and I put food out for them; crusts and peanuts, you know and seeds sometimes. Oh and I like the robin [*Erithacus rubecula*] that comes and it eats and hops about and it looks so nice. I like that, I like the robin, but I can't put a name to most of them, but I like them.

For a few interviewees, a feeling of responsibility, even duty, to birds was a key motivator, but for most respondents the key motivation for this type of human intervention in the garden was to observe birds better, more often and in greater numbers.

Many respondents felt a close attachment to the birds in their gardens; some personalised the birds, while others claimed to be able to identify 'our birds' from distinguishing features in

[1] This respondent was licensed to catch and ring birds under the British Trust for Ornithology Ringing Scheme.

plumage or behaviour. Most felt pride in the birds that visited their gardens and Roger even had a friendly competition with a near neighbour, complete with mild teasing when one garden was visited by a bird that had not been seen in the other garden. Some even confessed to feelings of jealousy when a particular bird was seen in the garden of a neighbour rather than in their own garden, but there were few expressions of personal possession or exclusive ownership of the birds and a number of respondents firmly resisted the notion of ownership of birds.

Although Beatrice spoke of 'our birds' she was amused rather than irritated when she saw those birds in the gardens of neighbours, and while Doreen initially claimed: 'they are *my* black-birds [*Terdus merula*]', she immediately corrected herself: 'no, they actually own the garden'. Ernie clarified the nature of mutual belonging between garden and bird by stating that although the birds in the garden were 'our own birds', they were not 'owned' by him; rather he was a 'steward' who managed the garden for the benefit of seeing and enjoying birds and other wildlife in return. Many interviewees recognised a similar form of mutual benefit where the number and diversity of birds in their garden was seen as an acknowledgement of the care and effort that had been put into gardening in a wildlife-friendly manner.

David Allen, writing about Gilbert White (one of the most celebrated birdwatchers and ecologists of all time) and his connection to place (Selborne), describes Selborne as 'the secret, private parish inside each one of us' (White 1977). Gardens can function on a similar level, and respondents typically viewed their gardens as personal, private spaces with the owners as arbiters of access, though almost all were keen to share the birds in their gardens. For Lottie, the garden is a private, personal space where she could influence the environment and where the presence of birds is a personal reward:

> If there are birds here it means it is favourable for birds. It's a private place and I would like to see birds in the garden; for example, goldfinch [*Carduelis carduelis*] – there were a hundred by the river and it was a thrill to see them, but *one* in the garden: that *would* be a thrill.

But, despite using the garden for birdwatching, all respondents saw the garden in the context of other people and other leisure activities and, although gardens were clearly personal spaces, there was often a stated willingness to share birds with others, including complete strangers. In this way gardens were also regarded as hybrid spaces where the social and cultural meanings of those spaces and interactions with other individuals and other activities mediate the desires of birdwatchers to experience nature in the garden.

As well as being a personal, private place where the owner can alter the environment, the garden also offered some birdwatchers an immediacy and security of observation. Garry professed the garden to be his favourite place for birdwatching, partly because he liked to see the birds feeding but also because he can recognise the birds that occur there. It appeared as if those who most valued garden birdwatching were those most likely to engage in the conscious environ-mental alteration of their gardens and that such action was influenced less by extraneous factors such as space, finance and time than by the type of birdwatching undertaken.

Most respondents valued the 'wildness' and 'independence' of the birds in their garden. Doreen may have been disappointed that the blue tit (*Cyanistes caeruleus*) that collected hair from her garden used it for nesting in a different garden but she recognised and appreciated the independence of the birds in her garden. It was evident that the unpredictability of birds is part of their fascination and appeal for many respondents.

DISCUSSION

The findings from this case study suggest that the degree of importance that a birdwatcher places on their garden for birdwatching does not appear to be related to the size and 'value' of that garden for birds; rather, it relates to the type of birdwatching that is undertaken. Thus the attributes of the garden are less relevant for how that location is used than the nature of the activity that the individual participates in. Those who valued their gardens most as birdwatching locations appeared to fall into two loose groups: those who enjoyed watching the behaviour of birds and those interested in keeping records of the birds using their gardens. Thus, an interest in birds is not likely to be a good predictor of an interest in 'gardening for birds'.

While some respondents manipulated the environments in their gardens by 'gardening for birds', few initially recognised that this was the case. It often required a relatively deep understanding of the individual respondent to elicit information about the link between location and activity. This clearly has implications for research into similar location-based leisure activities, and researchers need to be aware of the potential for some locations and activities to be 'taken for granted' and thus overlooked and undervalued by both participants and researchers. Environmental manipulation and alteration ranged from doing nothing through providing food, water and other resources and planting (or removing) plants and positioning furniture to maximise viewing potential to deliberate and comprehensive redesign of houses and gardens. While extraneous factors such as space, finance and time influence such actions, the actuality of environmental action appears to be influenced more by the type of birdwatching activity of the respondent: thus those who recognise and value the garden for birdwatching are those most likely to engage in gardening for birds.

'Gardening for birds' may be expected to be an altruistically motivated activity but it appears that, while for some respondents there existed a feeling of environmental responsibility, a much more powerful motivation for 'providing for the birds' was to be able to observe birds better, more often and in greater numbers and diversity. It seems clear that, for most of the respondents, there was an unspoken 'contract' between them and the birds: 'I'll provide the food; you come to get it where I can see you'.

The appeal of attracting birds into the garden appeared to have little to do with 'taming' wildlife; rather the 'wildness' and unpredictability of birds were powerful components of the appeal of seeing birds in a garden. While most respondents expressed some form of territoriality with respect to their garden (often strongly so) and most felt a close attachment to the birds in their gardens, there were few expressions of personal possession or exclusive ownership of the birds.

The findings from this study lead to a number of conclusions about the relationship between humans and non-humans in gardens. Gardens provide humans with contact with those elements of nature that are tolerant of, or oblivious to, human influence (Head and Muir 2006; Gaston *et al* 2005). As first-hand contact with nature can be a powerful stimulus to the development of environmental attitudes and relationships (Brook 2003), it might be expected that garden birds provide an appeal to, and engagement with, nature that is immediate, familiar and frequent and, by thus engaging the interest of garden owners, stimulate their actions in the same ways as have been demonstrated for plants (Hitchings 2003; Power 2005). However, the extent of 'gardening for wildlife' practices among birdwatchers appeared to be surprisingly low, with little evidence that respondents were using their interest to do much more than provide food, water and nest sites for birds.

The view of gardens as sites of human control and ownership, with gardeners taking central stage in a monologue produced by the all-powerful gardener (Power 2005; Anderson 1997), is open to challenge because gardens can also be seen as locations of overt bird activity with (generally) passive human observation and (some) human intervention. Rather than humans being central to gardens and gardening, it can be suggested that the non-human activity and the place can assume centrality as the stimulus for, and location of, human activity. Power (2005) has shown how plants can be understood as structuring the actions of gardeners by 'drawing' people into caring for them. By recognising that plants are 'enrolled' into the garden rather than being coerced, and have as much to 'gain' as the gardeners, it can be seen that gardens are less human-centred than they at first appear (Power 2005; Hitchings 2003). Similarly, it is possible both that birds are enrolled into the garden and that humans are enrolled into providing care for birds in a way that is beneficial to both birds and humans.

These findings, drawn from the views of some respondents in this study, challenge the view of nature as a passive 'other' that is used and exploited by humans. In particular, the view of gardens as sites of domestication where non-humans are expected to acquiesce to human-directed terms and conditions (Anderson 1997) seems unsupportable in this study, as it appears it is humans who have to agree to the 'terms and conditions' of birds if they want to attract them into their garden. The reality is that different species (and individuals) of birds respond in different ways to different gardens and the different ways of managing gardens. Further, different people respond to these birds in different ways. Gardens can therefore be viewed as locations of collaborative interaction between humans and birds, though it is unlikely that birds are consciously reciprocating what humans may see as a mutually beneficial process. Birds can clearly stimulate some humans to 'garden for wildlife' and by so doing modify garden environments to some extent.

For some garden owners, 'gardening for wildlife' is a reflective process, intertwining 'nature' and gardening involving ecological dilemmas, ambiguities and opportunities for human–nature relations operating within social conditions and norms of garden design and practice (Bhatti and Church 2001). Hence, environmental ethics should demonstrate a concern for the domesticated environment as well as the wild environment (King 2003), and it might be expected that those such as birdwatchers, with an interest in aspects of the wild environment, might demonstrate overt interest in adopting 'wildlife-friendly' gardening practices.

Surprisingly, the results from this study suggest that birdwatchers have not responded to calls for the adoption of 'gardening for wildlife' practices (for example, Toms et al 2008) for two reasons. Firstly, the key motivation for modifying the environment in gardens would appear to be in order to see birds better, in larger numbers and in greater diversity, yet there appears to be a recognition and acceptance of the difficulties of controlling or even influencing bird behaviour; and, secondly, and surprisingly, few respondents admitted to even trying to adopt 'gardening for wildlife' actions in the first place. This reluctance may be explained by a desire by garden owners to mediate their desire to experience nature by the interaction with other individuals and activities.

Lee (2007) argues that the relationship between humans and landscape needs to be understood as experiential, involving the subjectivities of people. Gardens thus become hybrid places: private retreats; settings for creativity and individuality; places for social interaction; displays of conformity and cultural conditioning; and locations for encountering natural worlds (Bhatti and Church 2001). Gardens and gardening practice clearly vary considerably between individuals (Brook 2003) and it is likely that competing inside/outside, private/public views of

domestic space combine with a variety of social meanings associated with gardens to interact with constructions of gardens as locales for engagement with nature to a far greater extent than the consideration of birdwatching as a leisure activity would suggest. Not only are there differing views of how gardens should operate, there are different views even within an apparently homogenous leisure group such as birdwatchers as to how gardens relate to that leisure activity. Further, human activities in gardens are framed by distinct understandings of 'nature', place and activity, yet how non-gardening practices impact on the construction and transformation of nature in gardens are far less well understood. It can be suggested, therefore, that further analysis of everyday practices of people in their gardens would be useful in uncovering how familiar places are viewed and transformed.

Bibliography and References

Anderson, K, 1997 A walk on the wild side: a critical geography of domestication, *Progress in Human Geography* 21, 463–85

Askew, L E, and McGuirk, P M, 2004 Watering the Suburbs: distinction, conformity and the suburban garden, *Australian Geographer* 35, 17–37

Bargheer, S, 2008 Towards a Leisure Theory of Value: The Game of Bird-watching and the Concern for Conservation in Great Britain, paper presented *at Inter-Ivy Sociology Symposium 2008*, Princeton University, available from: http://cas.uchicago.edu/workshops/soctheory/Stefan.doc [8 July 2008]

Bhatti, M, and Church, A, 2000 'I Never Promised You a Rose Garden': Gender, Leisure and Home-Making, *Leisure Studies* 19, 183–99

— 2001 Cultivating Natures: Homes and Gardens in Late Modernity, *Sociology* 35, 365–83

Bland, R L, Tully, J, and Greenwood, J J D, 2004 Birds breeding in British gardens: an underestimated population? *Bird Study* 51, 97–106

Brook, I, 2003 Making Here Like There: Place Attachment, Displacement and the Urge to Garden, *Ethics, Place and Environment* 6, 227–34

Castree, N, 2004 Nature is dead! Long live nature!, *Environment and Planning* 36, 191–4

Doolittle, W E, 2004 Gardens are us, we are nature: transcending antiquity and modernity, *Geographical Review* 94, 391–404

Gaston, K J, Warren, P H, Thompson, K, and Smith, R M, 2005 Urban domestic gardens: the extent of the resource and its associated features, *Biodiversity and Conservation* 14, 3327–49

Ginn, F, and Demerritt, D, 2009 *Nature: A Contested Concept*, in *Key concepts in Geography* (eds G Valentine and S L Holloway), Sage, London

Head, L and Muir, P, 2006 Suburban life and the boundaries of nature: resilience and rupture in Australian backyard gardens, *Transactions of the Institute of British Geographers, New Series* 31, 505–24

Hitchings, R, 2003 People, plants and performance: on actor network theory and the material pleasures of the private garden, *Social and Cultural Geography* 4, 99–113

King, R J H, 2003 Towards an ethics of the domesticated environment, *Philosophy and Geography* 6, 3–14

Lee, J, 2007 Experiencing landscape: Orkney hill land and farming, *Journal of Rural Studies* 23, 88–100

Loram, A, Tratalos, J, Warren, P H, and Gaston, K J, 2005 Urban domestic gardens: the extent and structure of the resource in five major cities, *Landscape Ecology* 22, 601–15

Macnaughton, P, and Urry, J, 1998 *Contested natures*, Sage, London

Palmer, C, 2003 Colonization, urbanization and animals, *Philosophy and Geography* 6, 47–58

Pope, C, Ziebland, S, and Mays, N, 2000 Qualitative research in health care: Analysing qualitative data, *British Medical Journal* 320, 114–16

Power, E R, 2005 Human–Nature Relations in Suburban Gardens, *Australian Geographer* 36, 39–53

Rotherham, I D, Doncaster, S, and Egan, D, 2004 Valuing Wildlife Recreation and Leisure, *Countryside Recreation* 12, 12–20

Smith, M, 2002 The 'ethical' space of the abattoir: on the (in) human(e) slaughter of other animals, *Human Ecology Review* 9, 49–58

Toms, M, Wilson, I, and Wilson, B, 2008 *Gardening for Birdwatchers*, British Trust for Ornithology, Thetford

Whatmore, S, and Hinchcliffe, S, 2003 Living cities: making space for urban nature, *Soundings* 22, 137–50

White, G, 1977 *The Natural History of Selbourne*, Penguin Books, London

The Image Mill:
A Sense of Place for a Museum of Images

Philippe Dubé

Quebec City is marked by a rich past and this multi-layered history is open to many interpretations. It goes without saying that this city, known as the *Vieille Capitale* for its status as the first capital of Canada, does not easily fall prey to those who attempt to ultimately box it into a highly restrictive identity framework. For centuries this city has inspired adventurers, tourists, walkers, poets, artists and commentators of all kinds. Quebec has also capitalised on its past to set itself apart from other attractive North American cities. *The Image Mill*, a project designed by Robert Lepage and explored in this article, is a large-scale, commemorative work of art which, through its innovative and imaginative approach, transcends any single artistic genre in an attempt to capture the distinctive nature of the place that is the city of Quebec.

Robert Lepage's vision was to project a series of images onto the grain silos in the Old Port of Quebec, and the adopted title, 'The Image Mill', is suggestive of the rotating movement of the vertical 'rollers' of the silos. This movement was consistent with the idea of bringing Quebec's history to life before our eyes; a *kinetic mural* created to honour Quebec in 2008 on the 400th anniversary of its founding as a French colony.[1]

I should first explain that my role was as co-developer of the original scenario for Lepage's multimedia show and that I worked as an exhibition maker and not as a historian. As such, my entire approach was more in the realm of research-creation rather than the usual arms-length academic research. Here I present my own viewpoint as just one person in a nine-member team formed in October 2005 at *Ex Machina* where I worked in tandem with designer Philippe Meunier of the Montreal-based firm Sid Lee. My specific contribution to the project was to write the scenario for an exhibit pathway; that is to say, to develop an idea for a public space based on objects and images and to define a strategy guaranteeing its transmission to as many people as possible; we wished to offer a view of Quebec's history – and to introduce the city as a multi-faceted and multi-layered place – to the people who live in the city and to those who enjoy visiting it.

The grand historical tableau offered by *The Image Mill* can be viewed as the product of a technological society where the use of specific media has a unique relationship with its context. Adorno (1974) suggested: 'Each work of art, no matter how perfectly harmonious, is in itself a series of problems. As such, it transcends its own unicity as it passes through history' [translation]. It is from this angle that I would like to examine this colossal work because it offers the prospect of a potential laboratory for a new epistemology. However, André Malraux (1946)

1 Robert Lepage's company, with its internationally renowned creative team *Ex Machina*, is housed at La Caserne; see: http://lacaserne.net/index2.php/ [10 July 2010].

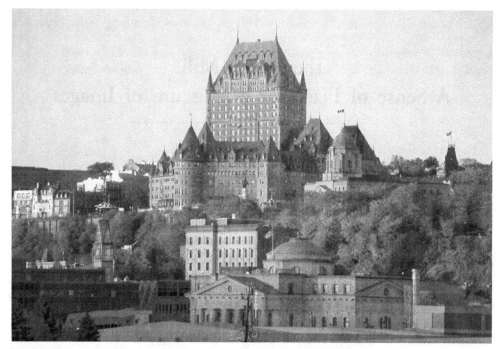

Fig 15.1. The Château Frontenac in all its architectural splendour.

provides a cautionary note: 'Concurrency of the transcripts and a suggestively meaningful specific moment in time, a truly "artistic" moment. Contained with the chaotic transcripts, obviously there will be auspicious events, but they can only be determined in reference to the specific method of artistic production employed' [translation]. I will therefore examine the *Image Mill* from a behind-the-scenes (chaotic) perspective – the rational *making of the exhibit* – in an attempt to shed light on the ideas behind the images selected to represent the city of Quebec.

What does this method of producing a show to commemorate the Old Capital in the form of a 'work in progress' entail? In truth, how can a team of non-historians be expected to portray a city with four full centuries of history? Is the material, often chosen for aesthetic reasons, credible in terms of historical accuracy? How can images alone, accompanied solely by sound, convey a story that played a pivotal role for the whole of French civilisation in North America? While there is no pretence behind the creative endeavour, there is a certain degree of presumptuousness. Indeed, prior to embarking on the artistic process, we assumed that an intuitive approach would be best for developing a common thread for the proposed narrative that is first and foremost based on images.

Quebec has chosen to take a theatrical approach to interpreting its past and Quebec as an extraordinary place. By taking this direction, the city has been led to adopt a role that could be described as building a 'city as museum'. In fact, this role of 'historical' city *par excellence* in North America was established unequivocally as early as the 19th century, when Lord Dufferin (a boardwalk in front of the Château Frontenac bears his name (Fig 15.1)) published a plan to restore and improve the fortifications around Quebec (*Morning Chronicle* 1875, 2). Dufferin

also succeeded in convincing the city council to abandon a proposal to demolish the walls surrounding the Old City, now listed as a World Heritage Site. It was a decisive moment for the future of the city, irrevocably establishing Quebec's urban identity within the *heritage* niche, and ultimately turning it into a 'rock and stone' (Noppen 1998) symbol of an entire civilisation.

The plan to enhance the historical military fortifications turned out to be a new baptism for the city and ultimately led to its designation as a World Heritage Site in 1985. Governor Dufferin's plan turned out to be what was perhaps the first campaign to safeguard and preserve a historical district in Canada. Without his intervention, the fortifications would no doubt have been lost forever. Similarly, the subsequent preservation of its military relics further consolidated its reputation as guardian and protector of the cradle of French civilisation in North America. As early as 1875, in an article in the *Morning Chronicle* on 22 November of that year, the city had already been given the title of 'the continent's spectacle city' (Murphy 1974), while a recent proposal to illuminate the city corroborates this relation to representation and self-referential – almost narcissistic – urban staging, which is further exemplified in the current development plan issued by the Commission de la capitale nationale. This detail prompts us to point out, first of all, that it was perfectly appropriate to call on a man of the theatre such as Lepage to add to the different layers of theatricality – Quebec's memory palimpsest – by providing the city with a new set of images as only an accomplished stage director would be capable of doing.

ORIENTATION

The collective artistic process gave free rein to Lepage's imagination by proposing a storyline that was both credible and capable of conveying the nature of the city from a unique and modern perspective. We sketched out a pathway similar to a museum exhibit in its pace and rhythm, combining reason and passion.

To some extent, *The Image Mill* is a museum of images suffused with its creator's vision, which blends dreams and authenticity, truth and illusion, the imaginary and the real. In short, all the necessary ingredients for composing a story are called into play so that the public can make it their own through the sensorial experience provided by the outdoor multimedia show. The visual drive of our society is so strong that it poses something of a threat, according to Jacques Lacan. In fact this is because it allows a shadow to be cast over itself since, as Bernard Stiegler asserts, 'dissociation is the destruction of the social' (Stiegler 2006, 44). Surprisingly, this is what appears to be gradually happening around us, but that is a different concern. It therefore seems essential to take the opportunity to reflect on an approach which, although it has not yet entirely proven itself, directly reflects this societal context, even though it is sometimes regarded as unsettling. The problem is first and foremost one of perception and it is the forced combination of disciplines that will provide a better understanding of what is paraded before our often astounded eyes. Our inability to see things clearly is in large part due to our poor judgement of the situation. Our own field, the historical and heritage sciences, which sometimes seems to be afflicted by blindness, is a case in point.

The method used to co-create *The Image Mill* turned out to be an approach suitable to portraying a city through images. To respect the creator's wishes, the use of any markers specifically referring to chronology, events and biographic details had to be completely avoided. This is a story without a timeline, events or characters, but a story nonetheless. Needless to say, Lepage's work is at the very heart of the problem of a narrative without a clear-cut script, as his stage

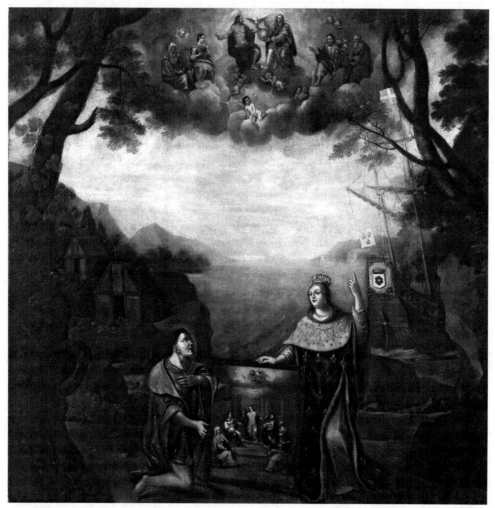

FIG 15.2. *FRANCE BRINGING FAITH TO THE HURONS OF NEW FRANCE*; ARTIST UNKNOWN, OIL ON CANVAS, LATE 17TH CENTURY.

writing strives to permanently break away from a written system. The creator himself admits that: 'In looking beyond the imagery and formal vocabulary that characterizes *Ex Machina* performances, what is immediately apparent is that the desire to tell stories lies at the very heart of the company's approach' (Caux and Gilbert 2007, 22).

But when this compulsory retreat from the textual language also leads to a slippery slope towards the non-event, this distancing, far from traditional reference points, creates a problem of narrative. This is particularly true if we bear in mind Maurice Halbwachs' (1992) words: 'Time is real only insofar as it has content, insofar as it offers events as material for thought.' And Fernand Dumont rightly and poetically points out that: 'Time may be a thread but it is also a fabric: it becomes palpable through the warp and weft of events' [translation] (1968, 232).

How can these principles therefore not be taken into consideration and how can a story still be deemed possible in light of these timely observations? It is as though a story should be believed even though it is no longer necessarily based on plausible proof or solid narrative moorings. But giving free rein to storytelling is not historically sound. Indeed, it is quite the opposite. Yet, for example, people in Quebec are expected to believe in the existence of its founder Samuel de Champlain, even though archaeologists have almost given up hope of finding his tomb. Though he is the founding father of New France, there is neither 'osteological' proof nor any trace of his remains. He is a mythical figure without relics. Similarly, the production team, faced with this historical void that had to be filled differently, had to rely therefore on a kind of act of faith. In the words of Létourneau (2006), we needed to deliver a new 'matrice historiale' (historical matrix). The subject matter had to be treated in a new manner: recount the story of a city, almost on the off-beat or at the very least in a radically different way. From this standpoint and above all in the mind of the creator, Quebec could no longer be the place 'where the river narrows', as it was named by the Algonquin, but rather the place 'where the river broadens'. After four centuries of settlement, he deemed the time had come to reveal the presence of the Quebec people (not simply the arrival of Europeans in the New World). This was the first step towards a revolutionary change in direction or at least of spirit. Lepage also decided from the very beginning that the silos in the Old Port of Quebec would serve as a display case rather than simply a screen and that in the summer of 2008 thousands of people on foot would flock to this area of the city every evening in search of a celebration that would bring them together.

The canvas therefore had to rely on a kinetic use of images and, if possible, no references to dates, people or events were to explicitly intervene in the storyline. Christianity has long resorted to images to transmit its message to as many people as possible. By way of example, one needs only think of the painting in the Quebec Ursulines' chapel entitled 'La France apporte la foi aux Hurons de Nouvelle-France', by an unknown artist and dating back to the 17th century (Gagnon 1975; 1984; Lacroix and Gagnon 1983) (Fig 15.2).

Behind the inception of the overall scenario that would permeate the creation from beginning to end are three founding concepts and three major writers. First, there was Le Corbusier's idea that the form must be suited to the purpose of the object created, without unnecessary detours that are harmful to the proper understanding of its function. In short, artifice kills art. The second idea is that of Marshall McLuhan: 'The medium is the message', meaning the vehicle is more important than, or at least as important as, the content conveyed; at the very least, the vehicle, or medium, has a considerable impact. The third idea was developed by philosopher-mediologist Régis Debray and proposes that the medium for transmitting culture transforms the content and, in so doing, shapes the underlying thought mechanisms, both at the sender and receiver points.

Each of these three writers, with their three key principles developed over succeeding generations, marked the 20th century, covering respectively the fields of architecture, communications and philosophy of culture. These notions will now be re-examined one by one so as to better understand firstly the *construction*, secondly the *communication* and lastly the *transmission* of *The Image Mill*'s messages that successive audiences have picked up over the many evenings spent watching Lepage's digital kinetic mural.

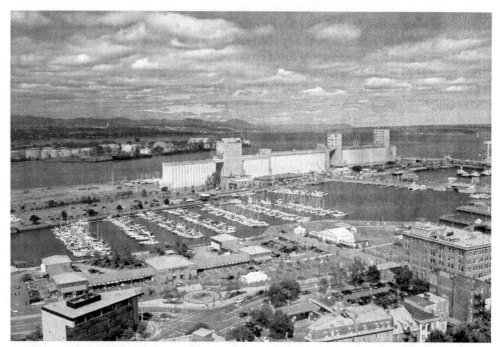

FIG 15.3. VIEW OF THE OLD PORT OF QUEBEC WITH THE BUNGE GRAIN ELEVATORS THAT SERVE AS A GIANT PROJECTION SCREEN FOR *THE IMAGE MILL*.

CONSTRUCTION

Beyond the stage director's instructions to recount history without examining in too much detail each episode in Quebec's story, it was necessary first and foremost to take into account the building and the site chosen for Lepage's creation. It was clear in the creator's mind that the concrete structure was to be seen and perceived as a monumental sculpture that would come alive in the Old Port's Louise Bassin. Each evening this mass of reinforced concrete would turn into the segmented body of a giant beast to act out the story it had witnessed (Fig 15.3).

First, it is crucial to understanding the structure created by 'kinetic muralist' Lepage and his *Image Mill*. The hostile mass of vertical cylinders was to become the story's narrator and, thanks to its undulating shape, would introduce – and through its moving volumetric expressions, even choreograph – a narrative without words. In short, the architecture itself would express its own message by taking full advantage of the available architectonic vocabulary, to express fixed points in this history-narrative of Quebec.

It is here that Le Corbusier, who rethought modern architecture from a functionalist point of view clearly favouring the 'aesthetics of the engineer', first comes into play. Le Corbusier, in a manifesto addressed to 'Messieurs the Architects' explained, in three lessons, what architecture is, deploring that architecture no longer reflected its origins: mass, surface and plan. He emphasises that: 'Mass [...] is the element by which our senses perceive and measure and are most fully affected. [...] Architecture is a thing of art, a phenomenon of emotion, lying outside questions

of construction and beyond them' (Le Corbusier 1927, 28). Commending the artistic work of engineers through the basic forms they create, he is emphatic about the value of a judicious assembly of masses, citing Canadian grain elevators as an example of the absolute expression of a 'vital organ', calling them 'the magnificent first fruits of the new age'. This first lesson establishes the basic material as an active material used directly to narrate the story. The structure, through the volume of space it occupies, speaks for itself because we know that volumes are a way of telling a story.

COMMUNICATION

Secondly, in terms of the underlying principles for the *Image Mill* story, we drew directly on the fundamental idea that Marshall McLuhan expounded using simple yet brilliant language with his famous 'The Medium is the Message'. Beyond the architecture of the grain silos – which become gigantic projection screens enhancing the work – the creator made, in effect, an editorial choice of using them with 27 projectors in all, so that the juxtaposed screens could be stitched side by side to form a sequence. This veritable patchworking of the story, with sequences told in parallel, sometimes interacting, sometimes not, determines the message to be shaped (Fig 15.4).

One thing is clear: the story is not linear even though it follows the conventional narrative form with a beginning, middle and something resembling an end. There are, however, gaps, holes, cracks and diversions, which make the story fundamentally fragmented. To some extent, onlookers invent their own story according to what is grasped in the space perceived through the gaps, which are like blank pages waiting to be filled (co-construction). This is similar to McLuhan's description of a museum, namely: 'It's a prepared environment, prepared for special effects' (McLuhan *et al* 2008, 151). This is exactly how the *Mill* functions in space, by launching ideas and images as the story unfolds in the form of capsules of emotion that the spectators/strollers can catch as they pass by to construct their own story and eventually pass it on to others.

TRANSMISSION

This new means of public communication brings us to our third concept, which Debray succeeded in defining through his philosophical system called *mediology*. He states: 'What mediology researchers are interested in is the back-and-forth motion between the transmitter (technical and therefore dated) and the transmitted (permanent and changing)' [translation] (Debray 2009). A type of perspective focused on the means, an extension of the McLuhan-style reasoning and that of his teacher, Canadian historian Harold Innis, which transmits cultural elements over a long period of time and thus differentiates communication from transmission. The interest here lies in analysing the history of Quebec through the networks that have enabled it to develop.

Debray provided an initial script proposal for the history of French North America, drawing on a major historical work by sociologist Dumont entitled *Genèse de la société québécoise* (1993), as part of a contribution he was commissioned to carry out related to a project for a fringe exhibition for *The Image Mill*, planned to have been shown simultaneously in Paris and Quebec in 2008. This first sketch led us towards a better mediological perception of our own history and it was through another parallel avenue that we came to see the possibility of addressing the four-century-long history of Quebec by prioritising channels of transportation: water for the 17th century, land for the 18th, rail for the 19th and air for the 20th. The mediological order

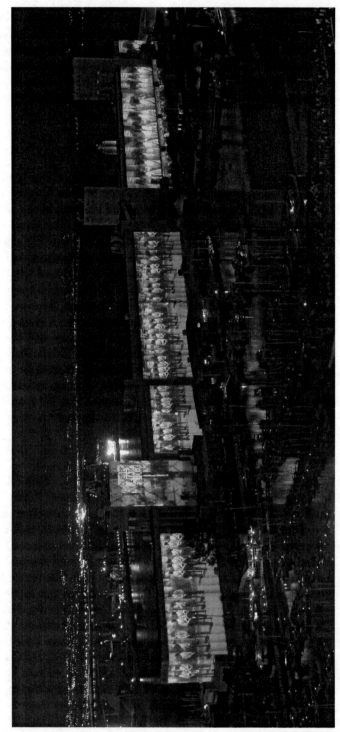

FIG 15.4. PANORAMA OF *THE IMAGE MILL* TAKEN DURING AN EVENING SCREENING.

unexpectedly provided a first way of organising the story by theme. For example, without boats it would have been impossible to cross the Atlantic and establish a new colony. Without ploughing implements, or horses, there would not have been colonisation. Without trains, territorial expansion would not have been so vast. Without electricity, no communication networks are possible, at least not on today's massive scale. Inductive reasoning would orchestrate everything else as it served as the ground rule for developing the narrative. The medium would indicate the boundaries and the content, the reference material.

This basic content analysis became the narrative plot that would serve as a backdrop for telling the story of Quebec. Exploring time through space provided the means for implicitly narrating the passage of years through Quebec's space-time. In short, Debray had abandoned any study of history by studying the available technical means. In other words, Quebec is a reflection of the techniques used to design it and this standpoint is communicated in a language akin to concreteness and often at a micro level that everyone can understand because it conveys the very substance that shapes and modulates the world in which we live – the one being built as well as the one we continuously destroy and then reconstruct – much like unrelenting Sisyphuses.

Finally, to come full circle and make certain of the relevance of the four routes that created Quebec City, we turned once again to Le Corbusier and his work entitled *Sur les quatre routes*, which informs us that: 'The four routes open up four better points of view [...] the landscape is wider, borders disappear along with new ways to size things up' [translation] (1970a, 41–2). But in conclusion to these specifics regarding the intellectual organisation of the work in question, it was Debray who was to have the final word on the anatomical planning of *The Image Mill* to situate the joy and more importantly the hopes we cherished in regard to our contribution to this monumental work. 'This is the advantage in being a nation that invents itself as it goes along using imagination and legend, and not simply an ethnic group with specific roots. [...] We can always change ancestors by choosing from among those who will maximise our chances of life' [translation] (2010, 124–5).

The idea, therefore, was to offer an 'iconorama' where visual and thematic textures combined at a frenetic pace, in an indeterminate order, while striving to create a work that was more sculptural than pictorial, using an unmoving mass of concrete that nonetheless adopted the shape of the successive vertical tubes reminiscent of a mill, if not of an image-producing robot. In regard to this structure – the silos – which was Lepage's main source of inspiration for *The Image Mill*, it should be recalled that Le Corbusier, as early as 1920, had already recognised this architectural form as being the perfect manifestation of his renewed vision of architecture in which the form had to necessarily bear witness to the building's purpose. What remains is but packaging and background noise, according to the architect's functionalist notion. This first consideration brought us back to Le Corbusier's testament, which by its doctrinal nature beckons to 'go beyond the contingency of the event' (Le Corbusier 1970b, 39). This is right in line with Lepage's initial concern and thus forcibly established the underlying thematic orientation of the story in which the tetralogy would take on its full meaning. Four centuries, four routes: a water route to sail towards the New World, a road by land to develop the colony, a railroad to convey the advent of industry and, finally, an air route transmitting information in the communications era. These multi-layers of time divided into different eras are obviously not as sharply defined as they may first appear and are instead long periods under construction, successive strata that are layered one on top of the other.

EXIT

If a picture is worth a thousand words, what are thousands and thousands of images worth?

We have attempted to provide a brief analysis using the example of Lepage's *Image Mill* of how a creative artistic approach can, through inductive reasoning, put together a story that is meant to be historical, without, however, being a historian. By supplying a backdrop aimed at providing the framework for the passage of four centuries at a given place using a succession of technological changes, this plot enables the development of a new perspective on the story of a city expressed through its transformations and its transmutations. The obviously mediological standpoint required a material-based perception of Quebec's urban development, brushing aside any romanticised or nostalgic vision – if not to say political in the ideological sense of the word – of a destination across the Atlantic which completely manifests its North American destiny. This viewpoint guided the selection of images that in turn would inspire sounds that were then converted into music under the artistic guidance of composer René Lussier.

What comes to light and seems to be common knowledge when taking a small step back is that theatre and spectacle occupied a central place, not just for the festivities celebrating Quebec's tercentenary in 1908, but as recently as 2008. As, according to our hypothesis, Lord Dufferin is responsible for the theatricalised portrayal of Quebec, it should be noted that the anniversary of the founding of the city one hundred years ago (1908) was celebrated through costumes, street theatre and lively spectacles, according to a method that has been around since Shakespeare, namely, *pageantry*, which Quebec adopted under the name 'historic pageant' (Tourangeau 1994). This was the path we followed, not in order to explain but rather to gain a better grasp of the issue unfolding today before our very eyes. Commemorative festivities offer a time for remembrance, a way of recalling the glorious past, for reasons that are obviously highly official, however. In other words, revisiting of the past is orchestrated in a manner that will provide a very modern assessment of the distance covered and as such provides the necessary momentum to continue on a road that not only has to be followed but also invented. Though the past may belong to the realm of the known because it has been lived, the future is virtual and calls for a projection of things to come that will reveal a glimpse of a viable and enviable horizon of hope. It is thanks to this skilful balance of reality and fiction that the story being told succeeds or fails to rally the general public. Lepage, with his *Ex Machina* team, set himself the mission of bringing out the spirit of the place (*genius loci*) not so much by a silo analysis of reality (cognitive approach) but by bursts of emotion (intuitive approach), which finally become the source of inspiration for the plot of a diverse story. It is an undeniable fact that reality always catches up with us – and it will no doubt do so again – but anniversaries are special moments for dreaming one's life using the materials handed down to us during its passage.

Were the efforts to find another truth in terms of the past all in vain? We are not so sure because it would be impossible to deny that historical facts deserve to be rethought through the intuition of the artist, the creator, who can sometimes give it more relevance. According to our interpretation, Dumont puts forward a vision in which the role of the arts (intuitive) and that of the sciences (cognitive) can finally be harmoniously combined, despite the tensions inherent in these two diametrically opposed relations to the world: 'It is in this very distance between two histories, in this acute tension between its meaning as an event and its meaning as advent that Man attests to his presence in the world as he has never done so before' [translation] (1971, 216).

The screenings of *The Image Mill* began in the summer of 2008 and subsequently fulfilled

their mission quite successfully according to various accounts. Since *The Image Mill* was first presented, on 23 June 2008, there have been approximately 60 screenings per season in each of the last three years. Each screening attracts around 10,000 spectators, meaning that the creation has been seen by more than half a million people per year. In a city with only half a million inhabitants, this is a true success story. In the first stage of the screening, we simply attempted to outline an alternative, '*The Image Mill*' mega-story, a new way to portray the story of a city in which the water will continue to flow past the mill, as it did before us and will continue to do after us on its seemingly unstoppable course.

Bibliography and References

Adorno, T, 1974 *Théorie esthétique*, Klincksieck, Paris

Caux, P, and Gilbert, B, 2007 *EX MACHINA: Creating for the Stage* (trans Neil Kroetsch), Talonbooks, Vancouver

Debray, R (ed), 2009 *Les Cahiers de médiologie, une anthologie*, Éditions CNRS, Paris

— 2010 *À un ami israélien*, Flammarion, Paris

Dumont, F, 1968 *Le lieu de l'Homme*, HMH, Montréal

— 1971 *Le lieu de l'Homme*, Hurtubise HMH, Montréal

— 1993 *Genèse de la société québécoise*, Boréal, Montréal

Gagnon, F-M, 1975 *La conversion par l'image. Un aspect de la mission des Jésuites auprès des Indiens du Canada au XVII^e siècle*, Bellarmin, Montréal

— 1984 L'implantation de la foi; *Le grand héritage: l'Église catholique et les arts au Québec*, Musée du Québec, Québec, 15–29

Halbwachs, M, 1992 *On Collective Memory* (edited, translated and with an introduction by Lewis A Coser), Heritage of Sociology Series, University of Chicago Press

Lacroix, L, and Gagnon, F-M, 1983 La France apportant la foi aux Hurons de la Nouvelle France: un tableau conservé chez les Ursulines de Québec, *Journal of Canadian Studies* 18 (3), 5–20

Le Corbusier, 1927 *Towards a New Architecture* (trans Frederick Etchells), The Architectural Press, London

— 1970a *Sur les quatre routes*, Les Éditions Denoël, Paris

— 1970b (1939) *Sur les 4 routes*, 2 edn, Denoël/Gonthier, Paris

Létourneau, J, 2006 Mythistoires de *Losers*: introduction au roman historial des Québécois d'héritage canadien-français, *Histoire sociale/Social History* 39 (77), 157–80

Malraux, A, 1946 *Esquisse d'une psychologie du cinéma*, Gallimard, III, Paris

McLuhan, M, Parker, H, and Barzun, J, 2008 *Le musée non-linéaire, exploration des méthodes, moyens et valeurs de la communication avec le public par le musée*, Aléas, Lyon

Morning Chronicle and Commercial and Shipping Gazette, 1875 Lord Dufferin and Quebec, Monday 22 November

Murphy, A, 1974 Les projets d'embellissements de la Ville de Québec proposés par Lord Dufferin en 1875, *The Journal of Canadian Art History* 1 (2), 18–30

Noppen, L, and Morisset, L K, 1998 *Québec de roc et de pierres. La capitale en architecture*, Éditions Multi-Mondes and Commission de la Capitale Nationale, Sainte-Foy, Québec

Stiegler, B, 2006 *Réenchanter le monde: La valeur esprit contre le populisme industriel*, Flammarion, Paris

Tourangeau, R, 1994 Les pageants historiques de scène comme médium du discours idéologique, *Theatre Research in Canada/Recherche théâtrale au Canada* 15 (1), available from: http://www.lib.unb.ca/Texts/TRIC/bin/getprint.cgi?Directory=vol15_1/&filename=Tourangeau.htm [July 2010]

Cultural Landscapes

Making Sense of Place and Landscape Planning at the Landscape Scale

Maggie Roe

Introduction

L andscape planning deals with the consideration of future landscapes and the action whereby landscapes can be enhanced, restored or created. Discussion of sense of place related to landscape has tended to centre on how to conserve or preserve existing sense of place, sometimes built up over many years, in highly valued landscapes. There has been little discussion about how we might create landscapes with a sense of place that is highly valued from landscapes that are presently degraded or ordinary. There are a number of interesting theoretical aspects to this which are worth examining here. One is whether there is some kind of relationship between value and sense of place. Following on from that is the issue of who places a value on the landscape, or who judges whether a particular landscape has a valuable sense of place or not. Assuming that we believe a sense of place is important, then is it possible to enhance or strengthen sense of place through landscape planning and is it possible to understand sense of place at a large scale?

Change is an inherent characteristic of the landscape, and understanding past landscape development and cultural values is important for the management of today's landscapes (Antrop 2005). Sense of place may be a perception by an individual or a community in a particular moment in the timeframe of a landscape, or it may be a sense that evolves over time.

This chapter explores ideas that are emerging through landscape planning research and practice in relation to these issues. In particular, it examines the issue of scale in landscape. Different cultures make sense of the landscape at the large scale in many different ways. Unlocking this knowledge is important for managing change in a way that does not destroy existing meanings embodied in the landscape and ensures that in the creation and reconstruction of landscapes we provide opportunities for positive interactions that can foster the development of new landscape meanings.

What are the Characteristics of Landscape Relevant to Sense of Place?

Article 1 of the European Landscape Convention defines landscape as 'an area, as perceived by people, whose character is the result of the action and interaction of natural and/or human factors' (Council of Europe 2000). This definition is now widely used within the disciplines concerned with landscape planning. Landscape is seen as multi-dimensional (Fig 16.1). The understanding of landscape as both territory and place is long-held in the literature but the emphasis in the past, particularly in UK protective legislation until the mid-20th century, has commonly emphasised the visual, or site and scene rather than occupance and occupation (Scazzosi 2004; Lowenthal

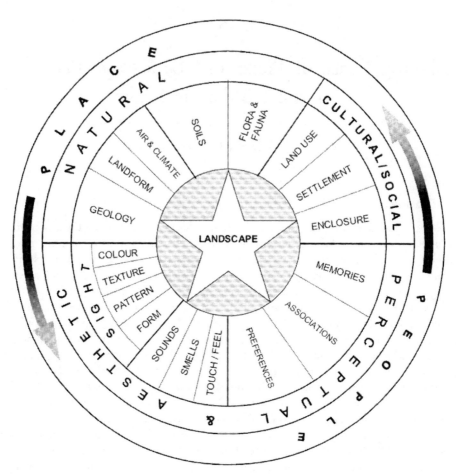

FIG 16.1. The multi-dimensional nature of landscape.

2007; Wylie 2007; Olwig 2005). Definitions of landscape have suggested that it is an area that can be seen in one sweep, sometimes equated with a view, but that it is also perceived as a site or sites created from an 'amalgam of places' where 'political or cultural entities manifest themselves' (Olwig 2005, 293). Since sense of place is associated with familiarity, memory, associations and visual complexity, interpretations of sense of place may be as diverse as those of the landscapes themselves. Defining the interpreter, the cultural and natural contexts of the landscape and the interpreter's interactions with that landscape are essential in understanding how the concept of sense of place can be used in landscape planning projects.

Sense of Place, Scale, Perception and Representation

Sense of place is perhaps most easily understandable at a site-based level; when we start to try to grasp this somewhat slippery concept at a larger or 'landscape' scale it gets more difficult (Roe

FIG 16.2. THE BLUE PLANET: EARTH FROM SPACE.

2007c). Research has suggested that consideration of sense of place can add value to natural resource management efforts (Cantrill and Senecah 2001). Definitions of landscape scale are variable depending on discipline interests. In landscape planning the concern is generally with areas of landscape that are larger than the site and some can be very large indeed. One of the main difficulties here is how we conceptualise and represent all the dimensions of landscape and the complexities of their interactions.

In the past we have often understood or made sense of the world beyond our immediate neighbourhood through mapping (eg the Mappa Mundi, a vellum map now in Hereford Cathedral, which indicates the medieval view of the world in spiritual and geographical terms) and through stories and songs (eg the early Anglo-Saxon legend of Beowulf; see Gelling 2002; Butts 1987). These provided not only an idea of the physical characteristics of places but gave meaning 'in the mind's eye' to the larger landscape or used depictions of landscape to convey specific images, indicate context and portray spiritual understanding, even if the accuracy of the depic-

tions are a little doubtful. The ultimate representation at the large scale was perhaps the pictures of the Earth through the lens of the Apollo cameras that were revealed in the 1970s. This gave us the sense of a 'blue planet' (Fig 16.2); it provided us with an awareness of the Earth as a whole (Lovelock 1979) and the interconnectedness of life which stimulated the growth of the sustainability movement. Many other representations have given us a sense of place in the landscape (and seascape) at the large scale; the pictures of Turner show how the importance of the composition is in the effect of the whole rather than simply the detail. Now Google Earth provides us with interactive representations. In all the many kinds of depictions of landscape, the issue of scale is central to our interpretation of the meaning. The Apollo pictures emphasised not only the completeness of our world but the smallness of the spaceship and, indeed, gave us insights as to the significance of the human race itself.

Landscape as a Perceived Space

Landscape perception is determined by our experience gained primarily through the senses, but also through traditions passed on over generations. Sense of place may be perceived through one experience of a landscape or built up over time through a number of experiences which may include all the senses, feelings and associations. Perception of the form and elements of the landscape are important, as are communication of the meanings and associations and a connection between the perceiver and the landscape which has some kind of resonance or feeling that may or may not be explicable. The visual, cognitive and experiential aspects of understanding landscape can be seen in terms of a network where there is multidirectional communication (Terkenli 2001) that is often continuous and interactive.

This idea, that sense of place may not be gained from a static experience but through interaction with, or movement through, a landscape, is one that is often used unwittingly by tourist companies but also portrayed by authors in travel texts and novels. In Cormac McCarthy's futuristic catastrophe novel *The Road*, the predominant sense is of a land that is 'barren, silent, godless' (2006, 2) where movement in the landscape means danger. This portrayal is a stark reminder of the importance of how climatic conditions, features of the landscape and the inhabitants (or imagined inhabitants) of the landscape contribute to sense of place. Some authors, such as Robert Louis Stevenson, have suggested that the compulsion to travel is sometimes justified simply in terms of a need to move and to come into contact with a changing physical world. He says:

> For my part, I travel not to go anywhere, but to go. I travel for travel's sake. The great affair is to move; to feel the needs and hitches of our life more nearly; to come down off this feather-bed of civilization, and find the globe granite underfoot and strewn with cutting flints.
>
> (Stevenson 1879, 115–16)

The Links between Landscape Scale and Sense of Place

Understanding sense of place at the landscape scale is difficult because physical complexity increases with scale increase. People's sense of place is confused by landscape heterogeneity: thus areas that are disjointed or, in many cases, are more built up in what is perceived as a fragmentary way, such as urban fringe areas, may not be legible in terms of a coherent sense of place.

FIG 16.3. WILD PONIES ON DARTMOOR.

Preference for coherence reflects the human capacity to see order in distinctive combinations of individual components and inferred meanings in the landscape (Roe *et al* 2010).

It seems that sense of place in landscape can also be defined by strong man-made and natural features – and even particular species – that define a 'mood' in the landscape and can provide a sense of place that affects large areas. The *Angel of the North* sculpture has become a symbol of 'entry' not only to the Gateshead and Newcastle area but to the northern region of England. It has come to represent the past in the way it references the industrial heritage of the area as well as the present community aspirations and identity (Bailey *et al* 2004). The 'Beast of Bodmin Moor', which is reported as a large wild cat-like animal, provides identity for a landscape in the South West of England 'as a region of enchantment where it is not uncommon for strange or morbid things to take place' (Laviolette 2003, 217) (Fig 16.3). One of the key issues in landscape planning is how ordinary people's attitudes to, and perceptions and associations of, the landscape can be reflected when dealing with larger-scale issues and whether involvement in landscape character assessment and planning can help communities define a sense of place that is meaningful to them, or to others who they may wish to have influence on landscape change, at the large scale.

LANDSCAPE CHARACTER AS A REFLECTION OF INTERACTION

Landscape character can be described as the distinctive pattern that has been created by particular interactions occurring over time and evolving from the attributes that make one landscape different from another and from its surrounding context. The National Character Areas (NCA) initiative in England has identified 115 character areas in the country. The study highlights the influences on the landscape that now determine its present character and aims to capture what

can be described as the objective (eg biodiversity, buildings, geology, morphology) and subjective (eg meanings, associations) attributes of landscape (Natural England 2010). The European Landscape Convention places considerable emphasis on documenting landscape character. Landscape character analysis commonly defines landscapes of a particular type (or landscape typology), as well as landscape character areas. This responds to the idea that different landscapes may provide a similar, but never the *same*, sense of place. Particular landscape types are seen to occur around the country in different areas – that is, they are landscapes with similar characteristics that can be described in generic terms, such as 'open upland plateau'. Landscape character areas are geographically/space specific; they have an individual identity but share character with other areas and can be defined as coherent areas which may contain landscapes of different types that have evolved as a result of unique conditions and circumstances as well as universal laws of physics and biology.

INTERACTION: THE ESSENTIAL COMPONENT OF SENSE OF PLACE

Day-to-day life in many Western cultures was until recently lived at a relatively small scale in the landscape. This changed with increased communications, the exchange of goods and services and, of course, globalisation. Settled cultures lived in relatively small landscape contexts, while more nomadic cultures often travelled significant distances, their imprint on the landscape often being in the form of a series of 'nodes' (places where activities commonly occurred) and 'links' (the routes which were commonly taken between the places) (Jordan 2001). Many nomadic cultures travelled through large areas of landscape according to the seasons; some still do (see other chapters in this volume). Sense of place in such communities was established partly as a response to the seasons and the affordances of the landscape, but also in response to the character of the spaces that developed, the activities carried out and the customs that grew up around the activities. As Nassauer (1995) observed, 'culture changes landscapes and culture is embodied by landscapes' (1995, 229).

Landscape can be seen as the product of the interactions between geology, ecology, climate, rivers, land use, land management and design, and almost all the Earth's landscapes have been affected directly or indirectly by human activities. Thus in the UK every landscape can be described as 'cultural' in terms of the way society, economy and environment interact. Naming a tract of land can also be seen as an indicator of cultural value, thus changing an area from a space into a place, or landscape. Such names are important indicators not just of association, ownership and other interactions that have occurred over time but also of the perception of the quality of character and the uniqueness of the particular landscape.

LANDSCAPE AS PROVIDING GOODS, SERVICES AND FUNCTIONS THAT INCLUDE SENSE OF PLACE

Among policymakers and landscape planners there is now considerable interest in the concept of goods, services and functions as a way to define and value the attributes of landscape. Functions are seen as the fundamental property of landscapes, whereas services are the human benefits gained. The categories used to classify functions and services are similar, as shown below:

- types of functions – regulation, production, habitat, information (Brandt and Vejre 2004; de Groot 2006);

- types of services – provisioning, regulating, cultural, supporting (MEA 2005).

A recent study linked to the National Character Areas initiative examined eight cultural services of landscape (Natural England 2009). These were:

- A sense of history (or heritage)
- A sense of place (identity, home)
- Inspiration (stimulus)
- Calm (relaxation, tranquillity)
- Leisure and activities (recreation)
- Spiritual
- Learning (education)
- Escapism (getting away from it all)

Further cultural services can also be identified relating to stress relief, health and exercise, quality time and relationships. Cultural studies have shown the considerable variability of people's interactions with landscape, ranging from the transactional (seeing landscape as somewhere to obtain exercise or entertainment) to the fundamental (seeing landscape as a part of everyday life). The conclusion is that landscape provides a range of interlinked cultural services including sense of place and these are important to human well-being and quality of life (Roe *et al* 2010). Economic opportunities such as potential tourism or encouraging settlement are seen to arise from landscapes with distinctive or high-quality landscape character which provide greater 'liveability'. This potential is now recognised around the world. In the rapidly urbanising areas of China, new developments are often given a name that describes an imaginary landscape to increase the desirability of the place (Fig 16.4).

Cultural services and benefits are often delivered by the landscape as a whole and therefore the provision of goods and services is potentially vulnerable when landscape is fragmented and coherence lost. Thus the 'goods and services' approach supports the understanding that landscape coherence is important in the perception of quality, in providing a strong sense of place and in increasing the potential for interactions in the landscape.

As people's mobility has increased and the interactions that people have with their local landscapes have changed, there has been a rise in communities of interest in relation to landscape and a decline in communities of place. However, it is also understood that these two types of communities may overlap and, certainly, experience of the landscape is a key consideration for both (Fig 16.5). Policymakers are now interested in the issue of how sense of place and sense of belonging to new locations can be built within migrant and immigrant communities or new communities of place (Macfarlane *et al* 2000; Rishbeth 2001). Many migrants are forced to leave familiar surroundings, and feelings of longing for 'lost' landscapes are commonly expressed in songs, poetry and art, such as in the Victorian paintings *The Last of the Clan* (1865), by Thomas Faed (in Kelvingrove Art Gallery & Museum, Glasgow), and J Watson Nicol's 1883 painting *Lochaber No More*, which illustrate the Highland Clearances (Mackenzie 2002; Basu and Coleman 2008). After the Scottish uprising in 1745, clan chiefs betrayed crofters – local people – who were dispossessed of their land to make way for sheep farming. Prebble (1963) relates that during the first three years of the 19th century 10,000 people left Scotland for Nova Scotia and Upper Canada, driven from the Highlands by 'poverty, by eviction and by sheep'

FIG 16.4. SELLING TO 'INSIDERS': THE REPRESENTATION OF NEW SETTLEMENTS TO POTENTIAL CHINESE BUYERS IN SHENZHEN, SOUTH CHINA, PROVIDES SOME STARTLING DESCRIPTIONS.

(1963, 189). Prebble's classic account is scattered with verses chronicling the despair of the dispossessed. The recognition of the power of the emotions that being forced away from familiar and much loved surroundings can engender has been used by dictators as a way to punish people for perceived crimes – including just being a member of a particular ethnic group – or subdue them through the disorientation and fear that displacement can provoke (see Guerif 2010).

In settled communities, sense of place may be altered through the removal, changing or obscuring of environmental systems. In Newcastle-upon-Tyne many of the small rivers which once ran through deep denes or valleys into the larger River Tyne have been culverted. The above-ground routes of these systems are still reflected in the landscape through place-names. This kind of loss, through the small-scale incremental demise of natural landscape features, is accelerating as a result of, for example, increased paving-over of front gardens in urban areas to create off-street car parking, and, at the larger scale, through massive residential and other development. In southern China, near Shenzhen, the natural landscape character is strongly influenced by the extraordinary rock and landforms. In some areas, small hills that form half-egg-like features are being totally removed and the excavated material used to extend the coastline into the South China Sea for building purposes. The character of the landscape is being destroyed by those wishing to exploit the potential functions of the landscape and thus the cultural service of sense of place associated with a particular landscape morphology will also disappear.

Communities of Place
- Indigenous knowledge
- Experiential knowledge

Community of Interest

Community of Place

Communities of Interest
- Expert knowledge
- Experiential knowledge

Fig 16.5. Community Types.

Conceptualising versus Understanding Landscape Change

It has been suggested that change in the landscape has been paralleled by technology changes and increased communications and data availability in society (Kienast *et al* 2007). A useful way of understanding landscape change is to examine the complexities and interactions of driving forces of change (Hersperger and Burgi 2007; 2009; Schneeberger *et al* 2007). Consideration of change is particularly important in landscape because it affects both the seen (land cover, land use) and unseen (lost memories and associations, impaired functionality); it may be slow or fast (Schneeberger *et al* 2007), slight or accumulative, obvious or imperceptible, directional (secular) or cyclical (seasonal), temporary or enduring. Change is rarely consistent and is sometimes described in terms of 'pulses', which may be large or small, slow or fast. Since change is endemic to landscape and is seen as a characteristic attribute rather than an impact on the landscape (Fairclough 2009), it follows that fast or slow change may be characteristic of certain landscapes and this may depend on the natural conditions and/or the human pressures.

People's perceptions and attitudes towards landscape change alter over time, sometimes over generations, as a result of changing values, styles and conditions (Foresight Land Use Futures Project 2010). There is considerable consistency in the narrative that the key problem of landscape change is that economic and social drivers, which are often large-scale and pervasive, as well as localised and specific pressures, have a deleterious impact on the distinctiveness and character that help define sense of place in landscape. It follows that since landscape is 'seen as an interactive "equation", ceaselessly making and remaking itself through processes of continuous (or incremental) and discontinuous change' (Wood and Handley 2001, 46), then sense of place in the landscape is similarly constantly being created, changed and recreated. This important principle is embedded within the European Landscape Convention (Council of Europe 2000).

The closeness of the links between society and landscape mean that landscape is sometimes seen as a mirror of our culture and it is also sometimes portrayed as a 'text' that can be read to understand change that has occurred. It has been observed that the material culture as indicated by landscape tells a different story to the documentation or description of that culture (Fairclough 2009). Landscape change is often portrayed as a bad thing or a loss, but it is important to remember that change in the landscape can be positive and a force for good in society.

PARTICIPATORY PLANNING AND LANDSCAPE INTERACTIONS

It is clear that sense of place is a fundamental consideration in good landscape planning. Investigation into sense of place at the large scale is primarily through landscape character analysis of some form and the key to identifying sense of place is through an understanding of the dynamics of landscape change, the interactions within the landscape and the processes by which cultural perceptions and attitudes about landscape are established. Knowledge creation and the facilitation of activities where 'mutual moulding' may occur can be seen as a way to enhance people's sense of place (Roe 2005). However, difficult decisions may need to be made about when to conserve or preserve existing sense of place, and/or to encourage the creation of a new sense of place through landscape planning and design.

Participatory processes are now often used within landscape planning. During the Kent Downs Jigsaw Project, inhabitants of the Kent Downs Area of Outstanding Natural Beauty (AONB) were asked to photograph elements that provided for them positive representations of landscape identity (Bartlett 1999). During a community workshop, a 'jigsaw' was made of these photographs (Fig 16.6). The jigsaw was an overall representation of how the locals regarded the way the character of this large landscape provided a sense of place. There are few such examples of methods for landscape representation along with practical methods for involvement in defining landscape character at the large scale. Thus the relationship between a community sense of place, landscape change and landscape planning remains unclear.

In landscape planning, understanding the relationship between structure and processes at the local level and the landscape scale is increasingly emphasised. There is now less interest in the development of a 'big vision' in landscape planning and more interest in forming an integrated mosaic of smaller understandings in relation to the landscape, based on a more pragmatic and sustainable approach (Turner 1998). Critical to this is to bring together the importance of local cultural needs, wants and livelihoods of those managing the land. For example, Payton *et al*'s (2002) study relating to farmers in Bangladesh and Kenya found that crop rotations were a result of information that included indigenous technical soil knowledge and local knowledge that emerged from the social and cultural context and experience of the landscape. Such knowledge was dynamic and developed through communication, interpretation and action, and was sensitive to context. In the Bangladesh study, the researchers deduced that unspecified socio-cultural factors other than soil type knowledge determined cropping decisions. They concluded that scientific surveys and understanding of local knowledge cannot alone reveal the whole picture of continuity and change in a landscape, but there is a need to grasp a broad context of local knowledge that includes not just technical information (in this case about soils) but also the complex and integrated cultural and biotechnical factors that may be used in land-use decision-making. Indeed, understanding interconnectedness and the integration of such complex factors is seen by a number of researchers as the key to understanding landscape (Mitchell 2002). Using

FIG 16.6. THE KENT DOWNS JIGSAW PROJECT WHERE LOCAL PEOPLE TOOK PHOTOGRAPHS THEN SELECTED THEM IN A COMMUNITY INVOLVEMENT EXERCISE TO CONSTRUCT A MAP THAT REPRESENTED LANDSCAPE IDENTITY.

indigenous knowledge is also seen as a way for indigenous peoples to 'regain control over their own cultural information' (Berkes 2008, 258).

In a three-year landscape study based in Rupsha Thana, near Khulna, Bangladesh, a GIS (Geographic Information System) was used to help collate and analyse the data, which came from a literature review, map-based information, field survey, community consultation and livelihood survey based on Participatory Rural Appraisal (PRA) techniques (Foxon 2005; Roe 2004a; 2004b). Thus, by using a combination of social science techniques and traditional landscape planning methods, a variety of representations of the landscape was developed to help identify opportunities that were based both on cultural perceptions and needs and the potential of the landscape. This kind of work has begun to show that, while sense of place is often portrayed as one perceived by the individual, there may be a community-held sense of place in landscape which is strongly linked to the affordances of the landscape (Fig 16.7). Research in a number of countries is now showing the value of a multi-method approach to understanding sense of place and place attachment (eg Brown and Raymond 2007).

CONCLUSIONS: LANDSCAPE PLANNING AND SENSE OF PLACE

Different cultures make sense of the landscape at large scales in a variety of ways, depending often on customary use, association, meaning and the services and functions that the landscape affords.

FIG 16.7. CATTLE-DUNG STICKS USED FOR FUEL DRYING OUTSIDE THE FORMER HOME OF THE POET RABINDRINATH TAGORE, BANGLADESH.

Unlocking landscape knowledge is important in ensuring that we manage landscape change in a way that does not destroy existing meanings embodied in the landscape and that in the creation and reconstruction of landscapes we provide the opportunities for positive interactions that can build new landscape meanings for future communities. However, it is also important to consider how we represent sense of place in the landscape at the larger scale, particularly when trying to build upon communities' existing knowledge through participatory action.

The European Landscape Convention does not value any one landscape above another; indeed, it recognises that local and ordinary landscapes, whether degraded or special, are just as likely to be of importance to the communities – or cultures – which inhabit them or the people who visit them as those that are labelled as having global importance. The Convention is revolutionary in the way that it has put 'ordinary' as well as 'special' landscapes on to government agendas throughout Europe. This is important in relation to sense of place. An ordinary, or even a degraded, landscape may have a sense of place that is valued by particular individuals or communities, but that is unrecognised in policy or by policymakers, politicians, professionals or other individuals in communities whose sense of place and values are different.

Sense of place may be gained over a period of time by repeated visits to a landscape, by living in the landscape or by one brief encounter with a landscape. It is clear that the identity and character of landscapes are intertwined with the cultural character of communities which have

moulded and have been moulded by them. It is important, therefore, to develop participatory processes in landscape planning that allow for individual and group expression of sense of place. Landscape character assessment is an approach to understanding identity at a variety of scales. When used with participatory approaches it can help to grasp group perceptions of sense of place at the larger scales. Such understandings are important because so much landscape association and meaning has been lost, often not through momentous or instant occurrences, although natural and man-made catastrophes (such as earthquakes and war) do destroy existing landscapes effectively and change meanings and associations. More often, it is the cumulative impact of many small and apparently insignificant actions that changes sense of place and can ultimately have an impact over wide areas of land.

Participatory processes in landscape planning are seen as having the dual role of potentially providing an outcome (eg consensus on a plan) and also helping to build social capital through the process undertaken (Margerum and Born 1995; Roe 2007a). Thus interactions related to landscape may be fostered through participatory action. Visioning processes for future landscapes can help bring an understanding that landscapes are not static but are as dynamic as societies and cultures. Landscape change may affect community sense of place, but through a better understanding of such change and of the interactions between communities and the landscape we can develop methods not only for more appropriate and sustainable planning for all landscapes but for recapturing a sense of place within communities.

Bibliography and References

Ali, A M S, 2003 Farmers' knowledge of soils and the sustainability of agriculture in a saline water ecosystem in Southwestern Bangladesh, *Geoderma* 111 (3–4), 333–53

Antrop, M, 2005 Why landscapes of the past are important for the future, *Landscape and Urban Planning* 70, 21–34

Bailey, C, Miles, S, and Stark, P, 2004 Culture-led urban regeneration and revitalisation of identities in Newcastle, Gateshead and the North East of England, *International Journal of Cultural Policy* 10 (1), 47–65

Bartlett, D, 1999 Kent Downs Jigsaw Project, *Landscape Design* 277 (February), 44

Basu, P, and Coleman, S, 2008 Migrant Worlds, Material Cultures, *Mobilities* 3 (3), 313–30

Berkes, F, 2008 (1999) *Sacred Ecology*, 2 edn, Routledge, New York and Abingdon

Brandt, J, and Vejre, H, 2004 Multifunctional landscapes – motives, concepts and perceptions, in *Multifunctional Landscapes Volume 1: theory, values and history* (eds J Brandt and H Vejre), WIT Press, Southampton, Boston

Brown, G, and Raymond, C, 2007 The relationship between place attachment and landscape values: toward mapping place attachment, *Applied Geography* 27, 89–111

Butts, R, 1987 The Analogical Mere: Landscape and Terror in 'Beowulf', *English Studies* 68, 113–21

Cantrill, J G, and Senecah, S L, 2001 Using the 'sense of self-in-place' construct in the context of environmental policy-making and landscape planning, *Environmental Science and Policy* 4, 185–203

Council of Europe, 2000 The European Landscape Convention text [online], available from: http://www.coe.int/t/dg4/cultureheritage/heritage/landscape/default_en.asp [10 June 2010]

de Groot, R, 2006 Function-analysis and valuation as a tool to assess land use conflicts in planning for sustainable, multi-functional landscapes, *Landscape and Urban Planning* 75, 175–86

Fairclough, F, 2009 Personal communication, Landscape Research Group Seminar: 'Reassessing Landscape Drivers and the Globalist Environmental Agenda', Lund, Sweden, 7 October

Foresight Land Use Futures Project, 2010 *Final Project Report*, The Government Office for Science, London

Foxon, A, 2005 Using participatory methods to establish local shrimp farmers' attitudes towards the environment, in the Ghatboag Union of Rupsha Thana, Southwest Bangladesh, unpublished MSc dissertation, School of Agriculture, Food and Rural Development, Newcastle University

Gelling, M, 2002 The landscape of Beowulf, *Anglo-Saxon England* 31, 7–11

Guerif, V, 2010 Making States, Displacing Peoples: A Comparative Perspective of Xinjiang and Tibet in the People's Republic of China, *Working Paper Series* 61, Refugee Studies Centre, Oxford Department of International Development, University of Oxford, available from: http://www.forcedmigration.org/papers/ [24 January 2011]

Hersperger, A M, and Bürgi, M, 2007 Driving Forces of Landscape Change in The Urbanizing Limmat Valley, Switzerland, in *Modelling Land-Use Change Progress and Applications* (eds E Koomen, J Stillwell, A Bakema and H J Scholten), Springer, Netherlands

— 2009 Going beyond landscape change description: Quantifying the importance of driving forces of landscape change in a Central Europe case study, *Land Use Policy* 26, 640–48

Jordan, P D, 2001 Cultural Landscapes in Colonial Siberia: Khanty Settlements of the Sacred, the Living and the Dead, *Landscapes* 2 (2), 83–105

Kienast, F, Wildi, O, and Ghosh, S, 2007 Change and Transformation: A Synthesis, in *A Changing World: Challenges for Landscape Research* (eds F Kienast, O Wildi and S Ghosh), Springer Landscape Series Vol 8, Dordrecht, 1–4

Laviolette, P, 2003, Landscaping Death: Resting Places for Cornish Identity, *Journal of Material Culture* 8, 215

Lovelock, J E, 1979 *Gaia: A new look at life on earth*, Oxford University Press, London and New York

Lowenthal, D, 2007 Living with and Looking at Landscape, *Landscape Research* 32 (5), 635–56

McCarthy, C, 2006 *The Road*, Picador, London

Macfarlane, R, Fuller, D, and Jeffries, M, 2000 Outsiders in the urban landscapes? An analysis of ethnic minority landscape projects, in *Urban Lifestyles: Spaces, Places, People* (eds J F Benson and M H Roe), Balkema, Rotterdam

Mackenzie, A, 2002 *Stories of the Highland Clearances*, Lang Syne, Glasgow

Margerum, R D, and Born, S M, 1995 Integrated Environmental Management: moving from theory to practice, *Journal of Environmental Planning and Management* 38 (3), 371–92

MEA (Millennium Ecosystem Assessment), 2005 *Ecosystems and Human Well-being: Synthesis*, Island Press, Washington DC

Mitchell, D, 2002 Cultural landscapes: the dialectical landscape – recent landscape research in human geography, *Progress in Human Geography* 26 (3), 381–9

— 2009 *Experiencing Landscapes: capturing the cultural services and experiential qualities of landscape* (Commissioned Report NECR024), The Research Box with Land Use Consultants & Rick Minter

Nassauer, J I, 1995 Culture and change landscape structure, *Landscape Ecology* 10 (4), 229–37

Natural England, 2010 National Character Areas information [online], available from: http://www.naturalengland.org.uk/ourwork/landscape/englands/character/areas/default.aspx [10 June 2010]

Olwig, K R, 2005 Editorial: Law, Polity and the Changing Meaning of Landscape, *Landscape Research* 30 (3), 293–8

Payton, R W, Barr, J J F, Martin, A, Sillitoe, P, Deckers, J F, Gowing, J W, Hatibu, N, Naseem, S B, Tenywa, M, and Zuberi, M I, 2002 Contrasting approaches to integrating indigenous knowledge about soils and scientific soil survey in East Africa and Bangladesh, *Geoderma* 111 (3–4), 355–86

Prebble, J, 1963 *The Highland Clearances*, Penguin, London

Rishbeth, C, 2001 Ethnic minority groups and public open space: how should designers respond? *Landscape Research* 26 (4), 351–66

Roe, M, and Hasan, M (eds), 2004a *Participatory Planning and Environmental Management for Salinity Affected Coastal Regions of Bangladesh*, BCHWSD/British Council-DfID, ISBN 984–32–1099–9

— 2004b *Sustainable Land Use Planning And Environmental Management for Salinity Affected Coastal Regions of Bangladesh: A Study on Rupsha Thana, Khulna District* (Part 1), BCHWSD/British Council-DfID, ISBN 984–32–1392–3

Roe, M H, 2005 *Community Forestry and Landscape Identity: Planning New Forest Landscapes*, 10th UNESCO Universities Heritage Forum, Newcastle, April

— 2007a The Social Dimensions of Landscape Sustainability, in *Landscape and Sustainability* (eds J F Benson and M H Roe), Routledge/E&FN Spon, London

— 2007b The European Landscape Convention: a revolution in thinking about 'cultural landscapes', *Journal of Chinese Landscape Architecture* 23 (143), 10–15 [in Chinese with English abstract]

—2007c Landscape Sustainability: An Overview, in *Landscape and Sustainability* (eds J F Benson and M H Roe), Routledge/E&FN Spon, London

— 2011 (forthcoming) Improving Intelligence Processes: the key to landscape sustainability?, in *Landscapes and Sustainability in Small Islands of the Mediterranean* (eds L Cassar and E Conrad), UNESCO

Roe, M H, Selman, P, and Swanwick, C, 2010 *The Development of Approaches to Facilitate Judgement on Landscape Change Options*, a Research Report to Natural England, Project No 21291

Scazzosi, L, 2004 Reading and assessing the landscape as cultural and historical heritage, *Landscape Research* 29 (4), 335–55

Schneeberger, N, Bürgi, M, Hersperger, A M, and Ewald, K C, 2007 Driving forces and rates of landscape change as a promising combination for landscape change research – an application on the northern fringe of the Swiss Alps, *Land Use Policy* 24 (2), 349–61

Stevenson, R L, 1879, *Travels with a Donkey in the Cevennes*, Thomas Nelson & Sons, London

Swanwick, C, and Land Use Consultants, 2002 *Landscape Character Assessment for England and Scotland*, Countryside Agency, Cheltenham and Scottish Natural Heritage, Battleby

Terkenli, T S, 2001 Towards a theory of the lacnae: the Aegean lacnae as a cultural image, *Landscape and Urban Planning* 57, 197–208

Turner, T, 1998 *Landscape planning and environmental impact design*, 2 edn, UCL Press, London

Wood, R, and Handley, J, 2001 Landscape dynamics and the management of change, *Landscape Research* 26 (1), 45–54

Wylie, J, 2007 *Landscape*, Routledge, London

Cultural Landscape and Sense of Place:
Community and Tourism Representations
of the Barossa

Lyn Leader-Elliott

Cultural landscapes and sense of place have many elements in common, and both are drawn on when tourism destinations are constructed and marketed. This is especially the case when place representations give weight to intangible cultural elements that have meaning for local communities. These elements include spiritual connections to country, philosophies of colonisation, music making and activities surrounding eating and drinking.

South Australia's Barossa region is one of the state's main tourism destinations, known typically for its wine, food and German descendant community culture. Government consultation and collaboration with regional communities from the late 1980s generated an agreed basis for establishing and communicating the cultural identity and cultural landscapes of the Barossa as the core of its distinctive sense of place and its appeal as a destination. Images and messages generated through this process informed regional marketing and promotions for the best part of two decades. The state's marketing focus has moved to wine and food experiences and, as a consequence, representations of the Barossa are becoming less culturally rich.

Communities assign more meanings to a place than do outsiders such as tourists or planners. A major community artwork, *The Barossa Valley Wall Hanging*, demonstrates this. Created to convey what the Barossa meant to its makers (its sense of place), it portrays a complex cultural landscape, rich with shared associations, memories and stories.

INTRODUCTION

Both cultural landscapes and places are made up of complex combinations of physical environments and tangible and intangible cultural elements, including ideas and values. Both are constructed by groups or individuals, for whom the meaning of the place or landscape will reflect their own connections and relationships with it. Both can be read in many different ways. Both place and landscape have multiple layers of meaning which depend on their cultural and natural history and the history, expectations and perceptions of different individuals or groups associated with the place or landscape. Several cultural landscapes may exist at the same time in the same spatial area: different social groups or individuals will interpret them in different ways and focus on different time scales, depending on their interests and points of view. We see landscapes and places through our existing mindsets, influenced in part by what we already know or expect and in part by the things which interest us most.

As early as 1925, Carl Sauer wrote of the critical role of humans in shaping landscape: 'The

cultural landscape is fashioned from a natural landscape by a culture group. Culture is the agent; the natural area is the medium. The cultural landscape the result.' (Sauer 1925, 343). He regarded culture itself as the shaping force of landscape, so that landscape becomes a cultural expression which necessarily varies over time and from place to place. There is now wide acceptance that cultural landscapes have both tangible and intangible elements, and that they include both cultural and natural landscape features (eg Birnbaum 1994; Cleere 1996; Head 2000; UNESCO 2010).

Intangible cultural landscape elements in Australia include the spiritual connections of the Aboriginal and Torres Strait Islander peoples, for whom the physical landscape is imbued with meanings and stories that may be hidden from all but an initiated few. These landscapes are not necessarily modified in any obvious way (for instance, they do not contain buildings) and their cultural significance derives from their association with *tjukurpa* (traditional lore, creation stories). As well as containing these ancient meanings, landscapes in the same area or region that have been modified during colonisation and settlement are likely to reveal the cultural value systems of the colonisers. The South Australian landscape, for instance, is characterised by the systematic approach to land division and allocation that reflected the philosophy of this planned model colony, founded in 1836. The ideal size of land holdings, the placement of towns at distances that would allow all families to attend church, send their children to school and meet each other at social gatherings – these concerns underpinned the official surveying required before land could be taken up, and which has left a landscape marked by the grids favoured by surveyors who were often from military backgrounds (Meinig 1970; Williams 1974). For instance, the surveys of the Barossa region, commissioned by wealthy colonists in 1837 and 1839, were carried out under the leadership of the Surveyor General of South Australia, Colonel William Light (Ross 1992, 10), while the villages of the first German settlers were based on the medieval land-use patterns of their homeland.

When intangible elements are combined with all the visible, material elements of human activities in landscapes, they form much of the raw material of what is conceptualised as 'sense of place'. Both 'cultural landscape' and 'sense of place' are terms used in tourism destination marketing and promotion, which are often built around significant elements of cultural landscapes. The term 'cultural landscape' is frequently used to refer to Indigenous cultural landscapes such as Kakadu and Uluru-Katatjuta National Parks (DEWHA 2010a; 2010b). It is also used quite commonly among cultural heritage professionals as a defined category for listing in World Heritage and national and state[1] heritage lists. Sometimes, 'cultural landscape' is used in a broad sense to include Indigenous, colonial and contemporary urban landscapes, or landscapes seen through the lens of art or literature. Tour operator Australians Studying Abroad led national discussions within the tourism and cultural industries on the interpretation of cultural landscapes in the 1990s, emphasising the visual and literary arts. The company maintains academic and general interest cultural landscape resources on its website (ASA 2010). Two Australian projects have specifically identified potential for tourism based on cultural landscapes beyond Indigenous landscapes. In the first, arts and tourism agencies in three states (South Australia, New South Wales and Victoria) collaborated to produce *Cultural Landscapes of Australia*, a publication designed to attract groups of Americans interested in cultural tourism (South Australian

[1] Australia has a three-tier Federal system of government: national, state and local.

Tourism Commission 1997). More recently, the Australian Collaborative Research Centre (CRC) for Sustainable Tourism released a scoping study for 'cultural landscapes tourism', using fieldwork case work studies from metropolitan, regional and rural areas in Victoria and New South Wales 'to explore the intersection between traditional and new cultural landscape precincts and the current and future patterns of Australian tourism' (Collins *et al* 2008, n.p.).

Landscapes can be considered as texts which will be 'read' differently by each reader and have different meanings for different groups and individuals (Duncan and Duncan 1988, 118; Arnesen 1998). Each landscape will have layers of meaning, which vary according to the perspective of the 'reader' (see, for instance, Meinig 1979; Schein 1997; Suvantola 2002). We see landscape through our existing mindsets, influenced in part by what we already know or expect, in part by the things which interest us most: history, archaeology, plant life, food and wine, visual arts, spirituality, architecture, anthropology, tourism marketing or product development. Place meanings are constructed as variously as meanings of cultural landscapes and, like them, are socially and cultural dependent (see, for example, Stedman 2008; Stokowski 2008; Williams 2008).

One key challenge for 'place sensitive' tourism is to seek ways in which the complexity of cultural landscape and place meaning can be retained and presented to tourists so that cultural integrity is respected. It is essential to have the knowledge and skills base to identify the elements of cultural landscape and sense of place: Stokowski (2008, 36) recommends considering 'interpersonal interactions, social processes, historical context and cultural influences on behavior' when analysing sense of place. Also essential is the involvement of communities which have close associations with these landscapes and places. Kyle and Johnson (2008, 111–12) suggest that people construct landscape meanings within social and cultural groups with which they are most intimately connected. American social scientist Daniel Williams (2008, 17–18) notes that members of a community will assign more meanings to a place than will visitors or other 'outsiders', such as planners. While the above papers focus on recreation planning and management, the same points can be extended to include planning and marketing for tourism. The tourism marketers who produce destination images are usually 'outsiders', not those for whom the destinations are 'home'. Representations developed by, or in consultation with, local communities are likely to be richer and more complex than those developed specifically as tourism 'product' (Kianicka *et al* 2005). Ideally, tourism destination marketing and planning incorporates the values and meanings (its sense of place) held by its resident community. In the Barossa region of South Australia, communities have developed a clear sense of what matters to them about their own place. This has found expression both through tourism marketing campaigns and the work of local artists.

THE BAROSSA REGION, SOUTH AUSTRALIA

The Barossa, one of South Australia's main tourism destinations, is 80km from the state's capital city, Adelaide. Barossa people are mostly descendants of immigrants from German or British backgrounds and the settlement patterns, architecture and lifestyle reflect that mixed heritage. Its villages are close together (unusual in regional Australia). Many landholdings are small, reflecting the early close settlement of the fertile valley land. In Bethany and Langmeil, the original German medieval village strip-farming layout is still visible. Social networks revolve around churches (the Lutheran Church in particular), schools, sports and music groups, as they did in the 19th and 20th centuries. In the Barossa, one of Australia's best-known wine regions, wine and food are important in local life as well as in the tourism market place, providing endless opportunities

for socialising within the community and for lively events aimed at bringing in visitors, such as the Barossa Vintage Festival, Gourmet Weekend and music festivals. These things are all part of the cultural landscape of the Barossa, and make up the sense(s) of place experienced by its residents and visitors.

Before its colonisation in the 1830s, the Barossa was the home of two groups of Aboriginal people: the Ngadjuri and the Peramangk. They were 'dispersed in the early days of white settlement', to use Norman Tindale's (1937) understated phrase, as the new arrivals invaded their lands, took over their food and water resources and spread deadly European diseases such as measles and small pox (Gara 1991; 2003; Warrior et al 2005). Aboriginal words persist in some street and town names, such as Tanunda and Nuriootpa, but there is no identifiable Aboriginal community in the region. There is little knowledge or awareness among the present Barossa communities of the Aboriginal subtext to their settled cultural landscape. Its first mention in a visitor guidebook was in a soundly researched publication produced by the Royal Geographical Society of South Australia (Barker and Ward 1991, 14–16). Brief information has been included in regional tourism guides for the last decade or so. Peramangk and Ngadjuri descendants are working to reconnect with their country, but most of their attention is focused on other parts of their traditional territory rather than on the Barossa (Coles and Hunter 2010; Lower 2010; Warrior et al 2005). Aboriginal connections do not form part of the sense of place for most residents and visitors, nor are they represented in tourism products in the region.

Marketing Sense of Place

Place marketing tends to concentrate on sights and attractions rather than sites and landscape meaning (eg Urry 1990, 11; Rojek 1997, 53). The fundamental product in tourism is the destination experience (Ritchie and Crouch 2000, 1) and tourism constructs places as destinations within which certain sorts of experiences will be available (Suvantola 2002; Ritchie and Crouch 2003).

Since the late 1980s, however, there has been a conscious effort to market the Barossa as a destination by communicating a sense of place that is built on understanding its cultural landscape. The German origin of the early settlers; the central place of the Lutheran Church; transformation of small-scale mixed farming to vineyards and winemaking; and continuity of cultural traditions around food and music are key elements of the cultural landscape that always appear and can be represented relatively easily through storytelling and images. The complexity of its social structure and community identity are more difficult to represent, but attempts have been made to convey aspects of these as well, by local residents engaging in regional tourism planning and marketing organisations and activities.

Reviewing the Barossa image[2]

Regional tourism in Australia is run by industry associations funded to varying degrees by local and state governments. In the Barossa, the tourism, winemaking and grape-growing industry

[2] The author lived in the Barossa from 1985 to 2005. She was directly involved in the discussions and projects mentioned here as tourism project officer, Vintage Festival volunteer event organiser and Board member, and president of the Barossa Region Residents' Association.

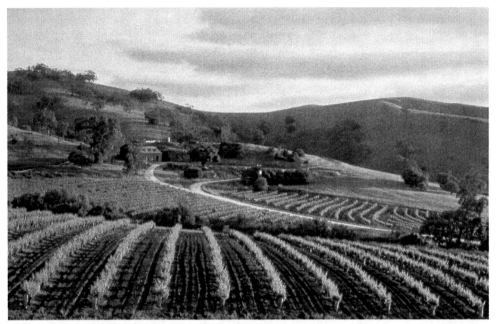

FIG 17.1. HILLSIDE VINEYARDS AND THE BETHANY WINES CELLAR DOOR; SIMILAR IMAGES HAVE BEEN IN USE FOR ABOUT 20 YEARS AND ARE USED ON THE BAROSSA WEBSITE.

associations worked together from the late 1980s until 2009 in the Barossa Wine and Tourism Association (BWTA), together with the Barossa Vintage Festival Committee, which marshals up to 2000 volunteers every two years to run the week-long Vintage Festival. One of the main reasons for bringing these four organisations together was to unite marketing efforts and project consistent images and messages into wine and tourism marketplaces to help boost tourism to the region and wine sales both within Australia and internationally. Key community values, activities, way of life, historic themes and other cultural landscape elements were progressively identified through intensive discussion over a period of months. John Ploog and Douglas Coats, professional photographers living in the region, were asked to capture the perfect example of atmosphere; landscape elements (such as historical buildings, church spires and vineyards); colour (the green of late spring rather than summer ochres associated with heat); settlement and crop patterns; local people and activities such as making music or kegeling (an old form of bowls). Their images were ideal for the purpose, some being used in promotions for many years.

The state government tourism agency (Tourism South Australia: TSA) supported this photography programme and subsequently funded and carried out regular photo shoots to build an image library for national and international promotional use. In the early 1990s, the planning and policy section of Tourism South Australia worked with the BWTA to build a Barossa regional tourism plan consistent with its strategy of building tourism products from the essential character of a place, respecting its culture and communities (see, for example, Leader-Elliott and Crinion 1991). Following consultations with a wide range of community organisations, including sporting clubs, TSA assembled a set of key images and themes for the Barossa. It issued a poster with 21

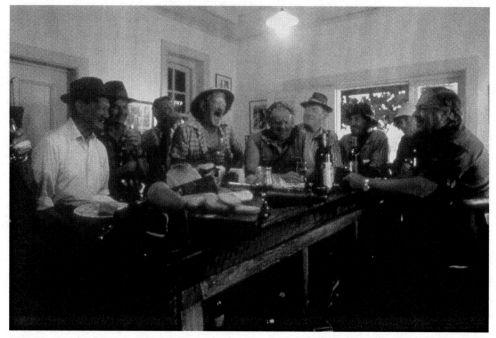

FIG 17.2. PETER LEHMANN AND BAROSSA GRAPE GROWERS IN THE WEIGHBRIDGE AT PETER LEHMANN WINES.

images (many taken by Ploog), each illustrating a thematic statement drawn from ideas expressed during the consultations. The main theme, 'A Sense of Continuity', was illustrated by a Ploog photograph taken behind the village of Marananga. Through a frame of eucalypts, the viewer's gaze moves from the Gnadenfrei Lutheran Church, past scattered farmhouses, vineyards and grazing sheep to the Barossa Range beyond.

Six other images on the poster included vineyards and the hills in different parts of the valley. The themes attached to them were: *Beyond suburbia: a bond with the land*; *A sense of purpose* (straight rows of vines march up and down small rises on the way to the Orlando winery); *Integration and informality* (small vineyard and hillside farm cottage); and *Clear horizons* (view of high vineyards in the Ranges). Wineries appear in four images. Their accompanying themes are *Sensitive architecture*; *Homely touches* (flowers in a cellar door window); *Understated grandeur* (Seppelts bluestone port store) and *Community grapevine* (the weighbridge at Peter Lehmann Wines, bustling with life, and where Peter himself is discussing the vintage and sharing a *schluck*[3] and a joke with grape growers) (Fig 17.2). Church spires (*Symbol of cultural identity*), food and wine festivals, traditional crafts such as making barrels (*Pride in craftsmanship*) and baking in a wood-fired oven (*Home-baked business*), and historic buildings (*Old country traditions adapt to a new home*) are the other images of places to which local people were attached, and which repre-

3 Schluck: Barossa Deutsch word for a little drink which has passed into local slang, where it always means a glass of wine.

sented many of their values as community members. Even the two images of accommodation houses on the poster have value statements attached: *Warm rural ambience* and *New echoes old.*

These images, and others like them, have been used consistently in the Barossa's regional visitor guides and tourism websites. Wine, food and aspects of German heritage feature in promotional writing about Barossa from the 1970s onwards. The state has worked steadily to achieve uniform design and content standards for regional guides, and continues to commission images that will reinforce its own strategic directions. In 1998, the South Australian Tourist Commission developed a marketing strategy it called 'Best Kept Secrets' which promoted 'authentic experiences and … created a "sense of place" that derived much of its impact from the use of iconic vision and images of South Australia' (James and Von Wald 2006, 191). For the duration of this campaign, the Barossa visitor guide was titled *Barossa Secrets.*

Since 2004, the Barossa, like other wine regions, has been significantly influenced by the state strategy to promote wine tourism as a globally recognisable product, rather than promoting local character which has limited recognition (South Australian Tourism Commission 2004). The 2009 State Tourism Plan (South Australian Tourism Commission 2009a) identified 'experience seekers' as its target market and focused on developing 'signature experiences'. Also in 2009, the state as a whole adopted the marketing brand '*South Australia. A Brilliant Blend*', chosen because it 'builds on the State's main strength – its wine reputation – without limiting its focus to wine' (South Australian Tourism Commission 2009b). With the drive towards wine tourism, the 'wine experience' has come to dominate the Barossa's tourism marketing imagery. Main images used for regional tourism guides have shifted over the last decade from a typical small Barossa Lutheran church surrounded by vineyard and framed by gum trees, to a happy foursome picnicking on the grass, wine glasses in hand, in a treed park in front of a winery designed in ersatz-chateau style, to glasses of red wine on top of an oak barrel, to the most recent iterations of laughing young people holding glasses of wine in a vineyard. It seems that as the grip of the wine marketing strategy tightens, a more limited view of the cultural landscape and sense of place of the Barossa is being conveyed to the main users of the guide: visitors to the region. There has been a gradual but definite shift away from the values approach adopted in the 1990s to one that is now sharply focused on wine marketing and the 'wine and food experience'. History and heritage, arts and crafts are offered as additional experiences, but the awareness of the rich cultural texture underlying the Barossa's sense of place has faded (southaustralia.com 2010a; 2010b).

THE *BAROSSA VALLEY WALL HANGING*

The *Barossa Valley Wall Hanging* (Fig 17.3) was intended from the outset to represent what the Barossa meant to the members of the Vine Patch Quilters group who made it. They were local and so was its intended long-term audience. Its first appearance was scheduled for the 1997 Barossa Vintage Festival, but it was not completed until 1999 (Leader-Elliott *et al* 2004). After tours to Adelaide and display in the Barossa Council Chambers, the hanging was transferred in 2004 to the Barossa Regional Gallery, where it is admired by visitors and local people alike.[4] Douglas Coats' photograph of the hanging (Fig 17.3) was used as the front cover image for the

4 The hanging is about 2.7m high and 3.2m wide – its dimensions determined by the size of the kitchen wall in the house where the Vine Patch Quilters met for one crucial planning meeting.

FIG 17.3. (LEFT) THE *BAROSSA VALLEY WALL HANGING*, CREATED BY VINE PATCH QUILTERS. (RIGHT) SECTION OF THE *BAROSSA VALLEY WALL HANGING*: DETAIL OF BARONS OF THE BAROSSA AND VINTAGE QUEEN BLESSING THE VINTAGE.

Royal Geographical Society's *Discover the Barossa* (Barker *et al* 2003). The women wanted other people to share the places they love and so prepared a key for all the places and activities shown in the hanging. Interest was so great that a book on the making and meaning of the hanging was written by this author in conjunction with two of its creators (Leader-Elliott *et al* 2004). The book includes the key and a map to show where visitors can see the original places.

Meanings are revealed in and through stories (Williams 2008, 24) and multiple stories attach to every image in this artwork, while its meanings multiply with every visitor who engages with it – especially for those who connect the textile landscape images with the actual places and people they represent.

The images to be included in the hanging were chosen through group discussion, based on memories, stories and aspects of daily life important to each woman, as well as what they considered to be Barossa landmarks. The project eventually took three years and those women who stuck with it became a tight-knit group for whom the overall picture, not just single images, truly represents the Barossa's meaning for them all.

Places and ideas represented in the hanging are similar to those used in the tourism marketing imagery developed throughout the 1990s, with some additions and many quirky details. The landscape view across the valley to the Barossa Range, framed by the large eucalypt on the left and interwoven with vines, is not unlike Ploog's earlier framing of the view from Marananga. The hanging includes many of the historic landmarks of the Barossa: wineries, churches, settlers' cottages, barns, bake-ovens and German wagons. Community celebrations such as the Barossa Vintage Festival are there, along with the music and food which are such an important part of Barossa life. The women who designed and made the wall hanging have drawn from their history and traditions, choosing and expressing elements which continue to have meaning in their own lives and the lives of their families; the Greenock Creek Tavern, for instance, was included because it was the favourite watering hole of one quilter's husband.

The importance of religion is clear in this 80-year-old woman's explanation of why she had chosen the Union Chapel at Angaston, and also relates to part of the Barossa founding story:

'I am a born Lutheran. George Fife Angas, one of the founders [of South Australia and the Barossa], was closely linked with the spiritual history of the Barossa. As a Baptist, he was committed to the highest ideals of religious liberty. His contact with Pastor Kavel laid the basis for the migration of pious Lutherans to settle this area. He also encouraged the English to migrate (Baptists, Congregationalists and Methodists faced the same discrimination in England at that time). George Fife Angas endowed the free chapel at Angaston, then called 'German Pass', for use by all Christian non-conformists. The recently restored Chapel is the oldest [religious] building in the Barossa.' She went on to say that she often passes the Chapel and always admires it. (Leader-Elliott *et al* 2004, 19–20)

Indigenous people are not represented in the hanging – pre-colonial life is represented only by kangaroos and grass trees up against the hills in the top right corner. This group of women concentrated on what was important in their own lives in representing a sense of place for their home. Likewise, potential connection with local Indigenous culture is missing from the region's tourism product, reflecting the lack of identifiable community and general interest in it within the Barossa region.

CONCLUSION

The concepts of cultural landscapes and sense of place were embraced in South Australian tourism planning from the late 1980s at state and regional level. In the Barossa, industry associations and community networks worked together and with the state government tourism agency to develop marketing strategies that communicated its identity as a place and its position as a tourism destination. The work put into community consultation ensured that marketers and planners could draw on images and themes that captured core elements of Barossa cultural identity and they were indeed used in this way for the best part of 20 years.

As the focus of the state's tourism marketing has swung towards sectoral priorities such as wine tourism, underpinned now by the requirement for 'signature experiences', it appears that a new paradigm is replacing that based on sense of place and cultural landscapes – one that is intended to be simpler for customers to grasp. It can be argued that the majority of tourists will have a narrower range of interests in the Barossa than will its residents and that material produced for visitors can therefore be narrower in scope than something produced primarily for residents. Works generated from within the community will continue to offer alternative and potentially richer views. The *Barossa Valley Wall Hanging* encapsulates Barossa culture and lifestyle and fascinates visitors so that they want to discover the places that inspired the Vine Patch Quilters.

Tourism destination marketing and product development can be based on an understanding of cultural landscapes and sense of place, and if local knowledge and creativity is linked to planning and projects being driven by wider policy agendas, there is greater potential for visitors to develop deeper appreciation of the cultural values of the places they visit.

BIBLIOGRAPHY AND REFERENCES

Arnesen, T, 1998 Landscapes Lost, *Landscape Research* 23 (1), 39–50

ASA, 2010 *Australians Studying Abroad Homepage*, available from: http://www.asatours.com.au/ [29 July 2010]

Barker, S, and Ward, B (eds), 1991 *Explore the Barossa*, South Australian Government Printer, Netley SA

Barker, S, Heathcote, L, and Ward, B, 2003 *Discover the Barossa*, Royal Geographical Society of South Australia, Adelaide

Birnbaum, C A, 1994 *Protecting Cultural Landscapes*, National Park Service, Technical Preservation Brief 36, available from: www.cr.nps.gov/hps/tps/briefs/brief36.htm [27 June 2010]

Cleere, H, 1996 The evaluation of Cultural Landscapes: the role of ICOMOS, in *Cultural Landscapes of Universal Value* (eds B von Droste, H Placter and M Rössler), Gustav Fischer Verlag Jena, Stuttgart, New York (in cooperation with UNESCO), 50–59

Coles, R, and Hunter, R, 2010 *The Ochre Warriors Peramangk culture and rock art in the Mount Lofty Ranges*, Axiom Australia, Stepney, South Australia

DEWHA: Department of Environment, Heritage, Water and the Arts, 2010a *Kakadu National Park*, available from: http://www.environment.gov.au/parks/kakadu/index.html [25 July 2010]

—– 2010b *Uluru-Katatjuta National Park*, available from: http://www.environment.gov.au/parks/uluru/ [25 July 2010]

Duncan, J, and Duncan, N, 1988 (Re)reading the landscape, *Environment and Planning D: Society and Space* 6, 117–26

Gara, T, 1991 Dreamtime, in *Explore the Barossa* (eds S Barker and B Ward), South Australian Government Printer, Netley

— 2003 Land of Ngarna, in *Discover the Barossa* (eds S Barker, L Heathcote and B Ward), Royal Geographical Society of South Australia, Adelaide

Head, L, 2000 *Cultural Landscapes and Environmental Change*, Arnold, London

James, J, and von Wald, D, 2006 The Development of the 'Secrets' Image of South Australia, *Tourism, Culture & Communication* 6, 191–203

Kianicka, S, Buchekere, M, Hunziker, M, and Müller-Böker, U, 2005 Locals' and tourists' sense of place: a case study of a Swiss alpine village, *Mountain Research and Development* 26 (1), 55–63, postprint available from: http://www.zora.uzh.ch [14 February 2010]

Kyle, G T, and Johnson, C Y, 2008 Understanding Cultural Variation in Place Meaning, in *Understanding Concepts of Place in Recreation Research and Management* (eds L E Kruger, T E Hall and M C Stiefel), US Department of Agriculture, Forest Service Pacific Northwest Research Station General Technical Report PNW-GTR-744 published in conjunction with University of Idaho, Portland, OR, 109–34

Leader-Elliott, L, Brooker, J, and Carter, P, 2004 *Creating the Barossa in Fabric: The Making of the Barossa Valley Wall Hanging*, The Art Shop, Tanunda, South Australia

Leader-Elliott, L, and Crinion, D, 1991 *Cultural Tourism: The Rewarding Experience*, South Australian Cultural Tourism Committee, Adelaide

Lower, K, 2010 Landscape archaeology and indigenous nation building in Ngadjuri country, unpublished M Arch thesis, Flinders University

Meinig, D, 1970 *On the margins of the good earth: the South Australian wheat frontier…*, Rigby, Adelaide

— (ed), 1979 *Interpretation of Ordinary Landscapes: geographical essays*, Oxford University Press, New York

Ritchie, J R B, and Crouch, G I, 2000 Editorial: The Competitive Destination: a sustainability perspective, *Tourism Management* 21 (1), 1–7

—— 2003 *The Competitive Destination: a sustainable tourism perspective*, CABI Publishing, Wallingford

Rojek, C, 1997 Indexing, Dragging and the Social Construction of Tourist Sights, in *Touring Cultures: Transformations of travel and theory* (eds C Rojek and J Urry), Routledge, London and New York

Ross, D, 1992 Special Surveys in a Land of Hills and Valleys, in *The Barossa a Vision Realised* (eds R Munchenberg, H Proeve, D Ross, A Hausler and G Saegenschnitter), Barossa Valley Archives and Historical Trust, Tanunda, 10–20

Sauer, C O, 1925 The Morphology of Landscape, University of California Publications in *Geography* 2 (2), 19–54, reprinted in 1963 *Land and Life: A Selection from the writings of Carl Ortwin Sauer* (ed J Leighly), University of California Press, Berkeley and Los Angeles, 315–50

Schein, R H, 1997 The place of landscape: A conceptual framework for interpreting an American scene, *Annals of the Association of American Geographers* 87 (4), 660–81

South Australian Tourism Commission, 2004 *Wine Tourism Strategy 2004–2008*, available from: http://www.tourism.sa.gov.au/tourism/plan/Wine_Tourism_Strategy.pdf [26 July 2010]

—— 2009a *South Australian Tourism Plan 2009–2014*, available from: http://www.tourism.sa.gov.au/tourism/plan/Tourism_Plan_09–14.pdf [14 February 2010]

— 2009b *South Australia. A brilliant blend*, available from: http://www.tourism.sa.gov.au/brilliantblend.asp [26 July 2010]

— 2010 Corporate website, available from: http://tourism.sa.gov.au/ [26 July 2010]

South Australian Tourism Commission, Tourism Victoria and Tourism New South Wales, c.1997 *Cultural Landscapes of Australia*, State governments of South Australia, Victoria and New South Wales

southaustralia.com, 2010a *Barossa South Australia*, available from: http://www.southaustralia.com/Barossa.aspx [20 July 2010]

— 2010b *Barossa*, available from: http://www.southaustralia.com/cellardoor/barossa.html [20 July 2010]

Stedman, R C, 2008 What Do We Mean by Place Meanings? Implications of Place Meanings for Managers and Practitioners, in *Understanding Concepts of Place in Recreation Research and Management* (eds L E Kruger, T E Hall and M C Stiefel), US Department of Agriculture, Forest Service Pacific Northwest Research Station General Technical Report PNW-GTR-744 published in conjunction with University of Idaho, Portland, OR, 61–82

Stokowski, P A, 2008 Creating Social Senses of Place, in *Understanding Concepts of Place in Recreation Research and Management* (eds L E Kruger, T E Hall and M C Stiefel), US Department of Agriculture, Forest Service Pacific Northwest Research Station General Technical Report PNW-GTR-744 published in conjunction with University of Idaho, Portland, OR, 31–60

Suvantola, J, 2002 *Tourist's Experience of Place*, Ashgate, Aldershot

Terkenli, T S, 2002 Landscapes of Tourism: towards a global economy of space, *Tourism Geographies* 4 (3), 227–54

Tindale, N B, 1937 Two Legends of the Ngadjuri Tribe from the Middle North of South Australia, *Transactions of the Royal Society of South Australia* 61, 149–53, available from: http://www.samuseum.sa.gov.au/Journals/TRSSA/TRSSA_V061/TRSSA_V061_p149p153.pdf [29 July 2010]

UNESCO, 2010 *Cultural Landscapes*, available from: http://whc.unesco.org/en/culturallandscape [27 February 2010]

Urry, J, 1990 *The Tourist Gaze*, Sage, London

Warrior, F, Knight, F, Anderson, S, and Pring, A, 2005 *Ngadjuri: Aboriginal People of the Mid North Region of South Australia*, SASOSE Council Inc, Meadows, South Australia

Williams, D R, 2008 Pluralities of Place: A User's Guide to Place Concepts, Theories, and Philosophies in Natural Resource Management, in *Understanding Concepts of Place in Recreation Research and Management* (eds L E Kruger, T E Hall and M C Stiefel), US Department of Agriculture, Forest Service Pacific Northwest Research Station General Technical Report PNW-GTR-744 published in conjunction with University of Idaho, Portland, OR, 7–30

Williams, M, 1974 *The Making of the South Australian Landscape*, Academic Press, London and New York

Territorial Cults as a Paradigm of Place in Tibet

John Studley

Historically, territorial cults were common in the three regions of Tibet (*chol khar gsum*) and epitomised association with a particular locality and formed an important part of religious life and Tibetan identity. They have, however, acquired new significance in contemporary Tibet and 'play a role in affirming identity' (Karmay 1998, 447). They are one of the main ways in which place comes to have a direct bearing on the identity of individuals and communities. This appears to be equally true of a single place or as a common reference for all Tibetan people (Buffetrille and Diemberger 2002).

Territorial cults are not protected under Chinese law and would be considered a despised form of 'superstition'. However, as a spontaneously recovered folk practice they lie outside the scope of state control (Schwartz 1994) and parallel the revival of folk religion in rural China (Lai 2003). This phenomenon is illustrated in this chapter from cognitive research the author conducted in Eastern Kham and provides evidence that place attachment is not only important to most Tibetans but that territorial cults are an integral part of place reclaiming in the face of the civilising propensities of outsiders.

INTRODUCTION

> Attachment to place is profound, ongoing and dynamic ... initiatives related to cultural landscapes offer an invaluable opportunity to address issues relating to social, spiritual and ecological alienation and disenfranchisement, both in urban and rural areas, and both among emplaced and displaced peoples.
>
> (PAP, n.d.)

Specific qualities of landscape infuse a site with a sense of place that has been forged and maintained out of a very intimate relationship and place-attachment between indigenous people and their 'topocosm' (Gaster 1961, 17). As a complex multidimensional phenomenon, sense of place has not been holistically defined in the literature (Jorgensen and Stedman 2006). There is some agreement, however, that sense of place addresses:

- 'Relations, perceptions, attitudes, values, and a world view that affectively **attaches** people and place' (Yan Xu 1995);
- 'Experiential, toponymic, numinous and narrative' elements (Raffan 1992, 379);
- 'Biophysical, psychological, socio-cultural, political and economic' dimensions (Ardoin 2006, 112);
- 'Cognitive, affective (emotional) and conative (behavioural)' components (Casakin and Billig 2009, 821).

There is also agreement that any loss of sense of place can result in 'humiliation, distress, aliena-tion and rootlessness' (Yan Xu 1995). Place attachment is integral to sense of place (Cajete 1995) and the literature places an emphasis on place attachment in the following contexts:

- Where national or group identity is bound to the environment, either specific forests or landscapes or idealised or imagined ones (Gupta and Ferguson 1997);
- As part of a post-modern turn to 'other' forest values that recognises attachment to place and may be linked to local wisdom (Feld and Basso 1996);
- Where peoples, their cultures or environments are threatened or their identity deterritorialised (Mackenzie 2002);
- In response to research in conservation psychology (Bott *et al* 2003).

The focus of this chapter[1] is primarily on place attachment among Tibetans in the face of land-scape expropriation and attachment to *numinous* (spiritual/supernatural) territories. The intro-duction of natural resource interventions and land occupation affect not only local attitudes but also levels of place identity and attachment. This is because of strong 'territorial' implica-tions when interventions are imposed by 'outsiders' and a perceived lack of local 'control' and 'discontinuity' (Bonaiuto *et al* 2002, 639). Local people respond in a number of different ways; some will manifest negative attitudes and opposition towards the authorities, especially if there is a perceived political threat to local identity, which may lead to violence or the breakdown of society (Turnbull 1984). Others, however, are able to react, as a coping strategy, by increasing their level of identification with their own group and by increasing group cohesion, sense of place and place attachment.

It is important, in the context of this chapter, to understand the distinction between place and location. Despite their mobility, migratory peoples often have a strong sense of place. The placement of Tibetan tents in a *yul* can create a sense of constant place-orientation at multiple locations (Langer 1953), and it would appear that 'place-bonding' (Proshansky 1978) emerges primarily from an interaction of cultural and natural setting and may function 'transpatially' (Feldman 1990) with loyalty to types of place or 'place congruity' (Hull 1992).

Whilst the Tibetan peoples have had a strong sense of national and cultural identity throughout much of their history (Karmay 1996a; 1996b), what bound them together were certain common-alties of culture, religion and identity.

Tibetan farmers and nomads have had to continually remake place and maintain belonging in the face of exogenous forces that have attempted to assimilate their beliefs and culture. This process began with the arrival of Tibetan Buddhism and was exacerbated by 'Confucianisation', 'Hanification', Communism, and the 'Socialist market economy'.

THE BASIS OF TIBETAN IDENTITY

During the Imperial Period (circa 7th–9th centuries AD), Tibetans had a strong sense of national and cultural identity which was eulogised in the literature celebrating Tibet's topographic location,

[1] An unabridged version of this chapter is available from: http://issuu.com/drjohn/docs/ter_cults?mode=a_p.

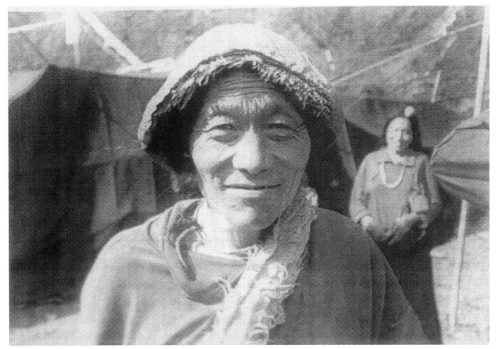

FIG 18.1. TIBETAN NOMADS LIVING IN THE *OBALA VALLEY* IN EASTERN KHAM.

its natural beauty, purity and wildness as an abode of the gods and its centrality in relationship to India, Iran, Turkistan and Han China (Karmay 1994). The customs associated with territorial numina (*yul lha*) were an essential element in Tibetan life and are place-based. They were fundamental for maintaining 'sense of place' and collective identity expressed in cultural, economic and political behaviour (Blondeau 2003) and a spiritually based ecological mind-set.

Throughout much of their history what bound lay Tibetans together were certain commonalities of culture, religion and 'Tibetanness' (Anand 2000, 271), which formed the basis of Tibetan 'ethnie' (Hutchinson and Smith 1996, 6). In terms of commonalities of culture, participation in territorial (*yul lha*) cults was always important. These cults epitomise association with a particular place and form an important part of the religious life of most Tibetan communities. The powerful sense of local belonging and identity, engendered by belonging to a 'cult', has to be manufactured and maintained on a regular basis (Ramble 1997).

The *yul lha* are protective deities associated with specific clans who come under their protection, and who bestow honour and blessing on the territory, people and political leadership (Diemberger 2002). They are numinous divinities who inhabit biophysical features of the landscape and are 'controlled' by a *lha pa* (shaman). The *lha pa* are responsible for maintaining harmony between humanity, the spirit world and nature. If the harmony is broken, the *yul lha* will allow malevolent *numina* to harm humankind with illness, floods or crop failure.

The rites associated with *yul lha* do not involve Buddhist clergy, and represent a supremely important element underlying Tibetan identity. The *yul lha* is worshipped as an ancestral and territorial divinity to ensure personal protection, the security of territory and abundance of

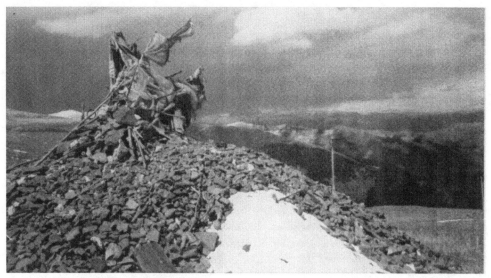

FIG 18.2. A *LA-BTSAS* WHERE *YUL-LHA* ARE HONOURED AND TERRITORY NUMINISED.

resources. *Yul lha* rituals take place daily at home and during communal mountain rituals which usually take place annually and are in sharp contrast to the Buddhist veneration of specific holy mountains. *Yul lha* worship attracts Tibetan lay people and is concerned with the immanent world through the use of rituals.

Typically during the communal rituals the *yul lha* are honoured and appeased through the building of wooden or stone cairns (see Fig 18.2) on mountain or hillsides which are annually constructed in ceremonies varying according to the lunar calendar. The rituals include fumigation offerings, the scattering of wind horses, the planting of prayer flags or arrows and prayer to the *yul lha*. Through invocation, geospatially discrete territory is

* evoked by the geographically ordered naming of land deities
* 'renuminised' (Martins 2002, 99) linking sacred and political territory with physical correlates (Bauer 2009).

The aim of the ritual is to restore the relationship between the community and the *yul lha* and consists of both offerings and requests. The worshippers call on the *yul lha* for personal protection, the realisation of ambitions and fortune, the subduing of enemies, success in hunting and forgiveness for environmental degradation (Gross 1997). They regard the *yul lha* as a provider of blessing, glory, honour, fame, prosperity, progeny and power for the people and their political and religious leadership. During the year the *yul-lha* circumnavigates the territory defining the community's boundaries and resources.

Participation in such a ritual implies total integration into the community, which in turn implies inherited social and political obligations, moral and individual responsibility, and an affirmation of communal solidarity in the face of external aggression. In lay Tibetan culture, community is tied to a definite geospatial territory (Bauer 2009).

CULTURAL THREAT AND REVITALISATION

Throughout the history of Tibet there have been three main 'civilising' projects, Buddhism, Confucianism and Communism, which have undermined place attachment and identity and have prompted lay Tibetans to repeatedly reclaim place.

The emergence of a powerful centralised Tibetan monarchy patronising Buddhist monasticism dates from the 7th century AD. During the course of 200 years, this monarchy expanded the frontiers of Tibet from western China to Kashmir and northward into Central Asia, but often to the detriment of indigenous culture and folk religion. This ongoing process of 'Buddhisation' (Buffetrille 1998, 18–34) resulted in the:

- unseating of nobles and adherents of indigenous animistic beliefs
- 'taming' of indigenous divinities
- cultural assimilation of animistic peoples
- transformation of gender constructs
- cultural transformation of nature
- 'denuminisation' of mountains and forests
- loss of god and soul
- loss of national identity and any sense of belonging
- deterritorialising and displacement of *yul lha*
- undermining of Tibetan selfhood

Buddhisation has been augmented by official Han discourse which has further undermined indigenous culture and folk religion (Studley 2005). It was not until the 1980s, possibly as a result of the failures of assimilation, that official discourse provided some space for the recovery of folk practices.

As a result many ethnic traditions, clan systems and customs were revitalised and celebrated (Harrell 2001) and a profound nativisation of culture began to take place. Revitalisation became significant not only as cultural and religious expressions, but as a way to contest the atheist ideology and technocratic 'place-making' strategies of the Chinese state.

We find evidence (Studley 2005) of cultural revival among the Tibetans expressed in Buddhism, Visionary movements, Millennialism, Animism/Shamanism, Territorial Cults and Epic Literature (Barnett and Akiner 1994). The revival of *yul lha* cults took on additional meanings as a way to reclaim places as 'Tibetan' (Kolas 2004).

The evidence of cultural revival is not only documented in the literature but, as the following case study demonstrates, when manifest through territorial cults it 'exhibits historic continuity of ritual performance, provides a platform for reinventing place and enhancing identity, provides an exemplar of explicit bio-cultural sustainability and … provides a means of defiance and ritual protest against oppression' (Studley 2005).

THE CASE OF EASTERN KHAM

Kham is one of the most unique biological regions on Earth. It is situated at the eastern end of the Himalaya between Qinghai-Tibetan plateau and China, and comprises one of the three major regions of Tibet. The region constitutes about 4 per cent of China's land area, includes seven mountain ranges and comprises Western and Eastern Kham (see Fig 18.3).

Kham's north–south mountain ridges, sandwiched between deep river gorges, contain the

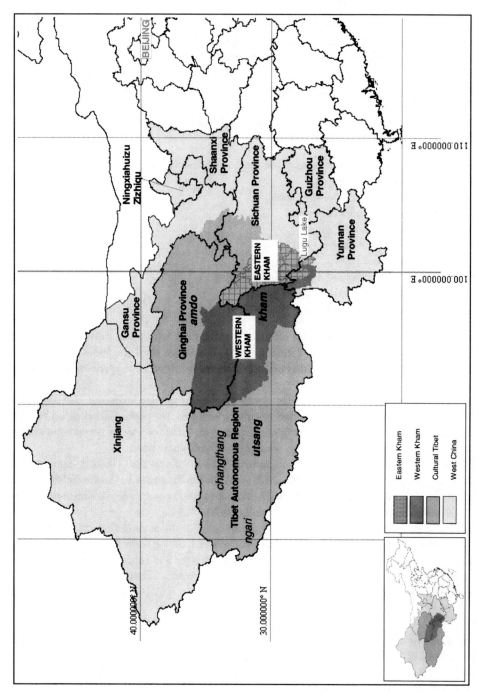

Fig 18.3. Map of the three *chol khar gsum* regions of Tibet (Kham, Amdo and Utsang).

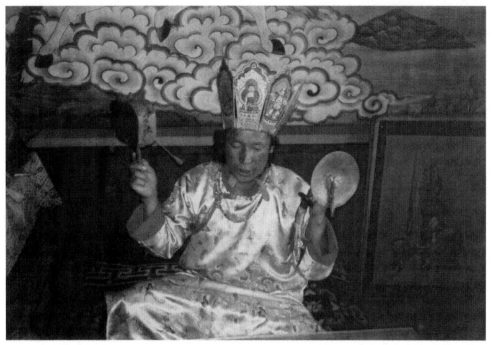

FIG 18.4. A MOSUO *DABA* NEAR LUGU LAKE IN SOUTH-EASTERN KHAM.

most diverse vascular plant flora of any region of comparable size in the temperate zone, and almost half of China's flowering plant species. Elevations range from 1000m to over 7556m with a mean of 3500m. Four of Asia's largest rivers, which originate on the 5000m-high Qinghai-Tibetan plateau and are of great economic importance, flow through the region. External impact on the region is increasing and poses a threat to the biocultural diversity which defines the area.

The region bears the strong imprint of Tibetan Buddhism and folk religion, evident in the large temple complexes, prayer flags, festivals, shaman (see Fig 18.4) and *numina* associated with sacred landscape features. Sacred mountains punctuate the landscape and they are unique in that their forests have not been logged.

PEOPLES OF EASTERN KHAM

Of the nearly 5 million 'Tibetans' living in China, approximately 2 million speak Kham, which is quite distinct from the Kham spoken in mid-western Nepal. The Khambas inhabit a vast area but are primarily concentrated in western Sichuan Province, eastern Tibet Autonomous Region (TAR), southern Qinghai Province and Northwestern Yunnan. The eastern Kham language is by far the most significant of the Kham varieties with possibly 1.2 million speakers.

There are also about 250,000 Qiangic-speaking peoples and 400,000 Nosu (Yi) peoples in Eastern Kham. The Qiangic-speaking peoples are classified as 'Tibetan' because of their culture, customs and beliefs. In common with the Khamba they are animistic/shamanistic as well as

Tibetan Buddhist, and burn incense and honour mountain gods at yearly festivals. They may speak Khamba as a second or third language, and are often matrilineal.

The region's inhospitable topography, altitude, weather and aggressive population have always united to deny entry to foreigners. There are few accurate maps that define its contours and record its villages and the secret routes of its nomads. To the Europeans, Chinese and Lhasa Tibetans, Kham is a vast no-man's-land. To the south, it is bounded by the Himalaya and the Bramaputra, to the north the Amne Machin range and the Tibetan region of Amdo, and to the east the Sichuan Basin.

Throughout their history there is evidence of a nascent sense of unique identity and place attachment among the Khamba peoples (Epstein 2002; Samuel 1993) which continues to this day.

METHODOLOGY

The significance of place attachment and identity is presented below against the background of a much larger study of ethno-forestry paradigms. The only research methods that appeared to be germane were from the fields of cognitive anthropology typified by Colby (1996) and predicated on cognitive mapping.

For cognitive mapping, a candidate list of pertinent forest-related variables was developed with the stakeholders and a psychometric survey was conducted among local nomads and farmers. The resulting scaled data were input into a multidimensional scaling programme for analysis and each variable was represented as a point on a cognitive 'map'.

RESULTS

Cognitive Mapping

Seventeen forest-related variables (Table 18.1) were identified as most apposite for the psycho-metric scaling survey, which was conducted at 57 sites throughout Eastern Kham.

Table 18.1. Forest-related variables

Local Values	Local Conservation, Blessing, Tibetan Buddhism, Yul lha, Natural Environmental Function, Forest Products, Natural Hydrological Function
Objects of Value	Forest, Wildlife
Actors	Men, Women, Self
Interventions	State Conservation, Hunting, Industrial Forestation, Socialism
Other	This Place, Ganzi Town[2]

The people of Kham (Fig 18.5) make sense of forest-related stimuli on the basis of four cognitive domains:

1 socio-economic
2 psycho-cultural
3 bio-physical
4 environmental and subsistence services

[2] Ganzi is an important town in Kham and was added to provide comparison with 'this place'.

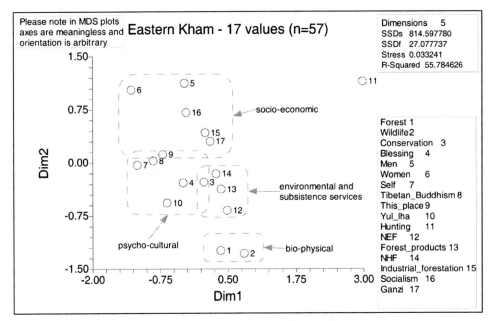

FIG 18.5. COGNITIVE MAP OF FOREST-RELATED VARIABLES IN EASTERN KHAM.

Domain 4 has some resonance with Bird-David's concept of a 'giving environment' and domains 2 and 4 (together) of his concept of 'cosmic economies of sharing' (1992). I think, however, that 'cosmic cycles of reciprocity' better describes the interface of the two domains.

In terms of this chapter it should be noted that the nexus of variables coalescing around 'this place' and 'Self' includes 'Tibetan Buddhism', '*yul lha*', 'Blessing' and 'Conservation'. This highlights the importance of spiritual belief in general and the *yul lha* cults in particular as a foundational element for Khamba 'self-hood' (Anand 2000, 282) or identity, place attachment and conservation.

During fieldwork it was noted that young people with some education appeared to be alienated from place and local culture. This is a fairly common phenomenon among indigenous people and is supported by the data. Young people (Fig 18.6) appear to identify more closely with 'socialism' than 'place' and appear to be alienated from '*yul lha*', 'Tibetan Buddhism' and 'Blessing'. Given the 'colonising' propensities of the state this result was anticipated.

In comparison, old people (Fig 18.7) identify strongly with 'place' and traditional values ('*yul lha*', 'Tibetan Buddhism', 'Blessing') and closely associate 'place' with '*yul lha*' and 'Tibetan Buddhism'.

The people of Kham do not appear to identify with 'the forest' because it is culturally and socially constructed as a place and as a category (Lye 2005; Nightingale 2006). It is not the physical or material aspects of the forest or wildlife that are important to the Khambas but their 'cycles of cosmic reciprocity' are important and render the resource apparent. This is reflected in the close proximity and overlap between the psycho-cultural and environmental and subsistence service domains (Fig 18.5).

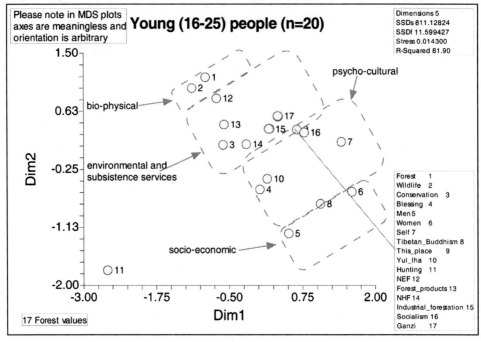

FIG 18.6. COGNITIVE MAP OF YOUNG (16-25) RESPONDENTS.

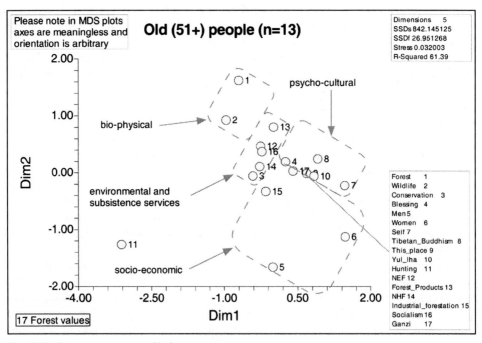

FIG 18.7. COGNITIVE MAP OLD (51+) RESPONDENTS.

DISCUSSION

Reference is deliberately made to the Tibetan toponym རྩོལ་ཁར་གསུམ of *or chol khar gsum* to describe the three main regions of Tibet because China only recognises one (ie The Tibetan Autonomous Region), and Tibetans do not use 'Greater Tibet'. The ongoing process of Hanification has either rendered Tibetan place names defunct or replaced them with Han Chinese ones that on occasion speak of conquest.

The Khambas did not volunteer 'place attachment' or 'identity' as forest values during field-work, but they were included because of their importance in the literature (Epstein 2002).

It is evident from the research and literature that the indigenous peoples of Tibet have become emotionally attached to places and place features, such as *yul lha* locales, and these attachments have become integral to their sense of place. In this respect they are typical of indigenous people in that they have become so completely identified with a place that they reflect 'its very entrails, its insides, its soul' (LaChapelle 1992, 1). Their sense of place and 'ensoulment' (Cajete 1994, 83) have been established as a result of long-term ties and intensity of experience over multiple lifetimes and generations and has become a 'reflection of their very souls' (Cajete 2000, 187).

It is important to understand, however, that 'sense of place' for rural Tibetans is predicated on indigenous epistemologies, native science (Cajete 2000) and ethno-economics (Cavalcanti 2002). Their 'ways of knowing' and economies of reciprocity may not resonate with the worldview or epistemology of non-indigenous people, earth-care professionals or the nation state (Posey 1999).

Indigenous epistemology is grounded in the self, the spirit and the unknown. An under-standing of place and place-making assumes there is a 'spirit of place', which for lay Tibetans is embodied by a *yul lha* with human personality (Blondeau *et al* 1998). Knowledge and sense of place and its re-making is audited through 'the stream of the inner space in unison with all instruments of knowing' (Ermine 1999, 108).

Many of these trans-rational altered states of consciousness are not considered valid processes for accessing knowledge by Western science. Sense of place and place attachment are main-tained not only through auditing and rituals but subsistence activities. These activities connect indigenous people to their own spirits, the spirits of the land, the animals, plants and other entities. Through hunting and tracking indigenous people learn (from the animals) the virtues of patience, courage, fortitude, humility and honesty (Cajete 1994; 2000) under the aegis of 'economies of reciprocity' (Delgardo *et al* 1998, 28).

Tibetan epistemologies and ethno-economies are a challenge for the Chinese state, paradig-mically and semantically. The religious paradigm it has adopted fails to address the validity of indigenous religious practice or folk beliefs. Semantically:

- The term for 'religion' is *zongjiao*, which is applied to foreign or foreign-influenced religious.
- The ubiquitous cultural practices of ancestor and local god worship, geomancy, divination, qigong and taboos elude designation within the official rubrics.
- Animism and shamanism are pejoratively labelled *mixin*, or superstitious, and not worthy of academic research (Lai 2003).

As a result it is not unusual to be told that the Chinese do not have a 'religion'.

The alienation of youth from place and culture is a fairly typical phenomenon among indig-enous people. Given the Han Chinese's disparaging depiction of minority culture and local place (Studley 2005), it is not surprising that young Khambas who have received some state education

have limited 'place attachment' and 'despise' traditional values. This might be an indicator of the impact of Sinicisation or Hanification, Socialism or modernity, although any attribution would require more research.

As a phenomenon it is a typical response to the negative influences of 'formal' education, development, agriculture, building, tourism, films and TV and resonates with similar processes of alienation among young Tibetans in Ladakh (Norberg-Hodge 1992). Paradoxically this process appears to be counterbalanced by a cultural revival that provides a platform for defiance and protest against the Chinese (Barnett and Akiner 1994; Schwartz 1994).

CONCLUSIONS

There is cognitive evidence of the importance of place attachment to the rural peoples of Kham and that the *yul lha* cult constitutes a spontaneously recovered folk practice for place remaking and ensuring 'topocosmic' harmony (Gaster 1961, 17). Cognitive mapping provides a statistically robust instrument to elicit the relative importance of place attachment and identity.

The peoples of Tibet, in spite of external pressure, are continuing to reclaim place through prayer, the building of cairns, fumigation offerings, throwing of wind horses, planting arrows, invocation of land deities, the renuminisation of territory and going to the *lha pa* to make restitution and ensure topocosmic harmony. It does appear that for the Tibetan peoples territorial cults do provide:

- a coping strategy (Bonaiuto *et al* 2002), for increasing their level of identification with their own group, social cohesion, and place attachment;
- a ritual means of protest and defiance against their oppressors (Barnett and Akiner 1994; Schwartz 1994);
- an exemplar of explicit bio-cultural sustainability and explicit nature conservation (Studley 2005);
- a continuity of ritual performance impacting social, economic and political life that pre-dates the Imperial Period, the arrival of Buddhism in Tibet, and any territorial claims of their oppressors.

In common with other indigenous peoples in China (Oakes 1993), the Khambas are continually reconstructing localised identity and place from the space made available by the broader systems of political economy and in common with indigenous peoples globally.

Although place attachment does not appear to be recognised in forestry or development policy in China, it is beginning to gain currency in occidental natural resource management and policy (Norton and Hannon 1997). There is recognition that the inclusion of place attachment in forestry or natural resource policies represents an about-face and it will take time to educate and to re-work laws and institutions and build local responsibility. This, however, appears to be the only route toward a democratically supportable approach (Norton and Hannon 1999) to sustainable use of resources that is predicated on the needs of people who live most intimately with place and natural resources.

BIBLIOGRAPHY AND REFERENCES

Anand, D, 2000 (Re)imagining Nationalism: Identity and Representation in the Tibetan Diaspora of South Asia, *Contemporary South Asia* 9 (3), 271–87

Ardoin, N, 2006 Toward an Interdisciplinary Understanding of Place: Lessons for Environmental Education, *Canadian Journal of Environmental Education* 11, 112–26

Barnett, R, and Akiner, S (eds), 1994 *Resistance and Reform in Tibet*, Hurst and Co, London

Bauer, K, 2009 On the politics and the possibilities of participatory mapping and GIS: using spatial technologies to study common property and land use change among pastoralists in Central Tibet, *Cultural Geographies* 16 (2), 229–52

Bird-David, N, 1992 Beyond 'The Original Affluent Society': a culturalist reformulation, *Current Anthropology* 33, 25–47

Blondeau, A-M, 2003 Territorial numina in Tibet, Personal Communication (email exchange with author), 4 February

Blondeau, A-M, and Steinkellner, E, 1996 *Reflections of the Mountain: Essays on the History and Social Meaning of the Mountain Cult in Tibet and the Himalaya*, Austrian Academy of Science Press, Vienna

— 1998 Tibetan Mountain Deities: Their Cults and Representations: Papers Presented at a Panel of the *7th Seminar of the International Association for Tibetan Studies*, Graz 1995, Verlag der Osterreichischen Akademie der Wissenschaften, Wien

Bonaiuto, M, Carrus, G, Martorella, H, and Bonnes, M, 2002 Local Identity Processes and Environmental Attitudes in Land Use Changes: The Case of Natural Protected Areas, *Journal of Economic Psychology* 23 (5), 631–53

Bott, S, Cantrill, J, and Myers, O, 2003 Place and the Promise of Conservation Psychology, *Human Ecology Review* 10 (2), 100–112

Buffetrille, K, 1998 Reflections on Pilgrimages to Sacred Mountains, Lakes and Caves, in *Pilgrimage in Tibet* (ed A McKay), Curzon Press Ltd, England, 18–34

Buffetrille, K, and Diemberger, H (eds), 2002 *Tibet and the Himalayas*, Brill, Leiden

Cajete, G, 1994 *Look to the mountain: an ecology of indigenous education*, 1 edn, Kivak, Durango, CO

— 1995 Ensoulment of Nature, in *Native heritage: personal accounts by American Indians, 1790 to the present* (ed A Hirschfelder), VNR AG, 55–62

— 2000 *Native Science*, Clear Light Publishers, Santa Fe, New Mexico

Casakin, H, and Billig, M, 2009 Effect of Settlement Size and Religiosity on Sense of Place in Communal Settlements, *Environment and Behavior* 41, 821–35

Cavalcanti, C, 2002 Economic thinking traditional ecological knowledge and ethnoeconomics: Principles of sustainability of primitive societies, *Current Sociology* 50 (1), 39–55

Colby, B, 1996 Cognitive Anthropology, in *Encyclopaedia of Cultural Anthropology Volume 1* (eds D Levinson and M Ember), Henry Holt and Company, New York, 209–15

Delgardo, F, Martin, J and Torrico, D, 1998 Reciprocity for Life Security, *ILEIA Newsletter*, December, 28–9

Diemberger, H, 2002 The People of Porong and Concepts of Territory in Introduction in Territory and Identity, in *Tibet and the Himalayas* (eds K Buffetrille and H Diemberger), Brill, Leiden, 33–55

Epstein, L, 2002 Khams Pa Histories: Visions of People Place and Authority: Piats 2000 Tibetan Studies

Proceedings of the Ninth Seminar of the *International Association for Tibetan Studies Seminar International Association for Tibetan Studies*, Brill, Leiden and Boston

Ermine, W, 1999 Aboriginal Epistemology, in *First Nations Education in Canada: The Circle Unfolds* (ed M Battiste), UBC Press, Vancouver, 101–12

Feld, S, and Basso, K, 1996 *Senses of Place*, School of American Research Press, Santa Fe

Feldman, R, 1990 Settlement – identity: psychological bonds with home places in a mobile society, *Environment and Behaviour* 22, 183–229

Gaster, T, 1961 *Thespis: Ritual, Myth and Drama in the Ancient Near East*, Anchor, New York

Gross, R, 1997 Buddhas and Mandalas: An Introduction to the Spiritual in the Arts of Tibet [online], available from: http://rolfgross.dreamhosters.com/Texts/Buddhas.htm [27 October 2010]

Gupta, A, and Ferguson, J, 1997 *Culture Power Place: Explorations in Critical Anthropology*, Duke University Press, London

Harrell, S (ed), 2001 *Perspectives on the Yi of Southwest China*, University of California Press, London

Hull, R, 1992 Image Congruity Place Attachment and Community Design, *The Journal of Architectural and Planning Research* 9 (3), 181–92

Hutchinson, C, and Smith, A, 1996 *Ethnicity*, Oxford University Press, Oxford

Jorgensen, B, and Stedman, R, 2006 A comparative analysis of predictors of sense of place dimensions: attachment to, dependence on, and identification with lakeshore properties, *Journal of Environmental Management* 79, 316–27

Karmay, S, 1994 Mountain Cults and National Identity, in *Resistance and Reform in Tibet* (eds R Barnett and S Akiner), Hurst and Co, London, 112–20

— 1996a The Tibetan Cult of Mountain Deities and Its Political Significance, in *Reflections of the Mountain* (eds A-M Blondeau and E Steinkellner), Academy of Sciences Press, Vienna, 59–76

— 1996b The Cult of Mount Murdo in Gyalrong, *Kailash* 18 (1–2), 1–16

— 1998 The Soul and the Turquoise: a Ritual for Recalling the bla, in *The Arrow and the Spindle, Studies in History, Myths, Rituals and Beliefs in Tibet* (ed S Karmay), Mandala Book Point, Kathmandu, 310–38

Kolas, A, 2004 Tourism and the Making of Place in Shangri-La, *Tourism Geographies* 6 (3), 262–78

LaChapelle, D, 1992 *Way of the Mountain Newsletter*, Silverton, CO

Lai, H, 2003 The Religious Revival in China, *Copenhagen Journal of Asian Studies* 18, 40–64

Langer, S, 1953 *Freedom and Form*, Charles Scribner's Sons, New York

Lye, T-P, 2005 *Changing pathways: forest degradation and the Batek of Pahang*, Malaysia, SIRD, Selangor, Malaysia

Mackenzie, A, 2002 Re-claiming place: the Millennium Forest Borgie North Sutherland Scotland, *Environment and Planning D* 20, 535–60

Martins, H, 2002 Genetic Jacobinism in the Republic of Choice, *Metacritica*, 93–108

Nightingale, A, 2006 *A Forest Community or Community Forestry? Beliefs, meanings and nature in northwestern Nepal* [online], Institute of Geography, School of Geosciences, University of Edinburgh, available from: http://www.era.lib.ed.ac.uk/bitstream/1842/1436/1/anightingale003.pdf [27 October 2010]

Norberg-Hodge, H, 1992 *Ancient Futures: Learning From Ladakh*, Oxford University Press, Delhi

Norton, B, and Hannon, B, 1997 Environmental Values: A Place-Based Theory, *Environmental Ethics* 19, 227–45

— 1999 Democracy and Sense of Place Values in Environmental Policy, in *Philosophies of Place* (eds A Light and J Smith), Rowman and Littlefield, New York, 119–43

Oakes, T, 1993 The cultural space of modernity: ethnic tourism and place identity in China, *Environment and Planning D: Society and Space* 11, 47–66

PAP (People and Plants), n.d. *Cultural Landscapes and Resource Rights* [online], available from: http://peopleandplants.squarespace.com/cultural-landscapes/ [29 November 2011]

Posey, D (ed), 1999 *Spiritual and Cultural Values of Biodiversity*, Intermediate Technology Publications and United Nations Environment Programme – UNEP, London

Proshansky, H, 1978 The city and self-identity, *Environment and Behaviour* 10, 147–69

Raffan, J, 1992 Frontier, Homeland and Sacred Space: A Collaborative Investigation into Cross-Cultural Perceptions of Place in the Thelon Game Sanctuary, Northwest Territories, PhD Dissertation, Queen's University, Canada

Ramble, C, 1997 The Creation of the Bon Mountain of Kingpo, in *Mandala and Landscape* (ed A Macdonald), D K Printworld, New Delhi, 133–232

Samuel, G, 1993 *Civilized Shamans: Buddhism in Tibetan Societies*, Smithsonian Institute Press, Washington DC

Schwartz, R, 1994 *Circle of Protest: Political Ritual in the Tibetan Uprising*, Hurst and Co, London

Studley, J, 2005 Sustainable Knowledge Systems and Resource Stewardship: in search of ethno-forestry paradigms for the indigenous peoples of Eastern Kham, PhD thesis, Loughborough University [online], available from: http://issuu.com/drjohn/docs/studley_phd_thesis [27 October 2010]

Turnbull, C, 1984 *The Mountain People: The Classic Account of a People Too Poor for Morality*, Triad, London

Yan Xu, 1995 *Sense of Place and Identity* [online], available from: http://www.eslarp.uiuc.edu/la/LA437-F95/reports/yards/main.html [27 October 2010]

Heritage and Sense of Place: Amplifying Local Voice and Co-constructing Meaning

STEPHANIE K HAWKE

INTRODUCTION

This chapter is premised on the understanding that multiple meanings can be constructed around heritage phenomena. If it is accepted that individuals and groups make sense of heritage subjectively, in ways that are affected by their social and political contexts, then all kinds of places, objects and experiences can be drawn upon in the heritage discourse. These ideas are explored within this chapter through the concept of 'sense of place'. The first section traces developments that have begun to dissolve the boundaries around notions of what 'heritage' means and it does so with reference to the 'cultural turn', to popular interest in everyday vernacular forms of heritage and to the wider context of globalisation. It posits that people increasingly draw on diverse notions of heritage in the articulation of their identities. This often occurs through a discourse of 'sense of place', definitions of which are presented from the perspectives of heritage studies, geography and environmental psychology. This leads into the main body of the chapter, which explores how 'heritage' can be seen to contribute to 'sense of place' through the accounts of people living in an upland area in the North of England with whom in-depth interviews were conducted. The kind of heritage evoked in the interviewee's accounts emerges as something gossamer, conjured through their interactions with a place over time and in the conversations between the people within it. The fourth section of this chapter draws out the difficulties that such subjective and contingent notions of heritage present for the established heritage discourse. Some of these difficulties are addressed in this chapter's final section which, by examining a selection of the principles which inform ecomuseology, concludes by arguing for an alternative heritage paradigm, one that is better able to articulate and safeguard local and intangible notions of heritage.

MULTIPLE MEANINGS

That heritage can represent countless meanings for limitless numbers of people is a conclusion made possible by the 'cultural turn' affecting the wider humanities. This is a development that places culture more soundly at the core of academic debates and demands acknowledgement for multiple interpretations of meaning (Gibson and Pendlebury 2009). The recognition of plural meanings sits awkwardly with the established heritage discourse which is rooted in an essentialist scientific approach and underpinned by the view that there are experts who hold the authority

to recognise the values intrinsic to heritage phenomena. These assumptions are largely Western and give primacy to 'universal' values and tangible, material forms. But, more recently, the field of heritage studies has begun to question these assumptions (Waterton 2005; Smith 2006; Smith and Waterton 2009). This is a discursive journey in which personal, 'plural' (Ashworth *et al* 2007) and sometimes 'dissonant' (Tunbridge and Ashworth 1996) heritages are legitimated. Indeed, in the UK, personal and multiple conceptualisations of heritage are encouraged by the approach adopted by the Heritage Lottery Fund, formed in 1994, whose schemes urge those applying to make their own definitions of cultural value (Robertson 2008). The ease with which multiple interpretations are accepted, especially when represented through heritage display, has been criticised. For those proponents of a historiography that strives to mitigate bias (Lowenthal 1985), pluralism has caused discomfort. Others (Samuel 1994) have celebrated the way in which heritage has provided a channel through which local people can explore their personal biography and collective culture in order to develop an 'identity-centred relationship with the past' (Dicks 2003, 125).

In this broadened heritage discourse, all classes, genders and ethnicities are encouraged to engage, 'providing an arena in which domestic and "everyday" heritage' (Littler 2008, 91) can be experienced. Definitions of heritage have extended to accommodate intangibility: the expression of cultural heritage as a song, dance, dialect, tradition, craft or culinary technique (Smith and Akagawa 2009). One result has been an increased local appetite for the exploration and display of 'vernacular' cultural heritage and these impulses have been situated within the discourse of globalisation. This is a term used to describe the speeding up of life through accessible and convenient global travel, instant electronic communications and the proliferation of multinational corporations that serve to make one place look increasingly like any other. Sociologist Manuel Castells suggests that, in the face of globalisation, 'people all over the world resent the loss of control over their lives, over their environment, over their jobs, over their economies' (Castells 1997, 72). Consequently, people are compelled to assert their local distinctiveness, characterised as 'militant particularism' (Harvey 1996, 306), which accounts for the increased curiosity of local people in their heritage. This jostling for a distinct identity in the context of globalisation has meant that identities are imposed upon places by authorities, or that local characteristics are asserted at community level. These authorities and their local communities alike articulate this local distinctiveness through the rhetoric of 'sense of place'. But what is sense of place and what exactly does heritage lend to it?

DEFINING SENSE OF PLACE

Sense of place is a phrase permeating every aspect of the humanities. Within heritage studies, scholars have cast light upon notions of 'sense of place' from several angles. Some have explored the way in which place is represented through heritage display (Dicks 2000), others the way in which it is moulded in top-down processes that select the stories most expedient to contemporary ends (Ashworth and Graham 2005). This can lead to conflict between 'official' and 'unofficial' notions of heritage and place (Crooke 2008; Smith 2006; Tunbridge and Ashworth 1996). In efforts within the heritage sector to knit representations of place better with local understandings, Kevin Walsh (1992) suggests museums should elicit meanings from local people. He suggests this can be achieved through cognitive mapping exercises of the type promoted by UK charity Common Ground. Activities such as illustrating A–Z charts and creating parish maps work to

engage local people in an identification of their special local features. Developing this notion of local voice, Emma Waterton's (2005) study of sense of place at Hareshaw Linn, Northumberland, reveals the positivist framework around which Western systems of heritage management have evolved. She emphasises the inadequacy of a system that fails to acknowledge the shifting, organic, plural and contextual process by which local people construct their own meanings of local places. David Atkinson (2007; 2008) similarly champions the heritage value of quotidian places to local people: the heritage of the 'mundane'. Laurajane Smith (2006) underlines and unpacks these ideas and the final section of this chapter proposes one possible alternative to the 'authorised' heritage discourse that she describes.

It is the field of geography, however, which takes 'place' as its central concern, suggesting sense of place is constructed and emerges when space is invested with meaning (Tuan 1977). Like scholars of heritage, for geographers, sense of place relates to the very subjective and emotional attachments that people make with place (Agnew 1987; Davidson *et al* 2005; Thrift 2004). Environmental psychologists develop ideas put forth in the field of geography to inform their empirical investigations of sense of place, a notion they view as imbued with meanings that are socially constructed. When these meanings are imposed 'top down' by those in positions of power, they are part of an 'authorised' heritage discourse (Smith 2006). This chapter, however, concerns itself with the way in which places are drawn upon in the construction of personal identities, producing an alternative heritage discourse. It does so via discussion of interview data collected among local people engaging with their heritage in the North Pennines of England.

HERITAGE AND SENSE OF PLACE IN THE NORTH PENNINES

The North Pennines Area of Outstanding Natural Beauty (AONB), sometimes described as 'England's last wilderness' (Bellamy and Quayle 1992), is an upland area in the north of England spanning the counties of Northumberland, Durham and Cumbria. It takes its beauty from a combination of peatlands, heather moors, upland wildflower-rich hay meadows and distinctive wildlife. A world-class geological heritage is recognised in the area's designation as a United Nations Educational Scientific and Cultural Organisation (UNESCO) Geopark. The region was once dominated by mining and its rich geology has been exploited through extractive industry since the Roman era. In the 18th and 19th centuries the lead-mining industry flourished, but this was a short-lived boom, the once swollen population rapidly dwindling. In the years which have followed, the Dales communities have built their economy upon agriculture and low-level tourism in and among the physical remains of lead-mining that lend to the region a palimpsestic quality.

In order to explore how this combined heritage contributes to sense of place in the North Pennines, 27 in-depth interviews were conducted with people engaging with their heritage through leisure activities there. Analysis of the interview transcriptions using a constant comparison approach inspired by Grounded Theory (Glaser and Strauss 1967) allowed for the teasing-out of the relationship between heritage and sense of place. It was possible to see that heritage in tangible and intangible forms helped interviewees to describe both their sense of continuity through time, in terms of social relationships and life-story, and also a particular notion of local character or 'disposition'. The discussion which follows explores these ideas, beginning with an examination of local distinctiveness then moving on to illustrate the way in which heritage lent respondents a sense of personal continuity in terms of their identities as local people. In

particular, continuity of identity was related to the feeling of being 'inside' the place, both socially and autobiographically. This 'insideness' was anchored by discursive processes of 'memory talk' (Degnen 2005), by which it was possible to see heritage as a process in and of itself.

When describing their sense of place, respondents made reference to a broad array of heritage phenomena. Interestingly, however, accounts of sense of place referred to less tangible notions of cultural heritage. When prompted to describe their sense of place, respondents repeatedly made links to the personality and characteristics of local people. They connected this traditional disposition to duration of stay, as one respondent explained, 'there's still a much bigger proportion of people who were born and bred in the North Pennines than you get in other parts of the country'. Local character included kind-spiritedness – 'people are quietly generous ...', 'they are just laid back, easy going and friendly ...' – and a patient, untroubled approach to life – 'people ... think things over more slowly'. There was a sense that these cultural characteristics were inherited from predecessors. Respondents expressed pride in the tenacity of those descendents of lead miners who 'hung on' during economic decline and the longevity of family lines celebrated with reference to familiar local surnames. What they described was a somewhat nebulous form of collective identity that seemed to draw on a shared experience of isolation and a hardy survival instinct. References were made to the cultural legacy of Dales people who, isolated for much of the year by harsh winters, 'turned in on themselves' so that a 'great tendency to be inward looking' endured. This was seen as a positive and distinct feature of North Pennines sense of place: 'it's relatively isolated so there's a stronger sense of identity'. Here is a way of viewing heritage that is socially constructed and subjective; meanings are not intrinsic or universal and as such it is a way of viewing heritage which falls without the established discourse.

Naturally, accounts of sense of place drew upon more easily recognisable forms of heritage. Respondents described their local distinctiveness in terms of the region's natural heritage, its internationally recognised geology, rare wildflowers and landscape beauty. They described the industrial archaeology that peppers their local landscape; the spectres of an extractive industry now consigned to history. Taken together, these features, and the intangible notions of local disposition described above, help individuals in the North Pennines define the way in which they are different or distinct from other people in other places. This is a concept developed within environmental psychology, where the sense of being distinct from other individuals or groups is seen as a component of identity often supported by place (Twigger-Ross and Uzzell 1996). The more conventional features of heritage to which respondents referred helped them to identify the ways in which the North Pennines differed from other places and, when linked to these more physical representations of local distinctiveness, the relationship between heritage and sense of place can plainly be seen. Beyond tangible heritage, however, respondents described a sense of local distinctiveness related to what Ashworth and Graham (2005) have described as the past's ability to convey 'timeless values'.

Respondents explained a keen awareness of the past in the North Pennines which they often described in terms of nostalgia: 'it feels like stepping back in time' and 'things have changed less'. For these respondents, people in the North Pennines held a set of agreeable social values which they felt had been lost in other more urban or less isolated communities. They described reciprocity and trust that meant generous favours were exchanged and children were safe to roam. This congruence of a place with an individual's personal values has been explored in the field of environmental psychology through the notion of 'place congruent continuity' (Twigger-Ross and Uzzell 1996). Here place lends continuity to a person's identity through an intangible cultural

heritage of shared social values. It is by developing this notion of continuity that a clearer explanation of the contribution of heritage to sense of place may be articulated. Temporal continuity is a familiar notion in the field of geography, Edward Relph noting that sense of place is the result of a 'growing attachment, imbued as it is with a sense of continuity' (1976, 32). Similarly, Yi Fu Tuan likens place to 'time made visible' and a 'memorial to times past' (1977, 179). Further to a shared local characteristic or 'disposition', shared values and physical features of local distinctiveness, sense of place for respondents was supported by a sense of continuity through time which drew on heritage in different guises. It is useful here to explore this sense of place through the notion of 'insideness'. In the North Pennines interviews, heritage was drawn upon in the construction of self-identity and presented a set of ethical, social and physical reference points which, combined, created a sense of belonging or 'insideness'.

For Relph (1976), insideness refers to the feelings of familiarity, security and belonging that make places meaningful. Subcategories that are particularly useful to an exploration of the contribution of heritage to sense of place are those of 'social' and 'autobiographical' insideness. In the North Pennines, it can be argued that heritage contributed to the respondents' experience of place by lending the people–place dialectic the three-dimensionality of temporal depth. The social bonds of community, for instance, were described in terms of interpersonal relationships steeped in generations of familiarity and shared biographical knowledge. It was possible to recognise within the accounts a sense of 'social insideness' which Graham Rowles has described as 'stemming from integration within the social fabric of a community' (1983, 302). As one respondent explained, 'you know nearly all the people', and another concurred 'you know them and you can go back over a lot of years'. The contribution of collective identity to sense of place in the North Pennines was clear to discern, as one respondent explained of visitors and newcomers, 'the thing that really takes people (is) … it's a community'. Notions of heritage lent this sense of community a temporal continuity, running like a thread through relationships where commonly people were known and knew others in the context of their forebears: 'there's a much bigger proportion of people who've spent their whole lifetimes here than you'll find in other parts of the country'. In the North Pennines the past permeates daily life, with history and memory inalienable (Samuel 1994). Heritage manifests in durable familiarity – 'it's about how people look like one another as they come through time' – and biographical knowledge – 'people know you and your history and … you know their history'.

Relph suggests that 'involvement with place is founded on the easy grasping of time spans of centuries, particularly by the persistence of tradition and through ancestor worship' (1976). 'Social insideness' in the North Pennines was formed partly of interfamily connections that spanned back through the generations. Temporal depth referred not just to relationships in the present, but also to relationships with people long since passed. When describing feelings of belonging and sense of place, respondents made significant reference to ancestors, with one respondent explaining, 'my family goes back to about 1700 here. I mean there are a lot of families here that go back much further than that.' Another reported a similar experience, 'I was actually born in the same house that my great, great, great grandfather was living in in the 18th century.' This long family history in the context of a particular place led to feelings of rootedness. This ancestral form of 'belonging' infused the community and the effect was not lost on newer residents. In efforts to develop a 'satisfactory account' (Savage et al 2005) of their sense of place, those not born and bred in the area explained a comparable process of reaching out to grasp a sense of their predecessors. Describing her sense of place, for example, this respondent,

with just five years' residence in the North Pennines, developed a keen sense of the interaction of humans with place over a long span of time and explained her feeling of 'following on in the footsteps of all these people who lived here'. The 'insideness' apparent in interview accounts reminded individuals of their genealogy, through the rich patina worked into sometimes ordinary and unremarkable places by generations of ancestors. When an individual's life story is intimately bound up with place in this way, the effect is one of 'autobiographical insideness'.

Ideas of biography and the indivisibility of history and memory combine in the notion of 'autobiographical insideness' (Rowles 1983), whereby a place acts as a physical reminder for the narrative of an individual's life. Kalevi Korpela (1989) has noted the way in which a place can secure and confirm a sense of identity and a strong sense of place is connected to a secure notion of home from which individuals confidently step out into the world. These ideas were reflected in North Pennines accounts of which the following response is characteristic: 'if I ever wanted to get away I would head up onto Bollihope Common ... I think as a child, we used to go out and walk on the fells loads ... the people change, but the landscape doesn't tend to.' These ideas are developed by notions of 'memory talk' (Degnen 2005), whereby places absent of any physical features of the past continue to be drawn upon as a 'topology of memories' (Atkinson 2007, 523) in which individuals insert themselves and others into a network of relationships between people and places, past and present. In this way, language elevates sense of place from the 'vaults of the mind' to the fore of human conversation (Dixon and Durrheim 2000). As Smith notes, heritage viewed in this way is 'not so much a "thing", but ... a cultural and social process, which engages with acts of remembering that work to create ways to understand and engage with the present' (2006, 2).

Shifts in the study of both place and memory have evidenced increased interest in theories of identity and also 'the inherently temporal aspects of both remembering and the experience of place' (Degnen 2005, 729). If heritage is conceptualised as a notion that combines place, identity and temporality, then these accounts make a case for ordinary and everyday places to be included within the heritage discourse. The discursive process of making social and cultural meanings is also a notion that demands greater acknowledgement. Here a challenge is presented, given that the 'authorised heritage discourse' has already been criticised as one formed around essentialist notions of outstanding or universal value, unable to value plural meanings (Smith 2006). In the North Pennines, place and history combined in a way that was significant for respondents and their particular sense of place, but would fall short of the listing criteria upon which those in authority draw in their official recognitions of heritage value. As a result, an alternative paradigm must be considered, one that emphasises the significance of discursive processes in the construction of sense of place, and one with the capacity to acknowledge both authorised or 'official' notions of intrinsic value, but also the more subjective and nuanced, unauthorised, 'unofficial' or 'insider' ways of making multifarious sense of place.

AN ALTERNATIVE HERITAGE PARADIGM

Sense of place has been recognised as a 'chameleon concept' (Davis 1999, 238), and it is perhaps by approaching heritage through a notion that accepts inherent changeability and plurality of meaning and value that an alternative to the authorised heritage discourse may be articulated. As Smith explains:

there is a hegemonic 'authorized heritage discourse', which is reliant on the power/knowledge claims of technical and aesthetic experts, and institutionalized in state cultural agencies and amenity societies …The 'authorized heritage discourse' privileges monumentality and grand scale, innate artefact/site significance tied to time depth, scientific/aesthetic expert judgement, social consensus and nation building. (Smith 2006, 11)

An alternative heritage discourse that uses sense of place as an organising concept might be better placed to embrace the grass-roots and multiple narratives of local people and the values with which they imbue ordinary places. As discussion has shown, 'sense of place' invokes heritage in material form, but also as an expression of culture and tradition or a discursive process of meaning-making. An approach informed by sense of place could thereby recognise all elements of place, both tangible and intangible. Such an approach has in fact been adopted at several hundred sites across the globe and it is an alternative heritage paradigm described as 'ecomuseology'.

Museologists have been at pains to succinctly articulate a definition of the ecomuseum and Peter Davis suggests that early definitions were broad, even 'guarded' (2004, 95–6). The ecomuseum most palpably departs from the traditional museum concept by dismantling its walls to embrace a holistic territory. The ecomuseum is a place rather than a building and its heritage resources are the distinctive features of a locality that contribute to its sense of place, rather than museum objects. These resources are tangible and intangible, fixed and portable – what Davis has described as a community's 'cultural touchstones' (1999, 40). He cites Sheila Stephenson, who suggests that 'the ecomuseum is concerned with collections management – the collection being everything in the designated area … flora, fauna, topography, weather, buildings, land use practices, songs, attitudes, tools …' (cited in Davis 2004, 96). Most significantly, however, the ecomuseum identifies its collection through processes of democracy and dialogue that amplify local voices.

An ecomuseum 'is a community-led heritage or museum project that supports sustainable development' (Davis 2007, 199). Interpretation of the ecomuseum paradigm in practice has proved fluid, diverse and inconsistent, and, for this reason, efforts have been made in recent years to assess how far ecomuseums achieve the original philosophy, particularly in relation to the elicitation of local opinion. The attributes of an authentic ecomuseum have been listed (Davis 1999, 228), among which an ecomuseum may be indicated by a heritage management system that empowers local communities, involving local people in museum activities and in the presentation and development of their cultural identity. Such lists have been further developed to help heritage projects and ecomuseums assess their performance against the ideal (Borrelli *et al* 2008; Corsane *et al* 2007b; 2007a), and the fundamental tenets of the ecomuseum philosophy have been reduced to 21 principles that can serve as indicators of ecomuseology in practice (Corsane 2006b; 2006a). A number of these principles have particular salience in addressing the issues of heritage and sense of place presented in the North Pennines interviews, and the remainder of this chapter will examine them in more detail.

This chapter has sought to identify the contribution of heritage to the experience of sense of place in accounts of individuals interviewed in the North Pennines AONB. It has been argued that heritage lends the relationship between people and place a temporal depth which manifests in feelings of social and autobiographical insideness. Here individuals and their life-stories are known in communities with an intimacy that stretches back over generations. Such insideness

can draw upon place as a physical aide-mémoire for biography. In this way place is imbued with history but, at the same time, can be ordinary or everyday, sometimes bearing little remaining evidence of the memories it works to support. In these circumstances, heritage manifests as a process through, for example, 'memory talk' (Degnen 2005), a discursive place sensing that inserts individuals past and present into a landscape of memory. As discussion has indicated, existing heritage management systems work to recognise heritage based on value-judgements made by experts and are ill-equipped to acknowledge the nuanced ways in which heritage contributes to sense of place for local people – people like those interviewed in the North Pennines.

Smith (2006) has emphasised the manner by which heritage can be conceptualised as a process, noting an annual heritage festival in Yorkshire, England, whereby the community are actively engaged with an educational and celebratory representation of local heritage, even when little fabric of the historic environment remains in their town. This discursive sense of place and the heritage process of 'memory talk' are encapsulated within ecomuseology, whose principles suggest that 'in an ecomuseum, an emphasis is usually placed on the processes of heritage management, rather than the heritage products for consumption' (Corsane 2006a; Corsane et al 2007a). The paradigm holds collective memory at its core; the Soga Ecomuseum in China, for instance, centres around a 'Memory Project' whereby local people record their sense of place through spoken recordings in their own non-written language (Corsane et al 2008). In this sense, ecomuseology defies Western knowledge systems to embrace the intangibility of oral tradition.

With a focus upon 'identity and sense of place' giving equal attention to 'immovable and moveable tangible material culture and to intangible heritage resources' (Corsane 2006a; Corsane et al 2007a), ecomuseology is also well placed to support the features of local distinctiveness that are identified by residents. Respondents in the North Pennines described local distinctiveness in terms of tangible natural and industrial heritage, but also in the less tangible feeling of nostalgia for the timeless values that place represented. Ecomuseums are equipped to tease out these local understandings since they are steered by local communities and emphasise the elicitation of local voice through 'public participation in all decision-making processes and activities in democratic manner' (Corsane 2006a; Corsane et al 2007a). With key tenets of democracy, joint ownership, an emphasis on process rather than product and on identity and sense of place in tangible and intangible forms, the ecomuseum paradigm presents a path towards an acknowledgement of the way in which heritage contributes to sense of place for local people. The approach offers solutions to the recognition of shifting and plural 'insider' values and stresses the subjective and contextual aspects of heritage: 'its approach is diachronic rather than synchronic' (ibid). Most significantly, however, the ecomuseum sets out an approach to co-constructing heritage meanings through joint ownership (ibid). Local people play a significant role in ecomuseum projects; the Écomusée Saint Dégan in France is run by local volunteers (Corsane et al 2008), the Kalyna Country Ecomuseum in Alberta is managed by a consortium of local people (Davis 2009) and the Ecomuseo della Canapa (Hemp Ecomuseum) in Italy is a success through united local voluntary efforts (Davis 2007). This is a paradigm that seeks to recognise local meanings while acknowledging the value of professional expertise. It offers a route towards dialogue between 'authorised' and 'alternative' or 'insider' perceptions of heritage which, if effective, might result in a closer co-construction of heritage meanings.

CONCLUSIONS

In the North Pennines, heritage contributes to sense of place by providing a temporal depth and a sense of rolling continuity, situating individuals fully 'inside' a place that can be read as a palimpsest for their ancestry and biography. While tangible heritage contributes to local distinctiveness through nature and industrial archaeology, heritage also manifests in a local cultural characteristic or 'disposition', in the continuation of 'timeless values' and in a discursive process of placing oneself and others in a landscape of places past and present through 'memory talk' (Degnen 2005). The material from which local people draw their sense of place can be ordinary, unremarkable, 'quotidian' (Atkinson 2007). It is a heritage discourse that falls without the 'authorised' paradigm, built as it is upon notions of innate and universal value decided upon by experts and carefully critiqued by Laurajane Smith (2006). This chapter has sought, however, to present the ecomuseum as a paradigm that points the way forward towards an elicitation of local voice, bringing together authorised and alternative notions of heritage in a co-construction of meaning. Guided by principles that embrace 'sense of place' and identity, the ecomuseum emphasises heritage as a process and encourages democracy and joint ownership. It is a paradigm that accepts the fluid nature of heritage as a set of ever-changing and plural meanings related to both the past and the present. Ecomuseology is an approach that allows a broader palette of meanings to be drawn upon by both heritage experts and local people in order to better communicate the subtle shade and texture with which heritage contributes to sense of place.

BIBLIOGRAPHY AND REFERENCES

Agnew, J A, 1987 *Place and Politics: The Geographical Mediation of State and Society*, Allen & Unwin, Boston

Ashworth, G, Graham, B, and Tunbridge, J, 2007 *Pluralising Pasts: heritage, identity and place in multicultural societies*, Pluto Press, London

Ashworth, G J, and Graham, B, 2005 Senses of Place, Senses of Time and Heritage, in *Senses of Place: Senses of Time* (eds G J Ashworth and B Graham), Ashgate, Aldershot

Atkinson, D, 2007 Kitsch geographies and the everyday spaces of social memory, *Environment and Planning A* 39, 521–40

— 2008 The Heritage of Mundane Places, in *The Ashgate Research Companion to Heritage and Identity* (eds B Graham and P Howard), Ashgate, Aldershot

Bellamy, D, and Quayle, B, 1992 *England's last wilderness: a journey through the North Pennines*, 2 edn, Boxtree, London [in association with Yorkshire Television]

Borrelli, N, Corsane, G, Davis, P, and Maggi, M, 2008 *StrumentIRES: Valutare un ecomuseo: come e perché. Il metodo MACDAB*, Istituto di Ricerche Economico Sociali del Piemonte, Turin

Castells, M, 1997 *The Power of Identity*, Blackwell, Oxford

Corsane, G, 2006a 'From 'outreach' to 'inreach': how ecomuseum principles encourage community participation in museum processes', *Communication and Exploration*, Guiyang, China, Provincia Autonoma di Trento

— 2006b 'From 'outreach' to 'inreach': how ecomuseum principles encourage community participation in museum processes', *Communication and Exploration: Papers of International Ecomuseum* Forum, Chinese Society of Museums, Beijing

Corsane, G, Davis, P, Elliot, S, Maggi, M, Murtas, D, and Rogers, S, 2007a Ecomuseum evaluation: experiences in Piemonte and Liguria, Italy, *International Journal of Heritage Studies* 13 (2), 101–16

— 2007b Ecomuseum Performance in Piemonte and Liguria, Italy: The Significance of Capital, *International Journal of Heritage Studies* 13 (3), 224–39

Corsane, G, Davis, P, and Murtas, D, 2008 Place, local distinctiveness, and local identity: ecomuseum approaches in Europe and Asia, in *Heritage and Identity: engagement and demission in the contemporary world* (eds M Anico and E Peralta), Routledge, London

Crooke, E, 2008 *Museums and community: ideas, issues and challenges*, Routledge, New York

Davidson, J, Bondi, L, and Smith, M (eds), 2005 *Emotional Geographies*, Ashgate, Aldershot

Davis, P, 1999 *Ecomuseums: A Sense of Place*, Leicester University Press, London

— 2004 Ecomuseums and the Democratisation of Japanese Museology, *International Journal of Heritage Studies* 10 (1), 93–110

— 2007 Ecomuseums and Sustainability in Italy, Japan and China: concept adaptation through implementation, in *Museum Revolutions: How Museums Change and Are Changed. Proceedings of The Museum: A World Forum*, Routledge, Leicester

— 2009 Ecomuseums and the representation of place, *Italian Journal of Geography* 116, 483–503

Degnen, C, 2005 Relationality, place, and absence: a three-dimensional perspective on social memory, *Sociological Review* 53 (4), 729–44

Dicks, B, 2000 *Heritage, Place and Community*, University of Wales Press, Cardiff

— 2003 *Culture on Display: the production of contemporary visitability*, Open University Press, Maidenhead

Dixon, J, and Durrheim, K, 2000 Displacing place-identity: a discursive approach to locating self and other, *British Journal of Social Psychology* 39, 27–44

Gibson, L, and Pendlebury, J, 2009 Introduction, in *Valuing Historic Environments* (eds L Gibson and J Pendlebury), Ashgate, Farnham

Glaser, B G, and Strauss, A L, 1967 *The discovery of grounded theory: strategies for qualitative research*, Aldine de Gruyter, Hawthorne, NY

Harvey, D, 1996 *Justice, nature and the geography of difference*, Blackwell, Cambridge, MA

Korpela, K M, 1989 Place-identity as a product of environmental self-regulation, *Journal of Environmental Psychology* 9, 241–56

Littler, J, 2008 Heritage and Race, in *The Ashgate Research Companion to Heritage and Identity* (eds B Graham and H Howard), Ashgate, Aldershot

Lowenthal, D, 1985 *The Past is a Foreign Country*, Cambridge University Press, Cambridge

Relph, E, 1976 *Place and placelessness*, Pion Limited, London

Robertson, I J M, 2008 Heritage from Below: Class, Social Protest and Resistance, in *The Ashgate Research Companion to Heritage and Identity* (eds B Graham and P Howard), Ashgate, Aldershot

Rowles, G D, 1983 Place and Personal Identity in Old Age: Observations from Appalachia, *Journal of Environmental Psychology* 3, 299–313

Samuel, R, 1994 *Theatres of Memory: Volume 1. Past and Present in Contemporary Culture*, Verso, London

Savage, M, Bagnall, G and Longhurst, B, 2005 *Globalization and Belonging*, Sage, London

Smith, L, 2006 *The Uses of Heritage*, Routledge, London

Smith, L, and Akagawa, N (eds), 2009 *Intangible Heritage*, Routledge, Abingdon

Smith, L, and Waterton, E, 2009 The envy of the world? Intangible heritage in England, in *Intangible Heritage* (eds L Smith and N Akagawa), Routledge, Abingdon

Thrift, N J, 2004 Intensities of feeling: towards a spatial politics of affect, *Geografiska Annaler: Series B, Human Geography* 86 (1), 57–78

Tuan, Y-F, 1977 *Space and Place: The Perspective of Experience*, Edward Arnold, London

Tunbridge, J E, and Ashworth, G J, 1996 *Dissonant heritage: the management of the past as a resource in conflict*, John Wiley, Chichester

Twigger-Ross, C L, and Uzzell, D L, 1996 Place and Identity Processes, *Journal of Environmental Psychology* 16, 205–20

Walsh, K, 1992 *The representation of the past: museums and heritage in the postmodern world*, Routledge, London

Waterton, E, 2005 Whose Sense of Place? Reconciling Archaeological Perspectives with Community Values: Cultural Landscapes in England, *International Journal of Heritage Studies* 11 (4), 309–25

Conservation, Biodiversity and Tourism

Sense of Place in Sustainable Tourism: A Case Study in the Rainforest and Savannahs of Guyana

Gerard Corsane and D Jared Bowers

Introduction

'Sense of place' is a human construct, which we develop as individuals and/or as groups as we relate to particular physical spaces or sites that we live in or move through. We develop our own notions of sense of place as we process our relationship with environmental factors associated with these spaces or sites, often drawing on our past experiences. Through the associations that we link to these factors, we invest meanings in these spaces or sites (Kyle *et al* 2004; Relph 1976; Scannell and Gifford 2010). It should also be considered that these environmental factors are not solely physical or geographical, but also include those of economic (Cross *et al* 2011), social (Uzzell *et al* 2002; Woldoff 2002), cultural (Mazumdar and Mazumdar 2004) and political aspects (Staeheli and Mitchell 2004).

Different individuals or groups that come into contact with the same space or site will construct a new sense of place dependant on their prior experiences and world views, temporal context and their specific associations with the environmental factors. As a consequence, in any one space or site there can be a layering of 'senses' of place based on the particular meanings invested by the individual or group (Massey 1991). However, even in this layering, there can be points of vertical continuity where perceptions of certain characteristics of the space or site are very similar or shared. Furthermore, an individual or a group which has come into contact with a space or site and developed their own sense of place will probably have been influenced by others (Scannell and Gifford 2010). In turn, their sense of place will contribute to those constructed by others.

This means that constructions of sense of place are complex, multi-layered and polyvocal (Rodman 1992, 641). An interesting example of this lies in Regions 8 and 9 in the interior of Guyana, in an expansive area which includes Iwokrama, a protected rainforest reserve, and the adjacent Rupununi savannah wetlands. The layers of sense of place developed over time in this area include those of the indigenous Amerindian communities, along with those of non-indigenous visitors and tourists who have passed through the region. Incorporating these different temporal layers is important in developing a comprehensive understanding of place, as Yeoh and Kong (1996, 56) state: 'If places are the amalgam of forms and meanings laid down in various historical eras, interpreting places involves understanding the human legacies of the past.'

The purpose of this chapter is to gain an understanding of different layers of sense of place that have been constructed in this area of rainforest and savannah. To do this, it will explore

both historical and current contexts relating to the constructions of sense of place and briefly analyse how two organisations, the Iwokrama International Centre for Rainforest Conservation and Development (IIC) and the North Rupununi District Development Board (NRDDB), have been facilitating the amalgamation of some of these layers into a more comprehensive sense of place. Although the mandates of the IIC and the NRDDB are not specifically associated with the development and interpretation of sense of place, the activities that they are involved in lend themselves to regenerating identity and sense of place. They do this by promoting an atmosphere where the different senses of place are brought to the surface and promoted for sustainable tourism. Defining the unique layers of sense of place on behalf of all stakeholders is essential if sustainable tourism is to be achieved – ie that the nuances of a unique local environment must first be recognised if it is going to be used responsibly and not destroyed.

The specific aims of this chapter, therefore, are to examine how these two organisations are working to understand and bring these different layers together in an effort to promote responsible conservation and heritage tourism. These aims will be achieved by considering a number of central themes, including indigenous and non-indigenous notions of place in both a historical and current context, the current role of the IIC and NRDDB, and how this translates into sustainable tourism.

INDIGENOUS AMERINDIAN NOTIONS OF 'SENSE OF PLACE'

Amerindians, the indigenous peoples of Guyana, have traditionally created notions of sense of place that are different to Western scientific constructs that divide culture and nature. As Rodman (1992, 640) points out, 'The people we study in non-Western, less industrialised countries may have even more immediate and full relationships with place insofar as time–space relations are less fragmented and they retain more local control over their physical and social landscapes.' Their sense of place in regards to the Rupununi has been grounded in their daily existence in a region where there are very few non-indigenous residents. The Rupununi has been largely inaccessible until recently, and, beyond the few cattle ranchers in the south of the region, three main indigenous groups occupy most of the land; the Makushi in the north, and the Wapishana and Wai Wai in the south (Conservation International 2010).

It has been shown through various archaeological studies that Amerindians have been living in the area that is present-day Guyana for over 7000 years. Although initially living as hunter-gatherers, land cultivation began occurring around 2000 BC, during which time they developed such skills as weaving baskets and crafting clay pots and dugout canoes, skills which they still use today (Smock 2008). From the earliest colonial encounters with Amerindians during the 16th century, their knowledge and appreciation of their physical environment has proven useful to explorers and colonisers who often hired them as guides. Amerindians were 'culturally adapted at surviving in a difficult but extremely fertile environment' and directly and indirectly made all colonial exploration into the region possible (Burnett 2002, 25).

However, it was more than their familiarisation with the physical environment that created Amerindian notions of sense of place. Possessing a world view limited to a specific geographical region provided few environmental factors (namely physical) in shaping Amerindian notions of place identity. In turn, place 'meaning' was allocated almost exclusively to the physical environment, with all of its geological, flora and fauna components. As indigenous community groups engaged with the physical environments – and with each other – various trends emerged

such as forming associated spiritual, social, cultural, political and economic landscapes (Salmon 2000).

The 'spirit of place', associated with particular sites and spaces, occurred through the forms of animism beliefs of the indigenous peoples. These beliefs focused on the existence of spiritual presences in natural objects and phenomena. For example, a publication written by an indigenous group called the Makushi Research Unit and funded by the NRDDB explains that traditional Makushi beliefs state that 'human beings possess a spirit as do other animals and some powerful plants' which is evident in the ritualistic use of certain plants in healing through their beneficial spirits (Makushi Research Unit 1996, 206).

The evolution of social, cultural and political landscapes stems from the pre-colonial sense of place created by Amerindians which was formed on the land-ownership principle that places are shared spaces, and not a locality for exercising total authority. As Forte (2006, 136) points out, Amerindian relationships with the land are 'rooted in distinct cultural and historical understandings and interdependence for nurture and well-being' which allowed for pre-colonial trading with neighbouring communities with no social disruption. In this instance, there existed a sense of place 'layer' shared by the different Amerindian tribes of the Rupununi where intangible and tangible cultural heritage was intermixed with the physical environment.

The cultural systems of the Amerindian groups articulated with traditional livelihood practices and influenced the construction of sense of place as economic landscapes. These practices included hunting, fishing, gathering and harvesting from the forest and savannah resources, and, for at least 3000 years, the cultivation of cassava. More recently, with the impacts of colonisation, modernity and globalisation, these traditional economic livelihoods have been threatened, which inevitably altered the peoples' mobility and perceptions of sense of place. With this has come the need to look at alternative livelihoods, one of which has been the development of products for sustainable tourism. It is through turning to tourism that there are possibilities of promoting and safeguarding aspects of these cultural systems. This is possible since several Amerindian communities still follow traditional lifestyles which bear 'strong allegiance to ancestral traditions' (Sinclair 2003, 143). The notion of sustainable tourism's role in conserving cultural landscapes will be developed in more detail in the section dealing with the activities of the IIC and NRDDB.

It has been suggested above that Amerindian perceptions of sense of place had been based on the undivided relationship between nature and culture. This relationship was a dynamic process embedded in a reciprocal interaction with the physical environment that in turn assisted in the creation of their cultural ideologies and practices (Makushi Research Unit 1996).

NON-INDIGENOUS PERCEPTIONS OF 'SENSE OF PLACE': EXPLORERS AND COLONISERS

The string of European explorers that first ventured to the present-day Rupununi region in Guyana constructed a shared sense of place that was dependant on the context of their individual journeys, which ranged from colonial expansion to scientific exploration. Rumours initiated in the 16th century by the Spaniard Juan Martinez of a lost city of gold, 'El Dorado', in the flooded wetlands of the Rupununi inspired several others to try to discover the mythical city (Daly 1974, 25). First among these was Sir Walter Raleigh (1596, 9), whose travels to the area were later recorded in his book *The Discoverie of the Large, Rich, and Bewtiful Guiana*, in which he describes the Rupununi as a place 'I shall willingly spend my life therein' presumably because 'whatsoever

Prince shall possess it, that Prince shalbe Lorde of more Gold, and of a more beautifull Empire, and of more Cities and people, than eyther the King of Spayne, or the Great Turke' (also quoted in Smock 2008, 4).

Raleigh's personal testimony instantly contributed to the 'sense of place' development in other explorers and colonisers who would later visit the area. As Burnett (2000, 25) points out, Raleigh established a 'mythical empire in the heart of the Guianas' which influenced a surfeit of explorers, including Robert Schomburgk, who set out to discover its location. The German explorer was commissioned in the early 19th century to conduct boundary surveys in the region and edit Raleigh's book. He wrote of the effect of Raleigh's book on other explorers, saying 'Such was the influence of this seducing picture, first sketched by rumour and then coloured by imagination …' and 'every page, nay almost every sentence, awakened past recollections, and I felt in imagination transported once more into the midst of the stupendous scenery of the Tropics' (Burnett 2000, 26–8). Later, as Schomburgk and also Alexander von Humboldt claimed to have found the site of 'El Dorado' in the present-day Rupununi region, the area served as the 'gravitational center of British Guiana' (Burnett 2000, 28).

Each of the individuals or groups that explored the interior of Guyana developed a particular sense of place based on their experience but all shared perceptions of certain environmental factors (economical, physical environment, socio-cultural) and this is evident in their documentations. These factors created a 'layer' that was integral in the vertical continuation of the Rupununi's place identity in the minds of the non-indigenous, which is manifested in the recurring exploration of the area for gold. The subsequent reports from these trips covered all aspects of the journey from the scenic natural environment to its indigenous habitants, and a mythical city that no-one could locate, rumours of which only worked to further persuade others to try. Ironically, the physical environment was often indicated as a basis for the topophilia in the Rupununi, long before Alexander von Humboldt, in addition to writer William Hillhouse, would ultimately conclude that the El Dorado myth was not entirely accurate, but a misrepresentation of physical environmental factors (wetlands flooding, shining granite) in the landscape (Burnett 2000, 31–5).

The period between the mid-19th and the late 20th century was largely defined in the Rupununi and Guyana in general by ongoing land disputes and independence from the United Kingdom in 1966. The discovery of gold in the 1870s again switched focus to the interior of Guyana, which in turn led to an increase of temporary and permanent residents in the region (Smock 2008, 12). As presented before in Raleigh's thoughts on the area, the land was available for claim by explorers and colonisers, regardless of the presence of Amerindian communities. The potential and then proven availability of natural resources for financial gain has consistently been a factor for non-indigenous visitors. Therefore, it could be assessed that non-indigenous visitors shared similar notions of sense of place with indigenous residents relating to the functionality of natural resources, but differed in a sense of belonging context. As Moreton-Robinson (2003, 23) states, 'It is a sense of belonging derived from ownership as understood within the logic of capital, and it mobilises the legend of the pioneer …', which differs from indigenous notions of sense of place which seem to emphasise an important belonging of human beings to the places they inhabit. Due to the presence of these conflicting notions of place, effective facilitation and management is needed to ensure a balanced approach is maintained towards cultural and natural conservation.

CURRENT CONTEXT: IWOKRAMA, THE NRDDB AND OTHER STAKEHOLDERS

Iwokrama, 'named for the sacred mountains of the Makushi people and known as the "green heart" of Guyana' (CATS n.d.), consists of nearly one million acres of rainforest in the Rupununi region (see Fig 20.1). Although the main administration offices are in Guyana's capital city, Georgetown, the heart of the conservation area and the 'living laboratory' is the Iwokrama River Lodge and Research Centre, located close to the Kurupukari ferry crossing on the Essequibo River in Region 8 in central Guyana (see Fig 20.1). It is about 320km from Georgetown on the Linden–Lethem road, which is the main road route through Guyana to Brazil (Smock 2008, 214).

The establishment of Iwokrama has its roots in 1989 when Desmond Hoyt, president of Guyana at the time, made an offer of conservable rainforest to the international community during the Commonwealth Heads of Government Meeting in Kuala Lumpur, Malaysia. The organisation was formalised further when the National Assembly of Guyana passed the *Iwokrama International Centre for Rain Forest Conservation and Development Act*, which was signed in May 1996 by the then president Cheddi Jagan. As an international centre, Iwokrama has been governed by a carefully selected Board of Trustees, with international, national and local representation, which meets regularly, while its day-to-day activities are administered by an employed management team and staff body. It is also important to note that His Royal Highness Prince Charles, the Prince of Wales, has been the royal patron to Iwokrama since 2000 (Iwokrama 2007; see also Smock 2008, 214–15).

Central to Iwokrama's success to date has been its engagement with all the key stakeholders, most especially the local Amerindian communities. From the inception of the Iwokrama initiative, local people have played a pivotal role in the decision-making processes and in helping to steer the project. The majority of these local communities consists of Makushi people, but also includes the Wapishana and Wai Wai. However, all of the Amerindian people represented in these communities have brought traditional indigenous knowledge systems, cultural traditions and skills to bear on the integrated management of the natural and cultural heritage resources, both in the Iwokrama protected forest area and the North Rupununi savannah landscape. This has principally been done through the NRDDB, which was established with some support from Iwokrama on 19 January 1996.

The democratic NRDDB has representation through the Tuschao (elected village leader) and village council systems of 16 local villages – including Fair View village (the one community living in the forest conservation area), along with those villages in the North Rupununi wetlands and savannah. Although a working partnership between Iwokrama and the NRDDB was in existence from the start of the Iwokrama project, it was formalised with the signing of a Memorandum of Understanding (MoU) in 2003 and a Collaborative Management Agreement in 2005. A more specific Agreement between Iwokrama and Fair View village was signed on 21 December 2006. The MoU contains some key tenets that have remained core to the partnership. These are that Iwokrama should 'respect community protocols, customs and traditions; work with the NRDDB to minimise potential negative social or and cultural impacts from Iwokrama activities; and, guarantee positive benefits and outcomes from business enterprises and other activities' (Iwokrama 2007).

Two very significant sub-groups have developed out of the activities of the NRDDB. These are the Makushi Research Unit (MRU) and the Community Tourism Board. The former, initially

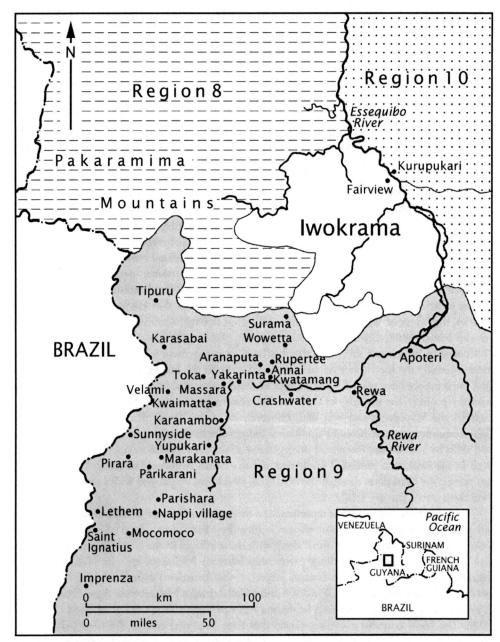

FIG 20.1. IWOKRAMA FOREST AND RUPUNUNI COMMUNITIES.

driven by women from the communities, has done some excellent work in documenting and researching Makushi language, culture, traditional skills and the relationship between people and the natural environment. The latter has become increasingly important as the NRDDB further identifies the potential of heritage and ecotourism for both the affirmation and validation of the cultural identities of people living in the North Rupununi communities, as well as the possibility of generating income for sustainable livelihoods.

Other key stakeholders involved in tourism provision in Regions 8 and 9 include Rock View, an entrepreneurial privately-owned family ecotourism business, and Wilderness Explorers, a tourism itinerary-development and package-tours company based in Georgetown. Surama village, one of the leading Makushi communities in the development of ecotourism, and these two other stakeholders have set up the Community and Tourism Services Incorporated (CATS) as a company to help develop tourism provision in North Rupununi (CATS n.d.).

In response to local stakeholders and others, Iwokrama has developed a set of guiding principles that recognise: the importance of seeking out appropriate partners for collaboration and cooperation; the adoption of a participatory approach that encourages active engagement with local communities and other stakeholder groups; the importance of developing as a self-sustaining enterprise, with environmentally friendly and socially responsible products; the value of indigenous knowledge and practices; the need for capacity building; the provision for education and training; and the importance of being involved in national and international forestry policy development (Iwokrama 2007).

In this, the working partnership between them tries to be sympathetic to the needs, concerns and interests of local indigenous Amerindian communities. The working partnership is more holistic in character and attempts to reduce the Western way of thinking, which often sets up an artificial divide between nature and culture. Iwokrama has taken on a role not only of place management in the Rupununi but also of facilitation. The diverse group of stakeholders in the region contributes to an extensive 'layering' of sense of place, and through its numerous partnerships with these stakeholders, Iwokrama is attempting to foster a unified notion of sense of place. This is done by utilising the overlapping meanings for the place shared by the groups into a vision that is mutually beneficial for all involved, most especially the indigenous communities. One of the key points of vertical continuity between the shared senses of place is the idea of using the natural and cultural resources for tourism. Heritage and (eco)tourism is seen by Iwokrama, the NRDDB and other shareholders and stakeholders – from the international level through to the local level – as potentially a central source of income generation.

SUSTAINABLE HERITAGE TOURISM IN IWOKRAMA AND NORTH RUPUNUNI

The activities of the IIC and the NRDDB, as they work with different stakeholders, are providing an atmosphere where the different senses of place are brought together and are stimulating the development of sustainable tourism. The heritage tourism and ecotourism provision in the Iwokrama protected rainforest area (Fig 20.2) is based at the Iwokrama River Lodge and Research Centre, located near the Kurupukari ferry-crossing of the Essequibo river. The centre provides different levels of accommodation (hammocks, cabins) and offers various ecotourism products that are mostly wildlife-orientated, including guided nature trails, game drives and river tours. In addition, a cultural trip to Fair View village can incorporate visits to the community-led butterfly farm, the Kurupukari Falls and the archaeological rock-art petroglyphs, with the earliest dating

FIG 20.2. IWOKRAMA RESERVE.

back to between 6000 and 7000 years ago. During a visit, tourists can also learn about the role that the historical village of Kurupukari played in the early 18th century, as a crossing point of the Essequibo river on the cattle and balata (rubber) trade route (Smock 2008, 222–23). Towards the southern border of the reserve, tourists can visit the unique Canopy Walkway, constructed from metal platforms and bridges suspended in the treetops, and the Atta Rainforest Lodge. These were developed through a partnership between Iwokrama and CATS (n.d).

Turning to the ecotourism provision in the North Rupununi, a promotional poster produced by the Community Tourism Board (c.2004) of the NRDDB outlining what is offered by certain villages shows the range of ecotourism opportunities that became available from the mid-2000s. The 'flagship' is still Surama village: the first eco-lodge was built here and opened in 2004, with four accommodation benabs set around a central meeting benab; there was also provision for mountain trails, cultural tours, wildlife viewing, birdwatching, river tours and fishing on the Burro Burro river. Other villages, such as Rewa, Annai and Wowetta, promote similar products that focus on both natural and cultural elements in the region.

With the success of, or at least initial positive responses to, the provision of ecotourism opportunities in these five villages, the other communities represented in the NRDDB have been keenly observing activities and have been considering developing their own tourism initiatives. The NRDDB's Community Tourism Board, drawing input from the Councillor with the tourism portfolio in each village, has been coordinating ongoing planning and development. This is vital to ensure that each village provides a product that has a 'unique selling point' and that the duplication and overlap of tourism provision is kept to a minimum. In this, the board is being assisted by CATS, especially by the company Wilderness Explorers. This itinerary-development and package-tours company has been active in ensuring that tour groups to Guyana visit both Iwokrama and the villages in North Rupununi. The facilitation of visits to the latter are seen to be crucial in order to ensure that there is equity between Iwokrama, with its international status and draw, and the local communities represented in the NRDDB.

Marketing by Wilderness Explorers and other tour companies for the Iwokrama reserve and the Rupununi savannah are based on similar senses of place that have been shared through the various visitors during the region's short history. For example, and as seen in promotional tourism literature: 'The Rupununi savannah of Guyana is a vast, remote landscape, still largely unknown to outsiders, but home to dozens of Amerindian communities struggling to preserve their traditions' (Laughlin 2006, 42), and '[Iwokrama] A lush carpet of emerald green canopy stretches as far as the eye can see … a melting pot of biodiversity …' (Explore Guyana 2009, 46).

In addition to this, it is often the Amerindian culture that is being used as the basis for what Smith (1996, 287–300) refers to as indigenous tourism, formed by the four Hs (heritage, history, habitat and handicraft). A recent blueprint created by Conservation International (2010) has outlined tourism in the Rupununi and detailed all of the indigenous communities looking to foster tourism in their village partly based on these four products. In relation to tourism product development, this blueprint states that:

> The Rupununi already has a good base of excellent birding, nature and culture tourism experiences, but to attract the special interest traveller segments … work must be done to polish existing experiences and create dynamic new ones that deliver a unique sense of place and make travellers feel the true essence of Guyana. (Conservation International 2010, 71)

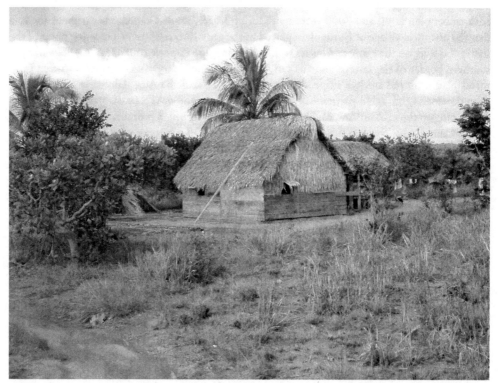

FIG 20.3. LOCAL AMERINDIAN HOME.

Assisting with these developments and at the heart of all progressive tourism movement are the IIC and NRDDB.

Tourism has often been accused of destroying an authentic 'sense of place' (Relph 1976, 117, taken from Oakes 1997, 35), but it has also been suggested that tourism acts in the 'ongoing construction' of place identity (Oakes 1997, 35). The IIC and NRDDB's managerial approach toward tourism places importance on the cultural and natural heritage of the region, and in doing so often tends to create a stronger sense of place attachment among individuals or groups, particularly stakeholders, using that space. This in turn can lead to a greater focus on the ecological and cultural well-being of an area by 'creating shared understandings and common ground through focusing on sense of place' (Farnum *et al* 2005, 25–33).

CONCLUSION

This chapter set out to gain an understanding of different layers of sense of place that have been constructed in the rainforest and savannah areas in Region 8 and 9 of Guyana. It has introduced both particular and shared notions of place about these areas, where the IIC and NRDDB have their key remits. In terms of identifying, communicating and packaging these layers, these two organisations, working with a range of other stakeholders and shareholders, are developing and

promoting tourism products and experiences. As presented in the chapter, many of these draw on the historical and current aspects of indigenous and non-indigenous notions of space and relationships with a range of environmental factors associated with these spaces or sites. In this work, the IIC and NRDDB have developed a collaborative and participatory approach that could provide a useful model for other areas, globally, where sense of place is being incorporated into the development of sustainable tourism. This type of model is not always easy to implement and requires ongoing cooperation and negotiation between all stakeholders to ensure continued success, especially when taking into account the different layers of sense of place.

BIBLIOGRAPHY AND REFERENCES

Burnett, D G, 2000 *Masters of All They Surveyed: Exploration Geography and a British El Dorado*, The University of Chicago Press, Chicago

— 2002 'It Is Impossible to Make a Step Without the Indians': Nineteenth-Century Geographical Exploration and the Amerindians of British Guiana, *American Society for Ethnohistory* 49 (1), 1–40

CATS (Community and Tourism Services Inc), n.d. *A Forest Walk with A Difference: Linking the Local Community of Forest Keepers with the Global World of Nature Lovers*, CATS [promotional poster]

Community Tourism Board, NRDDB, c.2004 *Community Tourism in the North Rupununi*, NRDDB [promotional poster]

Conservation International, 2010 *Community Tourism Enterprise Development in the Rupununi: A Blueprint* (eds E Nycander, C Hutchinson, J Karwacki, V Welch, C Bernard and G Albert), Conservation International Foundation Guyana Inc, Guyana

Cross, J, Keske, C, Lacy, M, Hoag, D, and Bastian, C, 2011 Adoption of Conservation Easements Among Agricultural Landowners in Colorado and Wyoming: The Role of Economic Dependence and Sense of Place, *Landscape and Urban Planning* 101 (1), 75–83

Daly, V, 1974 *The Making of Guyana*, Macmillan Education Ltd, London

Explore Guyana, 2009 *Iwokrama – The Story Unfolds*, Explore Guyana, 46

Farnum, J, Hall, T, and Kruger, L, 2005 A Sense of Place in Natural Resource Recreation and Tourism: An Evaluation and Assessment of Research Findings, *Gen Tech Rep PNW-GTR-660*, US Department of Agriculture, Forest Service, Pacific Northwest Research Station, Portland, OR

Forte, M C, 2006 *Indigenous Resurgence in the Contemporary Caribbean: Amerindian Survival and Revival*, Peter Lang, New York

Iwokrama, 2007 *Iwokrama: the Green Heart of Guyana*, available from: http://www.iwokrama.org/home.htm [28 February 2011]

Kyle, G, Mowen, A, and Tarrant, M, 2004 Linking Place Preferences with Place Meaning: An Examination of the Relationship Between Place Motivation and Place Attachment, *Environmental Psychology* 24, 439–54

Laughlin, N, 2006 Great Beyond, *Caribbean Beat*, September/October, 42–54

Makushi Research Unit, 1996 *Makusipe Komanto Iseru: Sustaining Makushi Way of Life* (ed Janette Forte), North Rupununi District Development Board, Guyana

Massey, D, 1991 A Global Sense of Place, *Marxism Today*, June, 24–9

Mazumdar, S, and Mazumdar, S, 2004 Religion and Place Attachment: A Study of Sacred Places, *Environmental Psychology* 24, 385–97

Moreton-Robinson, A, 2003 I Still Call Australia Home: Indigenous Belonging and Place in a White Postcolonising Society, in *Uprootings/Regroundings: Questions of Home and Migration* (eds S Ahmed, C Castaneda, A M Fortier and M Sheller), Berg Publishers, Oxford, 23–41

Oakes, T, 1997 Ethnic Tourism in Rural Guizhou: Sense of Place and the Commerce of Authenticity, in *Tourism, Ethnicity, and the State in Asian and Pacific Socities* (eds M Picard and R E Wood), University of Hawaii Press, 35–71

Raleigh, W, 1596 (1997) *The Discoverie of the Large, Rich, and Bewtiful Empire of Guiana* (ed N Whitehead), Manchester University Press, Manchester

Relph, E, 1976 *Place and Placelessness*, Pion, London

Rodman, M, 1992 Empowering Place: Multilocality and Multivocality, *American Anthropologist* 94 (3), 640–56

Salmon, E, 2000 Kincentric Ecology: Indigenous Perceptions of the Human–Nature Relationship, *Ecological Applications* 10 (5), 1327–32

Scannell, L, and Gifford, R, 2010 Defining Place Attachment: A Tripartite Organizing Framework, *Environmental Psychology* 30, 1–10

Sinclair, D, 2003 Developing Indigenous Tourism: Challenges for the Guianas, *Contemporary Hospitality Management* 15 (3), 140–46

Smith, V, 1996 Indigenous Tourism: The Four H's, in *Tourism and Indigenous Peoples* (eds R Butler and T Hinch), International Thomson Business Press, London, 287–300

Smock, K, 2008 *Guyana: the Bradt Travel Guide*, The Globe Pequot Press, CT

Staeheli, L, and Mitchell, D, 2004 Spaces of Public and Private: Locating Politics, in *Spaces of Democracy: Geographical Perspectives on Citizenship, Participation and Representation* (eds C Barnett and M Low), Sage, London, 147–60

Uzzell, D, Pol, E, and Badenas, D, 2002 Place Identification, Social Cohesion, and Environmental Sustainability, *Environment and Behaviour* 34, 26–53

Woldoff, R, 2002 The Effects of Local Stressors on Neighborhood Attachment, *Social Forces* 81, 87–116

Yeoh, B, and Kong, L, 1996 The Notion of Place in the Construction of History, Nostalgia, and Heritage in Singapore, *Tropical Geography* 17 (1), 52–65

Placing the Maasai

Mark Toogood

Introduction

Contemporary geographical approaches to place include those which understand locations as 'imbued with meaning that are the sites of everyday practice' (Cresswell 2009, 176). Anthropologists (notably Khazanov and Wink 2001; Spencer 1998; 2003a and 2003b; Talle 1999; Waller 1999; Waller and Spear 1993) interested in the Maa-speaking people of southern Kenya and northern Tanzania have paid close attention to meaning in Maasai practice and to the micro-dynamics of Maasai identity, relationships, beliefs and socio-economy. Such work, often ethnographic in nature, focuses in on sub-tribal levels[1] and is ineluctably concerned with the everydayness of place in Maasai culture. In contrast to these studies, the focus of this chapter is on how the Maasai are positioned or 'placed' in different, arguably less reflexive contexts, namely those of biodiversity conservation and safari tourism. It is in these particular contexts that the Maasai are 'positioned' in relation to notions of place which are widely produced in conservation and development. This chapter will survey how aggregate and frequently reductive definitions of the Maasai have been, and continue to be, constituted, which 'place' Maasai as a problematic and/or exotic people.

The chapter will argue that conservation and safari tourism has and continues to discursively and materially construct and order the Maasai and Maasailand. It argues that, in general, there is an asymmetrical set of power relations which marginalises Maasai people while framing Maasai-land as a place of particular global imagination. On the one hand, the Maasai are viewed as proud and free; as threatened; and as distant from modernity. Large-format books, lavishly illustrated, with titles such as *Last of the Maasai* and *Maasai – Beautiful People*, entice visitors to East African safari lodge gift shops. On the other hand, this romantic imaginary sits alongside other notions of the Maasai which position them as having declined from an historical state of (tribal) power to a contemporary state of relative powerlessness in which they are seen as intransigent pastoralists resistant to outside influence. In the following analysis of biodiversity conservation and safari tourism there are parallels to arguments made by several authors about the privileging of Western views of place over other 'less-developed cultures' (particularly Haraway 1989; Verran 2001; Ingold 2000). Ingold talks of the understanding of place being an issue of 'apprehension' which is shaped by culture (2000, 20). The 'apprehension' of Maasai within particular Western cultural perspectives has been a view of them as subjects of study or something to be acted *upon*. This perspective reflects Western ideas of places as '*substrate* for the imposition' (ibid, 35) of human societies rather than as lifeworlds which are quite different to such Western ontology.

[1] Such as *olgilata* or clan level.

Ingold suggests that this view of people and place derives from a Western 'idea that the "little community" remains confined within its limited horizons which "we" – globally conscious Westerners – have escaped ... [this] results from a privileging of the global ontology of detachment over the local ontology of engagement' (2000, 38).

The chapter is structured as follows. First I examine the concept of Maasailand itself. The geographical reality of the 'homeland' of the Maasai is strongly linked to the conceptualisations of Maasai people noted above. It is therefore important to trace the 'creation' of Maasailand in the early 20th century. Second, the chapter examines the position of the Maasai in the conservation of the habitats and wildlife of Kenya, venerated as the global heritage of biodiversity, with a particular focus upon pastoralism as 'threat' and upon the relationships of indigenous knowledge to scientific knowledge. Finally the chapter presents a condensed discussion on the ordering of Maasailand and the Maasai within safari tourism.

Making Maasailand

The binary constructs of Maasai as 'romantic' and 'awkward' have their roots in colonial literature dating from the late 19th century. Joseph Thomson's *Through Masai land* (1895 [1885]) termed the Maasai 'beautiful beasts' (Hughes 2006b, 269), and imagined Maasailand as a moral test for the imperial body and mind. Moreover, such writing reinforced colonial administrators' assumptions that Maasai occupation of place 'was aimless thereby justifying land snatching and forced moves' (Hughes 2006b, 274).

In 1906 the British restricted the Maasai to newly formed reserves in British East Africa – the 'Northern Masai Reserve' and the 'Southern Masai Reserve' (Hughes 2006a).[2] In 1916 all those in the Northern Reserve were moved to an expanded Southern Reserve. Prior to this date most Maasai were widely distributed and interspersed with other pastoralists and agriculturalists who did not necessarily speak Maa. The British argued for the formation of reserves to 'protect' the interests of Maasai as a 'tribe':

> Most administrators attributed the scattering to their continued suffering after the ravages of the epidemics and civil wars of the late nineteenth century [...], rather than to a conscious effort by Maasai to diversify economically, re-establish involvement with neighboring peoples, and reassert their own models of spatial interaction. Upset that such fragmentation and dispersal had occurred among 'the Maasai' of travelers' tales and colonial lore, they vowed to restore 'the Maasai' to their reputed former colonial glory and vitality as a 'tribe' by reuniting the scattered fragments and concentrating them in a single, bounded area. (Hodgson 2001, 51)

Thus, the modern notion of 'Maasailand' was made concrete as an ethnic geography with the creation, between 1916 and 1926, of two reserves in the driest areas of southern Kenya and northern Tanganyika. Furthermore, this newly fashioned geography itself became a place in which 'the Maasai' were constituted, as colonial administrators grouped together all Maa-speaking nomadic pastoralists who *seemed* to possess the same look, language and social structure. Such assumptions put into practice also meant that in the early 20th century the Maasai became regarded

[2] The Kenya colony came into existence in 1920.

as a people who were viewed as properly subject to external control. The British were, by the late 1920s, proud of themselves for 'saving' the Maasai when in fact what they had done was to politically demarcate a particular geographical area as a place they termed 'Maasailand' (Miller 1971; Hughes 2005), populated by a people removed from their traditional homelands.

After 1945 colonial livestock scientists focused on the transformation of savannah in the reserves for livestock production, or 'rangeland improvement'. Simultaneously, protected areas for game were also strengthened. The Swynnerton Plan[3] of 1954–1959 was designed to introduce 'models' of ideal land use which assigned a livestock quota to each Maasai household and a set area of land for each herd and imposed agreements to sell surplus stock to the government. However, '[m]ost pastoral groups viewed the colonial administration with suspicion and believed that the colonial government did not understand the real nature of pastoral cultures with their many attendant problems' (Ng'ethe 1993, 3). Indeed, the very notion of 'development' in the context of the Maasai, even by post-colonial state and international agencies since Kenya became independent in 1963, is a curious mix of idealising the 'tribalness' of the Maasai and simultaneously regarding them as 'backward' and 'uncooperative' because of their apparent unwillingness to 'modernise', particularly in respect of lack of cooperation with range management models. Group ranches were territorial arrangements with the emphasis on collective tenure of defined areas for livestock grazing outside protected areas. Males over a certain age are entitled to membership, but in practice the benefits of membership frequently accrue to the political elites within each of the circa 90 group ranches in Maasailand (Republic of Kenya 1990).

Throughout the 20th century, as the Maasai were being represented in popular culture for being noble primitives and guardians of the savannah, they were simultaneously portrayed by colonial and postcolonial governments as truculent, conservative and stuck in the past (Hughes 2007). On the one hand, an assumption is that they neglect the land and ignore opportunities for exploitation of their traditional resource. Yet, on the other hand, the alternate assumption is that they are interfering with range ecosystems by putting stock on land that is regarded as wildlife habitat, with the consequences of reducing water and grazing available for wildlife (African Conservation Centre 2010). There is, therefore, an inference that the Maasai are poor guardians of place and that other, more enlightened, interests are better poised to characterise and direct the management of 'rangeland'.

The problems of group ranches in Kenyan Maasailand – lack of recognition by Maasai pastoralists of state livestock quotas; supposed overgrazing; competition with wildlife; soil erosion; vulnerability to drought; conflict over resource access; social stratification and reinforcement of gender inequality – have been regarded by the state and by particular international non-governmental organisations as at least partly a product of the 'difficult' Maasai culture. Many development and conservation professionals would say the Maasai are recalcitrant and hard to modernise (Hodgson 2001). Taking an overview of colonial and post-independence multilateral development programmes in Tanzanian Maasailand, Dorothy Hodgson argues that this recurring focus on modernising the Maasai has had contradictory and even paradoxical effects:

[3] The Plan launched the enclosure of tribal lands so as to increase agricultural production and to better integrate 'tribal peoples' into the colonial land-use system.

Rather than producing food security, collective empowerment vis-à-vis the nation state, or adequate health and education opportunities, these development interventions increased stratification, limited food production and income strategies, and facilitated the economic and political disenfranchisement of women. Furthermore, despite these years of development, Maasai are still viewed as 'culturally conservative', stubbornly persistent in their pursuit of pastoralism and rejection of farming, sedentarisation, education and other more 'modern' ways of being (Hodgson 2001, 6).

In this section I have set out how the Maasai are constructed in certain categories by particular actors in relation to the environment and development. As Hodgson points out, such 'placing' of Maasai people and their lands has given rise to persisting effects that would seem to mitigate against integrating Maasai people more fully and from the bottom up into the objectives of environment and development.

Conservation and 'Community'

In recent years heritage conservation has undergone a process that has putatively moved away from the 'fortress model'. Fortress conservation is based on policies which emphasise the centrality of meeting scientifically derived aims and the creation and scientific management of protected areas. These territories – game reserves, sanctuaries, national parks – were removed from their surrounding everyday context by partitioning and by the exclusion of people and their everyday practices. Indeed, it has been common practice for conservation authorities to evict local residents from many protected areas around the world. Over the last 25 years a new model has arisen, however, based on ideas of integrating the needs of human development with conservation; it has moved from excluding to including local people and 'trusting' indigenous knowledge about, and ways of managing, ecosystems (Brockington *et al* 2008; Igoe 2004; Maffi and Woodley 2010). Organisations such as the International Union for the Conservation of Nature and Natural Resources and the World Wide Fund for Nature, as well as several others, are aligning conservation with development and, in particular, the rights of indigenous peoples. This internationalisation of the 'indigenous' by global conservation institutions raises several issues around inclusion and exclusion in conservation in Maasailand.

The first issue that is problematic in the new conservation model concerns the construction of Maasai community. One of the new modes of the new model is called community-based conservation (CBC) and this ostensibly integrates the protection of highly valued species, habitats and ecosystems while meeting the development needs of communities, especially the rural poor. However, conservationists often fall into what critics of mainstream top-down economic development call 'normal development'. This happens when conservation policy and practices effectively reify community knowledge by assuming all Maasai to be a single, homogenous community and thereby ironing out differentiation within a complex social system (Neumann 1995). Further, some Maasai in positions of power within group ranches and in Maasai NGOs based outside of Maasailand have, in order to gain international support, 'often intentionally manipulated and projected homogenized exoticised versions of their cultural identities to accord with "Western" stereotypes of "indigenous" peoples' (Hodgson 2001, 231). These points about the Maasai parallels work on CBC in other parts of Africa where assumptions by conservationists about 'community' (such as which actors hold traditional land rights) have led to the reassertion of the fortress

model of conservation when CBC seems not to have 'worked' as effectively as the conservation agenda required (see, for example, Sharpe 1998; Kumar 2005).

A second issue relates to the construction of indigenous knowledge, which is frequently assigned a subservient position in relation to scientific knowledge. For Goldman (2003), Maasai knowledge is constituted as something which has relevance to conservation but only in ways which ecologists and conservationists prescribe. She argues that aspirations on the part of scientists and conservationists to 'build bridges' between indigenous and scientific knowledge is flawed because within this process the balance between these knowledges is unequal. Indigenous knowledge cannot define itself on its own terms and becomes the political and scientific 'tool' of the conservation community rather than having epistemological equivalence. This hierarchy is maintained by the construction of boundaries between indigenous knowledge and conventional science within community conservation in Maasailand (Goldman 2007).

The majority of people living with wildlife are passive participants in its conservation and generally have no devolved power or say in the direction and conceptualisation of the results that conservation exists to deliver or for whom those outcomes are important (Brockington *et al* 2008). Indeed, there is often a great deal of hostility to wildlife and international conservation in Maasailand. This is evidenced in the continued killing of lions to 'protect' cattle despite the establishment of instruments such as the Predator Compensation Fund (covering Mbirikani group ranch in southern Kenya). It is also seen in Maasai frustration over denial of access to grazing because of exclusion from reserves supposedly established and run on CBC lines (such as Kimana Wildlife Sanctuary between Amboseli and Tsavo national parks in southern Kenya). It is not uncommon to hear complaints about the poor terms given to Maasai in such projects, or about the high status of wildlife in relation to Maasai interests, for example: 'The government is wildlife and wildlife is government' (male junior elder, Kuku group ranch, *pers comm* 2010). It would seem from these relations of conservation that place is conceived of in the overarching terms of global biodiversity and that Maasai concepts and knowledge of place are, despite aspirations, unincorporated into conservation.

Despite the idealism around CBC, the language and practices associated with protected areas largely reflect the culture of conservation rather than local culture: 'The intended (and at times unintended) landscapes of conservation are crafted for legibility, manageability and foreign scientific expertise, leaving little room for "indigenous" or "local" knowledge claims' (Goldman 2003, 835). Indeed, science-based international NGOs made a considerable protest when Amboseli National Park proposed allowing Maasai grazing within its boundaries (Thompson 2002). These sorts of actors, in Maasailand but organised and funded internationally, 'still have significant influence in representing protected areas as people-less spaces, conserved free from the influence and despoiling activities of people' (Brockington and Igoe 2006, 445). This concept of Maasai place as lacking modernity is one that is consumed around the world and, as the next section discusses, is an idea central to the safari industry in East Africa.

BEING AND SEEING ON SAFARI

Tourism is a mainstay of the Kenyan economy and most Kenyan tourism involves some participation in safari to look at wild animals and experience 'wild' habitats. The development of modern safari strongly relates to the growth of hunting in the colonial era as a key part of the construction of the European imagination of East Africa and by the 1930s Kenya had become

the centre of 20th-century safari. In Maasailand, wildlife conservation and safari tourism exist in a mutually reinforcing co-existence. This section discusses safari tourism as something other than simply a business. It will briefly explore how wildlife and Maasai geography are organised and framed through a combination of discourses, materiality and practices into a functional whole: what van der Duim calls a 'tourismscape' (2007). The discussion suggests a distance between the ordinary experience of place in Maasai everyday life and the experience of tourists on safari, primarily seeking to experience, and in certain respects to 'capture' through photography, the 'wild' savannah, its animal species and its tribal peoples.

One of the most powerful framings of geography in safari tourism – the safari tourismscape – is of Maasailand as being 'wild' or 'wilderness' (Cejas 2007). The Maasai, as long as they are in 'native' dress, are often part of this framing of Kenya as something other than modernity, as an Eden-like landscape. In the adherence of safari tourism to the globalised discourse of ecology, Maasai geographies of everyday dwelling places are fixed as an ahistoric landscape, meaning a landscape that is predominantly unchanged and is, somehow, imagined as being like the world 'as it once was' (Massey 2005). Maasailand as an 'ecological' destination for tourists, as a place outside of the modern world and with its own inherent 'natural' rhythms, seems a part of this process of rendering peopled places as wild and, therefore, people-less landscapes.

Safari itself comes in several forms, but most frequently has at its centre the evocation of a romantic kind of 'aristocratic' tourism promoted to European elites in the early days of the Kenya colony. This is tourism linked to an imaginary landscape, as land untainted by the depredations of the modern world. Indeed, the romanticism referred to here links to interwar literary expressions of what the original British colonialists felt about East Africa – that it was unaffected by the wider world and in particular by the erosion of values that was occurring in Britain, especially the loss of a particular rural way of life in the 1930s (Youngs 1999). The more 'upmarket' safari packages still trade on this romantic version of the African experience.

Another hierarchy implicit in the safari tourismscape relates to safari spaces themselves which are pre-eminently protected areas. The safari tourismscape is one in which globally mobile actors move through particular sites in Maasailand. In Kenya there is a hierarchy of parks built around notions of an ascending order of spectacle. Inevitably all parks build up to a visit to the Maasai Mara (in south-west Maasailand), as it is considered within the safari tourism industry to be the climax of visual spectacle in the Kenyan context. The location of places is crucial and many roads and facilities in rural Kenya exist primarily to serve safari traffic. It is not uncommon to experience roads of much better quality within protected areas than without. However, the main point is that the safari requires accessibility for globally mobile subjects. The tourist is the legitimised visitor to the wild, the 'natural' inhabitant of the touristic enclaves formed by the geography of protected areas. There is a distinct paradox in safari tourism, in that the imagination of, and usually non-African desire for, 'Africa' as extensive untamed geography collides with the fact that, in reality, such notions are confined to and played out in identifiable demarcated spaces.

Places such as Amboseli and the aforementioned Kimana Wildlife Sanctuary are presented to non-Maasai tourist markets as a point in a wider, threatened, ecological space (such as a gathering point for wild animals on migration). These places are marked by their familiarity to Westerners, as reassuring commodified locations; watered, comfortable zones of Africana. The safari lodge – with air-freighted luxuries – is an idea of a place in the savannah. The effort is spent on creating and maintaining the realism of the idea of safari. In the case of Kimana Wildlife Sanctuary, like so many other cases, the safari tourismscape (in this case supposedly ecotourism) ties to fortress

conservation. The people living in the area are often excluded from these spaces despite a reliance on such land for activities long practised in the area. This is the case in Kimana. As the Chief Warden of Kimana Wildlife Sanctuary once stated: 'people come to see wildlife, not Maasai or their cattle' (*pers comm* 2002). Thus there is an assumption about how many safari tourists expect to experience Maasailand as wild savannah.

A further dimension of the framing of Maasailand as 'wild' is in the meeting of (Western) human and non-human. In the safari tourist's quest for the 'big five',[4] encounters between human tourist and non-human hold within them inherent notions of 'realism', such as certain ideas of animal subjectivity, authenticity and specific models of human–animal relationships (Desmond 1999, 176). When the tourist on safari regards nature, a realist understanding is generally taken as being in play. The non-human is regarded primarily as an extra-discursive entity. Non-humans are evidence for the safari tourist of a (partly) asocial and ahistoric nature, one that by its apparently obvious apartness from modernity defines its existence. In this sense, to be in the presence of an elephant or a big cat is to be present among another reality, essentially one of an unmediated nature at its most fundamental. The wildlife comes to signify 'global ecology' and the safari tourist therefore may come to experience the safari encounter with wildlife species as part of a moral geography in the sense that safari encounters are part of a positive moral contribution to the conservation of 'global heritage' through safari tourist shillings feeding into conservation science and management.

Another feature of the safari tourismscape of 'wild' Maasailand is what may be called 'self-disciplining': the process of preparation, knowledge and comportment involved in being a safari tourist, such as the process of acquiring the necessary awareness of the correct behaviour for encountering a range of wildlife. Thus safari starts before the tourist arrives in Maasailand. Clothing, language, technology and so on are all vital and the subject of numerous texts on 'how to' experience the African wild. The contemporary use by tourists of optical equipment to 'see' and 'capture' animals is linked to a form of knowledge that is about seeking out, collecting, classifying and displaying animals (Ryan 1997), and this is a central part of the construction of Maasailand as an ecological domain. The space in which safari is staged displaces the everyday dwelling space of Maasai people and becomes framed by particular readings of global environmental concerns and discourse. Indeed, the driver guides are mediators of global environmental discourse when describing species and environments to tourists.

The Maasai position in the tourismscape is harder to characterise, perhaps. This is possibly because the image of the Maasai warrior in traditional dress, standing on one leg, or leaning on a spear, is a cliché in this context. Maasai moran in tribal dress are often employed by safari lodges as *askari* – armed guards – and to dance as part of visitor entertainment. The Maasai in this framing are self-evidently *the* people in the safari landscape as long as they are positioned and staged 'correctly'. For some Maasai, 'playing themselves' for tourist interest is an unproblematic performance, but elsewhere it has been noted that some safari tourists are resistant to the idea of 'Maasainess' as something that is staged for tourists as a performance (Bruner 2005); rather, safari tourists typically regard Maasai as authentic and any glimpse of the 'backstage' (ie Maasai not

4 The big five refers to the most valued target species for colonial hunters and for modern safari tourists: There are actually six species, as rhinoceros is usually grouped together: African elephant (*Loxodonta africana*); black rhinoceros (*Diceros bicornis*); white rhinoceros (*Ceratotherium simum*); lion (*Panthera leo*); Cape buffalo (*Syncerus caffer*); and leopard (*Panthera pardus*).

conforming to a particular physical representation of Maasainess) is resisted and even disregarded (Bruner 2001; Bruner 2005; Bruner and Kirshenblatt-Gimblett 1994; and see also Whittaker 2009). One thing that is pre-eminently left out by the framings of the safari tourismscape is the ordinary world of Maasai people, the sense of place experienced in the everyday.

CONCLUSION

This chapter has given an overview of how the Maasai are framed in conservation and safari tourism. The approach has emphasised the processes and ordering of the Maasai in relation to conservation and tourism as powerful (global) discourses and practices. The chapter has suggested that, on the one hand, Maasai are framed as indigenous people living in harmony with the savannah environment, and, on the other, the Maasai are framed as persistently stuck in the past, with a poor understanding of rangeland management in relation to wildlife and prone to wantonly disregarding rules such as refraining from grazing in protected/safari game reserves. The chapter also discussed how safari tourism emphasises the realism and romanticism of Maasailand and that this ties in strongly to the marginalisation of Maasai concerns in conservation. For some, the Maasai performing for tourists is an inauthentic act reinforcing negative stereotypes and is at a distance from enabling tourists to understand the realities of Maasai life. To others, Maasai people are entitled to present the 'stereotypes' of Maasainess for consumption by tourists. As analysed here it is as if these discourses and practices make the Maasai their subject and subjugate the different Maasai people's own lived environment; their own understandings of place.

I have also not discussed in the short space available in this chapter how, for example, Maasai people see their own place in the world. But it might be appropriate to end the chapter with the following anecdote from conversations with Maasai colleagues. Among the *Odo-mongi* (people of the red cow) subsection of Kenyan Maasai, the current *olaji* or age set of male junior elders were originally called *Ilkiponi* by their elders. This means 'innovators', or 'people who make things multiply', indicating an aspiration to increase the numbers and value of livestock. However, the self-chosen nickname for that age set is *Iltakerin*, which means 'a mix of traditional and modern' or, more accurately, 'hybrid people', reflecting their desire to be something other than how others see them and their place in the world. The (mis)placing of the Maasai is evidently in stark contradiction to their own, much more sophisticated, self-image.

BIBLIOGRAPHY AND REFERENCES

African Conservation Centre, 2010 Conservation Enterprise, available from: http://www.conservationafrica. org/en/conservation-enterprise.html [10 May 2010]

Brockington, D, and Igoe, J, 2006 Eviction for Conservation: A Global Overview *Conservation and Society* 4 (3), 424–70

Brockington, D, Duffy, R, and Igoe, J, 2008 *Nature Unbound: The Past, Present and Future of Protected Areas*, Earthscan, London

Bruner, E, 2001 The Maasai and the Lion King: authenticity, nationalism, and globalization in African tourism, *American Ethnologist* 28 (4), 881–923

— 2005 *Culture on Tour: Ethnographies of Travel*, University of Chicago Press, Chicago

Bruner, E, and Kirshenblatt-Gimblett, B, 1994 Maasai on the Lawn: Tourist Realism in East Africa, *Cultural Anthropology* 9 (4), 435–70

Cejas, M, 2007 Tourism 'Back in Time': Performing the 'Essence of Safari' in Africa, *Intercultural Communication Studies* 16 (3), 121–34

Cresswell, T, 2009 Place, in *The International Encyclopedia of Human Geography* (eds R Kitchin and N Thrift), Elsevier, Oxford, 169–77

Desmond, J, 1999 *Staging Tourism: Bodies on Display from Waikiki to Sea World*, University of Chicago Press, Chicago

Goldman, M, 2003 Partitioned Nature, Privileged Knowledge: Community Conservation in the Maasai Ecosystem, Tanzania, *Development and Change* 34 (5), 833–62

— 2007 Tracking Wildebeest, Locating Knowledge: Maasai and Conservation Biology Understandings of Wildebeest Behavior in Northern Tanzania, *Environment and Planning D: Society and Space* 25, 307–31

Haraway, D J, 1989 *Primate Visions: Gender, Race, and Nature in the World of Modern Science*, Routledge, London

Hodgson, D L, 2001 *Once Intrepid warriors: Gender, Ethnicity and the Cultural Politics of Maasai Development*, Indiana University Press, Bloomington, IN

Hughes, L, 2005 Malice in Maasailand: The Historical Roots of Current Political Struggles, African Affairs 104, 207–24

— 2006a *Moving the Maasai: A Colonial Misadventure*, Palgrave Macmillan, Basingstoke

— 2006b 'Beautiful Beasts' and Brave Warriors: The Longevity of a Maasai Stereotype, in *Ethnic Identity: Problems and Prospects for the Twenty-First Century* (eds L Romanucci-Ross, G A De Vos and T Tsuda), AltaMira Press, Lanham, MD, 264–94

— 2007 Rough Time in Paradise: Claims, Blames and Memory Making Around Some Protected Areas in Kenya, *Conservation and Society* 5 (3), 307–30

Igoe, J, 2004 *Conservation and Globalization: A Study of National Parks and Indigenous Communities from East Africa to South Dakota*, University of Colorado, Denver, CO

Ingold, T, 2000 *The Perception of the Environment: Essays on Livelihood, Dwelling and Skill*, Routledge, London

Khazanov, A M, and Wink, A, 2001 *Nomads in the Sedentary World*, Routledge, London

Kumar, C, 2005 Revisiting 'Community' in Community-based Natural Resource Management, *Community Development Journal* 40 (3), 275–85

Maffi, L, and Woodley, E, 2010 *Biocultural Diversity Conservation: A Global Sourcebook*, Earthscan, London

Massey, D B, 2005 *For Space*, Sage, London

Miller, C, 1971 *The Lunatic Express: An Entertainment in Imperialism*, Macmillan, London

Neumann, R, 1995 Ways of seeing Africa: colonial recasting of African society and landscape in Serengeti National Park, *Ecumene* 2, 129–48

Ng'ethe, J, 1993 Group Ranch Concept and Practice in Kenya with Special Emphasis on Kajiado District, in *Future of Livestock Industries in East and Southern Africa. Proceedings of the Workshop Held at the Kadoma ranch Hotel, Zimbabwe, 20–23 July 1992* (eds J A Kategile and S Mubi), International Livestock Centre for Africa, Addis Ababa, 187–200

Republic of Kenya, 1990 *Kajiado District Atlas*, ASAL Programme, Kajiado

Ryan, J, 1997 *Picturing Empire: Photography and the Visualisation of the British Empire*, Reaktion Books, London

Sharpe, B, 1998 'First the Forest …': Conservation, 'Community' and 'Participation' in South West Cameroon, *Africa* 68 (1), 25–45

Spencer, P, 1998 *The Pastoral Continuum: The Marginalization of Tradition in East Africa*, Clarendon Press, Oxford

— 2003a *Time, Space and the Unknown: Maasai Configurations of Power and Providence*, Routledge, London

— 2003b *The Maasai of Matapato: A Study of Rituals of Rebellion*, 2 edn, Routledge, London

Talle, A, 1999 Pastoralists at the Border: Maasai Poverty and the Development Discourse in Tanzania, in *The Poor Are Not Us* (eds D M Anderson and V Broch-Due), James Currey, Oxford, 106–24

Thompson, C, 2002 When Elephants Stand for Competing Philosophies of Nature: Amboseli National Park, Kenya, in *Complexities: Social Studies of Knowledge Practices* (eds J Law and A Mol), Duke University Press, Durham, NC, 168–90

Thomson, J, 1895 [1885] *Through Masai Land: A Journey of Exploration Among the Snowclad Volcanic Mountains and Strange Tribes of Eastern Equatorial Africa*, Low and Marston, London

Van der Duim, R, 2007 Tourismscapes: An Actor-Network Perspective, *Annals of Tourism Research* 34 (4), 961–76

Verran, H, 2001 *Science and an African Logic*, University of Chicago Press, Chicago

Waller, R D, 1999 Pastoral Poverty in Historical Perspective, in *The Poor Are Not Us* (eds D M Anderson and V Broch-Due), James Currey, Oxford, 20–49

Waller, R D, and Spear, T (eds), 1993 *Being Maasai: Ethnicity and Identity in East Africa*, James Currey, Oxford

Whittaker, E, 2009 Photographing Race: The Discourse and Performance of Tourist Stereotypes, in *The Framed World: Tourism, Tourists and Photography* (eds M Robinson and D Picard), Ashgate, Farnham, 117–49

Youngs, T, 1999 'Why is that White Man Pointing that Thing at Me?' Representing the Maasai, *History in Africa* 26, 427–47

Nature Tourism:
Do Bears Create a Sense of Place?

OWEN T NEVIN, PETER SWAIN AND IAN CONVERY

Extreme sports, adventure and ecotourism are bringing increasing numbers of people into remote backcountry areas worldwide. The number of people visiting wilderness areas is set to increase further and nature tourism is the fastest growing sector in the $3.5 trillion global annual tourism market (Mehmetoglu 2006). What impacts will this have on the social perceptions, economic and conservation values of these areas and the species which are found there? Reflecting on over a decade's research on the impacts of the bear-viewing ecotourism industry in British Columbia (BC), Canada, this chapter considers place and 'place making' via a case study of bear tourism in British Colombia.

INTRODUCTION

This chapter presents the argument that it is the experience of encountering a bear which defines the sense of place for the ecotourist. Many tourists who have encountered bears in heavily impacted secondary forest describe the place as 'pristine' or 'wilderness' (Swain 2006), while the location would not fulfil the conventional definitions of either of these terms. As Clapp (2004, 846) notes, 'The Great Bear Rainforest' of BC is wilderness in that it is a 'landscape hospitable to species excluded from modern industrial human settlements'.

Nature-based tourism (such as bear-viewing) covers a wide range of experiences and activities and, while it is difficult to generalise, it is typically about purchasing *experiences* rather than *things*, with particular emphasis on photographic tourism (Lemelin 2006). The market for nature-based tourism is increasing faster than traditional tourism, at rates of 10–30 per cent per annum (Mehmetoglu 2006). In some countries, notably Costa Rica, it has become the leading foreign exchange earner (Reynolds and Braithwaite 2001). Current nature tourism demands are centred on North America and Europe (Wight 2001), with the greatest number of nature tourists coming from the USA, the UK and Germany (Eagles and Higgins 1998). As Saarinen (2006) notes, nature-based tourism (as a subset of ecotourism) is based on the concept of sustainable development, which, while 'problematic, ideologically and politically', still provides a platform on which different stakeholders in tourism can interact, negotiate and reflect on their actions' consequences for the environment.

In BC, bear-viewing is centred on the North and Central Coasts of the province, which fall within the Humid Maritime and Highland Ecodivision (Demarchi 2004), an area of temperate climate and high rainfall, especially in the winter months. It is a rugged, largely mountainous region typified by steep terrain, long fjords and glaciated valleys. The landscape is extensively covered by old-growth forest (>250 years old) and it contains the world's largest tracts of intact

temperate rainforest (Coast Information Team 2004). Most importantly for grizzly (brown) bears (*Ursus arctos* Linn 1758), its rivers support major populations of six species of salmon: chinook (*Oncorhynchus tshawytscha* Walbaum 1792); chum (*O keta* Walbaum 1792); coho (*O kisutch* Walbaum 1792); pink (*O gorbuscha* Walbaum 1792); sockeye (*O nerka* Walbaum 1792); and steelhead (*O mykiss* Walbaum 1792) (Wood 2000). This landscape is, however, simultaneously an industrial centre and a 'wilderness' (Clapp 2004). There are salmon canneries and pulp mills alongside the old-growth temperate rainforest and alpine meadows.

The changing social and economic value of these 'wilderness' ecosystems have the potential to influence land-planning, resource extraction and conservation decision-making (Swain 2006). The presence of tourists, and their expectations and perceptions, can also affect the conservation value of the landscape through their consumption of specific species. In the following sections we briefly outline the history, characteristics and economics of the bear-viewing industry in North America, before then considering bear-viewing, the tourist gaze and the construction of place.

The Grizzly Bear Viewing Industry: An Overview

The history of managed bear-viewing in North America began with the establishment of McNeil River Game Sanctuary in Coastal Alaska, 1963. Subsequently, driven by considerable public demand, many more areas in North America opened up for bear-viewing (Aumiller and Matt 1994; Fagen and Fagen 1994; Olson and Gilbert 1994). Sites are typically located on salmon streams with high-quality habitat in surrounding areas, allowing for both a high local population of bears and a concentration of their activities at certain times of the year (Aumiller and Matt 1994). Many sites have, or have previously had, conflicting use with recreational fisheries or hunting (Crupi 2005; Tollefson *et al* 2005; Smith 2002; Wilker and Barnes 1998), and similar conflicts are prominent in BC (Parker and Gorter 2003).

The industry is relatively young in BC, being largely non-existent before the mid-1990s; for example, in 2006 most operators had been in the bear-viewing business for an average of 10 years (Swain 2006). With the establishment of the Khutzeymateen Grizzly Bear Sanctuary (KGBS) north of Prince Rupert in 1994, bear-viewing was given a considerable marketing boost and in the following ten years the industry saw marked growth; in 1995 the average operator took out 26 clients per year, a number which had increased to 564 by 2005 (ibid). While the industry as a whole provided approximately 17,000 client-days of bear-viewing in 2005, there were still fewer than 20 operators whose primary business was bear-viewing (ibid). On the whole these are small businesses with the average operator reporting 23.1 person-months per year of employment (equivalent to just under two full-time staff, although, given the seasonal nature of the industry, there are very few full-time posts).

The Economics of Bear Viewing

The land-use planning process in BC emphasises market economic values and largely favours production forestry as the 'base case' scenario (BC Ministry of Sustainable Resource Management 2004). However, the recognition of other non-market values such as biodiversity, recreation and ecosystem services has started to gain a greater role in all levels of planning in BC, from regional down to the watershed level (Swain 2006; Parker and Gorter 2003). We would argue that, when considering land-use planning at a watershed level and its impacts on broad-scale efforts to

preserve biodiversity on the Central and North Coasts of BC, commercial grizzly bear-viewing has the potential to contribute enough fiscal value to offset lost forest production.

Some recent studies (Swain 2006; Parker and Gorter 2003; Smith 2001; van Kooten and Bulte 1999) suggest that bear-viewing could add significant value to the landscape and become an important source of tourist revenue in BC. For example, Smith (based on an extrapolation of Tourism BC data which indicates a 32 per cent growth rate in wilderness tourism in BC from 2001 to 2005) projects that the value of the bear-viewing industry in 2015 would be $16 million and in 2025 $32 million (Smith 2010).

Moreover, bear-viewing is unusual when compared to other wilderness recreation in that it is discretely measurable through the permitting process at a watershed level and is generally a high-value tourism product (Swain 2006). By comparison, coastal tourism is often boat-based or otherwise involves travel over extensive areas using helicopters to support fly-fishing, sea kayaking or back-packing. As these activities are diffuse and spread out over many square kilometres, value per hectare is low when compared to extractive industries such as forestry (for example, the value of logging old-growth forests is around $15,000 per hectare). Similarly, contingent valuation has added non-market values to wilderness landscape that are trivial (less than $100 per hectare) on the watershed scale (Reid *et al* 1995; BC Ministry of Sustainable Resource Management 2003).

In the US, the Alaskan bear-viewing experience indicates a large market for bear-viewing with single sites providing $3 million annual revenues in combined fishing and bear-viewing experiences through an estimated 9000 visitors each year (Tollefson *et al* 2005). For example, the well-known Brooks River in Katmai National Park lists 40 plane operators offering access and more than 10,000 visitors annually (Olson *et al* 1997).

BEAR-VIEWING AND THE TOURISM GAZE

As Urry (2002, 1) notes, tourists are motivated to 'gaze upon or view a set of different scenes, of landscapes or townscapes which are out of the ordinary'. Almost inevitably, this means travelling to increasingly exotic and far-flung locations and such experiences frequently include natural spaces and wild animals (Curtin 2005). Our research suggests that it is the presence of the animal rather than the naturalness of the place which lends the sense of being 'out of the ordinary', as exemplified by historic dump-based bear-viewing in Yellowstone National Park (Haroldson *et al* 2008; Biel 2006). Tourists flocked to observe bears (and protested strongly when this practice was stopped) despite the less than natural setting.

In terms of the perceived (authentic) value of bears and their habitat, there is a good deal of literature pertaining to tourism and authenticity (MacCannell 1973; Wang 1999; Olsen 2002; Mantecón and Huete 2008) and it is beyond the scope of this chapter to review this literature thoroughly. However, Wang (1999, 349) notes how the usefulness and validity of the 'authentic' has been questioned because many tourist motivations or experiences cannot be explained in terms of the conventional concept of authenticity. As Urry (1991, 51) states, the search for authenticity is too simple a foundation for explaining contemporary tourism. Nevertheless, authenticity is relevant to some kinds of tourism, particularly those which involve the representation of the 'Other' or of the past (Wang 1999). We would argue that nature tourism also involves a search for authenticity, but that this is often an 'existential authenticity' rather than the authenticity of objects, animals or landscapes (Wang 1999, 351). Put simply, the emotional experience of the real self does not necessarily coincide with the 'epistemological experience of a real world

out there'. Thus, existential authenticity can often have nothing to do with the issue of 'reality'. Rather, tourists are in search of an experience which is existentially authentic, the authenticity of 'Being' (Wang 1999).

BC has based its international marketing on the concept of wilderness and wildlife. Best known for the 'Super Natural British Columbia' marketing effort in the early 1990s, the official website continues to rely on images of wildlife, outdoor adventure and wilderness as key selling features of the Province. It is reasonable to suggest that a larger portion of tourists are in fact drawn by nature-related motivations and a desire to experience a sense of wilderness. Notions of wildness are, however, inherently subjective (Convery and Dutson 2007). As Saarinen (1998, 30) argues, the memories and feelings of individuals combine with their concrete observations to create the experience of a wilderness. Thus wilderness is 'a state of mind', an experience of 'existential authenticity'. Biel (2006) also questions the line between cultural and natural land-scapes, and suggests that bears (in Yellowstone) fulfil a role as representations of nature (see also Dombrowski 2002). Citing the Leopold Report, which significantly changed National Park Management in the US during the 1960s, she states that American parks were remodelled to look natural, a 'reasonable illusion of primitive America', with signs and traces of management efforts concealed from the public, 'much as scene production is achieved at Disneyland'. This was the advent of the 'wilderness bear' (Biel 2006, 88). It is clear, therefore, that understanding the way that meaning is socially negotiated and contested is necessary for effective landscape management (Williams 2000), and ultimately for constructing 'place'.

The act of viewing bears in their natural setting, interacting with wildlife in close proximity, is a highly important aspect of the tourist experience (Lemelin 2006). Much of what motivates the nature tourist is captured in the concept of sense of place in that the setting of the bear encounter often adds greatly to the perceived value of the experience (Williams *et al* 1992). As Biel (2006) indicates, their meaning and significance far outweighs their simple presence. As we will discuss in the following section, the experience of viewing bears creates sense of place for many tourists, with the bears occupying a pivotal role as place makers and facilitators of existential authenticity.

Bear-viewing in particular tends to attract a subset of dedicated, though poorly studied, wildlife tourists. In the following section we discuss the first attitudinal study of nature-based tourism in BC (completed by one of the authors, Peter Swain, in 2006). The research focused in particular on the motivations of bear-viewers and the sector perspectives of tourism operators.

BC CASE STUDY

The study included all commercial grizzly-bear-viewing operations in the Province; black bear (*U americanus* Pallas 1780) viewing was excluded owing to a lack of dedicated operators. The final research design was influenced heavily by research approaches to cultural tourism (Stanley *et al* 2000), as visitation to special events bore some resemblance to the motivational aspects of speciality bear-viewing.

A total of 236 participants responded to the survey; of these, 33 per cent would have chosen another country or province for their trip had bear-viewing not been available; a further 14 per cent would have chosen another region within the province. Ninety-six per cent of respondents claimed viewing bears was important or very important in deciding to visit British Columbia. Although the high number was initially surprising, it may be a result of advertising. BC has long relied on its natural heritage to 'sell' the province overseas, and animals such as grizzly bears, killer

whales and bald eagles have been prominent in the visual images used in advertising. Furthermore, the opportunities to view wildlife were very important for respondents in terms of selecting a vacation destination. The importance of bear-viewing opportunities to their current vacation destination choice was found to be considerable. Almost all participants had booked their bear-viewing experience before leaving on their vacation. These are clearly tourists specifically motivated by the opportunity to watch bears. In terms of nationality, 55 per cent of the respondents were from the UK, 16 per cent from the US and Canada and 10 per cent from Australia and New Zealand, with other Europeans and Scandinavians making up the remaining 17 per cent. This corresponds reasonably well with other studies of nature tourists (as discussed earlier).

Perhaps unsurprisingly, the research identified that the most important factor for establishing successful bear-viewing operations was reliability of seeing bears; however, with the bear comes the landscape and the sense of place.

The research also included a survey for bear-viewing operators, and findings suggest that, while commercial bear-viewing requires considerable concessions from extractive users (forestry and hunting) in a multi-stakeholder scenario, these may be warranted because of the socio-economic benefits it provides. Furthermore, bear-viewing is also possible in areas of secondary (degraded) forest. Operators were asked to rank a range of impacts on their business on an ordinal ranking scale of one (very positive) to five (very negative). Areas of secondary forest or partial retention forestry (classed as 'visible forestry partial retention cuts'), where loggers select the highest grade trees and leave the rest, were ranked as having a positive impact on business. Logging operations of this sort have less visual impact than more traditional clear fell forestry. From the supply side, this suggests that bear-viewing operators do not object to logging itself, but do require their needs to be considered within broader forest management. It is also likely that operators are using forestry infrastructure, such as roads, for viewing. From the demand side, this also supports the argument that bears create place, as tourists who had viewed bears in secondary forest frequently described the environment as 'pristine' or 'wilderness'.

This finding is based on Swain's BC case study, but is also a product of over ten years of observation and research linked to bear-viewing in BC. Sitting with tourists in a lodge after a day of bear-viewing (in secondary forest), the conversation would usually go something like this:

> Tourist 1: it was amazing to see bears in a true wilderness;
> Researcher: is that how you imagined a wilderness landscape would look?
> Tourist 1: oh yes, but seeing the bears made the whole experience real, it made me think how lucky I was to be in their environment;
> Tourist 2: I've never been to such a wild place, that's how things looked before humans starting trashing the planet;
> Researcher: but what about the (logging) roads we used to drive close to the bears?
> Tourist 1: well that was necessary to get us there, but once we were there and we saw the bears, that was remote, that was wilderness all right.

The researchers found that by sitting at the end of a day and having a beer with tourists (some of whom were survey participants), they were able to gather remarkably candid observations and thoughts. These observations also fit with Biel's (2006) argument that people's ideal image of a bear is less to do with what people actually see and more about a general fuzzy image of what a bear in the wild is supposed to look like and do.

Our research suggests that the characteristics of bear-viewing operations mean that it can be successful in both pristine and modified/managed landscapes. This may be the case even in areas that have been severely compromised by logging, and bear-viewing operations may also play a role in preserving remaining stands of old growth timber. This links well to other research in BC, where a combination of partial retention forestry and tourism has been shown to be an efficient land use option (BC Ministry of Forests 2003). Bear-viewing also adds to an economic argument against clear felling and/or the removal of old growth forest stands.

Conclusions

The case of bear-viewing in British Columbia highlights the gap which often lies between perceived and real 'values' of a landscape. From a social constructionist perspective, the wilderness does not exist without an observer who experiences it (Saarinen 1998). As Biel (2006) memorably puts it, the bear of the imagination wanders a landscape of the mind waiting to enter the landscape of the eye. Understanding the motivation of the traveller can clearly be a powerful tool for accurately assessing the value of the landscape they visit. Tourists 'are in a way semioticians, reading the landscape for signifiers' of place (Urry 2002, 13). In this chapter we have argued that to some extent bears create place; they are the signifiers of wilderness. In terms of landscape perception, the implications are that tourists may view a landscape as authentic and/or pristine as long as landscape signifiers are present. The landscape is thus *authentic* to a tourist even though it may be severely degraded, because the presence of bears signifies wild nature.

The insights gained through detailed study of tourist preferences can inform development of wilderness tourism activities which are sensitive to, and potentially benefit, the ecosystem, and in the process create sense of place. In BC, bear-viewing could add significant economic value to the landscape as it can be successful in both pristine and modified/managed landscapes.

Bibliography and References

Aumiller, L D, and Matt, C A, 1994 Management of McNeil River State Game Sanctuary for Viewing of Brown Bears, *Ursus* 9, 51–61

BC Ministry of Forests, 2003 *Economic Benefits of Managing Forestry and Tourism at Nimmo Bay: a public perception study and economic analysis*, Forests Practices Branch, Victoria, BC

BC Ministry of Sustainable Resource Management, 2003 *Building Blocks for Economic Development and Analysis: Conventional Logging*, BC Ministry of Sustainable Resource Management, Victoria, BC

— 2004 *Resource Analysis Guide for Sustainable Resource Management Planning*, BC Ministry of Sustainable Resource Management, Victoria, BC

Biel, A W, 2006 *Do (Not) Feed the Bears*, University Press of Kansas, Lawrence

Clapp, A, 2004 Wilderness ethics and political ecology: remapping the Great Bear Rainforest, *Political Geography* 23, 839–62

Coast Information Team, 2004 *An Ecosystem Spatial Analysis for Haida Gwaii, Central Coast and North Coast British Columbia*, Coast Information Team, Vancouver, BC

Convery, I, and Dutson, T, 2007 Rural Communities and Landscape Change: A Case Study of Wild Ennerdale, *Journal of Rural and Community Development* 3, 104–18

Crupi, A P, 2005 Brown Bear Research and Human Activity Monitoring at Chilkoot River, 2003–2004, unpublished manuscript, 65

Curtin, S, 2005 Nature, wild animals and tourism: an experiential view, *Journal of Ecotourism* 4, 1–15

Demarchi, D A, 2004 *Ecoregions of British Columbia*, BC Ministry of Environment, Lands and Parks, Crown publications, Victoria, BC

Dombrowski, D A, 2002 Bears, Zoos and Wilderness: The Poverty of Social Constructionism, *Society & Animals* 10, 196–202

Eagles, P F J, and Higgins, B R, 1998 Ecotourism Market and Industry Structure, in *Ecotourism: a Guide for Planners and Managers Vol 2* (eds K Lindberg, M E Wood and D Engeldrum), The Ecotourism Society, North Bennington, Vermont

Fagen, J M, and Fagen, R, 1994 Interactions between Wildlife Viewers and Habituated Brown Bears, 1987–1992, *Natural Areas Journal* 14, 159–64

Haroldson, M A, Schwartz, C C, and Gunther, K A, 2008 From Garbage, Controversy, and Decline to Recovery, *Yellowstone Science* 16, 13–24

Lemelin, R H, 2006 The Gawk, The Glance, and The Gaze: Ocular Consumption and Polar Bear Tourism in Churchill, Manitoba, Canada, *Current Issues in Tourism* 9, 516–34

MacCannell, D, 1973 Staged Authenticity: Arrangements of Social Space in Tourist Settings, *The American Journal of Sociology* 79, 589–603

Mantecón, A, and Huete, R, 2008 The value of authenticity in residential tourism: the decision-maker's point of view, *Tourist Studies* 8, 359–76

Mehmetoglu, M, 2006 Typologising nature-based tourists by activity – theoretical and practical implications, *Tourism Management* 28, 651–60

Olsen, K, 2002 Authenticity as a concept in tourism research: the social organization of the experience of authenticity, *Tourist Studies* 2, 159–82

Olson, T L, and Gilbert, B K, 1994 Variable Impacts of People on Brown Bear Use of an Alaskan River, *Ursus* 9, 97–106

Olson, T L, Gilbert, B K, and Squibb, R C, 1997 The effects of increasing human activity on brown bear use of an Alaskan river, *Biological Conservation* 82, 95–9

Parker, Z, and Gorter, R, 2003 *Crossroads: Economics, Policy and the Future of Grizzly Bears in British Columbia*, Centre for Integral Economics, Victoria, BC

Reid, R, Stone, M, and Whiteley, T, 1995 *Economic Values of Wilderness Preservation*, Canada–British Columbia Partnership Agreement on Forest Resource Development, Victoria, BC

Reynolds, P C, and Braithwaite, D, 2001 Towards a Conceptual Framework for Wildlife Tourism, *Tourism Management* 22, 31–42

Saarinen, J, 1998 *Wilderness, Tourism Development, and Sustainability: Wilderness Attitudes and Place Ethics*, USDA Forest Service Proceedings, RMRS-P-4

— 2006 Traditions of sustainability in tourism studies, *Annals of Tourism Research* 33, 1121–40

Smith, J, 2001 *Bear viewing ecotourism in British Columbia: Economic, and Social Perspectives using a case-study analysis of Knight Inlet Lodge, BC*, Fisheries and Wildlife, Utah State University, Logan, UT, viii and 98

Smith, K J, 2010 *Wanted Alive, Not Dead: The Financial Vale of Thriving Bears*, available from: http://www.mapleleafadventures.com/blog/wanted-alive-not-dead-the-financial-value-of-thriving-bears-in-b-c [5 April 2011]

Smith, T S, 2002 Effects of human activity on brown bear use of the Kulik River, Alaska, *Ursus* 13, 257–67

Stanley, D, Rogers, J, Smeltzer, S, and Perron, L, 2000 Win, Place or Show: Gauging the Economic Success of the Renoir and Barnes Exhibits, *Journal of Cultural Economics* 24, 243–55

Swain, P, 2006 The value of watchable wildlife: measuring the impacts of bear viewing in British Columbia, unpublished MSc thesis, University of Central Lancashire

Tollefson, T N, Matt, C, Meehan, J, and Robbins, C T, 2005 Quantifying spatiotemporal overlap of Alaskan brown bears and people, *Journal of Wildlife Management* 69, 810–17

Urry, J, 1991 The Sociology of Tourism, in *Progress in Tourism, Recreation, and Hospitality Management* (ed C P Cooper), Belhaven, London

— 2002 *The Tourist Gaze*, 2 edn, Sage, London

van Kooten, G C, and Bulte, E H, 1999 How much primary coastal temperate rainforest should society retain? *Canadian Journal of Forest Research* 29, 1879–90

Wang, N, 1999 Rethinking Authenticity in Tourism Experience, *Annals of Tourism Research* 26, 349–70

Wight, P, 2001 Ecotourists: Not a Homogenous Market Segment, in *Encyclopedia of Ecotourism* (ed D B Weaver), CABI International, Edmonton, AB, 37–62

Wilker, G A, and Barnes, V G, 1998 Responses of brown bears to human activities at O'Malley River, Kodiak Island, Alaska, *Ursus* 10, 557–61

Williams, D R, 2000 *Personal and Social Meanings of Wilderness: Constructing and Contesting Places in a Global Village*, USDA Forest Service Proceedings, RMRS-P-14

Williams, D R, Patterson, M E, and Roggenbuck, J W, 1992 Beyond the commodity metaphor: examining emotional and symbolic attachment to place, *Leisure Sciences* 14, 29–46

Wood, A, 2000 *State of Salmon Conservation in the Central Coast Area: Background Paper*, Pacific Fisheries Resource Conservation Council, Vancouver, BC

What's Up? Climate Change and our Relationship with the Hills

Rachel M Dunk, Mary-Ann Smyth and Lisa J Gibson

This chapter examines how people value the upland landscape, and in particular peatlands, in the context of climate change. UK uplands represent an important carbon store, and upland land use has a direct impact on the carbon- and climate-regulating services provided. Trees and plants draw down atmospheric CO_2 which is ultimately stored in soils, while the felling of trees, peat extraction, the draining of bogs and ploughing all result in the release of CO_2 or other greenhouse gases.

The carbon sequestered by upland vegetation has an inherent value (in helping to regulate climate) and an economic value: it is potentially tradable. In order to trade carbon, carbon sources and sinks need to be measured accurately. This requires robust methodologies to quantify carbon stored in the uplands. With these in place, it should be possible to put a cost, or value, on the environment, and thus help to stop the environment from being degraded. The uplands therefore have an important role to play in helping the UK to store its carbon and address climate change. As people become more aware of the upland carbon bank, their relationship with the hills will deepen and new associations between people and place will emerge.

Introduction: The Climate Change Context

Climate change is now seen as the greatest collective challenge facing mankind (Ki-Moon 2009). The Intergovernmental Panel on Climate Change has reported that warming of the climate system is 'unequivocal' – global average temperatures are increasing, sea level is rising, and snow and ice are melting at an alarming rate. Furthermore, most of the warming that has occurred since c.1950–60 is 'very likely' to be due to anthropogenic (man-made) greenhouse gas (GHG) emissions (IPCC 2007). Put simply, adding GHGs to the atmosphere enhances the greenhouse effect and results in global warming.

Carbon dioxide (CO_2), which is mainly produced by burning fossil fuels, is the major anthropogenic GHG. Others include methane (CH_4), nitrous oxide (N_2O), and refrigerant or propellant gases such as hydrofluorocarbons (HFCs) and perfluorocarbons (PFCs). Not all GHGs are equal – some are more potent than others. To account for this, GHG emissions are expressed as CO_2 equivalents (CO_2e) – the mass of GHG emitted multiplied by its global warming potential (GWP – a measure of warming effect relative to CO_2). Table 23.1 gives the dominant anthropogenic sources of CO_2, CH_4 and N_2O, their GWPs, and the contribution each has made to the enhanced greenhouse effect.

Table 23.1. Anthropogenic sources of CO_2, CH_4 and N_2O, their global warming potentials (GWPs) and contribution to the enhanced greenhouse effect.

Greenhouse gas	Anthropogenic sources	GWP	Contribution to enhanced greenhouse effect
Carbon dioxide (CO_2)	Fossil fuel extraction and burning Cement production LUC (land use change)	1	55%
Methane (CH_4)	Fossil fuel extraction and burning Biomass burning Ruminant livestock Rice agriculture Landfills & waste treatment	21	16%
Nitrous oxide (N_2O)	Agriculture Fossil fuel burning and industrial processes Biomass and biofuel burning	310	5%

Source: GWPs (100-year time horizon) are from IPCC (1995) and are those used in the Kyoto Protocol. The contribution to the enhanced greenhouse effect is the additional radiative forcing due to each GHG expressed as a percentage of that due to all anthropogenic GHGs (IPCC 2007).

If we continue on a 'business as usual' basis we could see an increase in the global average temperature of c.4°C by 2100, bringing major changes to weather patterns and an increased frequency and intensity of extreme weather events such as hurricanes, heavy rainfall and heat waves (IPCC 2007; Met Office 2009). Such a large and fast change in climate is dangerous and will have severe and costly impacts (Stern 2007). Hundreds of millions of people will face water shortages, while others face flooding; our ability to produce food will decrease significantly and around a third of all species may become extinct (IPCC 2007).

There is a growing consensus that to avoid the worst effects of climate change we need to limit the global temperature rise to no more than 2°C (UNFCCC 2010). As a result, we will see an increasing regulatory requirement to reduce emissions – everyone will have to play their part in the drive to be a more resource-efficient, low-carbon society if we are to avoid catastrophic interference with the climate system.

THE TERRESTRIAL CARBON CYCLE, HUMAN ACTIVITIES AND CLIMATE

The global carbon cycle, the climate system and human activities are inherently linked. Firstly, the extraction and burning of coal, oil and gas adds fossil carbon (carbon stored on geologically long timescales) to the atmosphere – predominantly as CO_2 but also as CH_4 – thereby enhancing the greenhouse effect. Secondly, land use change (LUC) and agriculture alters the surface cover of the Earth (by, for example, replacing forests with cropland), perturbs the carbon cycle and results in GHG emissions.

Although not the focus of this chapter, LUC also impacts climate by changing the reflectivity (albedo) of the Earth's surface, which in turn determines how much of the sun's energy is reflected back to space. While the overall effect of changes to the Earth's albedo has been cooling (a light, flat desert is more reflective than a dark, multi-layered forest canopy), this is far outweighed by the warming effect of GHG emissions from LUC and agriculture (IPCC 2007).

In the carbon cycle, CO_2 is drawn down from the atmosphere during photosynthesis and stored in plant materials. When these materials are broken down the carbon is released back into the atmosphere as CO_2 (oxidation or aerobic respiration) or CH_4 (anaerobic respiration). In the pre-anthropogenic world, the uptake and release of carbon were in balance (IPCC 2007). However, in our modern era, human activities have had a marked impact. The conversion of carbon-rich environments such as forests and wetlands to agriculture has decreased the amount of carbon stored in plants and soils and increased the amount in the atmosphere, thereby exerting a warming effect on climate (IPCC 2007). LUC and agriculture are also the major sources of anthropogenic CH_4 and N_2O (IPCC 2007). Both are released during biomass burning. Rice paddies and ruminant animals (eg cattle and sheep) are major sources of CH_4 and the application of manures and inorganic nitrogen fertilisers to agricultural soils releases N_2O. Thus, as the global population continues to rise, and with it the demand for food and biofuels, it is imperative that we give serious attention to mitigating agricultural emissions of GHGs and maximising the carbon storage benefits offered by our landscape.

This chapter focuses on the UK uplands, the areas above the enclosed fields that are not used for intensive farming, and examines the value of the climate-regulating services provided by the upland landscape with a particular focus on carbon storage in peatlands.

PLACING A VALUE ON OUR HILLS

The upland landscape holds both intrinsic and extrinsic (or instrumental) value. The intrinsic value is the value that it has 'in itself' (in existing), while the instrumental value is the value placed on the uplands in relation to human interests and preferences (Nordstrom 1993; Maguire and Justus 2008).

While the intrinsic value of a landscape is an important concept, with roots in Aldo Leopold's ecocentric view of nature, it is also somewhat abstract and thus difficult to define or engage with. Nordstrom (1993) suggested that intrinsic value can play a more prominent role in landscape evaluation (and thus management) if it is approximated in human terms. For example, identification of the intrinsic cultural value of the upland landscape – the sense of place and the role of humans in defining the meaning of place – could be used to develop an ethic for preserving the uplands (Nordstrom 1993). In practice, the consideration of intrinsic value by itself may fail to provide an effective basis for conservation activities, particularly when conflicts arise between economic development and the protection of ecosystems (Maguire and Justus 2008). In such cases, a broad view of instrumental value which allows us to place a comparative value on the benefits received from the landscape may provide a more tangible foundation on which to base land management practices and conservation efforts (Maguire and Justus 2008).

If you asked a hundred people how they 'value' the uplands you would probably receive a hundred different answers that reflect a complex mixture of cultural heritage and the benefits each individual enjoys from their connection with the landscape, such as aesthetics, employment, recreation, physical health and spiritual well-being. Nevertheless, it is economic value that has long held sway in our modern consumer society, where the realisable value of our land has resided in the resources it can provide. Thus the dominant wealth of a forest is in the timber which can be felled for fuel or fibre, peats are a source of fuel, and cropland or pasture is often of greater value than forests or wetlands to those dependent on the land for their livelihood. This places much of our landscape at risk of over-exploitation and degradation and fails to take into

account the full instrumental value of the 'ecosystem services' provided, which include not only the provision of resources, but also regulating, cultural and supporting services (MEA 2005).

While the importance of ecosystem services has now been widely recognised, placing an economic value on many of these services remains problematic (de Groot *et al* 2010). However, as climate change has climbed the political and social agenda we have seen the concurrent development of the carbon markets – carbon is now a tradable commodity. An economic value can be (and has been) placed on the climate-regulating services, and more specifically the carbon-regulating services, provided by our landscape. This new approach values ecosystems and land management practices that maximise carbon storage by increasing carbon sinks or by avoiding practices which emit GHGs.

Our uplands are an important carbon store, and upland land use has a direct impact on the carbon- and climate-regulating services provided. Trees and plants draw down atmospheric CO_2 which is ultimately stored in soils, while felling trees, draining bogs, peat extraction (and burning) and ploughing (among other practices) result in the release of CO_2 or other GHGs. The development of a land-based carbon market thus provides the opportunity to align environmental best practice with economic development in upland areas, where maximising the production of saleable carbon credits would mean both conserving remaining upland habitats and restoring degraded habitat. While the value of the outcome will be perceived in different ways depending on the stance of an individual stakeholder, a general agreement on the positive nature of the process seems possible (Nijnik *et al* 2008).

CARBON IN THE HILLS

The amount of carbon stored in the hills depends on the ecosystem type and how the land is used (see Table 23.2). Within the UK, the majority of carbon is stored in soils rather than vegetation, and over half of the soil carbon is in the uplands of the north and west. Indeed, peats and peaty soils are the single largest carbon store, with the majority being in the Scottish uplands. Around 4.5 billion tonnes of carbon are stored in Scotland's peats: more than in all the forests of the UK and France combined (Smith *et al* 2007). The uplands therefore have an important role to play in helping the UK to store its carbon and address climate change.

Table 23.2. Indicative carbon storage and fluxes for a range of land use types.

Land Use	Vegetation (tC/ha)	Soil (tC/ha)	Sink (-) or Source (+) (tC/ha.yr)
Heath and bog	2	260	- 0.2
Arable	1	43	+ 0.1
Grassland	1	60–80	- 0.2
Old broadleaf wood	200	65	- 4
Commercial forest 30-year rotation drain/ plant/grow/harvest	100 (at maximum)	Variable, c75	- 6 (during growing – emits during clearfell and planting)

Source: Data compiled from Ostle *et al* 2009 (S275,277) and Read *et al* 2009.

Why Peatlands are Good at Banking Carbon

A peatland is an area with a layer of naturally accumulated peat (soil comprising at least 30 per cent organic matter) of at least 0.3m thickness (excluding the plant layer) (VCS 2010). Biomass in peatlands is produced faster than it is broken down due to anaerobic conditions in the water-logged soils, which limit microbial activity and decomposition. Any ecosystem where vegetative growth is more active than decomposition will store carbon and this commonly occurs when soil development is periodically 'arrested' – in salt marshes, flooded woods, wetlands, swamps, deltas and tundra (the repeated drowning of horsetail fern forests by the sea stored carbon in what we now call coal seams). Peat formation is a slow process in which carbon is accumulated and stored over thousands of years. While pristine peatlands store carbon, peat drainage releases carbon as the soils become aerobic, organic matter is broken down and CO_2 is emitted. Conversely, restoring drained peats allows more carbon to be stored, and also benefits flood control and biodiversity.

Carbon and Greenhouse Gas Fluxes in an Upland Peat

The carbon budget of an upland peat involves the flow of carbon between different reservoirs by various pathways and in a number of different forms (Fig 23.1).

Inputs of carbon to the peatland are:

- Uptake of atmospheric CO_2 during primary production (photosynthesis minus plant respiration)
- Dust and rainfall delivering dissolved organic carbon (DOC) and dissolved inorganic carbon (DIC)
- Weathering of the underlying rocks delivering DIC

Outputs of carbon from the peatland are:

- Aerobic microbial respiration of organic matter in the shallow soil, releasing CO_2 to the atmosphere
- Anaerobic microbial respiration in the deeper water-saturated soil, releasing CH_4 to the atmosphere
- River outputs of dissolved gases, DIC, DOC and particulate organic carbon (POC), where some of this carbon is returned to the atmosphere.

By examining all the flows into and out of a reservoir, we can determine the net change in carbon storage over time. The accumulation of carbon in a peatland is given by the sum of all inputs to the peatland less the sum of all outputs. Around one quarter of the carbon taken up by a peatland is stored in the peat, with (for example) moors in the Pennines taking up 0.2 to 0.9 tC/ha/yr (Fig 23.1a; Worrall *et al* 2009a). Similarly, the change in atmospheric GHG concentrations (due to peatland carbon fluxes) is given by the sum of all inputs to the atmosphere less all outputs (expressed in terms of CO_2e). A healthy peatland is a net source of GHGs, as some of the carbon is respired under anaerobic conditions and returned to the atmosphere as CH_4 (Fig 23.1b).

The area of the flux arrows has been scaled in proportion to the mid-range values presented by Worrall *et al* (2009a). DIC is considered relative to the expected equilibrium concentration,

a: Fluxes of C

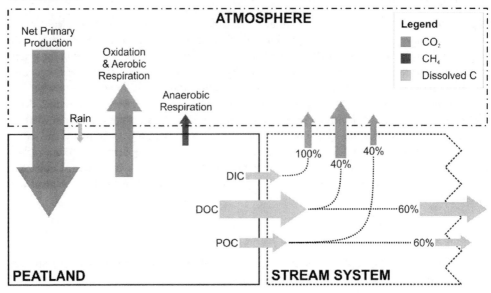

b: Fluxes of CO₂e

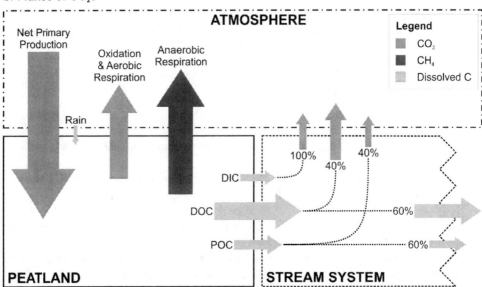

FIG 23.1. THE FLOW OF CARBON THROUGH UPLAND PEAT EXPRESSED AS (A) THE RELATIVE AMOUNT OF CARBON AND (B) THE RELATIVE AMOUNT OF CO_2E.

where it is assumed that rainwater is in equilibrium with the atmosphere (zero flux), and that 100 per cent of the riverine DIC is returned to the atmosphere (Worrall *et al* 2009a). While the ultimate fate of riverine DOC and POC is uncertain, it is assumed that 40 per cent of these fluxes are returned to the atmosphere as CO_2 (Worrall *et al* 2010).

CARBON EMISSIONS FROM DEGRADED PEATLAND

Peatlands release carbon if they are drained, mined, exposed, over-grazed or over-burnt. While draining peatlands to convert them to agriculture can decrease natural emissions of CH_4, this small benefit is outweighed by the consequent release of CO_2 and N_2O (Kasimir-Klemedtsson *et al* 1997).

As peats dry out (owing to climatic conditions or drainage) the soil becomes aerobic, carbon is released through oxidation and increased soil respiration, and loose fragments of peat get blown or washed away in storms. Drained peatlands emit carbon at a rate of c.2–4tC/ha/yr (an order of magnitude faster than the rate at which a pristine peat stores carbon) and shrink fast, with c.4mm of peat lost every year for each 0.1m of drainage depth (Couwenberg *et al* 2010). There are also indications that carbon loss is greater from peats that fluctuate between wet and dry states (Freeman *et al* 2004; Limpens *et al* 2008). Organic chemicals that suppress respiration can build up in saturated peats (Freeman *et al* 2004). When a peat dries, these chemicals are lost and, subsequently, when the peat is rewetted, degradation rates are initially higher (ibid). Keeping peat saturated is therefore important to maintain carbon storage, and permanently rewetting peat (by blocking drains) is the best way to stop peat from disappearing.

Exposed areas of peat are vulnerable to erosion, with carbon washed out into water courses. Heavy rainfall events after long dry spells result in loss of DOC and POC, and bog bursts may occur. At a recent experts' workshop, participants concluded that damage from tracks and construction should be minimised, and industrial peat extraction should be phased out, where re-vegetating exposed areas (ideally using sphagnum) is the best way to prevent further peat loss (Smyth *et al* 2010).

Moorland burning releases plant and soil carbon to the atmosphere. Cool burning (where the plant layer, but not the peat, is burned for management purposes) may result in faster recycling of soil carbon (through stimulating faster vegetative growth). At present, wildfires are a problem in the southern moorlands of England, but less so in the wetter uplands of northern and western Scotland. In the future, the northern moors may experience the desiccation and erosion problems presently affecting the south, and southern management methods may become useful to northern moors (Smyth *et al* 2010).

PEATY WATER IN RIVERS: FLOODING AND CARBON LOSS

The UK climate is already getting warmer, with drier summers, wetter winters (particularly in the western uplands), and more winter rainfall delivered in heavy downfall events (Jenkins *et al* 2008). The rain water is also less acidic than it used to be (because of improvements in pollution control) and the peat is often drier (because of drainage and warm dry summers). Consequently, the upland flood mitigation, carbon storage and water quality services are all impacted. Where peats have a decreased capacity to retain water, winter storms wash out more carbon, and the high loading of POC and DOC can discolour river water (Worrall *et al* 2004; Yallop and

Clutterbuck 2009). Indeed, water companies in northern Europe and America are now facing increasing costs associated with removing the brown colour from peaty water. Thus catchment scale peatland conservation and rewetting projects provide opportunities for land managers to work cooperatively to improve water quality at the same time as storing carbon and mitigating against flooding (CRC 2010; NE 2010).

CARBON OFFSETS: A NEW WAY TO MAKE MONEY IN THE HILLS?

Carbon offsetting involves a GHG emitter purchasing 'credits' produced by projects that have avoided emissions or sequestered GHGs in another place. For example, European polluters pay for communities in the developing world to develop renewable energy or avoid deforestation. The carbon offset market consists of two components, the compliance market and the voluntary market. The compliance market was established for countries and businesses that have legally binding emission targets, whereas the voluntary market allows those outside the compliance market to offset their emissions. The voluntary market is growing rapidly and can encompass some complex and controversial issues.

If upland managers want to fund peatland restoration and woodland creation projects by generating carbon offsets, then robust methodologies must be developed in order to ensure that only high-quality projects that deliver real carbon benefits are approved and certified. Various groups exist to agree such methodologies. In the voluntary market, one such group is the Voluntary Carbon Standard Association, and their recent consultation document sets out likely acceptable methodologies for measuring reductions in GHG emissions from Peatland Rewetting and Conservation projects (VCS 2010). Possible methods include direct measurement of peat depth, assessment of the carbon fluxes in rivers draining peatlands, the use of proxy measurements such as drainage ditch depth combined with water table depth and using remote sensing techniques such as LIDAR to measure peat topography and gullying or satellites to assess rates of photosynthesis (VCS 2010).

CARBON SEQUESTRATION BY FORESTS

Carbon is stored in forests in aboveground (trunks, leaves, etc) and belowground (roots) biomass, as deadwood, litter and as soil organic matter. The amount of carbon sequestered by forests depends upon tree age, growth rate, local climate, soil quality and management practices. During the growth phase a forest will typically store carbon at a faster rate than peatlands. However, when a tree dies, the stored carbon is ultimately returned to the atmosphere as the organic matter degrades. Thus once a stand of trees reaches maturity, the drawdown of atmospheric CO_2 is balanced by the release of CO_2 as organic matter is degraded and respired – and although the forest remains a carbon store, it is no longer a sink.

The UK Forestry Commission has produced a Woodland Carbon Code, a standard for generating carbon offsets through new woodland creation, and has published sequestration rates for a range of woodland types and management regimes (FC 2010). Figures indicate native woodlands sequester c.150tC/ha over a 100-year period, while commercial forests are somewhat more efficient. The impact on soil carbon must also be considered, where this will reflect both the initial land use and the type of woodland created (IPCC 2003). Broadleaf trees lock carbon into the deep soil via their root systems, whereas trees such as spruce tend to create shallower soils.

Therefore, while converting grassland to conifer plantation can decrease soil carbon, conversion to broadleaf woodland will have little effect, and converting cropland to either will typically increase soil carbon (Ostle *et al* 2009). In all cases, the initial soil disturbance during planting will result in carbon release. Clear felling similarly disturbs soils, causes more rapid decomposition of organic matter, and emits large quantities of carbon.

A particularly dramatic decrease in soil carbon occurs when peatlands are drained and converted to forestry. There is therefore a potential conflict between the need to plant more trees (to temporarily store carbon, and to provide non-fossil fuel and fibre), and the need to conserve peat (a perpetual carbon sink). In principle, an unharvested swamp-forest would provide a good method to sequester carbon, but, in practice, conifer forests are usually harvested, and the ground redrained and replanted – where each cycle causes significant releases of carbon. Thus emerging guidelines for upland carbon conservation identify the safeguarding of peat as the first priority, where peats deeper than 0.3m, areas of sphagnum moss and wetlands should not be afforested (except for swamp trees such as alder); as an excellent rule of thumb, if you have to drain it, do not plant it (Smyth *et al* 2010).

The Voluntary Carbon Standard Peatland Rewetting and Conservation proposal and the Forestry Commission Woodland Carbon Code are the first steps towards generating certified carbon offsets from the UK uplands. This could finance restoration of degraded moorlands and woodlands, such as those in national parks, where Worrall *et al* (2009b) suggest a carbon price of £26 would be sufficient to restore the Peak District's damaged peatlands.

Conclusion

Uplands, and especially peatlands, are an important carbon accumulator and store. Around one quarter of the carbon drawn down from the atmosphere during primary production is stored in peatlands on long timescales. Drained and damaged peatlands shrink, release carbon and contribute to climate change. Carbon is lost from drained peatlands at a rate around ten times faster than the sequestration rate in pristine peats. For carbon management, peat should not be drained or disturbed, and areas previously drained should be rewetted. Similarly, regenerating permanent forests on non-peaty soils is a good way to draw down and store atmospheric carbon.

This chapter has indicated the important role UK uplands have to play in addressing climate change, both environmentally and economically, with their ability to absorb, store and emit carbon. We recognise that carbon storage is only one of many ecosystem services provided by the uplands and that monetary values will capture only part of the true value of an ecosystem (de Groot *et al* 2010). Nonetheless, the development of a land-based carbon market has the potential to finance improved peatland restoration and more afforestation in the UK uplands, thereby also satisfying a diverse range of other uses, needs and desires. Carbon trading could therefore deliver a pragmatic alignment between economic and subjective value systems, enabling us to maintain and develop our sense of place as we conserve and restore our upland landscape.

Bibliography and References

Commission for Rural Communities, 2010 *High ground, high potential – a future for England's upland communities*, Commission for Rural Communities, Cheltenham

Couwenberg, J, Dommain, R, and Joosten, H, 2010 Greenhouse gas fluxes from tropical peatlands in southeast Asia, *Global Change Biology* 16, 1715–32

de Groot, R S, Alkemade, R, Braat, L, Hein, L, and Willemen, L, 2010 Challenges in integrating the concept of ecosystem services and values in landscape planning, management and decision making, *Ecological Complexity* 7, 260–72

Forestry Commission, 2010 *Woodland Carbon Code pilot v1*, 12.08.10

Freeman, C, Ostle, N J, Fenner, N, and Kang, H, 2004 A regulatory role for phenol oxidase during decomposition in peatlands, *Soil Biology and Biochemistry* 36, 1663–7

Intergovernmental Panel on Climate Change, 1995 *IPCC Second Assessment Climate Change 1995*, a report of the Intergovernmental Panel on Climate Change, Cambridge University Press, Cambridge

— 2003 *Good Practice Guidance for Land Use, Land-Use Change and Forestry*, available from: http://www.ipcc-nggip.iges.or.jp/public/gpglulucf/gpglulucf.html [7 June 2011]

— 2007 Climate Change 2007: Synthesis Report 2007, Cambridge University Press, Cambridge

Jenkins, G J, Perry, M C, and Prior, M J, 2008 *The climate of the United Kingdom and recent trends*, Met Office Hadley Centre, Exeter

Kasimir-Klemedtsson, A, Klemedtsson, L, Bergelund, K, Martikained, P, Silvola, J, and Ocenema, O, 1997 Greenhouse gas emissions from farmed organic soils: a review, *Soil Use and Management* 13, 245–50

Ki-Moon, B, 2009 Remarks at 39th plenary assembly of the World Federation of United Nations Associations, lecture by the UN Secretary General Ban Ki-Moon, *World Federation of United Nations Associations*, 10 August, Seoul, Republic of Korea

Limpens, J, Berendse, F, Blodau, C, Canadell, J G, Freeman, C, Holden, J, Roulet, N, Rydin, H, and Schaepman-Strub, G, 2008 Peatlands and the carbon cycle: from local processes to global implications – a synthesis, *Biogeosciences Discussions* 5, 1379–419

Maguire, L A, and Justus, J, 2008 Why intrinsic value is a poor basis for conservation decisions, *BioScience* 58, 910–11

Met Office, 2009 *Science – Driving Our Response to Climate Change: Informing Mitigation*, Met Office, Exeter, available from: http://webarchive.nationalarchives.gov.uk/+/http://www.metoffice.gov.uk/climatechange/policymakers/policy/informing-mitigation.pdf [7 June 2011]

Millennium Ecosystem Assessment, 2005 *Ecosystems and Human Well-being: current state and trends* (eds R Hassan, R Scholes and N Ash), Island Press, Washington, Covelo, London

Natural England, 2010 *England's peatlands – carbon storage and greenhouse gases*, available from: http://naturalengland.etraderstores.com/NaturalEnglandShop/NE257 [7 June 2011]

Nijnik, M, Zahvoyska, L, Nijnik, A, and Ode, A, 2008 Public evaluation of landscape content and change: several examples from Europe, *Land Use Policy* 26, 77–86

Nordstrom, K F, 1993 Intrinsic Value and Landscape Evaluation, *Geographical Review* 83, 473–6

Ostle, N J, Levy, P E, Evans, C D, and Smith, P, 2009 UK Land Use and Soil Carbon Sequestration, *Land Use Policy* 26S, S274–S283

Read, D J, Freer-Smith, P H, Morison, J I L, Hanley, N, West, C C, and Snowdon, P (eds), 2009

Combating climate change – a role for UK forests. An assessment of the potential of the UK's trees and woodlands to mitigate and adapt to climate change. The synthesis report, The Stationery Office, Edinburgh

Reed, M S, Bonn, A, Slee, W, Behany-Borg, N, Birch, J, Brown, I, Burt, T P, Chapman, D, Chapman, P J, Clay, G D, Cornell, S J, Fraser, E D G, Glass, J H, Holden, J, Hodgson, J A, Hubacek, K, Irvine, B, Jin, N, Kirkby, M J, Kunin, W E, Moore, O, Moseley, D, Prell, C, Price, M F, Quinn, C H, Redpath, S, Reid, C, Stagl, S, Stringer, L C, Termansen, M, Thorp, S, Towers, W, and Worrall, F, 2009 The Future of the Uplands, *Land Use Policy* 26S, S204–S216

Smith, P, Smith, J U, Flynn, H, Killham, K, Rangel-Castro, I, Foereid, B, Aitkenhead, M, Chapman, S, Towers, W, Bell, J, Lumsdon, D, Milne, R, Thomson, A, Simmons, I, Skiba, U, Reynolds, B, Evans, C, Frogbrook, Z, Bradley, I, Whitmore, A, and Falloon, P, 2007 *ECOSSE: Estimating Carbon in Organic Soils – Sequestration and Emissions*, Final Report, SEERAD, Edinburgh

Smyth, M A, Marrs, R, and Cox, C, 2010 Carbon Budgets in the Uplands, paper presented at a workshop for the Southern Uplands Partnership, Heather Trust and Crichton Carbon Centre conference: *Carbon in the Uplands*, 20–21 April, Moffat

Stern, N H, 2007 *The Economics of Climate Change: The Stern Review*, Cambridge University Press, Cambridge

United Nations Framework Convention on Climate Change (UNFCCC), 2010 *Report of the Conference of the Parties on its fifteenth session, held in Copenhagen from 7 to 19 December 2009: Addendum: Part Two: Action taken by the Conference of the Parties at its fifteenth session*, FCCC/CP/2009/11/Add.1, available from: http://unfccc.int/resource/docs/2009/cop15/eng/11a01.pdf [7 June 2011]

Voluntary Carbon Standard, 2010 *VCS Consultation Document: Proposal for inclusion of peatland rewetting and conservsation (PRC) under the VCS Agriculture, Forestry and Other Land Use (AFOLU) program*, 19 May

Worrall, F, Burt, T, and Adamson, J, 2004 Can climate change explain increases in DOC flux from upland peat catchments? *Science of the Total Environment* 326, 95–112

Worrall, F, Burt, T P, Rowson, J G, Warburton, J, and Adamson, J K, 2009a The multi-annual carbon budget of a peat-covered catchment, *Science of the Total Environment* 407, 4084–94

Worrall, F, Evans, M G, Bonn, A, Reed, M S, Chapman, D, and Holden, J, 2009b Can carbon offsetting pay for upland ecological restoration? *Science of the Total Environment* 408, 26–36

Worrall, F, Bell, M J, and Bhogal, A, 2010 Assessing the probability of carbon and greenhouse gas benefit from the management of peat soils, *Science of the Total Environment* 408, 2657–66

Yallop, A R, and Clutterbuck, B, 2009 Land management as a factor controlling dissolved organic carbon release from upland peat soils 1: Spatial variation in DOC productivity, *Science of the Total Environment* 407, 3803–13

Nature Conservation, Rural Development and Ecotourism in Central Mozambique: Which Space do Local Communities Get?

STEFAAN DONDEYNE, RANDI KAARHUS AND GAIA ALLISON

SENSE OF NATURE

Central Mozambique is endowed with rich natural resources and harbours a great diversity of unique plant and animal species. It forms the southern end of the great African rift valley, which runs north–south through East Africa from Mozambique up to the Red Sea. Gorongosa National Park and the Chimanimani Transfrontier Conservation Area are the two major conservation areas in this setting (Fig 24.1). Centred on the rift valley, Gorongosa National Park (about 4000km²) consists mainly of plains with savannahs, swamps and woodlands. The Chimanimani Transfrontier Conservation Area (2500km²) is a rugged terrain of mountains along the border with Zimbabwe. Vegetation varies from lowland rainforest and woodlands to montane forest and afro-alpine meadows. Nature in these areas has very different meaning to diverse categories of people, however.

In *The anthropology of space and place*, Low and Lawrence-Zúñiga (2003, 13) refer to how people 'form meaningful relationships with the locales they occupy'. Making a distinction between 'space' and 'place', they describe how people attach meaning to space, and thus 'transform "space" into "place"'. In our context, such meaning can be expressed in terms of local people's relationships with ancestors, which are mediated through ceremonies at specific sites in the landscape, and through relationships to particular 'spiritual' animals who occupy a particular space. But local people's 'special' spaces may also become formally 'protected areas', and thus hold different meanings as 'spaces' and 'places' for conservationists, tourists and potential investors.

Established in colonial times, Gorongosa National Park was initially a hunting reserve for administrators and their guests; in 1960 it was turned into a national park as the area had become popular for game-viewing. At that time it attracted the interest of conservationists for its flood plains, which supported large numbers of wildlife (Tinley 1977). The park is also of interest to national and international tour operators, particularly now that tourism in Mozambique is picking up. In Tsiquiri, 7km outside the park, we found people infuriated because they had been prohibited from exploiting gold in their area. To them the conservation area is an impediment to development (Dondeyne *et al* 2009). Other people are frustrated at having been evicted from the park, and hence dispossessed of land, forest and wildlife for their livelihoods. In a video clip showing interaction between staff of the Gorongosa National Park and inhabitants of the Nhanguo community, a man summarises his frustration with the park:

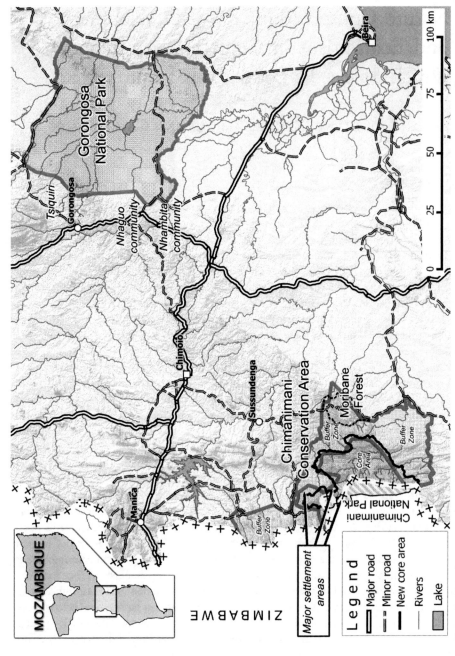

Fig 24.1. Location of Gorongosa National Park and Chimanimani Transfrontier Conservation Area in central Mozambique and new proposed boundaries of the core zone of Chimanimani, leaving out settlement areas.

The government told us to move from the park into a new area. Even if we join the two communities, there will still be confusion. The only one who can resolve the confusion is the government. You removed us, but the park is ours. We're getting nothing from the park. All we get is confusion.[1]

In contrast to their attitude to Gorongosa, the Portuguese colonial authorities showed little interest in nature conservation in the Chimanimani area. As the area is adjacent to the Chimanimani National Park in Zimbabwe, it was well known and much praised by 'Rhodesian' ecologists (eg Phipps and Goodier 1962) for the endemic flora. When the area was established as a conservation area in the 1990s, the envisaged strategy was to integrate conservation efforts and ecotourism development with local people's livelihoods.

In central Mozambique, traditional leaders play a pivotal role in the relationship between people and place by mediating between the material and the spirit world (Virtanen 2005a; Convery 2006). Mount Banya in Chimanimani, for example, is a sacred place of paramount importance for rainmaking ceremonies. The chief whose ancestors bring rain is viewed as the 'rightful authority', and drinking ceremonies validate the position of chiefs as both social deans and land managers (MacGonagle 2002). Setting out what characterises local land tenure in Chimanimani, Bell (2000, 7) states:

(i) land and its resources are believed to be owned by the spirits, usually ancestral;
(ii) the stewardship of a particular area is entrusted by the spirits to a 'mambo', the local chief, usually translated as Régulo;[2]
(iii) the *mambo* delegates control over land, resources and people in most of his area to sub-chiefs.

Sacred sites may be as varied as springs, pools, the confluence of rivers, burial sites (mostly in forests) or landmarks such as rocks and mountains. As people believe that land is 'owned' by the ancestors, the importance of ceremonial sites for mediating relationships with spirits can be readily understood. Indeed, a forest, which to an ecologist or a tourist would appear to be 'pure nature', may to local people actually be a 'cultural site'.

HISTORICAL PERSPECTIVE

In Mozambique, as in other African countries, the colonial approach to conservation was based on the then dominant 'preservationist' model, later labelled 'fortress conservation' because of the insistence on keeping local people out of the protected areas (Adams and Hulme 2001). At that time, Gorongosa National Park was an important tourist attraction on a par with national parks such as the Kruger in South Africa and the Serengeti in Tanzania. When Mozambique gained independence from Portugal in 1975, Gorongosa National Park was intact as a conservation

1 *Paradise lost … and found*, video produced by The Pulitzer Center on Crisis Reporting and Azimuth Media, reported by Stephanie Hanes, edited by Stephen Sapienza – available from: http://gorongosa.net/videogallery/all/paradise_lost_found [18 October 2010].

2 *Régulo* is a Portuguese word commonly used in Mozambique, designating local chiefs but literally meaning 'small or junior king', or 'king of a small state, or minor territory'.

area. Then, in the period from 1976/77 to 1992, the whole country was seriously affected by an armed conflict between the FRELIMO[3] government and RENAMO.[4] As the Park ended up functioning as a stronghold for RENAMO troops, wildlife was decimated and the tourism infrastructure was mostly destroyed (Hatton *et al* 2001). Currently, the US-based Carr Foundation, in partnership with the Mozambican government, is making major efforts to restore the park.

Africa's Lost Eden, an award-winning documentary from National Geographic, documented this restoration project. As the title suggests, the film evokes the beauty of a wild Africa and the efforts required to restore this 'lost Eden'. For conservationists, as well as for tourists, the restoration of wildlife is highly meaningful in terms of increasing biological diversity. Adams and McShane (1992) argued that westerners invented a 'mythical Africa', a place of vast open spaces, of virgin land unsullied by human hands and so important that people in Europe and North America organised a movement to save it. The conservation project of Gorongosa can be seen to be inscribed in such a movement.

Although the idea to give a formal 'protected area' status to the Mozambican part of the Chimanimani dates back to the 1970s (Dutton and Dutton 1973), the project was realised only after the peace instauration of 1992 as one of three 'Transfrontier Conservation Areas' in Mozambique.[5] Transfrontier Conservation Areas gained considerable international interest among conservationists during the 1990s as multiple land-use projects (Virtanen 2005b). By connecting protected areas that straddle several countries, such conservation areas would have the potential to conserve a greater diversity of species and habitats. Moreover, it was believed that the co-management of natural resources along geopolitical boundaries would contribute to the peaceful resolution of interstate conflicts and promote regional economic development and integration (Whande and Suich 2009). Over the last decade, research on land reform policy and nature conservation initiatives in Africa has expanded our knowledge on the multiple relationships between local people and their environment (Hulme and Murphree 2001; Peters 2009). A subsidiary theme in this research-based literature has been the complex links between people and place, and historical shifts in how such links are socially and culturally constructed.

As advisers and researchers we have been involved in rural development and conservation efforts in central Mozambique. Against the backdrop of current policy and legal frameworks, we seek to analyse how conservation and ecotourism projects around Gorongosa National Park and the Chimanimani Transfrontier Conservation Area affect people's relationship with land, investors and the state. The two conservation areas we describe are still off the track of large-scale organised tourism. In a national setting, they both actually served as sanctuaries during civil war. After the 1992 peace accord, the areas have also been considered locations of political opposition to the FRELIMO government.

3 Originally the 'Liberation Front of Mozambique'; after Mozambican independence in 1975, the governing party.
4 The 'National Resistance Movement', formed soon after Mozambican independence.
5 The two others are the Maputo TFCA bordering South Africa and Swaziland; and the Gaza TFCA at the borders with South Africa (and Kruger National Park) and Zimbabwe (with Gonarezhou National Park).

LEGAL AND POLICY FRAMEWORKS

In 1997 the Mozambican parliament passed a new *Land Law* (*Lei de Terras*, N° 19/1997), which has been heralded as the 'best land law in Africa' (DfID 2008). With this law, the legislator aimed at protecting the rights of local people while at the same time creating conditions for investments in land and agricultural development (Tanner 2010). The Land Law (Article 12) states that local communities and individuals can acquire land-use rights through occupancy in accordance with customary norms and practices as long as these do not contradict the Constitution. Though Article 13 explicitly states that absence of a land title shall not prejudice land-use rights, the same article provides for a procedure through which local communities, or individual community members, can get their customary 'land-use and benefit rights' registered.[6] The procedures, defined in a Technical Annex (*Diploma Ministerial* N° 29/2000), involve both men and women identifying the boundaries of the community land during a participatory mapping process. The map is subsequently cross-checked in the field in the presence of representatives of neighbouring communities. Finally, communities receive a land title certifying their customary 'land-use and benefit rights', the DUAT.[7] This land title does not exclude other persons or investors from acquiring land rights but such acquisitions require the consent of 'the community'.

As part of a general decentralisation policy, traditional and local authorities are now recognised by the state through a Governmental Decree (*Decreto 15/2000*). When issued in 2000, this Decree actually reversed the post-independence policy of the FRELIMO government of deposing traditional leaders' role and legitimacy (Kyed 2007). Traditional chiefs had been formally recognised – one may even say constituted – by the colonial power in a formal hierarchy of ranks from *régulo* (chief) at the top to 'chief of group of settlements' (*chefe de grupo de povoações*) and 'chief of settlement' (*chefe de povoação*). The modern state readopted this system. However, from a central-state perspective, the *Decreto 15/2000* primarily concerns the 'articulation' of state authorities with community authorities. Within the communities, chiefs are recognised for their mediation role whenever there are conflicts between community members. Traditionally they also had the authority to allocate land to individuals and families who request access to land, even to authorise strangers to settle within the community area. Given the prominent role of traditional leaders as mediators between people, ancestors and land, they tend to take a prominent role in any land delimitation process, seizing the opportunity to consolidate their authority.

The *Forest and Wildlife Law* (*Lei* N°10/1999) defines nature conservation areas as 'national parks, national reserves and areas of historical-cultural value'. Whereas the first two categories are meant for the protection of 'nature', the latter is meant for sites of cultural, historical or archaeological interest. The *Forest and Wildlife Regulation* (*Decreto 12/2002*) also foresees that 20 per cent of tax revenues obtained from tourism, or from the exploitation of natural resources, will be reverted to the local communities. Although land delimitation is not specified as a requirement, whenever communities had their land rights registered, it has been easier for them to claim and get this share of tax revenues.

6 *Direito de Uso e Aproveitamento da Terra* (in Portuguese) and commonly referred to as DUAT.
7 The land rights of a community, as formalised in a DUAT, are in legal terms equal to the DUAT rights that can be acquired by individuals or private companies through other proper legal and administrative procedures (Calengo and Chidiamassamba 2009, 39).

RURAL DEVELOPMENT AND ECOTOURISM

The PRODER programme[8] took a pioneering role in promoting rural development and natural resource management projects around the Gorongosa National Park. As described by Trusen *et al* (2010), as a first step 'communities' and their land were identified, following the prescriptions in the Technical Annex to the Land Law Regulations. Then, in each of the communities, committees for natural resource management were created, and community members were encouraged to carry out an analysis of their needs and wishes for the future. This analysis served as a basis for planning projects and development activities. Trusen *et al* (2010) indicate that the land delimitation process led to a change in community members' knowledge of their territory, and that it also allowed for a better handling of conflicts, both within and between communities. As communities acquired land titles, local people were informed about the legislation and their land rights. Finally, community representatives managed to get some of their priority projects financed with public funds by participating in local representational bodies created through the government's decentralisation programme. The process hence contributed to defining communities through a process of territorialisation and subsequently integrating communities' actions into a wider development programme of the state.

The delimitation process also established conditions for the development of partnership with private investors. An example is the Nhambita community to the south-west of the Gorongosa National Park (Fig 24.1), which entered into partnership with Envirotrade, a private organisation involved in carbon trading. This partnership aims at contributing to the creation of sustainable livelihoods in the buffer zone of the Park, while at the same time mitigating greenhouse gas emissions. It involves Envirotrade contracting farmers for specified land-use changes contributing to carbon sequestration and then selling the carbon credits on the international voluntary carbon markets (Trusen *et al* 2010).[9]

The philosophy of the Chimanimani Transfrontier Conservation Area project, which is similar to that of the PRODER model, has been to engage the local population in natural resources management, conservation and ecotourism projects. Principles for promoting a community-based approach were elaborated in the first management plan by Bell (2000), and were recently updated by Ghiurghi *et al* (2010). Local communities can benefit from Community Enterprise Funds created to promote ecotourism, or from other projects that contribute to sustainable management of natural resources.

An example, and the first of its kind in Mozambique, is the joint venture between Eco-MICAIA and the local association, Kubatana Moribane,[10] for setting up a tourist lodge in the

8 The German-funded PRODER programme (mid-1990s until 2006) has been instrumental in promoting community-based natural resources management approaches in Sofala province, particularly around the Gorongosa National Park; while the Danish-funded GERENA programme, which started in 2005, is still giving support to similar initiatives in the province.

9 The revenues are shared between the investor (66.6%) and the community (33.3%). In 2008, 1223 farmers participated in this scheme and 1740ha were reforested. Farmers received US $150,000 for their environmental service, while an additional US $28,000 was invested in a Community Development Fund. In the same year, the community received US $3500 from the Gorongosa National Park as their 20% share of the revenues obtained from tourism in the park.

10 'Cooperation of Moribane' in the Ndau language.

Moribane forest.[11] Moribane forest (Fig 24.1) is part of the southern-most tropical rainforest in Africa and still hosts elephants; it may become a tourist attraction in the Chimanimani Transfrontier Conservation Area. In an early analysis of community-based natural resource management in this area, Schafer and Bell (2002) describe a series of conflicts, problems and dilemmas. One of them had to do with elephants. Local people had earlier observed taboos on the hunting of elephants (Schafer and Bell 2002, 406). But during the civil war, while many people took refuge in Zimbabwe or in localities under government control, others remained and moved further into the forest (ibid, 407), and RENAMO established a stronghold in the area. By the end of the war, in 1992, the forest was largely intact, but the elephant population was reduced. Soon, however, local people – especially more recent in-migrants – expressed concerns about the recovering elephant population (ibid, 413). Chief Mpunga, however, argued that the elephant problem was 'spiritual'. In the end, people moved out of the area preferred by the elephants. When community members were to choose a name for the new tourist lodge in Moribane forest, they chose *Ndzou*, meaning 'elephant' in the Ndau language. They surely realised that elephants appeal to tourists, but it is also a statement about their cultural ties with elephants. It also illustrates how ecotourism projects may not only integrate local communities into the wider economic networks but also contribute to a rearticulation of cultural symbols and people's relationship with land and 'nature'.

When analysing the initial phase of the community-based conservation project in Moribane forest, Schafer and Bell (2002) argued that such projects can be used by the state to extend its reach and strengthen its power-base in rural areas, rather than as a means of 'devolving' control over natural resources to local communities. While their analysis was no doubt valid at the time, it is now interesting to observe shifts in power relations and changing constellations of local places' integration into wider national and global networks. Rodary (2009) has argued that community-based natural resource management projects can actually serve as a means for connecting local people and their 'places' into the global world. This is, in fact, also an aspiration of the Chimanimani Transfrontier Conservation Area project, when involving local communities in ecotourism projects.

CONSERVATION AND COMMUNITY LAND

The delimitation process of community land around Gorongosa National Park sparked a debate on community rights in and around conservation areas. While the land law is clear in stating that communities cannot claim rights to *use* land within national parks or reserves, the park administration objected to mapping the boundaries of their ancestral land within the park; proponents argued that it would be important to acknowledge local people's historical and cultural bonds (Allison 2006). Under such circumstances eviction from the park not only implies dispossession of land but also of cultural ties with the land. In 1965, when the boundaries of Gorongosa National Park were adjusted, the community of Matchungire, located around the current park headquarters at Chitengo, was transferred and resettled south of Gorongosa. As no new land

[11] The community's share in this joint venture is set at 60% of the total investment. It consists of time and effort spent by the partners, as well as in the provision of land, and the financial contribution provided through the Community Enterprise Fund established through the Chimanimani project. The remaining 40% of the investment is raised by Eco-MICAIA (Kingman 2010).

was allocated to Régulo Matchungire, he was not only dispossessed of his land, but also of his power as Régulo. Matchungire therefore threatens to return with his community to his ancestral land inside the park (Zolho 2005). We would argue that extending the delimitation process to include areas *within* the park could have contributed to a genuine recognition of these areas as both protected area *and* as part of the community's traditional land and history.

In the Chimanimani Transfrontier Conservation Area delimitation of community land was carried out inside the protected area, and this has proven helpful both for handling conflicts and in creating partnerships between communities and private investors to promote ecotourism. Still, some of the settlements within the National Reserve in the Chimanimani were perceived as a 'problem' by both government staff and conservation-project staff in the area. This issue was, however, 'resolved' in the most recent management plan by adjusting the boundaries of the Reserve and leaving the two major settlements outside the boundaries of the Reserve's core area (Fig 24.1).

In terms of conservation success, the approach taken by the administration of the Gorongosa National Park has been more effective than the 'inclusive model' taken in the Chimanimani Transfrontier Conservation Area. Wildlife population in the Gorongosa is growing steadily – though with major financial efforts – while in Chimanimani Transfrontier Conservation Area wildlife populations are at best stable, and at a low density. Though a participatory approach may have been less successful in attaining conservation objectives, our examples show that this approach has other merits, such as giving space to local people for linking their economic development ambitions with the global networks of the conservation project.

WHICH SPACE DO 'THE COMMUNITIES' GET?

The Mozambican policy and legal framework is, at least in theory, conducive to community-based natural resources management projects, including nature conservation and ecotourism. Still, various authors have reported on difficulties in implementing community-based natural resources management projects owing to bureaucratic obstacles or the reluctance of government officials to implement new policies (Mustalahti 2006; Castigo and Doerfler 2007). There are examples of lengthy procedures for communities to get their 20 per cent of the tax revenues and stalled land delimitation processes (Calengo and Chidiamassamba 2009; Trusen *et al* 2010). Such difficulties have been attributed to the organisational culture of a highly centralised government system, to a history of war and conflict, and to a legacy of bureaucratic distrust in the initiatives and capacities of local people.

Analysing an early 'community land' mapping process in central Mozambique, Hughes (2001, 759) suggests that, during this process, the 'polity' of the local chief was 'territorialised' and transformed into a 'geographical community of place'. Based on our experiences (2006–2009), we would say that the delimitation process serves as a process of self-identification through which a 'community' establishes its identity in terms of a territory. As the process institutionalises locally legitimate boundaries, 'space' is transformed into a meaningful 'place' as *community land*. The identity of the land-holding community is thus redefined through the establishment of mutual, meaningful and institutionalised links between 'community land' and the 'community' of local people. At the same time, links between the self-defined community and the state are being established through the participation of government staff in the delimitation process. Ultimately, this relationship gets formalised through the attribution of a land title to the community and

also through the attribution of the 20 per cent of tax revenues to the community. Constructive renegotiation of these relationships seems crucial in the context of post-conflict economic and social restructuring.

CONCLUSIONS

Traditionally, peoples of central Mozambique define their identity through lineages, which also include the ancestral spirits whom they associate with natural spaces, such as sacred forests, rivers, rocks and mountains. The Mozambican Land Law, in an innovative attempt to reconcile 'customary laws' with modern state organisation, opens an avenue for local people to defining themselves as a 'rural community'. Traditional chiefs can seize such a process as an opportunity for reinforcing their authority and for legitimising their role as mediators with the state in relation to land and people. Relationships between local people and state are further altered in this process as local communities enter a process of self-identification through 'territorialisation' and, reciprocally, are recognised and defined by both state agents and outsiders. While facilitating the integration of local people into the state, this process also opens opportunities for economic activities linked to the 'global economy'. Such processes can lead to a better integration of rural citizens into the structures and services of a developing state. In central Mozambique, it is also important that this integration may further contribute to reconciliation. As in other post-civil war situations, the state organisation still needs to further reconstruct its relationship with rural people.

The conservation, ecotourism and natural resources management projects we describe here show that such projects are intertwined with cultural, social and political processes at the local level. Though the 'back to barriers' conservation strategy followed in Gorongosa National Park, with reference to measurable indicators, is more successful in terms of biodiversity and habitat conservation objectives than the inclusive and participatory approach taken in the Chimanimani Transfrontier Conservation Area, the former carries the risk of not only marginalising local people but also subduing their sense of place and attachment to ancestral land. If 'fortress conservation' is deemed necessary – for the protection of specific areas or vulnerable species – it seems essential to implement such conservation in conjunction with community-based development activities, which the Carr Foundation is also indeed promoting. It should also be followed by real efforts towards mutual and participatory – though often conflictive – negotiation of different interests. No less important is the communication between different stakeholders about diverse meanings in relation to the 'same space' as a special place of particular value for different and diverse categories of people.

ACKNOWLEDGMENTS

For their kind collaboration in Gorongosa we would like to thank: Baldeu Chande, Roberto Zolho, Jean-Paul Vermeulen, Richard Beilfuss and Yvonne Doerfler; and in Chimanimani: Ana Paula Reis, Cândida Lucas, Milagre Nuvunga, Andrew Kingman, Andrea Ghiurghi and James Bannerman.

Bibliography and References

Adams, J S, and McShane, T O, 1992 *The myth of wild Africa: conservation without illusion*, University of California Press, Berkeley, CA

Adams, W, and Hulme, D, 2001 Conservation and community: changing narratives, policies and practices in African conservation, in *African wildlife and livelihoods: the promise and performance of community conservation* (eds D Hulme and M Murphree), Currey, Oxford, 9–23

Allison, G, 2006 *Síntese do encontro para uniformizar abordagens de zoneamento na zona tampão do PNG, Hotel Moçambique*, GERENA programme & Direcção Provincial para a Coordenação da Acção Ambiental, Beira

Bell, R H V, 2000 *Management plan for the proposed Nakaedo Biosphere Reserve Chimanimani Transfrontier Conservation Area*, National Directorate of Forests and Wildlife, Maputo

Calengo, A J, and Chidiamassamba, C, 2009 *Estudo sobre o processo das delimitações de terras comunitárias em Cabo-Delgado, Manica e Gaza*, Consultancy report prepared for Iniciativa para Terras Comunitárias, Chimoio

Castigo, P, and Doerfler, Y, 2007 *A união faz a força: experiências de maneio comunitário dos recursos naturais*, Centre for Sustainable Development of Natural Resources, Ministry for the Coordination of Environmental Action, Chimoio

Convery, I, 2006 Lifescapes and governance: the régulo system in central Mozambique, *Review of African Political Economy* 109, 449–66

DfID, 2008 *Mozambique: the best land law in Africa? Case study 1, Maputo: Department for International Development*, available from: http://webarchive.nationalarchives.gov.uk/ [31 May 2010]

Dondeyne, S, Ndunguru, E, Rafael, P, and Bannerman, J, 2009 Artisanal mining in central Mozambique: policy and environmental issues of concern, *Resources Policy* 34, 45–50

Dutton, T P, and Dutton, E A R, 1973 *Reconhecimento preliminar das montanhas de Chimanimani e zonas adjacentes com vista à criação duma área de conservação*, Direcção dos Serviços Veterinária, Repartição Técnica da Fauna, Lourenço Marques (Maputo)

Ghiurghi, A, Dondeyne, S, and Bannerman, J, 2010 *Chimanimani national reserve: management plan*, Agriconsulting SpA, Roma, Italy and Ministry of Tourism, Maputo (4 volumes)

Hatton, J, Couto, M, and Oglethorpe, J, 2001 *Biodiversity and War: A Case Study of Mozambique*, Biodiversity Support Program, Washington, DC

Hughes, D M, 2001 Cadastral Politics: the making of community-based resource management in Zimbabwe and Mozambique, *Development and Change* 32, 741–68

Hulme, D, and Murphree, M (eds), 2001 *African wildlife and livelihoods: the promise and performance of community conservation*, Currey, Oxford

Kingman, A, 2010 Joint venture ecotourism business in Mozambique, in *Alternatives to land acquisitions: agricultural investment and collaborative business models* (eds L Cotula and R Leonard), IIED/SDC/IFAD/CTV, London/Bern/Rome/Maputo, 41–51, available from: www.ifad.org/pub/land/alternatives.pdf [25 May 2011]

Kyed, H M, 2007 State Recognition of Traditional Authority: Authority, Citizenship and State Formation in Rural Post-War Mozambique, PhD Dissertation, Roskilde University Centre

Low, S M, and Lawrence-Zúñiga, D, 2003 Locating Culture, in *The anthropology of space and place* (eds S M Low and D Lawrence-Zúñiga), Blackwell, Oxford

MacGonagle, E, 2002 A mixed pot: history and identity in the Ndau region of Mozambique and Zimbabwe 1500–1900, PhD dissertation, Michigan State University

Mustalahti, I, 2006 How to handle the stick: positive processes and crucial barriers of participatory forest management, *Forests, Trees and Livelihoods* 16, 151–65

Peters, P, 2009 Challenges in Land Tenure and Land Reform in Africa: Anthropological Contributions, *World Development* 37 (8), 1317–25

Phipps, J B, and Goodier, R, 1962 A preliminary account of the plant ecology of the Chimanimani mountains, *The Journal of Ecology* 50 (2), 291–319

Rodary, E, 2009 Mobilizing for nature in southern African community-based conservation policies, or the death of the local, *Biodiversity and Conservation* 18, 2585–600

Schafer, J, and Bell, R, 2002 The State and Community-based Natural Resource Management: the Case of the Moribane Forest Reserve, Mozambique, *Journal of Southern African Studies* 28 (2), 401–20

Tanner, C, 2010 Land rights and enclosures: implementing the Mozambican land law in practice, in *The struggle over land in Africa: conflicts, politics & change* (eds W Anseeuw and C Alden), HSRC Press, Cape Town, 105–30

Tinley, K L, 1977 Framework of the Gorongosa Ecosystem, PhD Thesis, Faculty of Science, University of Pretoria, South Africa

Trusen, C, Calengo, A, and Rafael, B, 2010 *A study of the development and implementation of strategies for sustainable local land management based on practical experiences in Mozambique and Brazil. Part 1: Mozambique*, Work of Division 45, Agriculture, Fisheries and Food, GTZ, Eschborn

Virtanen, P, 2005a Land of the ancestors: semiotics, history and space in Chimanimani, Mozambique, *Social & Cultural Geography* 6 (3), 357–78

— 2005b Community-based natural resource management in Mozambique: a critical review of the concept's applicability at local level, *Sustainable Development* 13, 1–12

Whande, W, and Suich, H, 2009 Transfrontier conservation initiatives in Southern Africa: observations from the Great Limpopo Transfrontier Conservation Area, in *Evolution and Innovation in wildlife conservation: parks and game ranches to Transfrontier Conservation Areas* (eds H Suich and B Child with A Spenceley), Earthscan, London, 373–91

Zolho, R, 2005 Effect of fire frequency on the regeneration of miombo woodland in Nhambita, Mozambique, MSc dissertation, University of Edinburgh, available from: http://www.geos.ed.ac.uk/miombo/Documents.html [21 October 2010]

Rainforests, Place and Palm Oil in Sabah, Borneo

Ellie Lindsay, Andrew Ramsey, Ian Convery
and Eunice Simmons

Introduction

The conservation of tropical ecosystems is complex and contested, not least in terms of cultural and political perspectives between developed and developing nations (Bawa and Seidler 1998; Colchester 2000; Brosius and Hitchner 2010). In Sabah, on the island of Borneo, East Malaysia, much of the forest has recently been converted to oil palm plantations. The plantations cover vast areas and leave relatively little space for native flora and fauna. While efforts are underway to enhance biodiversity within the plantations, there is no clear consensus as to how this might best be achieved and this has led in part to divisions opening up among stakeholders (Othman and Ameer 2010). A range of non-governmental organisations (NGOs) working within Sabah endeavour to conserve threatened biodiversity; at the governmental level there are significant drivers for development and economic stability; while the plantation owners are trying to improve their yields and increase their global market. There is also considerable consumer pressure from Europe and North America linked to concerns about the survival of iconic rainforest species such as orangutans. These same economies, however, are consumers of plantation products. This chapter will consider these aspects within a context of globalisation and profound economic and social change within Malaysia. Aspects and theories of sense of place will be explored in this rapidly changing environment.

Borneo Development

As Teo and Huang (1996, 310) indicate, place is an 'active setting which is inextricably linked to the lives and activities of its inhabitants'. Place is also about situated social dynamics and is multi-dimensional, holding different meanings for different stakeholders. Thus rapid conversion of land from primary rainforest to oil palm plantation has not only changed the ecology of the area but has influenced the way that the land is governed, leading to conflict and unrest. In particular, where the rights of local people have allegedly been ignored there have been reoccupations of land and violent protests, which have led to allegations of the unwarranted arrest, abduction and killing of protesters (Gerber 2010; Wakker 2005).

Borneo, the world's third largest island, includes three separate countries. The Malaysian states of Sabah and Sarawak occupy most of the northern quarter of the island, whereas the southern parts of the island are dominated by the four Kalimantan provinces belonging to Indonesia. The Sultanate of Brunei is located centrally on the northern coast of the island, occupying less than 1 per cent of the territory. Malaysia has undergone an economic revolution since 1970,

with poverty rates falling from 49 per cent to less than 5 per cent in 2007. This has largely been based upon development of manufacturing in peninsular Malaysia and the growth of agricultural exports (such as palm oil and rubber) in East Malaysia (UNDP 2007a). Despite this, there is significant rural poverty associated with the reliance on agriculture in Sarawak and Sabah. As such, economic development in these regions is likely to be based on agricultural reform and the further exploitation of natural resources, which almost inevitably leads to environmental degradation and impacts on native fauna and flora. For example, declines of up to 75 per cent have been reported for both bird and butterfly species richness (Peh *et al* 2005).

The oil palm (*Elaeis guineensis*) is central to contemporary economic development in Malaysia. It is native to West Africa and was introduced to the then-British colony of Malaya in the early 1870s. In 1917 the first commercial planting took place at the Tennamaran Estate in Selangor with seeds sourced from Indonesia. This initial plantation laid the foundation for subsequent oil palm plantations and development of a palm oil industry in Malaysia which can be divided into several phases, beginning with the experimental phase from the late 1800s until 1916 (Rasiah 2006). The colonial private estates and plantation phase commenced in 1917 and lasted until 1960 (three years after Malaya became an independent nation in 1957). The third phase started in the 1960s in response to the government of Malaysia's diversification policy to reduce the national economy's dependence on rubber. Following a recommendation of a World Bank mission in 1955, the government started promoting the planting of oil palm. As such this political driver began to profoundly and rapidly change the natural features of the environment. According to Harvey (2001), people's identity and sense of place are constructed through their environment and their experiences within it. In a single generation there has been such rapid change that the cultural associations with the landscape may have contributed to one of the greatest shifts in sense of place within living memory. The dominant ecosystem before the drive to plant oil palm was natural tropical rainforest. While it was used by the local people, it retained a local distinctive character based on some of the most diverse forest on the planet. In contrast, the very worst palm oil plantations are monocultures covering hundreds of hectares. While the land is still covered primarily in trees, the ecosystem shift is so extreme that it is hard to imagine that any of the former drivers of sense of place could continue to exist. The gross topography may have changed little, but the loss of so much of the vegetation in such a short timeframe could only undermine the cultural and spiritual values associated with it.

Agnew (1987) describes the meaning of both location and locale of place, where location refers to the actual location of the place and the locale refers to characteristics that make it what it is. Through the removal of people from the lands that they traditionally inhabited, combined with a wholesale change in that environment, many people in Sabah have lost a sense of place on both these measures. Cultural identities strongly linked to natural systems now have to adjust to this new landscape.

Moreover, oil palm is not going to go away. Biodiesel consumption is estimated to reach 277 million tonnes per year in 2050; this will need an additional 114 million hectares of land to produce the oil crops (Koh 2007, 1373). The Malaysian palm oil industry is now a vital part of the domestic economy, the most widely-used oil in the global edible oils market and the biggest agricultural contributor to the Malaysian economy. Approximately 13 per cent of Malaysia's land mass and 60 per cent of its agricultural land is being used to grow oil palm (Economic Planning Unit 2006). In 2007, the industry's assets were valued at approximately RM 85 billion (US $25 billion) and around 860,000 people were directly or indirectly employed in the industry

(Ministry of Plantation Industries and Commodities 2007). Export earnings for all oil palm products (including palm oil, palm oil cake and oleochemicals) were a record RM 45.1 billion (US $13 billion) in 2007.

METHODS

This chapter is based on fieldwork conducted by the authors in Sabah, Borneo, in 2008. Individual and group semi-structured interviews were used to scope respondent perspectives of current and potential conservation strategies within oil palm plantations. The interviews were conducted from August to November 2008 in Sabah, either at the interviewee's place of work or at a pre-arranged meeting venue. A total of 12 respondents were recruited (via a snowballing approach) to the study, including 2 officials from a government environmental protection department, 5 managers from two oil palm plantations (1 individual interview and 1 group meeting), 1 university ecologist and 4 representatives of NGOs (3 environmental NGOs and 1 community-based NGO concerned with Indigenous rights). These respondents could be loosely termed as conservationists (representatives from the government departments, NGOs and the university academic – B01, B02, B03, B06, B07, B08, B09) and producers (oil palm plantation managers – B04 and group meeting B05). Interviews were analysed using the grounded theory–constant comparison method, where each item is compared with the rest of the data to establish and refine analytical categories (Pope *et al* 2000). Atlas Ti was used for data exploration and storage.

OIL PALM AND DEVELOPMENT IN MALAYSIA

The meaning that different stakeholders within the palm oil industry give to rainforest and oil palm, in effect the 'landscape', includes multiple perspectives based on the economic, social and environmental factors indicated above. Despite concerted efforts by environmentalists to raise awareness of environmental damage, deforestation continues across the tropics (Hansen *et al* 2008). Social, economic and ecological realities surrounding conservation in tropical regions have limited the effect of conservation efforts and forest continues to be cleared. Despite advances in the way that we can include intrinsic values of forests in total economic valuations, too often the benefits of maintaining rainforest are felt globally while the costs are borne locally.

Some local communities and national companies have benefited from high economic returns once natural forest has been cleared and converted to agricultural land. Thus producers have been willing to increase the areas of land under production and governments have often supported this action with the added incentive of subsidies. Economically there are few mature alternatives; there is market demand for these products and they cannot be produced in a sustainable way. Additionally, these products are bought and sold on a global scale and a global consensus towards sustainability rather than just Western concern will be required for broad-scale conservation to be effective. Large expanses of natural rainforest are considered one of the spectacles of the natural world, containing some of the most endangered species on the planet. However, Western ideologies and many conservation strategies can be disharmonious with the values of local communities and large corporations. To a local farmer or any large agricultural business, an area of rainforest is often seen as 'worthless' land that could be clear cut and used for production. To achieve better harmony between conservation and stakeholders, it is necessary to understand the basis of this dichotomy.

In Western Europe, traditional low-intensity agriculture often promotes high levels of diversity, or favours site-specific rare taxa (Robinson and Sutherland 2002, 157). Yet active conservation of biodiversity has often been confined to protected areas, even though they cover as little as 10 per cent of the Earth's surface. Most wild plants and animals live outside protected areas, often in agriculture-dominated landscapes: about 30 per cent of global land surface is occupied by crop and managed pasture land (Wood *et al* 2000). In Sabah, for example, it has been estimated that 60 per cent of the orangutan population lives outside of protected areas; more widely in Borneo it is estimated that 98 per cent of this habitat will be gone by 2022 (Ancrenaz *et al* 2005; Nelleman *et al* 2007). Orangutans may be symbolic of the rainforest to Western eyes, but this loss of forest habitat has a parallel effect on the culture of indigenous people (UNDP 2007b).

It would appear that efforts to conserve biodiversity may provide some opportunity for conservation of culture and sense of place in Sabah. Recent evidence suggests that, compared with intensive farming, wildlife-friendly farming (WFF) has a far less negative impact on biodiversity, including the ecological processes that maintain species and populations (Perfecto and Vandermeer 2002, 174; Naidoo 2004, 93). This has led some to argue for the adoption of WFF in the tropics (McNeely and Scheer 2001; Vandermeer and Perfecto 2007, 274). However, Ghazoul *et al* (2010, 644) believe that WFF is not a feasible long-term strategy because it will come at the expense of agricultural expansion into forests with little or no history of human use. They argue that WFF is not credible under current projections of demand for food, cars and other goods (Chamon *et al* 2008, 243; Koh 2007, 1373; Bruinsma 2003). It is important to explore whether such initiatives can have a positive effect on culture and sense of place and belonging for indigenous people in Sabah. The attitudes towards conservation of those in close proximity to wildlife habitats are strongly linked to the problems associated with wildlife (Newmark *et al* 1993, 177; Newmark *et al* 1994, 249). If biodiversity and native forest are to be effectively protected and if there is to be some retention of the elements that provided the traditional sense of place then it is crucial to have cooperation with the local communities and agricultural managers. It may be possible that by combining the two elements a stronger case for both cultural and biodiversity conservation can be made in a way that also provides benefits for growers. Forest clearance for farmland can, over time, worsen the situation for farmers because it can result in increased soil erosion, landslides, flooding and human–wildlife conflict (Wilk *et al* 2001; Nyhus and Tilson 2004). It is therefore important to ascertain whether growers are willing to make changes to their management techniques for the benefit of wildlife and ultimately their own livelihoods.

PEOPLE AND PLACE IN BORNEO

Between 1970 and 2000, the population of Malaysia more than doubled, from 10.7 million inhabitants to 23.3 million. During the same period, however, the population of Sabah increased four-fold, from 654,000 to 2,656,000. Much of this increase came from migration, both from West Malaysia and from other countries, notably the Philippines and Indonesia (Lim 2005). Approximately 25 per cent of the Sabah population are non-Malaysian, in part owing to the high percentage of immigrant workers on oil palm plantations, who are predominantly Indonesian. The population can be divided into two groups: the sparsely populated, highly tribalised groups of the interior, and the relatively dense agricultural populations along the coast and the lower

flood plains of the major rivers. The inland people (Dayaks) are primarily hunter-gatherers with some shifting cultivation.[1]

As Bell *et al* (2008) note, there is a strong connection between people's knowledge of nature and their relationship to place. 'Lifeworld' (Habermas 1987, 124) is the fabric of everyday life represented by a culturally transmitted and linguistically organised stock of patterns of interpretation, valuation and expression. The lifeworld reaches right into the heart of social reproduction as communication and facilitates what is necessary for social life to exist. Thus, for the Dayak lifeworld, a deep understanding of forest, river and land forms the basis for a 'good' life and linked to this is a sense of connection to place.

It is clear, however, that development is having an effect on Dayak culture. There are an estimated 4 million Dayak left in Borneo (Djuweng 1999, 105). While there was undoubtedly an impact on biodiversity from their shifting agriculture, this was sustainable in the long term. However, increasing demands for oil palm plantation would seem to be a death knell to this way of life. Pressures from recent modernisation and a shift towards Western culture have left a rapidly changing environment where 'modern' standards and consumerism replace the desire for land, forest and river.

> Everybody is still on an ego trip somewhere and there are only very small pockets of [Indigenous] people in very confined locations or isolated individuals that have actually found their way to live their life in a better way with less of this ego. Otherwise we still have a huge marketing and advertising industry that plays with this and fuels the desire every hour of every day. Whether it is the printed media or on TV [it says] do this and then you will satisfy such and such a desire. What are you going to do? Are you going to ban the advertising and marketing industry? Are you going to make an example of all these people? Who is going to feed them? At a philosophical level you can come down and say that these are some of the problems and we can solve them, but is that realistic? (B02)

Sabah has a recent history of large-scale migration, and many residents do not have a history or long association with any part of the island. Ingold (1992; 2000) refers to a being-in-the-world attachment to place and landscape, highlighting that through familiar fields and woodlands, roads and paths, people create a sense of self and belonging. For some residents, the landscape of Sabah is largely agricultural in character because that is all *they* have known, and oil palm represents their day-to-day reality. A conservation respondent (B06) notes that:

> [I've] never known anywhere like Sabah, where people just treat land as a tradable commodity. They don't really have any affiliation to the land compared to the Philippines and Morocco and Central America. Sabah is a bit like one end of the spectrum, there isn't much community or individual affinity and there are people quite happy to sell the land and move if it suits their interests.

Schama (1995, 15) writes of landscapes as tools that 'can be self-consciously designed to express the virtues of a particular political or social community'. As Furlong (2006, 50) notes, this then

[1] The seven main Dayak groups are the Iban (Sea Dayak); the Bidayuh (Land Dayak); the Kayan-Kenyah group; the Maloh; the Barito; the Kelabit-Lun Bawang group; and the Dusun-Kadazan-Murat.

opens spaces for new actors in the landscape by 'obscuring or removing the cultural markings of those that had previously claimed to be of the place'. Indeed, the lack of a felt continuity between people and nature is important in terms of limiting attachment to place (Bell *et al* 2008, 277). In this way the conversion of primary forest through to palm oil makes sense as a process of reshaping the land to suit hegemonic interests.

In Sabah this is true in part, though there are people who have been less willing to give up their land and who have come under pressure to release their assets for development by others. Certainly there has been some conflict over the acquisition of land for conversion into plantation crops, and an emphasis on developing the land for agriculture:

> Actually we didn't want to give up the land, we wanted to keep it like a forest but according to the land ordinance we have to develop it otherwise the government will take back the land. They will penalise, therefore we have to develop the land. (B05)

The drive towards economic regeneration and the insatiable demand for palm oil from the food and chemical industries has meant that many local people feel marginalised on their own land. Jessop *et al* (1993; cited in Furlong 2006, 47) note the disconnection between powerful 'strategic groups', who are able to orientate themselves into the environment they wish to manage, and the concerns of less powerful local people. Limited access to the forests that previously supplied all of the requirements for the Dayak people means that this type of livelihood remains barely possible. The lack of local rights over land ownership is seen as increasingly problematic. A conservation respondent (B07) describing the situation in parts of Malaysian Borneo stated:

> The local communities see it as disturbing, they feel marginalised by all this and this is when conflict happens, especially in an area where that they have been occupying for generations and the government just declare it as sold to other companies. On the Government record the Department of Land State, they put it as state land, owned by the state. On this land there are communities and these communities have been there for a long time … land is given to a company without realising that there are people living there, and this is where conflict comes in.

One aspect of oil palm plantations is the need for large economies of scale that allow for processing within the plantation. This has two impacts on native/local people. Firstly it requires that, wherever oil palm is present, there is the demand for almost wholesale conversion within the area. Secondly, it makes it almost impossible for small-scale growers and marginalised communities to become players in the oil palm industry. As one local academic stated:

> It is good to have land but you need the capital to actually develop the land and if you are a native tribal then no bank is going to give them credit … you have no means of developing the land if you are actually poor. So what is the use of that land to them, this is what they think. (B09)

Therefore it is very difficult for local/native people to become key players in oil palm; instead, they frequently have to accept relatively low-paid and low-skilled work. Thus they lose the resource that is associated with their former way of life and gain little or nothing from the presence of the oil palm. A community worker (B03) summarised this situation by stating that:

We have many communities who are facing a lot of problems as a result of the plantations. They need the forests but when it comes to plantations they don't see that, hence the conflict.

Conversion of land to oil palm often means that there is no alternative other than to work in the oil palm industry for low pay. It would appear that there is a lack of comprehension of the scale of oil palm conversion and a lack of realisation of what selling land actually means for the future of the people.

> [People] will just sell up and think in the same way as before. I mean, these people will migrate, they will move to an area for which they do not have a contract. I don't think they could comprehend what the selling of their land actually meant; [They thought] 'so what, we will live over there', they couldn't comprehend that over there would not exist anymore. (B07)

There are concerns from some in the environmental sector that the oil palm industry needs to be better regulated and controlled in the future. For example, a respondent from the Malaysian Environment Protection Department (B01) notes that:

> Sabah has the largest plantation areas in Malaysia ... having such big plantations areas it converts some of the forest areas into mono crops and Sabah is a place where it is famous with eco-tourism, so expansion in my personal opinion perhaps needs to be controlled because we already have enough ... maybe in the future the level of oil palm has to be controlled otherwise we cannot afford to have Sabah to be all development. We need forest for its tangible for fresh air, for water and for biodiversity.

However, in a sense, the materialistic desires and the subsequent shift away from a subsistence economy in Borneo are but an echo of what has happened in the rest of the world. It is easy to criticise the oil palm plantations, but if it were not oil palm, the suspicion is that is would be other agricultural crops, grazing or unsustainable logging. As a respondent (B06) from an environmental NGO stated regarding the maintenance of traditional rural life:

> There is a big sense of romanticism in this, that if you keep out the oil palm everything will be alright; that is a broad brush approach.

Conclusions

Massey (2002) emphasises place as 'a doing'. However, place-based knowledge is neither static nor bounded (Bell *et al* 2008, 277). It is clear that the rate of change in modern Borneo has been and continues to be dramatic; while conversion to oil palm in Malaysian Borneo has now slowed considerably, in Indonesian provinces it continues apace. It is unlikely that much oil palm will be stripped out for either social or environmental reasons.

Indeed, for many residents of Sabah, oil palm is very much part of their day-to-day reality, part of their connection to place. As Lee (2007, 88) notes, through interactions/interactivity with the land, people shape their surroundings according to intentional patterns of use in the future as well as the past. There is thus a mutually constructive relationship between people and place. What does this mean for the future of Sabah? Perhaps the answers to living with this change

lie within the dialogue between stakeholders. From a biodiversity point of view it is difficult to argue that there is such a thing as a 'wildlife-friendly' oil palm plantation. However, we have witnessed plantations that are striving to minimise their impact on biodiversity by establishing conservation areas that go beyond the spirit and letter of any current sustainability criteria. When compared to Western farming practices, many of the oil palm plantations have undertaken more environmental initiatives in a shorter space of time. In addition, many take a genuine interest in their workers, providing schools for workers' children and striving to improve living and working conditions. The development of a modern society in Malaysia means that the natural ecological balance is changed forever and the people and places have changed with them. While people can adapt and change rapidly, biodiversity cannot. As such there is a desperate need for multidisciplinary studies that encompass the needs of all local people, the economy and the biodiversity, not only of Borneo but of South East Asia as a whole. Only then can sustainable compromises be reached and irreplaceable natural resources be preserved for the future.

BIBLIOGRAPHY AND REFERENCES

Agnew, J, 1987 *Place and politics*, Allen & Unwin, London

Ancrenaz, M, Gimenez, O, Ambu, L, Ancrenaz, K, Andau, P, Goossens, B, Payne, J, Sawang, A, Tuuga, A, and Lackman-Ancrenaz, I, 2005 Aerial surveys give new estimates for Orangutans in Sabah, Malaysia, *PLoS Biology* 3, 0030–37

Bawa, K, and Seidler, R, 1998 Natural Forest Management and Conservation of Biodiversity in Tropical Forests, *Conservation Biology* 12 (1), 46–55

Bell, S, Hampshire, K, and Tonder, M, 2008 Person, Place and Knowledge in the Conservation of the Saimaa Ringed Seal, *Society and Natural Resources* 21, 277–93

Brosius, P, and Hitchner, S, 2010 Cultural Diversity and Conservation, *International Social Science Journal* 61 (199), 141–68

Bruinsma, J (ed), 2003 *World agriculture: towards 2015/2030: an FAO perspective*, Earthscan, London, and FAO, Rome

Chamon, M, Mauro, P, and Okawa, Y, 2008 Mass car ownership in the emerging market giants, *Economic Policy* 23, 243–96

Colchester, M, 2000 Self Determinism of Environmental Determinism for Indigenous Peoples in Tropical Forest Conservation, *Conservation Biology* 14 (5), 1365–7

Djuweng, S, 1999 Dayak Kings among Malay Sultans, *Borneo Research Bulletin* 30, 105–8

Economic Planning Unit, 2006-last update Strengthening agriculture and the agro-based industry, *Ninth Malaysia Plan 2006–2011*, available from: www.epu.jpm.my/rm9/english/Chapter3.pdf [28 August 2009]

Furlong, K, 2006 Unexpected Narratives in Conservation: Discourses of Identity and Place in Sumava National Park, Czech Republic, *Space and Polity* 10, 47–65

Gerber, J, 2010 Conflicts over industrial tree plantations in the South: who, how and why? *Global Environmental Change* 21, 165–76

Ghazoul, J, Koh, L P, and Butler, R A, 2010 A REDD light for wildlife-friendly farming, *Conservation Biology* 24 (3), 644–8

Habermas, J, 1987 *The Theory of Communicative Action: A Critique of Functionalist Reason* (trans T McCarthy), Polity Press, London

Hansen, M C, Stehman, S V, Potapov, P V, Loveland, T R, Townshend, J R G, DeFries, R S, Pittman, K W, Arunarwati, B, Stolle, F, Steininger, M K, Carroll, M, and DiMiceli, C, 2008 Humid Tropical Forest Clearing from 2000 to 2005 Quantified using Multitemporal and Multi-resolution Remotely Sensed Data, *Proceedings of the National Academy of Sciences* 105 (27), 9439–44

Harvey, P M, 2001 Landscape and Commerce: creating contexts for the exercise of power, in *Contested Landscapes: Movement, Exile and Place* (eds B Bender and M Winer), Berg, Oxford, 197–210

Ingold, T, 1992 Culture and the perception of the environment, in *Bush Base, Forest Farm: Culture, Environment and Development* (eds E Croll and D Parkin), Routledge, London, 39–56

— 2000 *The Perception of the Environment: Essays on Livelihood, Dwelling and Skill*, Routledge, London

Jessop, B, Nielsen, K, and Pedersen, O K, 1993 Structural competitiveness and strategic capacities: rethinking state and international capital, in *Institutional Frameworks of Market Economies: Scandinavian and Eastern European Perspectives* (eds J Hausner, B Jessop and K Nielsen), Athenaeum Press, Newcastle Upon Tyne, 23–44

Koh, L P, 2007 Potential habitat and biodiversity losses from intensified biodiesel feedstock production, *Conservation Biology* 21, 1373–5

Koh, L P, and Wilcove, D S, 2008 Is palm oil agriculture really destroying tropical biodiversity? *Conservation Letters* 1 (2), 60–64

Lee, J, 2007 Experiencing landscape: Orkney hill land and farming, *Journal of Rural Studies* 23, 88–100

Lim, G, 2005 Is Sabah truly Malaysia? *Aliran Monthly* 25 (4), available from: http://www.aliran.com/oldsite/monthly/2005a/4g.html [10 June 2010]

McNeely, J A, and Scheer, S J, 2001 *Reconciling Agriculture and Biodiversity: Policy and Research Challenges of 'Ecoagriculture'*, UNDP\IIED

Massey, D, 2002 Globalisation: what does it mean for geography? Keynote lecture presented at the *Geographical Association Annual Conference*, UMIST, April 2002

Ministry of Plantation Industries and Commodities, 2007 *Statistics on Commodities 2006*, 20 edn, MPIC, Putrajaya

Naidoo, R, 2004 Species richness and community composition of songbirds in a tropical forest–agricultural landscape, *Animal Conservation* 7, 93–105

Nellemann, C, Miles, L, Kaltenborn, B P, Virtue, M, and Ahelenius, H, 2007 *The Last Stand of the Orangutan – State of Emergency: Illegal Logging and Palm Oil in Indonesia's National Parks*, Rapid Response assessment for UNEP/UNESCO

Newmark, W D, Leonard, N L, and Sariko, H I, 1993 Conservation Attitudes of Local People Living Adjacent to 5 Protected Areas in Tanzania, *Biological Conservation* 63, 177–83

Newmark, W D, Manyanza, D N, Gamassa, D G M, and Sariko, H I, 1994 The conflict between wildlife and local people living adjacent to protected areas in Tanzania: human density as a predictor, *Conservation Biology* 8, 249–55

Nyhus, P, and Tilson, R, 2004 Agroforestry, elephants, and tigers: balancing conservation theory and practice in human-dominated landscapes of Southeast Asia, *Agriculture, Ecosystems & Environment* 104 (1), 87–97

Othman, R, and Ameer, R, 2010 Environmental disclosures of palm oil plantation companies in Malaysia: a tool for stakeholder engagement, *Corporate Social Responsibility and Environmental Management* 17 (1), 52–62

Peh, K, De Jong, J, Sodhi, N, Lim, S, and Yap, C, 2005 Lowland rainforest avifauna and human disturbance: persistence of primary forest birds in selectively logged forests and mixed-rural habitats of southern Peninsular Malaysia, *Biological Conservation* 123, 489–505

Perfecto, I, and Vandermeer, J, 2002 Quality of agroecological matrix in a tropical montane landscape: ants in coffee plantations in Southern Mexico, *Conservation Biology* 16, 174–82

Pope, C, Ziebland, S, and Mays, N, 2000 Qualitative research in health care: analysing qualitative data, *British Medical Journal* 320, 114–16

Rasiah, R, 2006 Explaining Malaysia's export expansion in oil palm, in *Technology, Adaptation and Exports: how some developing countries got it right* (ed V Chandra), available from: http://siteresources.worldbank.org/INTEXPCOMNET/Resources/Chandra_2006.pdf [16 June 2010]

Robinson, R A, and Sutherland, W J, 2002 Post-war changes in arable farming and biodiversity in Great Britain, *Journal of Applied Ecology* 39, 157–76

Schama, S, 1995 *Landscape and Memory*, Knopf, New York

Sellato, B, 1994 *Nomads of the Borneo Rainforest*, University of Hawaii Press, Honolulu

Teo, P, and Huang, S, 1996 A Sense of Place in Public Housing: A Case Study of Pasir Ris, Singapore, *Habitat International* 20, 307–25

UNDP, 2007a *Malaysia: Measuring and Monitoring Poverty and Inequality*, United Nations Development Programme (UNDP), Malaysia

— 2007b *Human Development Report 2007/2008: Fighting Climate Change: Human Solidarity in a Divided World*, Palgrave MacMillan, New York

Vandermeer, J, and Perfecto, I, 2007 The agricultural matrix and a future paradigm for conservation, *Conservation Biology* 21, 274–7

Wakker, E, 2005 *Greasy Palms: The social and ecological impacts of large scale oil plam plantation development in South East Asia*, Friends of the Earth, available from: http://www.foe.co.uk/resource/reports/greasy_palms_impacts.pdf [13 June 2010]

Wilk, J, Andersson, L, and Plermkamon, V, 2001 Hydrological impacts of forest conversion to agriculture in a large river basin in northeast Thailand, *Hydrological Processes* 15, 2729–48

Wood, S, Sebastian, K, and Scherr, S J, 2000 *Pilot Analysis of Global Ecosystems: Agro-ecosystems*, available from: http://www.ifpri.org/sites/default/files/publications/agroeco.pdf [15 June 2010]

Untying the Rope

Josie Baxter

This short story examines the implicit and invisible nature of the sense of place that belongs only to a rooted 'native'. There is a dawning awareness, expressed in recent books and articles, that not only is a 'way of life' disappearing, and there may be reasons to believe that is a good thing, but that the people who lived that life are disappearing too. With them vanishes a way of knowing, an intimacy with their surroundings, that comes only from long daily immersion in a place and a need, often economic, to read one's surroundings in all their aspects.

They were nearing Walter's home. The road had been rising imperceptibly, each change of direction lifting them another few feet until they reached a saddle of land that still had the power to make his eyes widen.

'Stop a minute,' he said. Martin braked sharply and came to a standstill on the wide verge. He followed Walter's gaze south to the mountains of the Lake District, blurred in the distance, then swivelled in his seat to take in a sweep of the Solway curtained with rain.

'It's a hell of a view,' said Martin. 'Bet you'll miss this.'

'Aye,' Walter nodded, his attention now fixed on the Kershope hills to the north.

'But you're a long way from a pint out here aren't you? Just think, when you're in the new spot you'll be able to bob out to the shops whenever you feel like it.' Walter chose not to respond and, as the silence lengthened, Martin steered the 4x4 onto the road again. It was easy to get lost in the web of lanes; there was nothing to enlighten the casual visitor, an occasional herd sign hanging at a farm gate was all that distinguished one house from another; nobody wanted to be a landmark. There were stories of people driving the roads for hours, trying to deliver a parcel, or searching for a pylon that needed fettling. After passing through the same crossroads four times they'd give up and go away. Shankhill, Sleetbeck, Haggbeck – the names told you all you needed to know.

Walter took in the young man beside him – Martin Elliot, an estate agent, quiet enough now the deal was done. Walter wondered what the lad's granda would have made of him: the way he drove, one hand on the wheel; the immaculate suit that went with the shiny office and the lassies behind the computers, all lipstick smiles. Jimmy Elliot, the grandfather, had been a livestock auctioneer, tweed jacket, brown cotton kitle, hard as nails but knew the business, remembered all the faces, never forgot a name. When this lad's father started in the business they all knew he wouldn't last; he never had Jimmy's knack of creating an atmosphere, couldn't get the crowd on his side, and he'd no head for livestock. Sellers dreaded seeing him at the ringside on sale days and buyers took advantage. There was general relief when he took to selling houses to town folk and left agriculture behind. Martin had followed him into the estate agency; just as well, Walter thought, he didn't look the sort of lad who'd want to spend his time talking up a parcel of rowdy Galloways on a raw morning.

He wondered if he would still go to the auction after he moved into town. He'd already

become one of the lame old gadgers who could barely stagger up the steps before flopping into a knot of cronies, chatting, laughing, sitting a little straighter when a particularly eye-catching beast came into the ring. But could you sit and look at stock with any self-respect when all you had back home was a few square feet of grass and an onion patch?

When they reached Walter's road end and turned up the track Martin seemed to relax. There were already two cars and a Land Rover parked in the yard. The agricultural agents were getting to work. Tomorrow they were selling all the tackle on the farm; then, once the place was cleared, the house and land would be auctioned. Martin came round to open the passenger door, waited until the old man was steady on his feet, then stuck out his hand in an unmistakeable gesture of conclusion.

'It's been a pleasure doing business with you, Mr Jackson. If there's any problems you give us a call.'

'I'll do that.'

I will too, thought Walter, as he watched the younger man fasten his seatbelt. He had seen the way Martin looked at the long trusses of grass rotting in the cracks of the concrete yard, and the gutter that swung from a broken bracket on the lean-to scullery.

It's weary work getting ready for a sale. Walter had helped at a fair few over the years. The big stuff had to be got out from the buildings and lined up in a field where people could get a proper look at things, kick the tyres, and start the engines. The small tools and gear were the worst: hundreds of items to be sided up, put into lots, ranged round the walls inside a building so folk could have a good root through under cover; a sale in October, you can guarantee it'll be pissing with rain. You try to be careful at first, putting like with like, but when another bucket of rusting nuts and washers gets dragged from the back of the workshop and you snag your jacket on another bundle of wire, you don't care any more. Things end up thrown together in heaps and boxes and you just pray someone will be daft enough to stick their hand in the air and pay something for it.

They were finding all sorts in the old stone barn; once the big new building had gone up in the 1970s it had become a dumping place for the stuff that was in the way somewhere else, all the detritus that he'd told himself might be useful for spares and repairs. He felt a sort of shame looking at the tattered remnants of his life as they were carried from the gloom into the daylight: ropes that should have been thrown out years ago, bits of chain that belonged on some long-forgotten implement. Why in God's name had he hung onto this stuff? Was it simply because a barn without an old rope halter, a bent scythe, a toothless hay rake ceased to be a barn?

When he'd built the new loose housing for the cattle he should have unfastened the wooden toggles on the rope neck-ties in the old byre, unhooked the steel rings that slid up and down the stanchions to enable the cows to stand up and lie down; he should have chucked the lot away. But he hadn't, and now he stood looking at them from the ginnel where he'd spent years of his life shovelling shit from behind his cattle. He could still see their breath steam in the winter light and hear the champ and murmur of them when they were fed, feel the warm curves of their bodies as he shoved between them to check the drinkers.

He heard voices and turned to see Scott Nixon, the auctioneer, shaking hands with a man in the yard. The man did that thing with the keys that made his car yelp like a pup and flash its lights. He caught Walter's eye and raised a hand as he drove away. Walter did not know him; when farms were sold now, the houses went to strangers and the packets of land belonging to

them got shed and shared between the people still farming. Those solid boundaries that used to mark you out and measure who you were seemed now to shift continuously.

Two weeks to go until the house and land were sold and there were still people looking over the place: neighbours desperate for a few more acres, eyeing the ooze where the rushes were taking over, totting up how many hours it would take a lad on a digger to put it right; farmers from a few miles away having a nose; and bewildered people from down country, come to see if property was cheap in Cumbria; they'd expected signposts and scenery, now they looked about them, disappointed that there were no mountains or lakes.

Walter had met their sort before. The folk who bought the bungalow at the road end had driven him near mad with their twining. Walter's cattle attracted flies, couldn't he keep them away from the boundary hedge? How come it was legal for tractors to haul silage trailers on the public highway? He'd bided his time, certain that they'd give up and go away once the reality of living here asserted itself. But they'd hung on, grim-faced, unneighbourly, as if they knew he was waiting for them to leave and they weren't going to give him the satisfaction. Now he was the one who was going, and they – the retired people from Chester who'd spent a fortune putting duckboards in the corner of the garden so they could 'enjoy the view' and didn't ever sit there because it was scourged by the westerly, spring, summer and autumn – they would still be there at his road end.

Scott wanted a last walk round with Walter; he was prepared to go at the old man's pace, happy not to talk. He stopped from time to time, made notes, hefted gates, pulled at wire that no longer offered any resistance, squatted to peer into culverts, pushed the ballcocks on the field troughs. Walter saw the place through Scott's eyes, the rusting heck propped in the dyke, the black pool in the bottom of the big meadow and the hump higher up where the blocked field drain was heaving itself to the surface. The ground here was deep and peaty; in wet years he'd had to bring the silage out in half loads or risk sinking the trailers up to their axles.

'This tree's a bit of age,' said Scott, smacking the trunk of a massive ash.

'It is that,' agreed Walter. It was the tree under which his grandfather had found two horses dead from lightning strike just before harvest in 1940. The ash had survived and flourished and Robert Gibson had loaned them a young horse. It did the job but it had reared with fright when the bull roared at it in the yard, and when the lead rope jerked, Walter's grandfather tore a ligament in his shoulder that had never healed right. Walter hadn't thought of it for decades but now he felt eight years old again, remembered his terror when the huge animal skidded on the cobbles as it plunged back to earth, how it sweated and shook as his grandfather, face contorted with pain, quietly took it back to the stable, rubbed its neck, told it not to be so daft. Granda had bought the horse, brought it on, and had to shoot it five years later when it got in a field of green barley and went down with a twisted gut. By then they'd got a tractor and they never owned another horse. But his grandfather had hated the tractor and all the tractors that came after, cursed them for making him feel foolish.

'Must be a strange feeling, Wat, leaving all this?' Scott was watching him.

Walter blinked and left his grandfather in the past. 'No choice, lad. My legs are shot at, if I can't drive I can't stay can I? And I've left it a bit late to find a wife and breed.' He half smiled.

The truth was, something had changed. He couldn't say what, it wasn't just the foot and mouth in 2001, it had begun before that. Men had stopped working until they died, they retired instead. Farmers' sons were different too, they wanted holidays, in Spain. He blamed the Young Farmers' clubs, with their trips and treats: what had skiing got to do with farming? And the

women didn't want to stay at home, they had cars and jobs in town. The last time he'd hay-timed at Gibson's two years ago, Mike had had to put the tea on himself and the cake came out of a cardboard box.

'It's never too late, Wat,' said the auctioneer. They walked on and paused on a breast of land that ran down to the river. It looked like good pasture but somehow stock never liked it, they'd ratch about round the hedges or stand jostling together in a corner till the ground was poached and paddled.

'It's a queer spot this,' said Walter, 'the way it catches the wind, nothing would ever settle.'

Scott pulled up the collar of his waxed jacket against the chill that funnelled up from the water. 'Not sure I'd want to spend much time here myself. Come on, I've seen all I need to now.'

They found the auction men in the stone barn sitting on straw bales, pouring tea from flasks. Walter eased himself down beside them and listened to the banter, the speculation about who'd buy the farm. He kept his eyes on his mug of tea; you could tell who'd heard the story: the way they glanced up, just a flick, no staring, you can cut down the rope, but you can't take out the beam. Walter had walked under it for fifty years, not looking up. When they still made hay they'd lead it into the barn on a trailer; by the sixth load the mow would be drawing level with the beam and whoever was on the stack would have to steady themselves with one hand against the solid bulk of the pitch pine as they leaned down to catch the strings on the bales. He didn't like to touch it, as if there was a stain on his hand afterwards.

As the lads left, with promises to be back early the next day, Walter smiled at their cracks about how much he'd be worth when the farm was sold and how the women in the town would all be after him – he'd be a new man. He knew he should be thinking about the future but he couldn't.

He'd grown up with his Granda's tales of reiving and revenge: the hard borderers who could ride fast through serious country, picking their routes through mires and scrub with a gaggle of snatched cattle. His neighbours, descended from families that had formed alliances and feuds over the centuries, could still turn dour when hungry sheep strayed or shared water supplies ran dry. The ghosts of that violent past had never entirely gone away and the shame of a faithless wife could drive a man to desperation. Walter's father had waited a month to see if she'd return, too proud to go looking for her though he knew where the potato pickers were headed next. Then he'd taken the rope into the barn.

That had been fifty years ago, when Walter was twenty-eight: strong, skilled, a good catch. But who'd want a son-in-law whose mother had run away with the gypsies and whose father had hanged himself from a beam? After that he'd toiled as if work were a drug, unable to sleep at night unless he was bone-tired. With his grandfather he had laid hedges, knocked in fence posts and stretched wire round every field margin. He'd felt the elation of making the top price at the Christmas fatstock sale in Carlisle and relished the cool sweetness of rain on his face after the last load of hay had been stacked. He'd slapped the clegs from his neck as he'd clipped sheep and rolled their warm, oily fleeces. Then a stroke mowed his grandfather down and he was moved from the hospital to an old folk's home in Carlisle. Walter would wheel him into the garden on fine days. It pained him to see the old man lift his chin and search the horizon for a sight of fields, like a bullock scenting for water. After two years' exile he died, and though his cap still hung on the back of the kitchen door the echoes of his presence in the house had grown fainter each year.

Walter put some coal on the Rayburn, ate his supper and noticed that he hadn't turned the

page of the calendar since last month. He went to bed at nine so as to be ready for tomorrow's early start.

Next morning he got himself dressed while it was still dark, took a stick and set out through the empty fields. He was slow, but walking made the pain better, or maybe just helped him forget it. He'd walked this way one night, guided by the tender, unmistakeable sound of a newly calved cow speaking to her calf; he'd found them in the moonlight, in the lee of some Scots pines. His father had planted them as a sheep shelter for the winter. Walter had been a schoolboy – he'd helped shovel back the earth and stamp it firm round the whippy young trees. Strange how he remembered nothing of some years while others seemed to haunt him.

Sometimes, when it was damp and cold like this he could swear he still smelled blood. He couldn't work out of it was real or just a sort of memory from the foot and mouth. After the slaughter they'd taken the carcasses away in the high-sided wagons. What he remembered most clearly about the two days was the silence after they'd all gone, standing in the yard with his dog. The silence. It was the next farm that had the infection, nothing of Walter's tested positive, so they'd not insisted on him tearing every building to bits to disinfect them – he'd been allowed to leave the old barn alone. The big cattle shed where they'd done the killing was washed down and steamed and picked over till it was bleached pale and unrecognisable. And it had stood scoured and empty ever since, fresh cobwebs catching the drifts of summer pollen, mice shredding the wiring.

He'd been desperate to have his own livestock around him again. His neighbours told him not to bother; stock was hard to come by and too dear when you found it. But he could not imagine life without at least a few sheep so he'd persevered, gone to a farm near Kendal to look at some Mules with a lad from the auction who helped him with the licences and paperwork. As the haulier let down the tailgate of the wagon he'd said, 'they're lish', and they'd hurtled down the ramp in a clattering tide of energy that unnerved Walter. They were too fast for his ageing sheepdog and when he needed to shift them between fields they were a torment: not knowing their way to the gates, not anticipating the clockwise outrun of the dog, not responding to the rattle of a feed bag. That first lambing time they seemed susceptible to everything going and when he set out to check on them of a morning he could never find them in the old flock's favourite lambing spots. He'd blunder about, searching for them, only to find them hidden in swampy corners or in the filthy winter scrow under trees, their lambs drenched and cold. The months without livestock had blurred the maps in his head and one evening when it was slippery underfoot he'd fallen badly. It shook him: to fall in his own field where he'd walked the trods for over seventy years, to trip on a rock end that he'd seen every day of his life, how was that possible? It was not the bruises that hurt him so much as the other loss of balance, between himself and his home.

The next step happened almost imperceptibly. Walter knew he couldn't manage the sheep, they seemed wild and unknowable, and he doubted he'd live long enough to breed a new flock that were truly his own. So when the Gibson's lad had come to the back door one evening, sat down at the kitchen table, and asked if Walter would consider agisting the land it seemed sensible to consider it. Sam was a reliable youngster, hard working, a good stockman. Walter agreed terms, sold the sheep with a sense of relief, and settled to a life of watching another man work. But after a year without regular activity his knees stiffened, he became slow and unsteady and he didn't feel safe to drive.

He couldn't pinpoint the moment at which he'd allowed the thought of selling up to enter his mind, only that once he'd done so he became a different sort of man.

In a few weeks he would live in a house next to other houses, on a road that buses went down, where you could hear the shouts of children in the playground two streets away. He would walk to the Spar shop, waiting to cross the road as the traffic thundered north and south, crossing and re-crossing the border.

It was growing lighter. Across the fields he could hear the clang and scrape of gates on concrete and motors in the yard. The folk from the auction were arriving. He went back through the field where the bigger implements, the rolls of fencing wire, kists and troughs, were laid out in rows ready for the buyers; a rackety graveyard. The mist hung in rags above the bleaching autumn grass, no need to flush the pastures now to bring the ewes on for tupping; he couldn't recall when he'd last spread any till.

By the time he got back to the house they were frying bacon in the catering van and a couple of Land Rovers were already bumping across the field they were using for a car park. He'd always enjoyed a sale, the flicker in his guts, the tension and the jokes. He could read the minute nods and glances of the buyers, the tilts and shakes as they withdrew from the bidding. What he didn't know was how much of himself would be left at the last fall of the hammer.

Glossary

Agisting: letting grazing. Differs from tenancy agreement in that payment is per head of livestock for a defined period and the landowner retains responsibility for repair and maintenance of the land.

Bullock: castrated male cattle reared for meat.

Clegs: large biting horseflies which can draw blood.

Dyke: ditch, also used for hedge or wall in some areas.

Fettle: to make right.

Flush the pastures: applying fertiliser in order to get a 'flush' of good nutritious grass to help maximum fertility in ewes before breeding season (see tupping). Also used in relation to livestock: 'to flush the ewes'.

Foot and mouth: a disease of cloven-footed animals. Cumbria suffered a huge outbreak and mass slaughter of sheep and cattle in 2001.

Gadger: codger, bloke, mate.

Galloway: breed of hardy beef cattle.

Granda: grandfather.

Hay rake: a large, long, wooden rake with wooden teeth, used for turning and rowing-up hay.

Hay time: period of several days when grass is cut, turned to dry out and made into hay; also used as a verb, hay-timing.

Heck: hurdle, a portable length of metal or wooden rails that can be linked to others to make pens or used singly as a barrier.

Kist: (old-fashioned) large, lidded chest, wood or metal, used for storing feed.

Kitle: a cotton work jacket.

Laid hedges: method of rejuvenating a hedge; old wood is cut out and strong branches are cut almost through, then bent (laid) diagonally along the length of the hedge, which then re-grows, becoming thicker and more stock-proof.

Lambing time: spring period of six to eight weeks when the flock is producing lambs.

Leading (hay or silage): loading and fetching in from the field.

Lish: lively, energetic.

Mire: bog.

Mow: hay stack.

Mules: cross-bred sheep from Swaledale ewe and Bluefaced Leicester ram. Much sought after to breed lamb for meat. Large and prolific with good-quality fleece.

Outrun of the dog: the first sweep a sheepdog makes when gathering a flock.

Poached: grass worn away to mud or bare earth.

Ratch: fidget, bother.

Rope halter: a sort of rope bridle used to lead horses or cattle.

Scrow: mess.

Till: fertiliser.

Trod: path made by habitual repeated use by livestock or people.

Tupping: putting the ram in with the ewes.

Twining: whining, grumbling.

Contributors

Gaia Allison is a Forester, currently working as a Rural Growth specialist in Tajikistan. She has long-term experience in community-based forestry and natural resources management projects in Asia, South America and Africa. From 2006 until 2009 she was adviser for the Danish-funded GERENA programme in Sofala province in Mozambique.

Josie Baxter farmed in South Cumbria for 26 years. She was a support worker on the Farmers' Health Project (http://www.lancs.ac.uk/fass/ihr/publications/farmershealth.pdf) and for three years was a Research Associate on Lancaster University's study of the health and social consequences of the 2001 foot and mouth epidemic in Cumbria, and a co-author of 'Animal Disease & Human Trauma'. Most recently, she was Project Officer for EFORTT (http://www.lancs.ac.uk/efortt/index.html). She has had a short play aired on Radio Cumbria and is part of a writing collective whose plays have been broadcast on Radio 4.

Amanda Bingley is a Lecturer in Health Research in the Division of Health Research, Faculty of Health and Medicine, Lancaster University. Following doctoral research on the influence of gender on landscape perception, she has focused on the relationship between mental health, well-being and place, including research with older people and the benefits of gardening, the effects of woodland spaces on mental health in young people, and a number of projects in palliative care. She has published in *Social and Culture Geography*, *Social Science and Medicine*, *Palliative Medicine* and in edited collections including as a co-author of *Subjectivities, Knowledges and Feminist Geographies* (Rowman and Little 2002) and in the forthcoming volume *Touching Space, Placing Touch* (Ashgate 2010).

Jared Bowers is a PhD researcher at Newcastle University who has worked and researched in tourism development in several countries around the world. Specific roles have ranged from ecotourism consultant and manager to adventure tour guide. His research interests are in the processes of sustainable tourism development and the management of natural and cultural heritage resources. He received an MSc in Ecotourism from Edinburgh Napier University (UK) and a BA in Communications from Elon University (NC, USA). He is currently working towards his PhD on using ecomuseology principles as a management tool in developing sustainable tourism in the Rupununi region of Guyana.

Penny Bradshaw is a Senior Lecturer in English at the University of Cumbria. She works and publishes primarily within the field of Romanticism and is interested in the work of women Romantic poets, as well as in the legacy of Romanticism within post-Romantic regional literature. She is currently working on a study of literary responses to the Lake District from the Romantic period to the present.

Paul Cammack is Senior Lecturer in Geography at the University of Cumbria, where his research interests include the development of ecotourism and the teaching of geography in primary

schools. For over 20 years he has been an active birdwatcher and has contributed to numerous fieldwork projects and surveys. He is currently a committee member and editor of the annual report for a local bird club, as well as a qualified bird ringer and trainer through the British Trust for Ornithology; his main ringing projects include pied flycatchers, sand martins, woodland birds in winter and urban birds.

Michael Clark is a geographer with an MSc in Urban & Regional Planning and a PhD on 'Planning Processes & Ports'. He is Course Leader for the University of Central Lancashire's BSc (Hons) Environmental Management and Environmental Hazards programmes, where he teaches human geography, environmental management, policy and regulation, auditing and assessment, waste management, hazards, emergency planning and disaster relief, and urban and regional planning. His research interests are in sustainable development, built environment performance, emerging geographies, Environmental Impact Assessment, maritime, estuarine and coastal management, governance and planning and sense of place.

Ian Convery is Reader in Conservation & Forestry in the National School of Forestry, University of Cumbria. His main research interests are related to community resource use and place studies, with a particular focus on conservation, nature and health.

Gerard Corsane is Dean for International Business Development & Student Recruitment in the Faculty of Humanities and Social Sciences at Newcastle University. He is also a Senior Lecturer in Heritage, Museum & Gallery Studies in the International Centre for Cultural & Heritage Studies (ICCHS), School of Arts and Cultures. He teaches across the museum studies, heritage management, interpretation and education modules of the postgraduate programmes in ICCHS. His research interests are in community participation in sustainable heritage tourism, integrated heritage management, ecomuseology and the safeguarding of intangible and tangible cultural heritage expressions and products.

Peter Davis is Professor of Museology at Newcastle University. His research interests include the history of museums; the history of natural history and environmentalism; the interaction between heritage and concepts of place; and ecomuseums. He is the author of several books, including *Museums and the Natural Environment* (1996), *Ecomuseums: a sense of place* (1999; 2nd edition 2011) and (with Christine Jackson) *Sir William Jardine: a life in natural history* (2001).

Stefaan Dondeyne is a post-doctoral fellow at the Catholic University of Leuven, Belgium. His main interests are in ecology, rural development and participatory research in the field of natural resources management. Since 2005 he has been active in Mozambique as an ecologist and environmental adviser.

Philippe Dubé has a PhD in Historical Ethnology and is Professor at Université Laval (Québec, Canada), where he has taught on the Masters diploma programme in museology since its inception in 1988. He also acts as graduate studies supervisor in the fields of conservation and heritage development and is particularly interested in micro-museology. His teaching and research is enhanced by a wide-ranging background in cultural heritage development; a former curator with the Canadian Parks Service and the Musée de Charlevoix, he was also project manager of the permanent MÉMOIRES exhibition at the Musée de la Civilisation in Québec City. He established the Group for Research-Action in Museology at Université Laval (GRAMUL) in 1990 and was a founding member of Forum-UNESCO: University and Heritage, held in Valencia,

Spain, in 1996. He also organised the 2nd International Seminar Forum-UNESCO (Québec City, October 1997). Since 2004, he has directed the *Laboratoire de muséologie et d'ingénierie de la culture*, conducting experimental museology through digital technologies.

Rachel Dunk is Academic Director at the Crichton Carbon Centre, Dumfries. She runs post-graduate and management courses in carbon management, and is a specialist in the role of the oceans in global environmental and climate change, with particular interest in ocean–earth–atmosphere interactions and the impact of fossil fuel CO_2 on ocean geochemistry and ecosystems. She supervises research into a variety of greenhouse gas and climate issues, including biochar, carbon management and behavioural change. She has a PhD in chemical oceanography/geochemistry, and Masters degrees in oceanography (MSc) and chemistry (MChem).

Kenesh Dzhusupov is a physiologist whose research focuses on the physiological impact of living at high altitude in remote rural communities in Kyrgyzstan. Working as a co-researcher in the *Visible Voice* projects, he combines his bioscience experience with social and epidemiological insights to contribute to the participatory, multi-disciplinary approach to research and community development that provides the foundation for *Visible Voice* collaborations.

Lisa Gibson is a research assistant at the Crichton Carbon Centre with an MSc in Carbon Management. As a student, she carried out research on biochar, examining potential feedback streams and uses in Scotland. Currently, her research interests relate to carbon management in rural small and medium-sized enterprises, investigating the drivers and barriers they experience to reduce greenhouse gas emissions.

Helen Graham joined Newcastle University's International Centre for Cultural & Heritage Studies in 2008, working with Rhiannon Mason and Chris Whitehead on the AHRC *Art on Tyneside* project. She is currently co-investigator with Rhiannon Mason and Nigel Nayling (University of Wales, Trinity Saint David) on the AHRC *Partnership and Participation: Copyright and Informed Consent*. Her research interests explore the theory and practice of 'collaboration' and 'participation'. Her current research is concerned with deploying theoretical insights associated with post-social theory for developing understandings of participation, community engagement and inclusion in the contexts of education, museums and heritage sites and social policy. She recently completed a Museum Practice Fellowship at the Smithsonian Institution (November 2010 to January 2011), where she worked collaboratively with people with learning difficulties on a project titled *Museums for Us: Exploring Museums with People with Intellectual Disabilities*.

Christopher Hartworth has a social science doctorate and has been working in research and evaluation for 20 years. He started his career working in developing countries and was involved in poverty alleviation programmes across Africa. In the late 1990s he worked on the evaluations of humanitarian responses to disasters, eg the Rwandan Genocide and Kosovo. In 2000 he returned to the UK and began research and development work with disadvantaged communities in the North East. Most recently he has completed significant work around community safety and criminal justice. He set up and runs Barefoot Research and Evaluation with his wife, Joanne.

Joanne Hartworth has a first-class honours degree in Sociology and a postgraduate teaching qualification. She is a specialist in adult literacy programmes, including ESOL projects, and has managed community literacy programmes in disadvantaged areas in Newcastle. She has designed and led a series of research and evaluation projects, and is an accomplished project manager

and trainer as well as a specialist in qualitative research. She has been working in Newcastle for 20 years and has significant local knowledge, particularly around vulnerable and hard-to-reach groups and associated service delivery agencies.

Stephanie Hawke has recently completed her PhD at Newcastle University's International Centre for Cultural & Heritage Studies. Her research interests relate to sense of place, community engagement and ecomuseology. She has presented her research at several international conferences, including the ICOMOS 16th General Assembly and International Scientific Symposium in 2008 and the SIEF 10th International Congress in 2011. A regular contributor to taught programmes at ICCHS, she received an MA in Heritage Education and Interpretation from Newcastle University in 2002 and currently works in heritage and arts education.

Mark Haywood is a writer on visual culture and a practising artist. In both capacities his work reflects a fascination with the historical factors that have shaped environmental aesthetic values. He was born in Lancashire, completed his doctorate at the Royal College of Art and lived for several years in post-apartheid South Africa as Professor of Fine Art at Rhodes University. He currently lives on the Solway coast and works at the University of Cumbria's Centre for Landscape & Environmental Arts Research.

Jesse Heley is a Research Associate in the Wales Institute of Social and Economic Research, Data and Methods (WISERD) in the Institute of Geography and Earth Sciences at Aberystwyth University. He contributes to the 'Knowing Localities' programme of WISERD, developing new perspectives on understanding the role of locality in contemporary social and economic relations, with a particular focus on Mid and West Wales. His previous doctoral research examined the lifestyles of the 'New Squirearchy' in rural England.

Randi Kaarhus is Associate Professor at the Department for International Environment and Development Studies at the Norwegian University of Life Sciences. During the last decade she has been involved in research, consultancies and development cooperation in Mozambique, Malawi and Tanzania, with a particular focus on resource management, formalisation of land rights and women's rights to land.

Tamara Kudaibergenova is a pharmacologist with an interest in the medicinal properties of plants and folk remedies. She also has an extensive knowledge of Kyrgyz cultural traditions. In recent years her post-doctoral work has enabled her to pursue her interests in bioethics, culture and decision-making. She is currently Leverhulme Trust Visiting Research Fellow at the University of Cumbria, where she is looking at cultural influences on decision-making in Europe and Central Asia.

Lyn Leader-Elliott is Adjunct Senior Lecturer in Cultural Heritage and Tourism at Flinders University in South Australia. Her interest in the different constructions given to 'sense of place' began when she lived in the Barossa region of South Australia and worked with a team of residents to reshape the way the cultural identity of the region was represented in the tourism marketplace. She carried this interest through into her teaching and research after joining Flinders University in 2000. She is committed to working with communities, heritage professionals and the tourism industry to achieve positive outcomes for all sectors.

Ellie Lindsay is a Researcher in the Wildlife Conservation Department at the University of Cumbria. She is currently using an interdisciplinary method to assess the effects of conserva-

tion intervention on oil palm estates in South East Asia. Prior to this, she worked as a research assistant and conservation volunteer in South and Central America and parts of South East Asia.

Lois Mansfield is Quality Group Lead for Outdoor Studies at the University of Cumbria. She is a geographer whose research interests include upland agriculture and the environment, footpath erosion and countryside management. She sits on various professional committees advocating the continuity of hill farming and she has recently completed a textbook entitled *Upland Agriculture and the Environment*.

Rhiannon Mason's research interests include cultural theory, museological history, new museology, and museum representations of cultural identities. Her work to date has focused on two main areas: national museums and national identities, and museological theory relating to issues of representation, communication, identity, diversity, and history curatorship. In 2007, she published a major single-authored book on the National Museums of Wales, which also examined debates about identity in relation to its collections. This work has led her to new research interests in Englishness and Britishness; the relationship between government, politics, museums and galleries; and how museums and galleries contribute to public perceptions of place, belonging, and identity. She recently worked on a major research project to explore the relationship between identity, place, and art, working on the redevelopment of the Laing Art Gallery's 'Art on Tyneside' display. She is Director of the International Centre for Cultural & Heritage Studies at Newcastle University.

Doreen Massey is Emeritus Professor of Geography at the Open University. She has long-term interests in the theorisation of 'space' and 'place' and in demonstrating the importance to both everyday life and wider politics of how we conceptualise both space and place. Empirically her work has engaged with a critique of current forms of globalisation, issues of regional uneven development, and of the city. In all of this the aim has been to work between, and to show the relationship between, philosophical and conceptual issues on the one hand and the directly political on the other. Current work on *Voices of Places* broadens this out to ask what role there might be in this globalised world for a radical politics of place. Since 2007 she has also been working in Venezuela, where her concept of power-geometry has been adopted as a means of thinking through the programme of decentralisation and equalisation of political power. In particular this involves affording the possibility of giving a meaningful political voice to both poorer regions and the previously excluded within the cities. Her most recent books are *For Space* (2005) and *World City* (2007/2010).

Owen Nevin is Head of the National School of Forestry at the University of Cumbria and is a member of the Board of Governors of the Society for Conservation Biology. He is a population and behavioural ecologist specialising in large mammals and forest ecosystems. He has worked extensively with brown bears in North America and his studies of bear-viewing ecotourism were the first to demonstrate quantifiable direct benefits of ecotourism for the species being viewed.

Vincent O'Brien is an ethnographer and filmmaker who is interested in how participatory visual communication can help provide insights into the complex dynamics of everyday life, culture, environment, health and well-being. His work with Kenesh Dzhusupov and Tamara Kudaibergenova in Kyrgyzstan inspired him to establish *Visible Voice*, a participatory visual ethnography project working with communities living in the remote mountain villages of Kokjar and

Tolok. Today *Visible Voice* projects are also active in Rocinha, Brazil's largest favela community, and with refugees, asylum seekers and other migrant communities in the North West of England.

Andrew Ramsey is a principal lecturer in conservation biology and research coordinator at the University of Cumbria. Trained as a horticultural entomologist, his early academic career was spent teaching a wide range of agriculturally focused programmes. He has a broad range of teaching and research interests but is primarily interested in conservation of biodiversity in cultural landscapes. He is especially interested in developing strategies for maximising the total economic value of cultural landscapes and ensuring that the combined worth of culture and biodiversity are not ignored.

Carol Richards is a post-doctoral fellow in the School of Social Science at the University of Queensland, Brisbane, and was previously a Lecturer in Human Geography at Aberystwyth University. Her research interests focus on the sociology of agriculture and food and the political economy and culture of sustainability, including current research on the role of supermarkets in the food supply chain.

Maggie Roe is Senior Lecturer and Convenor of the Landscape Research Group, School of Architecture, Planning & Landscape, Newcastle University. She joined Newcastle University in 1994 following work in practice and research at the Graduate School of Design, Harvard University. She has experience on a wide range of multi-disciplinary research and consultancy landscape projects. Her research focus is generally on landscape planning and sustainability with a special focus on participatory landscape planning, cultural landscapes and landscape change. Recent research includes assessment of UK policy relating to the implementation of the European Landscape Convention (ELC). She has worked in Europe, North and South America, Bangladesh, China and India. Research and project funding bodies she has worked with include ESRC, UNESCO, British Council/DfID, DEFRA, SNH, Natural England, English Nature, The Forestry Commission and the Environment Agency. She is a Director of the Landscape Research Group Ltd and, as editor of the international peer-reviewed journal *Landscape Research*, she has helped to focus attention within the journal onto cultural landscape issues.

Jennifer Rogers is an interdisciplinary researcher in the National School of Forestry at the University of Cumbria. Her background is in ecology and her recent work has focused on community renewable energy projects in rural areas, looking at social and environmental aspects of their development and impacts.

Eunice Simmons is currently Dean of the School of Animal, Rural and Environmental Sciences at Brackenhurst Campus, Nottingham Trent University. Her earlier academic career took her to Wye College, University of London, the National School of Forestry, UCLAN and the University of Cumbria, where she led programmes and departments focused on the management and conservation of habitats, landscapes and natural resources. Her work is increasingly centred on enabling demonstrations of the wise application of technologies; enhancing knowledge of interdependent production and conservation systems; and sharing her appreciation of how access to nature is fundamental to our well-being.

Mary-Ann Smyth is a rural consultant based in south-west Scotland. One of the founders of the Crichton Carbon Centre (Dumfries), Mary-Ann has nearly 20 years' experience in rural and environmental policy, assessment and review. She specialises in sustainable development and

the rural environment, and works at a strategic level for government, conservation agencies and partnerships. She also works at a practical level in developing various regional initiatives and networks. She has a PhD in volcanology and an MA in geographical science.

David Storey is a Senior Lecturer in Geography at the University of Worcester. He has research interests in both political geography and rural geography. David has extensive research expertise in rural socio-economic change, rural development policies and the interconnections between place, identity and territory. He has explored the utilisation of community-based partnership responses to developmental problems in rural areas in both Ireland and Britain, the use of local heritage in rural place promotion, and geographies of national identity. His published work includes *Territories. The Claiming of Space* (2 edn, Routledge, 2012).

John Studley is an ethno-forestry consultant, a Fellow of the Royal Geographical Society and a Chartered Geographer. He has a PhD in Geography, an MA in Rural Social Development and Diplomas in Forestry, Cross-cultural Studies and Theology. He has spent most of his life in High Asia working among animistic mountain people groups. His research interests include: ethno-forestry, indigenous knowledge systems and epistemologies, natural sacred sites and landscapes, economies of reciprocity, spiritual-based paradigms of nature conservation, indigenous or native science, shamanic environmental accounting, spirits of place, polyphasic cultures, endogenous development and forest-care, knowledge-brokerage, indigenous forest values (including place attachment), indigenous acculturation and post-modern forest-care paradigms.

Peter Swain is Head of Visitor Services for South East Alberta Provincial Parks. He completed a Masters by Research at the University of Central Lancashire where his research ('The value of watchable wildlife: measuring the impacts of bear viewing in British Columbia') was supervised by Dr Owen Nevin. He has worked extensively as a naturalist guide in Western Canada and was General Manager of Knight Inlet Lodge, Canada's premier bear-viewing destination.

Ian Thompson is Reader in Landscape Architecture in the School of Architecture, Planning & Landscape at Newcastle University, where he is currently the School's Director of Postgraduate Research and Internationalisation. He is also a Chartered Landscape Architect and Town Planner. His research has been mostly within the fields of landscape design history and theory. His book *Ecology, Community and Delight*, based upon his PhD research into the value systems of landscape practitioners, won a Landscape Institute Award (communications category) in 2000. Ian also has an interest in heritage and in cultural landscapes. His study of the creation of the gardens of Versailles was published as *The Sun King's Garden* (Bloomsbury, 2006) and was Highly Commended in the Landscape Institute Awards of 2007. His most recent book, *The English Lakes: a History* (Bloomsbury, 2010) was shortlisted for the Portico Prize, a major literary award for books connected with the North of England.

Mark Toogood is head of Geography at the University of Central Lancashire. His research interests are in the historical geographies of ecology and nature conservation in Britain and in the history and effects of colonial natural sciences in East Africa. He is an Honorary Research Fellow at the Centre for the Study of Environmental Change at Lancaster University, and is also a board member of the non-governmental organisation The Maasai Centre for Field Studies, which is owned and run by members of the Kuku Group Ranch near Kimana in southern Kenya.

Suzie Watkin is a Research Associate in the Wales Institute of Social and Economic Research, Data and Methods (WISERD) in the Institute of Geography and Earth Sciences at Aberystwyth University. She contributes to the 'Knowing Localities' programme of WISERD, developing new perspectives on understanding the role of locality in contemporary social and economic relations, with a particular focus on Mid and West Wales. Her previous research has explored rural youth employment and social exclusion and rural protest.

Andrew Weatherall grew up in a place where there were more lampposts than trees. Once he worked this out, he headed north to a place where there are more woodlands than car parks. Now he teaches and researches in the National School of Forestry at the University of Cumbria.

Chris Whitehead leads the Art Museum and Gallery Studies programme at Newcastle University's International Centre for Cultural & Heritage Studies. His research activities focus on both historical and contemporary museology. He is the author of *The Public Art Museum in Nineteenth-Century Britain* (Ashgate, 2005), *Museums and the Construction of Disciplines* (Duckworth, 2009) and *Interpreting Art in Museums and Galleries* (Routledge, 2011). In addition to this he has interests in the relations between art, place and identity in museum representations which he has been able to develop through work on the 'Northern Spirit' permanent display at the Laing Art Gallery, Newcastle.

Michael Woods is Professor of Human Geography at Aberystwyth University. His research ranges across the field of rural geography, including work on rural politics and protest, rural community governance, and globalisation and rural localities. Current projects focus on developing Europe's rural regions in the era of globalisation (DERREG), and on Australian farmers as transnational actors. His authored books include *Rural* (Routledge, 2010), *Rural Geography* (Sage, 2005) and *Contesting Rurality: Politics in the British Countryside* (Ashgate, 2005), and the edited volume *New Labour's Countryside: Rural Policy in Britain since 1997* (Policy Press, 2009).

Index

Addison, Joseph 26
Amboseli National Park, Kenya 265, 266
Angel of the North 135, 195
Appleby Horse Fair 46
Art on Tyneside 133
Art Galleries
 as democratic space 139
 local knowledge and sense of place 137–9
 as nexus 134
 and polyvocality 139
 and relationship to place 134–7
Attention Restoration Theory (ART) 109, 110
Australian Collaborative Research Centre for
 Sustainable Tourism 209
Authenticity
 of place experience 24
 and nature tourism 273

Baldwin, Stanley 16
Balkans and territory 15, 16
Barossa, South Australia 207–15
Barossa Valley Wall Hanging 207, 213–15
Bears (and place-making) 271–6
Bear viewing, tourism and economy 272–4
'Beast of Bodmin Moor' 195
Biodiesel consumption 304
Biodiversity conservation and communities
 264–5, 291–9
Birdwatching
 and place 169–75
 as ritual 171
Borneo 303–10
Borrowdale, Lake District 37
Bristol Docks 124
British East Africa 262
Brontë, Emily and Charlotte 36
Brown, 'Capability' 165
Burke, Edmund 26

Caldewgate (Paddy's Market) 49, 50

Carr Foundation and community-based
 development 294, 299
Castlefield, Manchester 123
Chimanimani Transfrontier Conservation Area
 291
Climate change (and place) 279–87
Co-ethnography as research method 43–4
Coleridge, Samuel Taylor 24
Collaborative and participative ethnography
 79–81
Commission for Rural Communities 99
Common Ground 236
Commons Registration Act 2005 71
Community connections and sense of place
 71–3, 207–15
Community-based conservation 264, 297
Community types 199
Connectedness (types of) 70
Conservation and development 264, 291–9
Cooper, A. A. (Earl of Shaftesbury) 160
COST Action 39 107, 110
Costa Rica 271
Crosthwaite, Peter 30
Cultural Landscapes, tourism representations
 207–15
Cumberland, Richard 27
Cumbria 33–40, 96, 99
 literature and place 33–40
 regional identity 34

Debray, Régis 181, 183
Defoe, Daniel 23, 33
Dyaks (Borneo) 307

Ecomuseums 240–2
 Definition 241
 Indicators 241
 Soga Ecomuseum, China 242
Ecomuseology 235, 241–2
Ecotourism 271–6, 291–9

Eco-vernacular 120
Ecovillage Community Sustainability
 Assessment 121
'Englishness' 57
Explorers and sense of place (Guyana) 251–2
European Landscape Convention 191, 196,
 199, 202

Farming, place and identity 12–14, 67–76
Farming
 economy 57–65
 hill farming 67–76
 organic 64
Flintoff, Joseph 31
Food tourism 60
Footpaths (as traces) 31
Fordhall Community Land Initiative
 (Shropshire) 64
Forest Education Initiative (FEI) 111
Forests
 and enhancement of education 109
 meanings 108
 people and health 107–113
 as places of good and evil 112
 as restorative spaces 110–112
 social forests 108
Forest Schools Movement 107
Forestry Commission (UK) 108
Fortress conservation 264, 293
FRELIMO 294

Gather (of sheep) 69
Gardens and parks 159–67, 169–75
 and conservation 169
 as contact zone with nature 173
 definitions 162
 connections to home and identity 169
 as hybrid places 174–5
 as personal space 172
 relation to 'nature' 159–60
 as representations of nature 160
 and place making 165–7
 scale and landscape 164
 significance of 162–4
 styles and authenticity 163
Genius loci 160–61
Georgetown, Guyana 253
Globalisation and place 14
Gorongosa National Park, Mozambique 291

Grand Tour 25
Gray, Thomas 34
Green movement 25
Guthrie, Woody 17
Gypsies, identity and place 43–51, 45–6
 family ties 46, 50
 horses as symbols of identity 47
 Roma gypsies 46
 Sense of self 47

Hall, Sarah 39
Hareshaw Linn, Northumberland 237
Hefting 68–9
Heritage
 alternative paradigm 235
 authorised heritage discourse 235, 237
 'everyday' heritage 236
 indigenous management of 253
 industry 14
 meanings 235
 of the mundane 237
 as process 238, 240, 240–2
 and sense of place 235–43
Heritage Lottery Fund 236
Hillhouse, William 252
Hoyt, Desmond 253
HRH Prince Charles, Prince of Wales 253
Human rights (in Borneo) 303, 308
Humboldt, Alexander von 252

Identity
 theoretical perspectives 11
 and local belonging in Tibet 220–2
 and lineages 299
 and ancestors 299
Image Mill, The 177–87
Indigenous cultural landscapes 208
Indigenous knowledge 265
Insiderness/insideness 2, 238, 239
Intangible cultural landscapes (Australia) 208
Intangible Cultural Heritage 236, 251
Intergovernmental Panel on Climate Change
 279
International Union for the Conservation of
 Nature (IUCN) 264
Iwokrama International Centre for Rainforest
 Conservation and Development 250

Jagan, Cheddi 253

Katmai National Park, Canada 273
Kavanagh, Patrick 13
Kent Downs Jigsaw Project 200
Kenya (and the Maasai) 261–8
Kham and Khamba peoples, Tibet 223–6
Khutzeymateen Grizzly Bear Sanctuary 272
Kimana Wildlife Sanctuary, Kenya 265, 266–7
Kirkby New Town 119
Kyoto (gardens) 160, 162
Kyrgyzstan and Kyrgyz villages
 Ancestral space 90–1
 Ethnoregionalism 85
 Issyk Kul 82
 Kyrgyz 'Map of the World' 86
 Naryn 82
 Nomadic 'homeland' 84
 Place, culture and everyday life 79–91
 Place and ancestral space 82
 Sacrality and place 85–6
 Sacred places 89–90
 Sense of place 82–91
 Spiritual qualities of localities 83
 Tolok 84
 Yurts and their significance 86–8

Laing Art Gallery, Newcastle upon Tyne 133
Lake District 23–31, 33
 literature and place 33–40
 Romantic poets 24
 and the romantic sublime 25, 34
 scenery and place 23–31
 World Heritage Site 24
Land
 territory and identity 11–8, 62–4
 and rural people 57–65
Landscape
 change 199–200
 characteristics and sense of place 191–2
 character and interaction 195–6
 cultural services of 197
 generic 15
 imagery 16
 imaginary 266
 lost landscapes 197
 mapping 28–9
 multi-dimensions of 192
 and participatory planning 200–1
 as perceived space 194

as provider 196–8
scale 191–203
scale and sense of place 194–5
spiritual dimensions 110, 208, 251
as therapy 113
as tool 307
veneration (of landscape) 15
Le Corbusier 181, 182, 185
Leopold Report (US National Park management) 274
Lepage, Robert 177
Lifescapes
 concepts of 145–6, 261
 people and place 155
 of everyday places 154
 of sex workers 145–55
Lifeworlds 261, 307
Lifestyle migrants (incomers) 63–64
 and revival of traditions 64
Light, William 208
Lussier, René 186

Major, John 16
Maasai (and place) 261–8
 Stereotypes and self-image 268
McLuhan, Marshall 181, 183
McNeil River Game Sanctuary, Alaska 272
'Memory talk' 238, 240–1, 243
Mozambique 291–9

National anthems and place 16
Natural Character Areas (NCA), England 195, 197
Nature
 as contested concept 170
 deficit disorder 108
 fear of 108
 forms of 159–60
 as heritage 238
 relationship to people 163, 169–75, 308
 sense of 291–3
 tourism 271–6
Newcastle upon Tyne 198
New Islington, East Manchester 120, 125–6
Nomadism 45–51
 and sense of place 220
 as state of mind 45, 51
 in Kyrgyzstan 79–91

North Pennines Area of Outstanding Natural
 Beauty 237
North Pennines UNESCO Geopark 237
North Rupununi District Development Board
 250
Northern Spirit 113

Oil Palm (development in Sabah) 303–10
Orangutan 303, 306
Ordnance Survey 29

Palm Oil 303–10
Parks for People programme 166
Participatory planning 200–1
Participatory Rural Appraisal (PRA) 201
Peatlands (and attribution of value) 279–87
Picturesque and place 24–25
Place
 abandonment and reuse 127–19
 and apprehension 261
 artists and place reclamation 128
 attachment 2–4, 220, 229
 communities of 199
 'congruent continuity' 238–9
 creating urban place 122–7
 and cultural characteristics 238
 dependency 2–4
 as doing 309
 envisioning 135–7
 explorers and colonisers 251–2
 as framing device 140–2
 geographical communities of 298
 in gardens and parks 159–67
 and *genius loci* 160–1
 and global detachment 262
 graphic representation 30–1
 gypsies and travellers 43–51
 and health 107–13
 and hill farming identities 67–76
 and identity 2–4
 images of 177–87
 and indigenous epistemologies 229, 306
 and kinship activities 43, 48
 linkages 14, 294
 and literature 33–40
 and local engagement 262
 local knowledge and consultation 121
 mapping 193–4
 marketing 210

 and memorable urban places 119–30
 narratives 44
 and national anthems 16
 and nostalgia 238
 people and locale 291
 physical attributes and inhabitants 36, 37,
 39
 and pride 122
 as product 119
 and renewable energy 93–102
 renewal via successful urban
 planning 119–30
 restorative values of natural places 107–13
 sacred places 293
 and shared cultural values 48, 97–102, 251
 spiritual values 304
 and technology 95
 theoretical perspectives 1–5, 11–14
Plaid Cymru 15
Pope, Alexander 160
Product of Designated Origin (PDO) 73
Product of Geographical Indication (PGI) 73
Project for Public Spaces 166
Public Art Galleries and sense of place 133–42
Public Parks (in Britain) 166

Quebec City 177–87
 Chateau Frontenac 178
 Champlain, Samuel de (City founder) 181
 'City as museum' 178

Rainforests 249–59, 303–10
Raleigh, Sir Walter 251
Register of Parks and Gardens of Historic
 Interest 166
REMANO 294
Renewable Energy, communities and place
 93–102
 Community attitudes towards development
 93–4
 Community-based RE development
 96–102
 Place and attitudes towards development
 94–6
Rupsha Thana, Bangladesh 201
Rough Fell Sheep Breeders Association 73
Rural crafts 61
Rural England
 Characteristics of 58–62

Communities and connections 64
Diversity 57
Economy 57
Pressures on rural communities 98
Rural people, land, identity 57–65
Rural tourism 60
Ruskin, John 24, 36

Sabah, Borneo 303–10
Salmon 272
Sandby, Thomas and Paul 29
Sauer, Carl 207
Scenery
 and beauty 27
 Lake District 23–31
 changes and place 27
Schomburgk, Robert 252
Sedentarism 44
Sense of Place
 Amerindian notions of 250–1
 ancestors and belonging 239, 291, 313–18
 and collective identity 238–9
 and connections 71–3
 and cultural landscapes 207–15, 219
 definitions and concepts 120–1, 219–20,
 236–7, 249
 and distinctiveness 67, 236, 237–40
 as economic landscape 251
 and 'everyday' heritage 236
 and everyday lives 250, 261, 268
 and genius loci 160–1
 geographical 67, 73
 and health 107–13
 and heritage 235–43
 and immersion 313–18
 intangible aspects (upland farming) 68–73
 and landscape interactions 196, 219
 interpretations of 192
 in Kyrgyzstan 82–91
 and landscape scale 191–203
 layering 249
 and lived experience 67
 and marketing 210
 and natural resource management 193
 and networks (upland farming) 71–3
 and recovery of urban environments 120
 of residents 100–2
 and rootedness 313–18
 and sacred places 293

scale, perception, representation 192–4,
 207–15
 and scenery 23–31
 shifts in 304
 and social capital 70–72
 and sustainable tourism 249–59
 theoretical perspectives 1–5, 67, 120–1
 and tourism 207–15
 use in marketing products 73
 and upland farming 67–73
 visual sense of place 133–42
 and walking 23–31
Shell Oil (development and impact on place)
 17–18
Shenzhen, China 198
Shepherds' meet (in relation to place) 70
Schwartz, Martha 162
Smith, John 'Warwick' 29
Southey, Robert 24
Stress Reduction Theory 109, 110
Survival Sex Work 145–155
Sustainable tourism
 collaborative and participatory approaches
 259
 and biodiversity conservation 253, 261
 and conservation of cultural landscapes 251
 and forest management 275–6
 ecotourism 255, 271–6, 291–9
 indigenous tourism 257
 in Iwokrama and North Rupununi 255
Swynnerton Plan (1954–59) 263

Tanzania (and the Maasai) 261–8
Terrestrial Carbon Cycle 280–1
Territorial cults in Tibet 219–30
Territory
 cults and sense of place 219–30
 defining communities 296
 and identity 14–18
 generic 15
 and nation 14–17
Tibet 219–30
 cultural threats and revitalisation 223–5
 emotional attachment to place 229, 230
 and Han Chinese 229
 place names 229
Tibetan identity 221
Tourism
 in the Barossa Valley 207–15

bear-viewing 271–6
 in British Columbia 271–6
 and construction of place identity 258
 destination marketing 208
 and destruction of sense of place 258
 in Guyana 249–59
 in Kenya 265–8
 place sensitive tourism 209
 safari tourism 261, 265–8, 291–9
 wine tourism 213
Tourism South Australia (TSA) 211
Tourismscape 266
Trollope, Joanna 57
Tsavo National Park, Kenya 265
Turner, W. M. 28

Uluru-Katatjuta National Park, Australia 208
Upland farming
 and climate change 279–87
 intangible cultural heritage 68–73
 loss and consequences 74–6
 and social capital 70
 systems and sense of place 67–76
Uplands – values and sense of place 281–2
 as carbon stores 282–5
 and carbon trading 286–7
 and climate change 279–87

Urban Parks Initiative 166
Urban Parks Programme (Heritage Lottery
 Fund) 166

Versailles 163, 164
Visible Voices 79

Wildlife-friendly farming (WFF) 306
Wainwright, Alfred 30
Walking as research methodology 24
Walpole, Hugh 37–8
Welsh Nationalists 15
West, Thomas 23
White, Gilbert 172
Wilderness 23, 267, 271–6, 274
Wordsworth, Dorothy 24
Wordsworth, William 24, 34
World Bank 304
World Class Places 127
Worldwide Fund for Nature (WWF) 264

Yellowstone National Park 273
Yul lha (protective deities) 221, 227
Yurts 79–81, 82, 86–9

Heritage Matters

Volume 1: The Destruction of Cultural Heritage in Iraq
Edited by Peter G. Stone and Joanne Farchakh Bajjaly

Volume 2: Metal Detecting and Archaeology
Edited by Suzie Thomas and Peter G. Stone

Volume 3: Archaeology, Cultural Property, and the Military
Edited by Laurie Rush

Volume 4: Cultural Heritage, Ethics, and the Military
Edited by Peter G. Stone

Volume 5: Pinning Down the Past: Archaeology, Heritage, and Education Today
Mike Corbishley

Volume 6: Heritage, Ideology, and Identity in Central and Eastern Europe:
Contested Pasts, Contested Presents
Edited by Matthew Rampley

Volume 7: Making Sense of Place: Multidisciplinary Perspectives
Edited by Ian Convery, Gerard Corsane, and Peter Davis

Volume 8: Safeguarding Intangible Cultural Heritage
Edited by Michelle L. Stefano, Peter Davis, and Gerard Corsane

Volume 9: Museums and Biographies: Stories, Objects, Identities
Edited by Kate Hill

Volume 10: Sport, History, and Heritage: Studies in Public Representation
Edited by Jeffrey Hill, Kevin Moore, and Jason Wood

Volume 11: Curating Human Remains: Caring for the Dead in the United Kingdom
Edited by Myra Giesen

Volume 12: Presenting the Romans:
Interpreting the Frontiers of the Roman Empire World Heritage Site
Edited by Nigel Mills

Volume 13: Museums in China: The Politics of Representation after Mao
Marzia Varutti